Virtual Art

Leonardo

Roger F. Malina, series editor

Virtual Art

From Illusion to Immersion

Oliver Grau

translated by Gloria Custance

The MIT Press
Cambridge, Massachusetts
London, England

This book is a translation of a revised and expanded version of a book entitled *Virtuelle Kunst in Geschichte und Gegenwart: Visuelle Strategien* (Berlin: Reimer, 2001).

This book was set in Garamond 3 and Bell Gothic on 3B2 by Asco Typesetters, Hong Kong.

Printed and bound in the United States of America.

Library of Congress Cataloging-in-Publication Data

Grau, Oliver.
 [Virtuelle Kunst in Geschichte und Gegenwart. English]
 Virtual art : from illusion to immersion / Oliver Grau. — [Rev. and expanded ed.]
 p. cm. — (Leonardo)
 Includes bibliographical references and index.
 ISBN 0-262-07241-6 (hc : alk. paper), 0-262-57223-0 (pb)
 ISBN-13: 978-0-262-07241-0 (hc : alk. paper), 978-0-262-57223-1 (pb)
 1. Panoramas. 2. Virtual reality in art. 3. Computer art. 4. Art and electronics. I. Title. II. Leonardo (Series) (Cambridge, Mass.).
 N7436.5 .G7313 2003
 751.7′4′01—dc21 2002067829

10 9 8 7 6 5 4

Contents

Series Foreword

The cultural convergence of art, science, and technology provides ample opportunity for artists to challenge the very notion of how art is produced and to call into question its subject matter and its function in society. The mission of the Leonardo book series, published by the MIT Press, is to publish texts by artists, scientists, researchers, and scholars that present innovative discourse on the convergence of art, science, and technology.

Envisioned as a catalyst for enterprise, research, and creative and scholarly experimentation, the book series enables diverse intellectual communities to explore common grounds of expertise. The Leonardo book series provides a context for the discussion of contemporary practice, ideas, and frameworks in this rapidly evolving arena where art and science connect.

To find more information about Leonardo/ISAST and to order our publications, go to Leonardo Online at ⟨http://mitpress.mit.edu/Leonardo/⟩ or send e-mail to ⟨leo@mitpress.mit.edu⟩.

Joel Slayton
Chairman, Leonardo Book Series

Book Series Advisory Committee: Pamela Grant-Ryan, Michael Punt, Annick Bureaud, Allen Strange, Margaret Morse, Craig Harris.

Leonardo/International Society for the Arts, Sciences, and Technology (ISAST)

Leonardo, the International Society for the Arts, Sciences, and Technology, and the affiliated French organization Association Leonardo have two very simple goals:

1. to document and make known the work of artists, researchers, and scholars interested in the ways that the contemporary arts interact with science and technology, and

2. to create a forum and meeting places where artists, scientists, and engineers can meet, exchange ideas, and, where appropriate, collaborate.

When the journal *Leonardo* was started some 35 years ago, these creative disciplines existed in segregated institutional and social networks, a situation dramatized at that time by the "Two Cultures" debates initiated by C. P. Snow. Today we live in a different time of cross-disciplinary ferment, collaboration, and intellectual confrontation enabled by new hybrid organizations, new funding sponsors, and the shared tools of computers and the Internet. Above all, new generations of artist-researchers and researcher-artists are now at work individually and in collaborative teams bridging the art, science, and technology disciplines. Perhaps in our lifetime we will see the emergence of "new Leonardos," creative individuals or teams who will not only develop a meaningful art for our times but also drive new agendas in science and stimulate technological innovation that addresses today's human needs.

For more information on the activities of the Leonardo organizations and networks, please visit our Web site at ⟨http://mitpress.mit.edu/Leonardo⟩.

Roger F. Malina
Chairman, Leonardo/ISAST

Foreword

Virtual Art: From Illusion to Immersion by Oliver Grau is a comparative historical analysis of how virtual art fits into the art history of illusion and realism. Offering an insightful study of the evolution of immersive visual spaces, Grau reexamines the term *image* to reflect on the implications of computer-simulated virtual environments.

Grau describes virtuality as an essential relationship of humans to images and demonstrates how this relationship is evidenced in both old and new media of illusion. Postulating that the technological convergence of image and medium is driven by the desire for illusion, Grau describes the paradigm of virtuality as one of physical and psychological perception of essence manifested as a sensorial experience in the observer. Beginning with the Great Frieze in the Villa dei Misteri at Pompeii created in 60 B.C., Grau traces the aesthetic preconcepts of virtual art and connects them to the present state of new media, which incorporate real-time computation, sensorial interactivity, relational databases, distributed networks, knowledge engineering, artificial intelligence, telepresence, and artificial life functionality. It is an analysis that helps frame questions about the representational function of images and the paradoxical character of virtual reality. According to Grau, reflection on the applications of these technologies in virtual art reveals a hyperlogical and utopian quest for illusionism. *Virtual Art: From Illusion to Immersion* helps us to understand the implications of such desire.

A robust discourse on the topic of virtual art necessitates a multidisciplinary approach that is inclusive of art history, engineering, media and cultural theory, architecture, literature, computer science, and cinema.

Research for the book was done in close cooperation with artist/researchers Christa Sommerer and Laurent Mignonneau, Charlotte Davies, Monika Fleischmann and Wolfgang Strauss, Paul Sermon, Knowbotic Research, Maurice Benayoun, Simon Penny, Ken Goldberg, Seiko Mikami, Jeffrey Shaw, ART+COM, and Jane Prophet. *Virtual Art: From Illusion to Immersion* is informed by the philosophical texts of Descartes, Leibniz, Kant, Heidegger, Foucault, Benjamin, Arnheim, Baudrillard, Virilio, Levy, and Kittler. Grau also draws on texts by Margaret Morse, Michael Heim, Lev Manovich, Erkki Huhtamo, Martin Jay, Eduardo Kac, Roy Ascott, Michael Benedict, Machiko Kusahara, Marcos Novak, Arthur Kroker, Allucquère Rosanne Stone, Manuel De Landa, Norbert Bolz, and many others, contextualizing the book and the subject within contemporary and popular media cultures.

Joel Slayton

Acknowledgments

In 1998, while in Sao Paulo, I was approached by Roger Malina, who asked whether I would be interested in writing a book for the Leonardo series. It is thanks to Roger Malina and Doug Sery, my superb editor at MIT Press, that this project proceeded so smoothly and successfully to its completion. In Gloria Custance I found the ideal translator for my book; her breadth of knowledge is on a par with her creative skill with language. The fine editing and professionalism of Judy Feldmann accompanied me through all stages of production and guaranteed the quality of the final product.

I should like to express my thanks to friends and colleagues, who encouraged me and supported this project at a time when its realization appeared very distant indeed. For unstinting advice and suggestions in the course of many discussions, I thank Roy Ascott, Rudolf Arnheim, Richard Barbrook, Dominik Bartmann, Hans Belting, Claudia Benthien, Horst Bredekamp, Andreas Broeckmann, Annick Bureau, Wendy Coones, Edmond Couchot, Wolfgang Coy, Dieter Daniels, Robert Derome, Hans Dickel, Söke Dinkla, Scott S. Fisher, Stefan Germer, Ken Goldberg, Volker Grassmuck, Kilian Heck, Hans-Dieter Huber, Kathy Rae Huffman, Jon Ippolito, Jasdan Joerges, Martin Kemp, Eunji Kim, Friedrich Kittler, Stefan Koppelkamm, Herbert Lachmayer, Hannes Leopoldseder, Thomas Y. Levin, Thomas Macho, Iris Mahnke, Roger Malina, Peter Matussek, Anne-Sarah Le Meur, Matt Mirapaul, Joseph Nechvatal, Jack Ox, Joachim Paech, Christiane Paul, Ingeborg Reichle, Itsuo Sakane-san, Christine Schoepf, Doug Sery, Ludwig Seyfarth, Edward A. Shanken,

Yukiko Shikata, Christoph Tholen, Sherry Turkle, Will Vaughan, Martin Warnke, Tanja Weingärtner, and many other friends.

For their invaluable help and assistance in producing this book, I thank my assistants Anja Schmalfuss, Lena Bader, and Patrick Hutsch.

My special thanks are due to the artists, who accompanied me in my work on this book, found answers to my never-ending questions, directed discussions into innovative channels, and gave me access to so much unpublished material: Louis Bec, Maurice Benayoun, Luc Courchesne, Charlotte Davies, Monika Fleischmann, Franz Fischnaller, Agnes Hegedues, Jenny Holzer, Christian Huebeler, Eduardo Kac, Maja Kuzmanovic, Bernd Lintermann, Simone Michelin, Laurent Mignonneau, Seiko Mikami, Michael Naimark, Simon Penny, Daniela Alina Plewe, Daniel Sandin, Joachim Sauter, Paul Sermon, Jeffrey Shaw, Christa Sommerer, Wolfgang Strauss, and Yvonne Willhelm.

I am very grateful to the following institutions and their staff for providing help and support that far exceeded expectations and the call of duty, particularly, the Kunsthistorisches Seminar of the Humboldt-Universität Berlin, the Geheimes Staatsarchiv in Berlin, the archives of the Hochschule der Künste, Nationalgalerie, and Zentralarchiv in Berlin, the Centre Pompidou, Yukiko Shikata and Art Lab, Tokyo, Hypermedia Research Institute, London, CAiiA, Newport, IAMAS, Gifu, Gesellschaft für Mathematik und Datenverarbeitung, St. Augustin, Art+Com, Berlin, Fraunhofer Institute, Stuttgart, ZKM, Karlsruhe, ATR Lab, Kyoto, as well as Deutsches Kunsthistorisches Institut, Florence, National Library of Scotland, Bibliotheca Hertziana, Rome, and Warburg Institute, London. Many thanks are due to the computer centers of the universities of Hamburg and Berlin for the many years' use of their multimedia labs.

I should also like to express my gratitude to Goethe Institute/Internationes and the Young Academy of the Berlin-Brandenburg Academy of Sciences for the grants, which made this translation possible.

Virtual Art

1

Introduction

"The most elemental process of modern times is the conquest of the world as images."
—MARTIN HEIDEGGER, *Holzwege*, p. 92. Frankfurt: Klostermann (1980).

"Das Wahre hat keine Fenster. Das Wahre sieht nirgends zum Universum hinaus. Und das Interesse an Panoramen ist, die wahre Stadt zu sehen. . . .—Die Stadt im Hause. Was im fensterlosen Hause steht, ist das Wahre. [The interesting thing about the panorama is to see the true city—a city inside a building. What stands in the windowless building is the truth . . . (the truth has no windows; nowhere does it look out upon the universe.)]"
—WALTER BENJAMIN, *Das Passagenwerk. Gesammelte Schriften*, vol. 5, 2, p. 1008. Rolf Tiedemann (ed.). Frankfurt/Main: Suhrkamp.

What is virtual art? Never before has the world of images around us changed so fast as over recent years, never before have we been exposed to so many different image worlds, and never before has the way in which images are produced changed so fundamentally. To an unprecedented degree, so many utopian expectations are intertwined with so much skepticism. The scale of recent and current encroachment of media and technology into the workplace and work processes is a far greater upheaval than other epochs have known, and, obviously, it has also affected large areas of art. Media art, that is, video, computer graphics and animation, Net-art, interactive art in its most advanced form of virtual art with its subgenres of telepresence art and genetic art, is beginning to dominate theories of the image and art. We are experiencing the rise of the computer-generated, virtual spatial image to image per se, to images that appear capable of autonomous change and of formulating a lifelike, all-embracing visual and sensory sphere. As yet, digital art still exists in a state of limbo, rather like photography before Stieglitz. The evolution of media of illusion has a long history, and now a new technological variety has appeared; however, it cannot be fully understood without its history. With the advent of new techniques for generating, distributing, and presenting images, the computer has transformed the image and now suggests that it is possible to "enter" it. Thus, it has laid the foundations for virtual reality as a core medium of the emerging "information society." Since the end of the 1980s, new interfaces communicate three-dimensional images using the head-mounted display (HMD) or the more recently developed CAVE[1] (fig. 1.1). The suggestive impression is one of immersing oneself in the image space, moving and interacting there in "real time," and intervening creatively.

Virtual reality was discovered early on by artists, who appropriated it with their own methods and strategies. Through cooperation with many leading representatives of virtual image culture and their international media labs, but also extensive research in archives, this book rests on much unpublished source material. Media artists represent a new type of artist, who not only sounds out the aesthetic potential of advanced methods of creating images and formulates new options of perception and artistic positions in this media revolution, but also specifically researches innovative forms of interaction and interface design, thus contributing to the development of the medium in key areas, both as artists and as scientists.

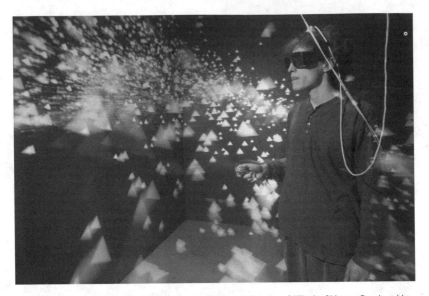

Figure 1.1 *CAVE*. Electronic Visualization Laboratory, University of Illinois, Chicago. Developed by Dan Sandin, Carolina Cruz-Neira, et al. By kind permission of Dan Sandin.

Art and science are once more allied in the service of today's most complex methods of producing images.

The new art media are also having far-reaching impacts on the theory of art and the image. In this context, this book endeavors, first, to demonstrate how new virtual art fits into the art history of illusion and immersion and, second, to analyze the metamorphosis of the concepts of art and the image that relate to this art. Art history, as the oldest discipline concerned with images, has the resources of a broad material base to analyze these concepts, including recent developments connected with computers. Although art history and the history of the media have always stood in an interdependent relationship and art has commented on, taken up, or even promoted each new media development, the view of art history as media history, as the history of this interdependent relationship that includes the role of artistic visions in the rise of new media of illusion, is still underdeveloped. Yet art's close relationship to machines in particular and technology in general, including the new media of images and their distribution, spans all epochs, from classical antiquity to the present day.

In many quarters, virtual reality is viewed as a totally new phenomenon. However, a central argument of this book is that the idea of installing

an observer in a hermetically closed-off image space of illusion did not make its first appearance with the technical invention of computer-aided virtual realities. On the contrary, virtual reality forms part of the core of the relationship of humans to images. It is grounded in art traditions, which have received scant attention up to now, that, in the course of history, suffered ruptures and discontinuities, were subject to the specific media of their epoch, and used to transport content of a highly disparate nature. Yet the idea goes back at least as far as the classical world, and it now reappears in the immersion strategies of present-day virtual art.

Further, it is the intention of this book to trace the aesthetic conception of virtual image spaces, their historical genesis, including breaks, through various stages of Western art history. It begins with the broad, primarily European tradition of image spaces of illusion, which was found mainly in private country villas and town houses, like the cult frescoes of the Villa dei Misteri in Pompeii, the garden frescoes in the Villa Livia near Primaporta (ca. 20 B.C.), the Gothic fresco room, the Chambre du Cerf, and the many examples of Renaissance illusion spaces, such as the Sala delle Prospettive. Illusion spaces also gained in importance in the public domain, as evidenced by the Sacri Monti movement and the ceiling panoramas of Baroque churches. One of the most exceptional vehicles for painted illusionism is the panorama, patented by Robert Barker in 1789. Paul Sandby's landscape room at Drakelowe Hall (1793) was a direct response to this invention. All these examples of image spaces for creating illusions are not, obviously, technically comparable with the illusions now possible with the aid of computers, which the user can experience interactively. However, this study shows clearly how, in each epoch, extraordinary efforts were made to produce maximum illusion with the technical means at hand. Before the panorama, there were successful attempts to create illusionist image spaces with traditional images, and after its demise—together with many artistic visions that never left the drawing board—technology was applied in the attempt to integrate the image and the observer: stereoscope, Cinéorama, stereoptic television, Sensorama, Expanded Cinema, 3-D, Omnimax, and IMAX cinema, as well as the head-mounted display with its military origins.

This book does not interpret virtuality per se as an anthropological constant, for then it would begin with the cave paintings of Cluvet, Altamira, and Lascaux. Instead, attention centers on 360° images, such as the

fresco rooms, the panorama, circular cinema, and computer art in the CAVE: media that are the means whereby the eye is addressed with a totality of images. This book engages with media in the history of art that concentrate on immersive image spaces.

The activation, or "domestication," of the human senses lay with changing forms of art and media; however, "the will to art" pursued comparable categories. The image spaces and media discussed here are the subject of many treatises, but never before have they been examined in the context of an art-historical analysis of the concept of immersion. So far, there has been no historically comparative or systematic theoretical approach to virtual realities. I endeavor to summarize and categorize existing work to present a coherent theoretical framework and analyze the phenomenologies, functions, and strategies of all-embracing image worlds to provide a historical overview of the idea of virtual reality. It is not a comprehensive history of this phenomenon nor of perception, although certain findings are of interest in this respect: it is a portrayal of the continuity of this idea and a characterization of its applications in the history of art.

The panorama demands special consideration for two reasons: first, this illusion space represented the highest developed form of illusionism and suggestive power of the problematical variety that used traditional methods of painting. The panorama is also exemplary in that this effect was an intended one, a precalculated outcome of the application of technological, physiological, and psychological knowledge. With the contemporary means at hand, the illusion space addressed the observer as directly as possible; this latter was "implicit." Second, the study of the panorama can help to lay the foundations of a systematic comparison, where the metamorphosis of image and art associated with computer-aided virtual reality emerges in a clearer light. The case study presented here of perhaps the most important German panorama (and political event), *The Battle of Sedan* by Anton von Werner (1883), has not been analyzed in this detail before and reveals in exemplary fashion the strategies for removing boundaries and psychological distance between observer and image space. Further, the normative forces of economics and their constraining effect on the role of the artist is examined, together with the artist's position within the configuration of coworkers, image techniques, and the interests of the client. How and with what effect does the strategy of immersion operate here, which methods are implemented, in what intensity and with which in-

tentions vis à vis the audience? The in-depth depiction of these mechanisms is, at the same time, a prehistory of the immersive procedures of computer virtual reality.

Integration of virtual reality into the history of immersion in art must not lead to disregard of the specific characteristics of virtual computer art, which, as Theodor W. Adorno warned, may be negated in the interests of drawing comparisons: "All the same, nothing is more damaging to theoretical knowledge of modern art than its reduction to what it has in common with older periods. What is specific to it slips through the methodological net of 'nothing new under the sun'; it is reduced to the undialectical, gapless continuum of tranquil development that it in fact explodes.... In the relation of modern artworks to older ones that are similar, it is their differences that should be elicited."[2] It is precisely to crystallize this specificity, this difference, that the second focus of this study engages with the metamorphosis of the concept of the image under the conditions of computer-generated virtual image spaces as driven by, for example, interface design, interaction, or the evolution of images.

In virtual reality, a panoramic view is joined by sensorimotor exploration of an image space that gives the impression of a "living" environment. Interactive media have changed our idea of the image into one of a multisensory interactive space of experience with a time frame. In a virtual space, the parameters of time and space can be modified at will, allowing the space to be used for modeling and experiment. The possibility of access to such spaces and communication worldwide via data networks, together with the technique of telepresence,[3] opens up a range of new options. Images of the natural world are merged with artificial images in "mixed realities," where it is often impossible to distinguish between original and simulacrum.

The media strategy aims at producing a high-grade feeling of immersion, of presence (an impression suggestive of "being there"), which can be enhanced further through interaction with apparently "living" environments in "real time." The scenarios develop at random, based on genetic algorithms, that is, evolutionary image processes. These represent the link connecting research on presence (technology, perception, psychology) and research on artificial life or A-Life (bioinformatics), an art that has not only reflected on in recent years but also specifically contributed to the further development of image technology.

In this book, examples of artistic illusion spaces are discussed in depth and against the outline of this historical tradition, the transformation engendered by the digital media, which has enduring effects on the internal structure of the relationship between artist, work, and observer, and is exemplified by analyses of contemporary virtual reality installations. Analogies and principal differences in art production, image/work phenomenology, and audience reception are revealed. This comparative approach is best suited to provide insights into the aesthetic innovations of this medium, with its growing societal and artistic importance, and the new status of the image under the hegemony of the digital. Recent but already well-known works of virtual computer art are integrated here for the first time within a broad art historical context. The intention is not to establish this young branch of art's credentials in terms of historical legitimation but rather to demonstrate the recurring existence of the intermedia figure of immersion together with its intentions and problematic potential. I am not suggesting that virtual reality should be viewed in terms of a prehistory of logical developments leading up to it; what is described here are individual and varied stages, each representing in contradictory, disparate, or dialectic form a new status of perception vis à vis older media. With these historical foundations, the study aims to facilitate comparison and enable critique of contemporary developments, emancipated from current media propaganda, both futuristic and apocalyptic—no more, no less. The approach is intentionally broad, linking historic media art with digital art in the hope of better understanding the quality of the new art form and contributing to the emerging science of the image by distilling some basic aspects of a history of media of illusion and immersion.

In a historical context, this new art form can be relativized, adequately described, and critiqued in terms of its phenomenology, aesthetics, and origination. In many ways, this method changes our perception of the old and helps us to understand history afresh. Thus, older media, such as frescoes, paintings, panoramas, film, and the art they convey, do not appear passé; rather, they are newly defined, categorized, and interpreted. Understood in this way, new media do not render old ones obsolete, but rather assign them new places within the system.[4]

Interactivity and virtuality call into question the distinction between author and observer as well as the status of a work of art and the function

of exhibitions. Therefore, it is important to determine which character-istics of virtual image systems distinguish them from images of traditional artworks or cinema. It is necessary to explore and analyze the new aesthetic potential that technology has made possible. What new possibilities of expression are open to the artist working with computer-aided, interactive, real-time images? What constraints does the technology impose on artistic concepts? What new potential for creativity does it make available to the artist and to the observer? How can the new relationship between artist and observer be characterized, and which artistic strategies result from this situation? How do interaction and interface design affect reception of the work? And finally, on the basis of knowledge of art history, how should the concepts of contemporary virtual art be assessed?

This book does not attempt to equate historic spaces of illusion with contemporary phenomena of virtual reality in order to construct a histori-cal legitimation of the latest trends in art. Instead, the new art of illusion is investigated and relativized historically and, in a further step, analyzed and assessed. My contention is not that virtual art from the computer is always directed at maximizing illusion. However, it must be said that it does operate within the energy field of illusion and immersion—the para-digm of this medium. Whether the individual artists are critical of this aspect or implement it strategically, nevertheless, it remains the founda-tion on which this art operates.

The visualization potential of virtual artworks exceeds by far a purely mimetic view. The visualizations of complex systems, which the majority of artists in this book strive for, encompass a potential for creativity and image techniques that demand analysis. How are the observers affected by the kaleidoscope of endogenous viewing perspectives and the tension between physical and abstract experiences?

The creation of expanded image spaces experienced polysensorily and interactively, which enable processual situations, promote the trend toward performance art. In this way, the categories of game and game theory gain new significance. Thus, in addition to presenting the long and complex tradition of the concept of immersion, it is essential to portray the most recent dynamic changes that have taken place in images, brought forth by the new options of interaction and evolution.

From the point of view of both technology and art theory, it is illumi-nating to take an in-depth look at internationally acclaimed works that are

already classics of the new image culture. Here we'll discuss further important parameters of virtual art, such as the interface,[5] interaction,[6] and image evolution.[7] The interface, which connects the human senses to the image worlds of virtual art, is the main focus of the chapter on *Osmose* (1995), a work by the Canadian artist Charlotte Davies that is particularly relevant with regard to this parameter. Interaction and image evolution, or the creation of artificial life in the form of images, a highly topical and controversial theme in view of recent developments in gene technology, robotics, and nanotechnology, are discussed with reference to examples of genetic art. The contention is that these factors mold not only the artistic options of expression but also the experience of the observer, the level of participation and immersion. A question that needs to be asked in this connection is whether there is still any place for distanced, critical reflection—a hallmark of the modern era—in illusion spaces experienced through interaction. I show how immersion techniques, such as the vanishing interface, or the so-called natural interface, affect the institution of the observer and how, on the other hand, strongly accentuated, visible interfaces make the observer acutely aware of the immersive experience and are particularly conducive to reflection.

Media art has been promoted institutionally since the 1980s. In addition to the tradition of strong engagement in this area in the United States, with the foundation of new media schools in Cologne,[8] Frankfurt, and Leipzig and the Zentrum für Kunst und Medientechnologie[9] in Karlsruhe, Germany is a heartland of media art, together with Japan and its new institutes, such as the InterCommunication Center in Tokyo[10] and the International Academy of Media Arts and Sciences[11] near Gifu. More recently, other countries, such as Korea, Australia, China, Taiwan, Brazil, and especially the Scandinavian countries, have founded new institutions of media art. In spite of this considerable activity at the institutional level, museums have only begun to open their doors hesitantly to the art of the digital present.[12] Media art, which put in its first appearance at festivals,[13] has rapidly found public acceptance; yet so far, museums have neglected to build up systematically any collections. There are gaping holes, in both collections and academic engagement with this art, which will not be easy to close in the near future. A further problem is that the longevity of digital art depends on its storage media. The permanent process of changing operating systems, for example, means that it is no longer possible to

show some works that are not even ten years old. Perhaps like no other art genre in history, the continued existence of media art is in danger. Trained curators and conservators are almost entirely lacking as are any concepts for systematic collection, for example, in cooperation with computer centers, technical museums, or manufacturers of technical equipment.

The Science of the Image

For the last ten years, there has been an ongoing discussion about the status of the image in art history, philosophy, and cultural studies,[14] which has gained in topicality and brisance through the advent of media art. The new media, and particularly the art realized through and with them, demand that this question be posed with new intensity and with a new quality. Currently, no other image medium polarizes the discussion about the image more radically than virtual reality. Yet what, precisely, distinguishes the images of media art from those of bygone ages?

The rapidly spreading virtual techniques have acquired influence over many and diverse areas of scientific disciplines, the majority of which lie outside the sphere of art. To attempt a closer understanding of the phenomenon of virtual realities and contribute to the theoretical debate on the so-called iconic turn or pictorial turn,[15] I attempt to trace at least in part the long and complex tradition of this image concept and to sketch its vitality and almost revolutionary character that is emerging through the potential of interaction with and evolution of images. It is imperative to leave aside approaches that are technology-centered and, instead, situate the artistic images of virtual reality within the history of art and the media, although it is necessary to treat aspects of how the latest technology of illusion functions. Regarded historically, it is possible to relativize the phenomenon of virtual reality and determine what makes it unique. Through historical comparisons, it is possible to recognize and describe more clearly analogies or innovations. This is an attempt to take stock, in a clear and level way, on the basis of art history without invoking apocalyptic scenarios, for example, as Neil Postman, Jean Baudrillard,[16] or Dietmar Kamper[17] have tended to do, or indulging in futuristic prophesies, of the variety associated particularly with the "Californian Dream."[18]

The project of a science of the image, in which this book is involved, deliberately pursues a policy of transgressing established boundaries of specifically "artistic images." It is at liberty to comprise elements of

Warburg's early sketch of a science of the image based on cultural history, Panofsky's "new iconology," as well as the studies on vision by Norman Bryson[19] or Jonathan Crary.[20] Since the 1960s, discussion of the concept of image representation has expanded enormously. Starting point was the groundbreaking work of Nelson Goodman,[21] Roland Barthes,[22] and Ernst Gombrich.[23] Since then, studies and analyses of the concept of the image, which used to operate exclusively on the terrain of art history, have been undertaken in disciplines such as psychology, physiology, aesthetics, philosophy, cultural studies, visual studies, and computer science. Particularly in art history, the oldest discipline engaged with images and media, the interrogation of the concept of the image has burgeoned; interestingly, this has been in parallel to the rapid developments in the field of the new media and their image worlds.[24] Currently, to take an expression of Walter Benjamin's, media art history has "the wind of world history in its sails." The emerging discipline of a science of the image complements the history of the science of artistic visualization,[25] the history of the art and images of science,[26] and, particularly, the science of the image as it is pursued in the natural sciences.[27]

Inspirations for this book are the studies on visualization in the Cartesian tradition, in Martin Jay's expression "the ocular character of all Western culture,"[28] and Guy Debord's fundamental critique in *The Society of the Spectacle.*[29] However, I have drawn primarily on the theoretical discussions of interactive media art at congresses such as the Inter-Society for Electronic Art,[30] SIGGRAPH,[31] Ars Electronica,[32] the Centre for the Advanced Inquiry in the Interactive Arts[33] (CAiiA)/Newport, Interface,[34] and many other interdisciplinary meetings.

For several years, the dramatically changed function of images wrought by the new media has been a subject of cultural studies research. Some of the most important work in this field is by Roy Ascott,[35] a visionary theoretician whose published work on interactive computer art goes back many years. At the Centre for the Advanced Inquiry in the Interactive Arts (CAiiA-STAR), where Ascott is director, many of the most important contemporary media artists are studying for Ph.D.s.[36] The early work of Myron Krueger[37] also belongs in this canon together with the research work of Eduardo Kac,[38] Machiko Kusahara,[39] Simon Penny,[40] Erkki Huhtamo,[41] Margret Morse,[42] and the overviews of immersive works edited by Mary Anne Moser[43] that commenced publication in the mid-

1990s at the Banff Centre. In Japan, the research and analysis conducted by Itsuo Sakane,[44] founding director of IAMAS, is of prime importance; unfortunately, very little of his work has been translated. An eloquent history of concepts of space since Roger Bacon—not of immersive image worlds—has been written by the journalist Margret Wertheim.[45]

Immersion

Immersion is undoubtedly key to any understanding of the development of the media, even though the concept appears somewhat opaque and contradictory. Obviously, there is not a simple relationship of "either-or" between critical distance and immersion; the relations are multifaceted, closely intertwined, dialectical, in part contradictory, and certainly highly dependent on the disposition of the observer. Immersion can be an intellectually stimulating process; however, in the present as in the past, in most cases immersion is mentally absorbing and a process, a change, a passage from one mental state to another. It is characterized by diminishing critical distance to what is shown and increasing emotional involvement in what is happening.

The majority of virtual realities that are experienced almost wholly visually seal off the observer hermetically from external visual impressions, appeal to him or her with plastic objects, expand perspective of real space into illusion space, observe scale and color correspondence, and, like the panorama, use indirect light effects to make the image appear as the source of the real. The intention is to install an artificial world that renders the image space a totality or at least fills the observer's entire field of vision (fig. 1.2). Unlike, for example, a cycle of frescoes that depicts a temporal sequence of successive images, these images integrate the observer in a 360° space of illusion, or immersion, with unity of time and place. As image media can be described in terms of their intervention in perception, in terms of how they organize and structure perception and cognition, virtual immersive spaces must be classed as extreme variants of image media that, on account of their totality, offer a completely alternative reality. On the one hand, they give form to the "all-embracing" ambitions of the media-makers, and on the other, they offer the observers, particularly through their totality, the option of fusing with the image medium, which affects sensory impressions and awareness. This is a great difference from the nonhermetic effects of illusionistic painting, such as trompe l'oeil,

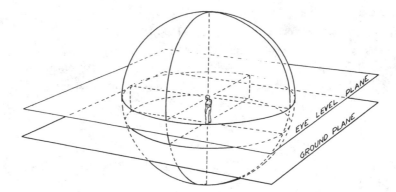

Figure 1.2 *Spherical Field of Vision*. Drawing by John Boone. In Karen Wonders, *Habitat Dioramas: Illusions of Wilderness in Museums of Natural History*, Uppsala: Almqvist and Wiksell, 1993, p. 207. By kind permission of Karen Wonders.

where the medium is readily recognizable, and from images or image spaces that are delimited by a frame that is apparent to the observer, such as the theater or, to a certain extent, the diorama, and particularly television. In their delineated form these image media stage symbolically the aspect of difference. They leave the observer outside and are thus unsuitable for communicating virtual realities in a way that overwhelms the senses. For this reason, they do not form part of this study.

Of the two main poles of meaning of the image, representative function and constitution of presence, it is the second that concerns this study. The quality of apparently being present in the images is achieved through maximization of realism and is increased still further through illusionism in the service of an immersive effect. The image and simulation technique of virtual reality attempts to weld traditional media together in a synthetic medium that is experienced polysensorily. The technological goal, as stated by nearly all researchers of presence, is to give the viewer the strongest impression possible of being at the location where the images are. This requires the most exact adaptation of illusionary information to the physiological disposition of the human senses.[46] The most ambitious project intends to appeal not only to the eyes but to all other senses so that the impression arises of being completely in an artificial world. It is envisaged that this kind of virtual reality can be achieved through the interplay of hard- and software elements, which address as many senses as possible to the highest possible degree with illusionary information via a

"natural," "intuitive," and "physically intimate" interface.[47] According to this program of illusion techniques, simulated stereophonic sound, tactile and haptic impressions, and thermoreceptive and even kinaesthetic sensations will all combine to convey to the observer the illusion of being in a complex structured space of a natural world, producing the most intensive feeling of immersion possible. Virtual reality may not be in the headlines any longer, but it has become a worldwide research project.[48] As soon as the Internet is able, image spaces will be available online that at present can be seen only in the form of elaborate and costly installations at festivals or in media museums.

The expression "virtual reality"[49] is a paradox, a contradiction in terms, and it describes a space of possibility or impossibility formed by illusionary addresses to the senses. In contrast to simulation, which does not have to be immersive and refers primarily to the factual or what is possible under the laws of nature, using the strategy of immersion virtual reality[50] formulates what is "given in essence," a plausible "as if" that can open up utopian or fantasy spaces.[51] Virtual realities—both past and present—are in essence immersive. Analog representations of virtual realities appear oxymoronic when multifarious virtual spaces are viewed in sequences or when they are partially visible simultaneously. Unresolvable contradictions have the power to irritate and distress, but they can also mature into fullblown artistic concepts, as in the case of mixed realities. Immersion in the artificial paradises of narcotics, for example, as described by Charles Baudelaire,[52] dream journeys or literary immersions past and present (in Multi User Dangeous [MUDs] or chat rooms),[53] refer mainly to imagination addressed through words, as expressed by the concept of *ekphrasis*.[54] They differ fundamentally from the visual strategies of immersion in the virtual reality of the computer and its precursors in art and media history, which are the subject of this book.

Mimesis, in the Platonic sense, mimics. The more lasting the effect, the less abstract it is; it is able, simultaneously, to be evident in a creative sense and to represent the intelligible.[55] The concepts of trompe l'oeil or illusionism aim to utilize representations that appear faithful to real impressions, the pretense that two-dimensional surfaces are three-dimensional. The decisive factor in trompe l'oeil, however, is that the deception is always recognizable; in most cases, because the medium is at odds with

what is depicted and this is realized by the observer in seconds, or even fractions of seconds. This moment of aesthetic pleasure, of aware and conscious recognition, where perhaps the process of deception is a challenge to the connoisseur, differs from the concept of the virtual and its historic precursors, which are geared to unconscious deception. With the means at the disposal of this illusionism, the imaginary is given the appearance of the real: mimesis is constructed through precision of details, surficial appearance, lighting, perspective, and palette of colors. From its isolated perfectionism, the illusion space seeks to compose from these elements a complex assembled structure with synergetic effects.

In connection with the concept of mimesis, it is worthwhile to recall another, ancient image concept, which goes back to to precivilized times. This is the original meaning of the German word for picture or image, *Bild*, with its etymological Germanic root *bil*: its meaning refers less to pictoriality and more to living essence; an object of power in which resided irrational, magical, even spiritual power that could not be grasped or controlled by the observer (in Ancient Greek, *dia zoon graphein* also comprises an element of the living), an aspect that so far has received little attention in image research.

In spaces of illusion, the moving observer receives an illusionary impression of space by focusing on objects that move toward or away from him. The depth of a painted space, however, is experienced, or presumed, only in the imagination. Gosztonyi defines the experience of space as follows: "The virtuality of the movement must be emphasized; one can also 'enter' the space virtually, i.e., in thought or imagination, whereby the distances are not actually experienced but rather *assumed*."[56] The technical idea that is virtual reality now makes it possible to represent space as dependent on the direction of the observer's gaze: the viewpoint is no longer static or dynamically linear, as in the film, but theoretically includes an infinite number of possible perspectives. The word *cyberspace*, coined by the science fiction writer William Gibson in 1984, derives from *cybernetics* and *space*, and could be given as cybernetic space. Gibson understood cyberspace to be an array of networked computer image spaces, a matrix, which as "collective hallucination" would find millions of users daily.[57] The subculture, which rapidly grew up around the idea of virtual reality in the late 1980s, co-opted this term, which plays only a minor role in this study.[58]

In virtual space, both historically and in the present, the illusion works on two levels: first, there is the classic function of illusion which is the playful and conscious submission to appearance that is the aesthetic enjoyment of illusion.[59] Second, by intensifying the suggestive image effects and through appearance, this can temporarily overwhelm perception of the difference betwen mage space and reality. This suggestive power may, for a certain time, suspend the relationship between subject and object, and the "as if" may have effects on awareness.[60] The power of a hitherto unknown or perfected medium of illusion to deceive the senses leads the observer to act or feel according to the scene or logic of the images and, to a certain degree, may even succeed in captivating awareness. This is the starting point for historic illusion spaces and their immersive successors in art and media history. They use mutlimedia to increase and maximize suggestion in order to erode the inner distance of the observer and ensure maximum effect for their message.

Even six-year-old children are able to differentiate between reality and "as-if worlds,"[61] yet in Western art and media history there is a recurrent movement that seeks to blur, negate, or abolish this differentiation using the latest imaging techniques. It is not possible for any art to reproduce reality in its entirety, and we must remain aware that there is no objective appropriation of reality—Plato's metaphor of the cave shows that. It is only interpretations that are decisive. This has been one of the major themes in philosophy in the early modern era: the work of Descartes, Leibniz, and Kant can also be viewed as marvelous attempts to reflect on the consequences that result from perspective, the mediation of perception and thus the cognitive process, which ultimately cannot be overcome. Further, artificiality and naturalness are also concepts of reflection. They denote not objects but views, perspectives, and relations.[62] In addition to copying it, the transformation of reality is the central domain and essence of art: the creation of reality, individual reality, collective reality.[63] Interestingly, recent findings in neurobiology propose that what we call reality is in fact merely a statement about what we are actually able to observe. Any observation is dependent on our individual physical and mental constraints and our theoretical scientific premises. It is only within this framework that we are able to make observations of that which our cognitive system, dependent on these constraints, allows us to observe. In

what way and to what extent there have been attempts to create "reality," virtual reality, with the means of the image in art history, is elucidated in this study.

In the following, I shall introduce some exceptional examples of enclosed virtual illusion spaces taken from different epochs in history. It goes without saying that this is not an exhaustive account of the phenomenon. My intention is to demonstrate the continuing presence of this image form in the history of European art, and the examples have been selected because they make the most intensive use of the illusion techniques of their time. The aim is to shed light on the visual strategies and specific functions of virtual spaces in the history of the art and media. Although hundreds of seventeenth- and eighteenth-century illusion spaces exist in the palaces and villas of Europe, to which access is difficult in the majority of cases, little research has been undertaken, and where research does exist, other questions tend to be in the foreground.[64] In particular, the transmedia continuum of their function, the enduring tendencies to enclose and immerse the observer regardless of the form of the medium, has not been recognized, and will be emphasized in what follows.

Notes

1. The CAVE (Cave Automatic Virtual Environment) is a cube of which all six surfaces can be used as projection screens, surrounding the visitor(s) inside with an image environment. Wearing "shutterglasses," light stereoglasses, the users see the images in 3-D (Cruz-Neira et al. 1993).

2. Adorno (1973), p. 36 (Engl. trans., Adorno 1997, p. 19).

3. Grau (2000).

4. Friedrich Kittler, "Geschichte der Kommunikationsmedien." In Huber et al. (1993), pp. 169–188 (see p. 178).

5. Bolt (1984); Laurel (1990, 1991); Deering (1993); Halbach (1994B); Grau (1997b).

6. On human-machine communication, see: Krueger (1991), MacDonald (1994), Smith (1994) (technological); Ascott (1989, 1992), Rötzer (1989, 1993),

Huhtamo (1996, 1997), Dinkla (1997) (art theory); Weibel (1989a, 1991a, 1994a) (affirmative); and Grau (1994) (critique).

7. On introducing "life" to artificial spaces (through genetic algorithms, agents, etc.), see: Goldberg (1989); Ray (1991); Schöneburg (1994); Thalmann (1994); Steels et al. (1995); Sommerer and Mignonneau (1996, 1997).

8. ⟨http:www.khm.de⟩.

9. ⟨http:www.zkm.de⟩.

10. ⟨http://www.ntticc.or.jp/⟩.

11. ⟨http://www.iamas.ac.jp/⟩.

12. These include the Centre Pompidou, MOMA, Bundeskunsthalle, Henie Onstad Kunstcenter, and the Wilhelm Lehmbruck Museum.

13. Ars Electronica, ⟨http://www.aec.at⟩; Interactive Media Festival, Siggraph, ⟨http://www.siggraph.org/s98/⟩; imagina, ⟨http://www.ina.fr/INA/Imagina/imagina.en.htm⟩; the Biennales in Kwangju, ⟨http://www.daum.co.kr/gallery/kwang/han/index.html⟩; Lyon, Nagoya, ⟨http://www.tocai-ic.or.jp/InfoServ/Artec/arte⟩; and St. Denis, ⟨http://www.labart.univ-paris8.fr/index2.html⟩.

14. See, for example, Mitchell (1995); Freedberg (1989); Belting (1990); Bredekamp (1995, 1997a,b); Crary (1996, 1999); Jay (1993); Manovich (2001); Stafford (1991, 1998); and Stoichita (1998).

15. Jay (1993); Mitchell (1995b); Bredekamp (1997a). See also the early reflections of Bryson (1983), pp. 133ff. Mitchell's book in particular has become one of the poles in this debate. Although he was not the first to point out the growing influence of visuals on modern societies, he situates their images as tied to the discourse of power that appears primarily in textual form. Following Panofsky, he proposes an overhauled iconology, which explains the images in terms of interrelationships of mutual dependence on texts.

16. Baudrillard (1996) continues to develop his position, first formulated in the 1970s, that denies contemporary technical images any reference to the factual,

which is covered by his concept of hyperreality. This "crisis of representation," a "mimesis without foundations," however, does not necessarily differ qualitatively from the conditions of representation found in older image media.

17. Kamper (1995).

18. One example among many from the media theorist Youngblood (1989), p. 84; see also Walser (1990).

19. Bryson (1983).

20. Crary (1992, 1999).

21. Goodman (1968).

22. Barthes (1980).

23. Gombrich (1982).

24. Examples are: Belting (2001); Böhm (1994); Bredekamp (1997a); Didi-Huberman (1999); Freedberg (1989); Grau (1997a, 2000b); Elkins (1999); Kemp (2000); Stafford (1998); and Stoichita (1998).

25. Kemp (1990).

26. Latour (1996); Sommerer and Mignonneau (1998a); Kemp (2000).

27. The congress on "Image and Meaning," held in the summer of 2001 at MIT, was an expression of the natural sciences confronting the phenomenon of digital images and can be viewed as the founding event of this new discipline.

28. Brennan and Jay (1996).

29. Debord (1983).

30. ⟨http://www.artic.edu/~isea97⟩.

31. ⟨http://helios.siggraph.org/s2001/⟩.

32. ⟨http://www.aec.at/⟩.

33. ⟨http://CAiiAmind.nsad-newport.ac.uk/⟩.

34. ⟨http://www.interface5.de/⟩.

35. Ascott (1966, 1999).

36. CAiiA-STAR is a research platform that integrates two centers of doctoral research: CAiiA, the Centre for the Advanced Inquiry in the Interactive Arts, at the University of Wales College, Newport; and STAR, the center for Science, Technology, and Art Research, at the School of Computing, University of Plymouth. CAiiA was established in 1994 as an outcome of the success of the country's first interactive arts degree. STAR was formed in 1997, building on the School of Computing's research achievements in the domain of interactive multimedia and the associated fields of artificial life, robotics, and cognitive science.

37. Krueger (1991a).

38. Kac (1996).

39. Kusahara (1998).

40. Penny (1995).

41. Huhtamo (1996).

42. Morse (1998).

43. Moser et al. (1996).

44. Sakane (1989).

45. Wertheim (1999).

46. Heeter (1992); Kelso et al. (1993); Slater and Usoh (1993, 1994a); Schloerb (1995); Witmer (1998); Stanney (1998).

47. Steuer (1992); Gigante (1993a); Rolland and Gibson (1995).

48. This is borne out by institutions such as the National Research Agenda for Virtual Reality, supported by ARPA, the Air Force Office for Scientific Research, Army Research Lab, Armstrong Lab. NASA, NSF, NSA, and so on. In 1999 alone, several dozen international congresses were held on this subject.

49. When Jaron Lanier coined the term in 1989, it was also an attempt to combine diverse areas of research on the human-computer interface with different labels with utopian dreams in one, albeit paradoxical, catch phrase with a strong popular appeal.

50. On the concept of "virtual" in history and philosophy, see Wolfgang Welsch, "Virtual Anyway?" at ⟨http:www.uni-jena.de/welsch/papers/virtual_ anyway.htm⟩.

51. The metaphor of the mirror, as used by Esposito, does not adequately express the phenomenon of the virtual, which can also comprise elements of the impossible (under natural law), the fantastic, and the awesome; see Esposito (1995, 1998).

52. Baudelaire (1899).

53. See Wulf Halbach, "Virtual Realities, Cyberspace und Öffentlichkeiten," pp. 168ff. in Krapp et al. (1997).

54. Lucian's art of description succeeded in getting images to appear before the inner eye of his listeners. In this connection, the section *De Domo* is exemplary, where the listeners were taken into a richly furnished hall; see Lucian (1913), pp. 176ff. In Schönberger's opinion, this effect also demonstrates the "real meaning of Philostratos' rhetoric ... to transport the observer to another sphere of existence by communicating to him the entire effect, the total impression, of the image." Schönberger (1995), p. 171.

55. See Recki (1991), p. 117.

56. Gosztonyi (1976), p. 959.

57. Gibson (1990).

58. Marcos Novak has given one of the most compact summaries of the vision of cyberspace:

Cyberspace is a completely spacialized visualization of all information processing systems, along pathworks provided by present and future communications networks, enabling full copresence and interaction of multiple users, allowing input and output from and to the full human sensorium, permitting simulations of real and virtual realities, remote data collection and control through telepresence, and total integration and intercommunication with a full range of intelligent products and environments in real space. Cyberspace involves a reversal of the current mode of interaction with computerized information. At present such information is external to us. The idea of cyberspace subverts that relation; we are now within information. In order to do so we ourselves must be reduced to bits, represented in the system, and in the process become information anew. Cyberspace offers the opportunity of maximizing the benefits of separating data, information, and form, a separation made possible by digital technology. By reducing selves, objects, and processes to the same underlying ground zero representation as binary streams, cyberspace permits us to uncover previously invisible relations simply by modifying the normal mapping from data to representation. (Marcos Novak, "Liquid architectures in cyberspace," in Benedikt 1991, p. 225)

59. Neumayer (1964), p. 13.

60. Ibid.

61. See Fisher and Watson (1988).

62. Welsch (1995).

63. On the dissolution of reality, see Vattimo (1998).

64. On the motif of landscapes, see Börsch-Supan (1967).

2

Historic Spaces of Illusion

Immersive Image Strategies of the Classical World

Wall paintings from the late Roman Republic painted in the Second Style of Pompeii have survived that include not only mimetic but illusionary elements. Through the device of seeming to extend the wall surface beyond a single plane, the room appears larger than its actual size and draws the visitor's gaze into the painting, blurring distinctions between real space and image space.[1] The most effective examples of these frescoes use motifs that address the observer from all sides in a unity of time and place, enclosing him or her hermetically. This creates an illusion of being *in the picture*, inside an image space and its illusionary events.

A truly impressive example of this image strategy is found in one of the most famous surviving frescoes of antiquity: the Great Frieze in the Villa dei Misteri at Pompeii. Created ca. 60 B.C., the frieze covers the entire walls of Room no. 5 in the Villa Item, known as the Villa dei Misteri.[2] Twenty-nine highly realistic, life-size figures against a background of glowing red and marble incrustations, rhythmized by *lisières*, are grouped in the oecus, which measures 5 × 7 meters (fig. 2.1). The spectacular painted scene almost entirely fills the observer's field of vision. This is not a hidden chamber; it can be accessed easily from the southwestern side of the building where it is connected, via a portico, to a terrace that, in former times, afforded a good view of the Gulf of Naples. With the exception of this opening in the wall, which is less than three meters wide, the visitor to the room is surrounded hermetically by a 360° vision with unity of time and place. The overall effect is to break down barriers between the observer and what is happening in the images on the walls. This is accomplished by a suggestive appeal to the observer from all sides that utilizes illusionism techniques.[3]

It is a chamber dedicated to the cult of Dionysius, used by his followers for rites of initiation and ritual.[4] In the presence of Ariadne and Dionysius as painted images, preparations are being made for a Bacchic rite: the initiation of a woman into the mysteries. This is, in my opinion, the most convincing interpretation advanced so far, therefore, I shall follow it here.[5] The fresco brings gods and humans together on the same pictorial level: A woman in dignified apparel wearing a double cloak approaches a boy, who is reading, and a seated matron. Next to them, a serving girl carrying a tray with slices of ritual cake turns to face the observer. The next group of three people is attending to the sacrifice—a direct reference to the realm

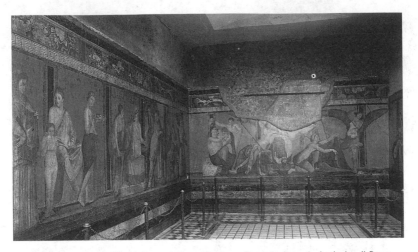

Figure 2.1 Villa dei Misteri. Room 5, Pompeii, 60 B.C. Soprintendenza Archeologica di Roma.

of the mysteries: a priestess has a serving girl sprinkle water on a myrtle wreath while another attendant hands her a tray.[6] A silenus, dressed in purple—the color of the Dionysian cult—and playing music, leads into the neighboring bucolic scene: Two young satyrs, one with a pan flute and the other suckling a goat, are sitting on the rocky ground. Simon is of the opinion that these may be contemporary portraits embellished with the pointed ears associated with satyrs.[7] Drama is lent to the scene by a young maenad who, panicked and anxious, throws her clothes about her with a defensive movement of the hand in a gesture of pathos and ecstasy. She is depicted as being on the brink of leaving the level of the other painted figures, as about to step over the edge of the wall painting, out of the picture, and into the space of the observer. Her gestures and expression are reactions to what is happening on the adjacent right-hand wall; according to the logic of the work, they point across the intervening area, traversing the space of the observer.

This wall, the centerpiece of the painting, is devoted to the procession of Dionysius: nine figures, dominated by Dionysius-Bacchus and Ariadne, or Venus.[8] The two gods lie intertwined, intoxicated and oblivious to their surroundings. The embracing bodies exude sensuality; although the initiation itself is not visualized, in Simon's view, the epiphany character of the scene is given because of the volatile immediacy emanating from the divine pair.[9] To the left is a papposilenus with two more satyrs. In the

mirror of a vessel, one of the satyrs appears to espy the mask of intoxication, another symbol of this cult. To the right, hidden under a purple cloth, the liknon is about to be uncovered, wherein the most sacred cult object of the Dionysian initiation is concealed—for Burkert, the real *fascinosum* of the rite:[10] here, the phallus remains out of sight. Next, a winged female demon raises her arm to strike a mighty blow with a whip; again the dramaturgy of the painting transcends the limits of the second dimension, for the lash falls—or so one imagines—across the observer's space on the back of a girl kneeling on the opposite wall (fig. 2.2). With hair still wet from the ecstatic dance, her head lies in the lap of a confidante whose face reflects the agonized expectation of the ritual flagellation, a means for the maenads to achieve trance, a spiritually ecstatic state. Holding a wand—the thyrsus, symbol of the initiated—in her hand, a bacchante bends over the neophyte. The naked dancer in this group of figures symbolizes the successful completion of the rite of initiation to bacchante: in an ecstatic trance, she appears to be in an exalted state of divine possession. Indeed, this was the core of the Bacchic rites: *Ek-stase* and *En-thusiasmós*, physical and psychological immersion of the individual in the god to attain fulfillment, submerged in an ecstatic state together with others and the god, a regression of consciousness, a journey of initiation into an infinite unity. This was the end to which techniques for achieving ecstatic states were used.[11]

In the context of this study, primary interest centers on the picture's function as an illusion. The events depicted are not shown in succession but as a spatial and temporal unity.[12] The main illusionistic intention of the fresco, which seeks to meld the observer spatially with the mythical scene, demands a pictorial form that will envelop the observer hermetically. In addition to a highly realistic method of portrayal using great detail, for example, the finely veined marble and alabaster, the gauzy transparency of a serving-girl's chiton, the silvery gleam of a vessel, or the fine rendering of the hirsute silenus playing his instrument, there is particular use of the individualized portrait.[13] The positioning of the megalography, which is partly staggered, on a podium painted in perspective approximately one meter from its base on the floor, contributes to the optical effect of a relief, and thus of depth. However, the most important effect of all is its totality;[14] it is an image space that addresses the observer from all sides: "The visitor to the chamber falls under the spell of the gaze

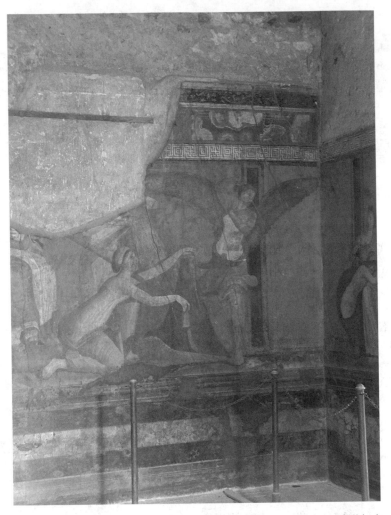

Figure 2.2 Villa dei Misteri. Room 5, detail, Pompeii, 60 B.C. By kind permission of Michael Greenhalgh, The Sir William Dobell Professor of Art History, Australian National University.

directed at him from all three areas, which rivets him for as long as he remains in the room."[15] And one can almost feel the dialogic communication between the figures, from wall to wall, as a lingering, almost physical reality.

Three groups of figures can be distinguished: the mortals making preparations for the initiation, the initiated mystes, and the group of guardians of the enigmatic Dionysian revelations, which includes the immortals.[16] A

decisive factor for the function and effect of the fresco is that all three groups, each with a different form of existence, are depicted on the same level and, additionally, fuse spatially with the observer.[17] This combination of human cult followers and Dionysian divinities in the picture pursues the objective of intensifying the observer's identification with the events. The picture is a gateway, which allows the gods to enter the space of the real, and, in the other direction, transports their mortal assistants into the picture. The glowing red color heightens the sensual and ecstatic atmosphere and its climax, the consummation of the sexual initiation rite, ultimately succeeds in involving the observer as well. With its suggestive exclusiveness and the resultant psychological effect, this pictorial form represents the maximum that the image medium of the fresco could achieve with the means available at the time.

Although the frieze still presents a wealth of unsolved riddles,[18] for all that, it is clearly a palpable testimony to a virtual reality, which not only sought to involve the observer through its subject but also, through the use of panoramic images, specific colors, and dramatic gestures, aimed at emotionally arousing the observer to ecstatic participation: the psychological fusion of observer and image in the cult.

Whereas ritual drives the concept of immersion in the Villa dei Misteri frieze—images aimed at creating a particular state of mind—the totality of the fresco images in the Villa Livia at Primaporta create the illusion of an artificial garden. Dating from 20 B.C.,[19] these wall paintings of a peaceful refuge flooded with light surround the observer completely (fig. 2.3).[20] The scene depicted on the walls of the room, which measures 12 × 6 meters, follows nature closely. There are cypress trees, oleanders, pines, and carefully detailed acanthus, roses, and irises. Realistic birds populate the natural-looking space, including jays, quails, and orioles; Gabriel has counted around thirty species.[21] Although the picture's flora and fauna are painted exactly true to their natural size, it is nevertheless an ensemble that does not occur in this form in nature. Selection and combination present an ideal that improves on nature (fig. 2.4).

The landscape addresses the observer frontally and, so it seems, in close proximity. The effect is to incorporate the visitor physically into the space of illusion, yet without creating an impression of great depth, owing to the nebulous turquoise background. Illusionistic painting techniques create an artificial space into which the observer is "integrated." Completely filling

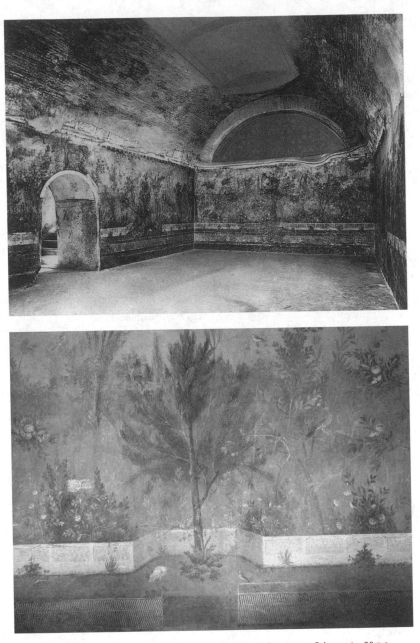

Figure 2.3 Landscape room in the Villa Livia. South wall, fresco, near Primaporta, 20 B.C.
Soprintendenza Archeologica di Roma.

Figure 2.4 Landscape room in the Villa Livia, detail. By kind permission of Michael Greenhalgh, The
Sir William Dobell Professor of Art History, Australian National University.

Figure 2.5 Landscapes from *The Odyssey* on the Esquiline Hill. Rome, 40 B.C., detail, Vatican Museum. Author's archive.

the field of vision, there is no possibility for the observer to compare extraneous objects with the scene, which might relativize the impression made by the picture. As in the Great Frieze of the Villa dei Misteri, the principle of unity of time and place is also used here. Further, the observer confronts a simultaneous image that envelops panoramatically and transports him or her into another space.[22] To increase the effect of the illusion and maintain continuity, light falls into the chamber from an opening in the wall immediately below the ceiling, which is painted to represent the overhanging rocks of a grotto. This construction is similar to the lighting method used later in panoramas.

Archaeological research has not succeeded in discovering what this room was actually used for. Yet it is apparent that, with the aid of the most advanced contemporary techniques of painting and representation, the intention was to create a virtual refuge in the form of a peaceful garden.

These "heroic" landscapes from Homer's epic poem stand apart from the illusion spaces discussed above because of the smaller vertical dimensions of their panoramic vistas.[23] In the remains of a building on the Esquiline Hill in Rome, which dates from the late republican era and is of unknown function, a frieze was discovered with pictures of mythological scenes from Cantos 10 and 11 of *The Odyssey*. Each picture is approximately 1.50 meters high and 1.55 meters wide, and together they form a sequence (fig. 2.5). Experts agree that originally, the frieze formed a band on the upper part of a side wall in a room that measured approximately 20 × 14 meters. The only surviving portion began at a height of some

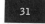

3.50 meters and is from a single wall. Opinions differ as to whether these scenes, which represent only a small excerpt from the poem, continued on the other walls of the room that have not survived.[24] I wish to focus on a different aspect: although the scenes are arranged in chronological order, they are set against a background of a continuous and uniformly rocky landscape and although the frieze is broken up into sections, framed by illusionistic, painted pilasters, the cursory representation of the natural landscape is a unity. Thus, the observer's gaze is dominated horizontally, but not vertically, by the panoramic landscape.[25] The effect is not all-pervasive and does not dominate the observer's field of vision; yet it is a prospect of a distant panorama. The use of aerial perspective together with the discreet integration of the small-scale figures of the protagonists in an image space with differentiated color-shading is very similar to techniques employed much later in the panorama.[26] The resulting effect of illusion is that of "a form of second reality,"[27] which opens into the space of illusion but does not evoke a feeling of presence or immersion in it.

A further similarity with later panoramas is that the eye point of the vista is located above the landscape, which has the effect of pushing back the horizon even further into the distance. The framing pilasters, rendered in parallel perspective, are oriented toward the observer standing a few meters below, but the elevated position of the frieze (about 4.50 meters from the floor) prevents the observer from aligning his or her eye with the painted horizon and thus also from relating directly to the landscape, which would create a feeling of presence. Instead, the observer gazes up at the far-off mythological landscape of *The Odyssey*;[28] a mechanism that serves to relativize one's own existence. The employment of this same mechanism was perfected in the painted ceilings of the Baroque.

The triad of mystery, magic, and pictorial illusion that was used to such effect, for example, in the Villa dei Misteri functioned in the ancient world and was understood by and communicable to many people. This tremendous power of the image was recognized by the early Christian church and banned. The influence enjoyed by monasteries in the early Byzantine period was due in no small part to the worship of images, or idolatry, that they organized for the people. In the seventh and eighth centuries, the iconoclasts sought to break this influence. It was not until 787 that the Council of Nicaea conceded it was permissible to worship God through the veneration of images. This victory for the monastic orders opened up

the way for the production and worship of icons, the quintessential sacred representations of early Christianity. Although for centuries these religious images conformed to rigid rules of depiction, they nevertheless facilitated mental and emotional reception of the subjects they presented.

The *Chambre du Cerf* in the Papal Palace at Avignon

In Western painting, the earliest postantiquity example of an entire space of illusion is the *Chambre du Cerf* (Chamber of the Stag) with its hunting scenes, which date from 1343. At the beginning of his pontificate, Pope Clement VI extended the new fortified palace at Avignon by adding a forty-meter-high tower on the south side, the Tour de la Garde-Robe. From the top, there is a spectacular view of the Provence countryside. The Chambre du Cerf, which measures 8 × 9 meters, is located on the fourth floor and served Clement VI as a study and living room. The frescoes cover all four walls, and experts agree that they were created in the autumn of 1343.[29] They are attributed to Matteo Giovanetti, the *pictor papae* of Clement VI.[30] With the exception of the windows, where the paintings end abruptly, and the beamed ceiling, which is painted with heraldic devices, the entire wall space is covered with a lush dark forest landscape with only a thin strip of azure blue sky above the treetops (fig. 2.6). Parts of the frescoes were destroyed by the temporary addition of two fireplaces, including the main section, a life-sized stag that gave the room its name.

The paintings present some uses and pleasures of nature from the standpoint of the rulers of feudal society, in particular, fish farming and the hunt. There are scenes of hunting the stag and wild boar, hare coursing, trapping, and hunting with the longbow, cross-bow, ferrets, decoys, and the falcon, a form of hunting reserved almost exclusively for the nobility. On the south wall, young men are pictured bathing in a prominently placed piscarium, a fish pond surrounded by a low yellow wall, where young attendants are trying to catch pike, carp, and bream with hand-nets and bait.[31]

The frescoes are remarkable because they surround the observer entirely and almost completely occupy the field of vision.[32] Although the murals begin at around 1.20 meters from the floor, the room can be classified as a space of illusion because of the effect created by its 360° design and, most important, the fact that there are no framing elements, neither painted nor architectonic.[33]

Figure 2.6 *Chambre du Cerf*. Tour de la Garde-Robe, Papal palace at Avignon, view of the north wall. Fresco, 1343, photo postcard. © Henri Gaud.

Even today, the paintings' intention to create an overall immersive effect is unmistakable. Bluish-green trees form a palisade-like barrier on the lower part of the painting, which encloses areas of blooming vegetation and fruit-laden trees: an idealized, idyllic, and domesticated landscape containing identifiable flora and fauna.[34] Integrated within the landscape are young men whom the artist has portrayed with individual facial features and clothing so that these figures achieve a remarkable degree of presence.[35] Certain figures are even enhanced by three-dimensional modeling of hands and face. Like the representations of individual species of fish, they evidence a very precise observation of nature.

The painted sky runs around the entire room and, together with the regular distribution of birds in the treetops and the hunting scenes arranged on different levels of the painting, suggests depth and the aesthetic impression of a panorama. Without going into detail, Blanc also makes this association: "it remains to add that it constitutes a true panorama in the sense that the eighteenth century ascribed to the word in coining it: a vast encircling tableau, here in the form of a rectangle, with the spectator located at its center."[36] The artist's endeavor to create the

effect of spatial depth is particularly in evidence in the depiction of the fish pond: One figure stands at its front edge and a second immediately behind. Although contemporary painting techniques were unable to render a horizon effectively, the desire to create a pictorial illusion and the attempt to portray in perspective are apparent. The high degree of realism in conjunction with these attempts at spatial effects enhances the illusion such that the real panorama, as seen from the top of the Tour de la Garde-Robe, is complemented by an illusionist allegory—the profane frescoes in the Chamber of the Stag.

The only extant example of its kind, this work is unique for its time and, unlike other works of the period, does not appear to have primarily a symbolic meaning. Four years after Ambrogio Lorenzetti's politically informed allegories in the *Sala dei Nove* in Siena, Matteo Giovanetti created here an idealized fertile landscape that banished all barrenness and danger and gratified aesthetic curiosity about the world outside. Nature, which Petrarch had recently gone in search of and had described so spectacularly,[37] returned to Western painting once more in a highly illusionistic form after more than a thousand years. Francesco Petrarch climbed Mont Ventoux, and his description of this experience marked a turning point in how the world was viewed. Initially, he was driven by "merely the desire to acquaint myself by sight with this unusually high spot on Earth."[38] However, when he arrived at the top, he found himself "moved by a completely free view all around, like someone intoxicated."[39] He saw the Alps "ice-bound and covered in snow," almost close enough to touch, the Gulf of Marseille, and the Rhône. This experience of the horizon as a landscape spreading into the distance and its grandeur led Petrarch to reflect on time and space in a letter written some seventeen years later to Francesco Dionigi. In contradiction to these worldly, analytical thoughts, as though in inner flight prompted by St. Augustine's *Confessions*, he finally turned his eye on himself.[40] Vacillating between aesthetic worldliness and contemplative meditation, he reflects the threshold of a new age as no other of his time. The dimensions of the paintings fix the observer's gaze on a vision of a landscape, the overwhelming aspect of the world, but it could not yet convey the experience of awe-inspiring distance that Petrarch had on the summit of Mount Ventoux. Simone Martini, the first painter to use monumental landscapes as a background, brought the Gothic style to

Avignon where he met Petrarch in 1338.[41] Although there is no proof, it is not unlikely that Martini influenced the design of the frescoes more than Petrarch. Be that as it may, it is nonetheless striking that the revolutionary activities of both artists at the same time in the power center of Avignon coincided with a radically new portrayal of natural landscapes.

Considering that the *Chambre du Cerf* was the center of the Pope's private quarters, the theme of the paintings is also extraordinary: the hierarchical order of contemporary varieties of hunting as reflected in literary documents of the period.[42] This fact underlines the profane nature of the illustrations and would appear to discount interpretations based on Christian symbolism.[43] Furthermore, in view of the secular spirit that prevailed in Avignon at the time, a worldly interpretation of the paintings is indicated. In this overpopulated medieval city, which had seen explosive growth within a very short period of time, simony and corruption were rampant. Prestigious representation on a grand scale, cosmopolitan extravagance at court, and blatant nepotism characterized the "Avignon system" of Clement VI.[44] This mondain pontificate existed side by side with incredible squalor and poverty of broad sections of the town's population. By 1327, there were forty-three Italian banks, which entertained close connections with the curia and were entrusted with all their considerable financial transactions.[45] The lifestyle of the curia was hardly any different than that of the nobles at a secular court, which prompted the Archbishop of Canterbury in 1342 to deplore the decadence and depravity of the clergy in Avignon. He denounced their disregard for the tonsure, the keeping of jesters, hounds, and falcons, the lavish displays of pomp and splendor.[46]

Petrarch, who maintained close connections with the clergy for many years, later became the sharpest critic of this worldly pontificate. In the sixth eclogue of his *Liber sine nomine*, Petrarch has St. Peter himself rail at Clement VI: "May the earth devour you, you thief! Woe betide that the flock is entrusted to such a one! What has become of the office of the devout shepherd? Woe to thee! At what price have you purchased these riches and the glory of your dwelling?"[47] Boniface VIII, Clement VI's predecessor, under whom the decline of the Church began, comes to a very bad end, which Petrarch considers is richly deserved: Dogs defecate on his grave and gnaw his bones.[48] Petrarch's grim humor is particularly reserved for Clement VI's passion for the chase, which he indulged freely, surrounded by an imposing entourage,[49] and his sumptuous palace, which

Petrarch likens to the Tower of Babylon.[50] In 1347, the plague swept across Europe, claiming many thousands of victims in Avignon alone, and many saw in this a just punishment wrought by the hand of God.[51] For the frescoes in the Chamber of the Stag, a maximum of skill was mobilized to satisfy a secular curiosity to look, the Pope's passion for hunting, and the sharp eye of the huntsman. Clement VI survived the Black Death in Avignon, placed between two fires by his physicians, in the *Chambre du Cerf*.

In Rome on Mount Olympus: Baldassare Peruzzi's *Sala delle Prospettive*

Fifteenth-century Italian artists, such as Brunelleschi, Masaccio, and Ghiberti, opened up the depths of space through their mastery of perspective. Alberti, and later, Leonardo, translated this into the metaphor of the window. A picture is a window that opens onto another, different reality.[52] With the aid of the visual technique of perspective, strategies of immersion received a tremendous boost, for they allowed artists to portray convincingly much that formerly could only be alluded to. In Brunelleschi's work, visual perception becomes the point where findings of the natural sciences, which seek to control nature, converge. The Renaissance discovery of *perspectiva artificialis* introduced distance and breaks in perception, whereas previously it had been directly oriented on the representational nature of objects. Once it was also characterized by a symbolic relationship, but now the entire process of perception became reduced to mathematical form. Following scientific principles and oriented on the visible *natura naturata*, a second fruitful nature was created, *natura naturans*. As in the legend of Zeuxis, the artist was now capable of improving on nature through selection. Perspective replaced the system of symbolic reference from which medieval painting derived its meaning. Without knowledge of the basic text of this art, the Bible, reception did not function. Perspective now provided this art with the additional option of objective representation, as it might appear to the eye and, like virtual reality today, it tended in the direction of deception or, rather, related to it to a greater or lesser extent. Piero della Francesca's wide area of activity paved the way for perspective to become *the* Italian mode of visualization. Urbino, where he worked intermittently, became in the 1470s the center of the perspective revolution for a time and provides a link with Baldassare Peruzzi.[53]

Figure 2.7 *Sala delle Prospettive*. Baldassare Peruzzi, fresco, 1516, Rome, Villa Farnesina. By kind permission of Walter de Gruyter GmbH & Co.

Peruzzi painted the *Sala delle Prospettive* in 1516–1518, in the Villa Farnesina in Rome, a work commissioned by the Sienese banker, Agostino Chigi. It is the most remarkable example of a High Renaissance space of illusion. Chigi was one of the wealthiest men of his age, with over one hundred businesses, his own port, salt-works, and mines. Much of his reputation in Roman society was derived from, and consolidated by, his obsessive patronage of artistic and literary visualizations "staging" his elevated social position.[54] Peruzzi, who was an experienced painter of scenery for the theater, among other things, gratified these eccentricities of his client. After extension work on the Sala Grande of the villa had been completed, Peruzzi and other artists from his studio created a fresco, painted in exact perspective, of a hall with columns, which surrounded visitors to the room (fig. 2.7).[55] Between the pillars of the colonnaded portico, the observer "sees" a view of Rome's buildings nestling in a realistic portrayal of the Roman Campagna.[56] Gerlini recognizes, for example, San Spirito, the Porta Settimiana, and Teatro di Marcello.[57] Here, the illusion of depth, which is created by use of mathematical perspective, is not contradicted or undermined by any elements of decoration in the Villa

Farnesina, and this produces the feeling of an irresistible relationship with the painted landscape: immersion.

It has been said that Peruzzi was the first to succeed in "bringing together individual walls of the views to form a spatial unity."[58] Although the claim is not entirely accurate, this observation does call to mind obvious associations with the panorama. Individually, the sections of the view of Rome are limited in their appeal, unremarkable and marginal. Combined, however, they acquire significance through the fact that the horizon in the landscape is continuous; the sections of visible landscape added to those hidden by the painted architecture form an *inner, mental picture* of a panorama.

Real connecting doors, framed by painted architectural features in perspective, contribute to the illusion. In a harmonious contrast, the double row of free-standing Doric columns in front of the landscape and the real wall elements form a system that is colossal in its effect. Above the triple beams and the frieze,[59] which runs around the room, is a real and heavily coffered ceiling, which appears to be supported by the illusionistic column arrangement. Thus three-dimensional architectural features with a real function combine with purely pictorial elements in a total effect where nothing interferes with the illusion or interrupts its effect. The best view of the illusion space is from the western entrance: It was from this spot that the perspective was organized.[60] The pattern of the real marble floor continues, painted, in the illusion space. Ceiling, walls, and floor—the entire room is subject to the principle of illusion. The result is virtual presence of a quality that is both consummate and compelling. Serlio was moved to express his respect and admiration;[61] even Tizian, according to Vasari, refused at first to believe that he was looking at a painting.[62] The primary function of the frescoes—to give the visitor the feeling of being in a virtual temple—does not map onto Alberti's metaphor of the window; so far, this has not been addressed adequately in the literature.

Between architecture and landscape, no connecting area interposes.[63] The monumentality of the architecture seems to increase the distance to the faraway hills of which the view is from an elevated position. It is just possible to make out the tiny houses on them while the landscape stretches out beneath the observer's eyes. The illusionistic temple hall imparts an impression of massiveness and proximity, presenting a stark contrast with the distant landscape: It is a visual experience of distance that, conversely,

strengthens the sheltering effect of the temple. It is a refuge, whose unique location elicits feelings of awe-inspiring grandeur: the splendid isolation, which one otherwise associates with being at the top of a mountain. This aspect certainly possesses symbolic character:[64] In connection with the erection of the Villa Farnesina, in 1511, Chigi commissioned Aegidus Gallus to write a panegyric poem in which he was eulogized as conqueror of the arduous peaks of virtue.[65] Chigi's contemporary, Marcantonio Casanova, even compared the Villa Farnesina, designated by Chigi as seat of the gods, with the palace on Mount Olympus.[66] These commissioned works provide the key to deciphering this enigmatic picture of architecture: an illusionistic temple on an imaginary Olympus high above a virtual Rome. In this virtual space, the idea of the image and its method of realization visualize a dream of ancient greatness.

Panofsky's dictum regarding perspective, that it facilitates "objectification of view," is now classic.[67] Perspective is an effective tool for creating distance; it reduces the size of objects, moves them back, or fades out things that do not fit in with the horizon it envisions. However, perspective is not an expression of natural vision; it is a technical construction, and what it presents to the perception follows specific conventions. Panofsky's analysis of perspective is undoubtedly apposite. However, in enclosing, encircling spaces of illusion, which at the same time use perspective to open up space, perspectival distance is inverted. It becomes a visual field of immersion that is integrated into the picture's narrative and addresses the observer suggestively from all sides. Distance between the observer and the object viewed is removed through ubiquitous mathematical analysis of the structure of image space, the totality of its politics of suggestion and strategy of immersion. Notwithstanding, to achieve rational interior design the new art of perspective was obliged to impose severe limitations. The psychophysical space perceived by the observer as spheroid, a result of the permanent movement of the eyes, had to be abstracted to a flat linear perspective construction.[68] In the classical world, which did not view objects from a linear perspective, spherical curvatures were taken for granted. It was not until the seventeenth century, with astronomers such as Kepler, and the nineteenth century, with physicists such as Helmholtz, that the spheroid form of space was rediscovered. It has often been suggested that liberation from, or nonadherence to, the laws of perspective is rooted in religious motives and serves transpersonal metaphysics.[69]

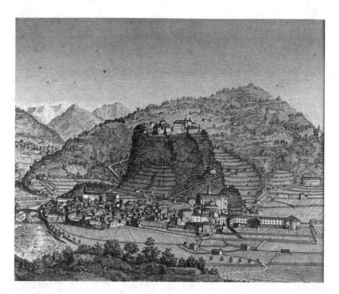

Figure 2.8 *The Holy Mount at Varallo.* G. Bordiga, etching, 1830. Picture library of the Kunsthistorisches Institut der Universität Hamburg.

Immersion in Biblical Jerusalem: Gaudenzio Ferrari at Sacro Monte

Chigi availed himself of the image strategy of immersion in a private context in the interests of self-worship and making a lasting impression on his guests from Rome's upper classes. However, it was also possible to develop this suggestive potential in a public space and address a mass, anonymous audience. In a letter to Lodovico il Moro, dated April 1495, the Franciscan friar Bernadino Caimi outlined his plans to erect a series of buildings associated with the stations of Christ's life.[70] Fra Bernadino Caimi's idea was to create edifices marking the stations of Christ's life, the *luoghi della passione*, the places of Christ's suffering in Jerusalem, crucifixion, ascension, and so on: The faithful would not see the actual, contemporary buildings but the Jerusalem of the Bible and St. Augustine's *Meditationes*.[71] Pope Innocent VIII authorized the plan in 1486 with the intention of creating an institutionalized form of *Sacre rappresentationi*[72] at the complex on Sacro Monte of Varallo,[73] which Caimi, designated guardian of the Holy Sepulcher in Jerusalem, had founded a few years previously.

During their ascent of the mount, the faithful can begin to feel that they are pilgrims (see fig. 2.8). On reaching the top, they enter a diorama-like, highly illusionistic virtual reality.[74] In eleven stations, the pilgrim

experiences the life of Christ, from the Annunciation to the Last Supper, and seventeen further image spaces present the final dramatic events, beginning with the taking of Jesus and ending with the Pietà. Five stations, including where the shroud is displayed and two later chapels dedicated to St. Francis and Carlo Borromeo, complete the sequence. In the firm belief that the experience of seeing with one's own eyes strengthens faith and religious fervor and in the knowledge that the expansion of the Ottoman Empire would probably soon make pilgrimages to Palestine difficult, if not impossible, work began on this large-scale project to construct a topographical simulation of the sacred places.[75] In all, forty-three chapels were built. Visitors from all walks of life came in their thousands—daily—also from abroad;[76] this demonstrates the untenability of the assertion that the panorama was historically "the first optical mass medium."[77]

In 1507, Girolamo Morone, a man of established discernment in artistic matters and one of the most important players in Milanese politics, wrote a letter from Varallo to his acquaintance, the humanist Lancio Curzio, in which he confirmed that the buildings of the entire complex matched their counterparts in the Holy Land. He also emphasized that the scale and distances of the terrain and buildings were identical and that the buildings contained faithful copies of the same images and pictures.[78] Morone, who was also a humanist, was very enthusiastic about his experience in the image space and its effect.[79] Of the Franciscans, it was Caimi himself who was the guarantor of the historical authenticity of the image complex.[80] He had been a diplomat in Palestine, with responsibility for the holy places connected with Christ, and knew the topography well from personal experience.[81]

Gaudenzio Ferrari, who developed within the clerical tradition and was one of the leading representatives of the Piedmontese school, returned time and again to work on the Sacro Monte project as a sculptor and fresco painter in the period 1490–1528. In addition to other diorama-style spaces of illusion, he was responsible for the chapels showing *The Adoration of the Magi* (1527–1528), *The Child Murder* (fig. 2.9), and the famous *Calvary* (1518–1522) (fig. 2.10).[82] Largely ignored today, Ferrari's contemporaries did not hesitate to put him on a par with Raphael, Michelangelo, and Leonardo.[83] The style of his early work was characterized by manneristic delicate grace, but in Varallo the proportions of Ferrari's figures tend toward greater realism, his palette glows with natural colors, and

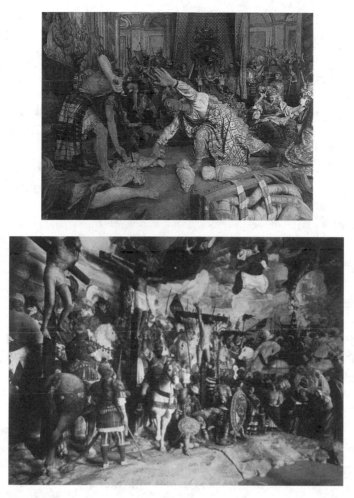

Figure 2.9 The *Calvary* at Sacro Monte, Varallo, chapel no. 13, detail: *The Child Murder*, by Gaudenzio Ferrari, 1518–1522. Picture library of the Kunsthistorisches Institut der Universität Hamburg.

Figure 2.10 The *Calvary* at Sacro Monte, Varallo, chapel no. 38, by Gaudenzio Ferrari, 1518–1822. Picture library of the Kunsthistorisches Institut der Universität Hamburg.

some of his life-size, terracotta figures wear real clothes and have real hair and glass eyes. This technique of representation creates the illusion of fusing a colorful, three-dimensional foreground of figures—a variety of *faux terrain*—with a two-dimensional fresco in the background. The term *faux terrain* was first used in the mid-nineteenth century to describe three-dimensional objects that appear either to grow out of the picture's surface or stand free in the area between the observer and the image. This creates the illusion of adding a third dimension to a flat representation. The join between wall and floor, the transition from horizontal to vertical, is concealed, and the picture's limits are extended. In Ferrari's *Calvary*, two-dimensional space is combined with a third dimension through half-figures that grow out of the frescoes on the wall and into the observer's space—a technique that was perfected during the Baroque period and, after 1830, was used regularly in panoramas.

In the image space of the *Calvary*, Ferrari used the northern European model of Crucifixion with Crowd. A three-dimensional, realistic, and detailed crucifixion is connected directly with the seething mass of figures in the fresco. These are also part of the foreground, occupying the same logical pictorial level, and the overall effect is "extroverted."[84] This immersive illusionism with such powerful images appeared to transport the observer to the historical place and occupied the observer's mental images, fixing them unforgettably in the memorial exposition of the faithful.[85] It operates by offering the eye a surfeit of images, which renders differentiation impossible. In 1606, Federico Zuccaro traveled to Varallo on the recommendation of Carlo Borromeo, who had visited the Sacro Monte himself three times. Zuccaro recorded his impressions of the *Calvary*: "It is these figures of colorful plasticity, as I said, that appear true, and their effect is likewise the truth."[86] All distance disappears as the observer is involved physically and mentally in the depicted events. This illusionistic concept is enhanced further by the image content of the frescoes; in the majority of cases, following the logic of the picture, the *faux terrain* blends with the fresco's representation of depth. The combination of illusionistic fresco and three-dimensional sculptures, which the observer views in close proximity, endows the scene with an immersive presence that draws the observer in to become a part of the mise-en-scène. Not surprisingly, the Franciscan friars encouraged pilgrims to enter the space between the simulacrum of Christ and the fresco: to participate physically as well as emotionally in the im-

age.[87] Proportions, colors, and particularly the artist's dramatic and highly emotional, even ecstatic representation of events send out a forceful appeal to the observer. When the visitor moves, perspectival perception of the work changes accordingly. At night, the chapels were lit by torches, which further enhanced the illusion of living impressions.[88]

It has been claimed that the principal aim of the representations' *verisimiltudine* with its topographical details was to propose "a framework for contemplation" to the pilgrims.[89] However, if this were the case, it surely would not have been necessary to go to such lengths, as described above, where nothing is left to uncertainty and imagination is suspended. This is illusionism that uses all available means and devices to create the deception of real presence: The Franciscans who conducted the pilgrims around the complex were constantly obliged to remind the visitors that this was not the real Jerusalem.[90] The observer is not presented with a variable field for imaginings[91] and interpretation, adaptable for all levels of education, but is subjected to maximum illusionism that is devoid of symbols. This may have created briefly the impression of being in a faraway place— telepresent—but it certainly left a much more lasting impression on the memories of the pilgrims who, from then on, became "witnesses."

This image complex with its immense suggestive power was so successful and convincing that in the following years a whole series of Sacri Monti were constructed and commenced operation, not least with the aim of erecting an *image wall* against the Reformation, where the Catholic Church enclosed its own with powerful images and welded them together in a common outlook. Their patron and mentor was Carlo Borromeo. After San Vivaldo, 1515, there followed—particularly after the Council of Trent—strategic image programs directed against the Reformation: Orta 1576, Crea 1589, Varese 1589, Valperga Canavese 1602, Graglia 1616, Oropa 1620, and Domodossola 1656, the majority founded by the Franciscans. The Sacri Monti movement is a good example of the fact that innovations in the history of visualization and illusion techniques are rarely the work of individuals; rather, spaces of immersion are the product of collective efforts, which combine art and technology in new ways and constellations. In connection with the later medium of the panorama, it is interesting that the Franciscans chose the sites for their Sacri Monti in high forests with panoramas of the horizon, for according to St. Francis, in these places the aesthetic view of "divine nature" could be experienced

most directly. The Sacri Monti movement traveled over the borders of Italy to France, Portugal, and—after seven centuries of Islamic rule—reached Granada, Spain, in 1498. This image-strategic instrument of religious hegemony for shoring up the power of Catholicism was even exported as far as Mexico and Brazil, where it flanked the enforced Christianization of the South American continent, in the course of which the number of people who lost their lives remains unparalleled in history.

Baroque Ceiling Panoramas

Spaces of illusion enjoyed tremendous popularity in the sixteenth century: Giulio Romano's Stanza dei Giganti in the Palazzo del Te at Mantua, for example, or the frescoes by Paolo Veronese in Palladio's Villa Barbaro in Maser, to name but two of the leading artists. Andrea Mantegna's Oculus in the Camera degli Sposi was the first work to open up the ceiling as a space of illusion[92] and paved the way for the development of the large-scale illusions of Baroque ceiling panoramas,[93] which culminated in works such as the nave of Sant'Ignazio in Rome (1688–1694) by the Jesuit Andrea Pozzo. From there, ceiling panoramas found their way into the sacred spaces of southern Germany and Austria.[94]

Pozzo painted the ceiling of the church of Sant'Ignazio with a picture of heaven (fig. 2.11). In the airy space and on different levels, important figures of the Christian religion and hosts of angels hover around Ignatius of Loyola, founder of the Jesuit order, in a grandiose aureole of luminous bodies: an open-air cathedral, roofless. With great skill and the aid of science, Pozzo employed the techniques of illusion in order to merge the real with the painted architecture and extend it upward into heaven, as if heaven and the church space of the devout were one and the same place. By contrast, the real architecture has the effect of a stage set that surrounds the visitor. On entering the church, the observer first experiences the painted architecture as a contradictory impression, seen from a skewed angle. Schöne views this as deliberate, as "dynamizing the illusory architecture, an arching movement of its elements between the abstract movement of Gothic ribs and the organic movement of natural beings."[95] Kerber, however, argues that this dynamism was not Father Pozzo's intention.[96] He cites evidence to prove that the famous round slab of marble in the middle of the church floor, which provides the ideal viewing point for seeing the painting in correct perspective, is not a later, twentieth-

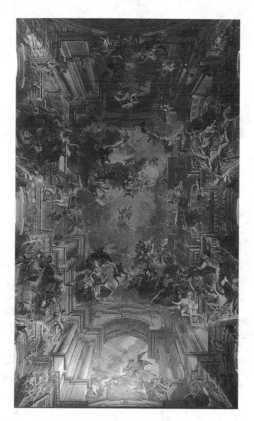

Figure 2.11 *The Nave of Sant'Ignazio*, by Andrea Pozzo, fresco, Rome 1688–1694. By kind permission of Joseph MacDonnell, S.J.

century addition, as Schöne assumes, but is already mentioned by historical sources in 1694.[97] Further, in his treatise, *Prospettiva* (fig. 2.12), which demonstrates a high level of understanding of art and science, Pozzo himself had argued for the *punto stabile* that guaranteed correct spatial form and a lasting illusion—at least with regard to the architecture.[98] Interestingly, when the visitor stands on this favorized spot, it becomes clear that the heavenly sphere was constructed from a different point of view and is in contradiction to the architecture. The kaleidoscopic ring of figures rotating around Ignatius of Loyola appears withdrawn from the "rational" area of the illusionistic architecture whose perspective does, however, move Christ alone into its center.[99] The architectonic space, with Christ as its focal point, confronts the representation of church and religious dignitaries, so

Figure 2.12 Andrea Pozzo, *Treatise*, vol. I, frontispiece from the English edition, London, 1707.
In A. Battisti (ed.), *Andrea Pozzo*, Milano-Trento 1996, p. 190. Author's archive.

that these constellations of heaven and building, respectively, gape apart. One might term this effect stereoscopic, yet only in a narrow sense; not as a reference to the images developed for the special viewing apparatus in the nineteenth century.

This interplay with the representation of heaven, which takes in the entire building and penetrates the interior by way of the windows, creates an effect that represents a new facet in strategies of immersion: Andrea Pozzo has laid out several locations of rotating images in this pictorial space at different distances from the observer. For Battisti, the trompe l'oeil effect is so powerful that the space literally grips the observer and incorporates him or her into the events in the pictures. Through gazing at the painted figures on the ceiling, "the physical body" of the observer

achieves "lightness" and is drawn up into heaven by an artistic portrayal of verticality hitherto unparalleled; the observer is seized by a transport of bliss, the end point and goal of which is the figure of Christ. In this sense, as Battisti pointed out, the entire construction may be compared with a whirling centrifuge that makes us lose consciousness, hurls us into eternity, and anchors us there.[100]

Although the powerful immersive effect of the fresco cannot be denied, this description is rather overstated. Depictions of heaven were often juxtaposed with immersive spaces of illusion, so the weightless ascent to the Redeemer is more a projection on the part of Battisti. Moreover, it is questionable from a logical point of view whether the intention of the fresco really was to render the observer one with Christ. For if the observer were to achieve the goal of religious mass on earth—to be in bliss, in the image of heaven, with Christ—how could religious doctrine explain the inevitable return to earth, and what interests of the Jesuits would be served by such a short sojourn in heaven? The vertical architecture and constellation of figures are, indeed, staged effectively and powerfully, but this is more a demonstration of power from above. One suspects that the purpose of the suggestive images is a calculated attempt to captivate the observer's perception and rational consciousness. It is a mise en scène of intangible heavenly promise, put on for the visitor standing on the church floor, and of an authority of religious control. The church building is a continuation of heaven down below. In contrast with the other immersive spaces discussed in this study, here the images do not attempt to draw in the observer; instead, they reinforce the earthbound believers' duty of obedience to the Holy Church.

Even before 1600, *quadratura*[101] had brought forth important representatives of spatial illusion. Notable examples include Pomarcino who, together with Matthijs Bril, was responsible for the ceiling of the Sala della Meridiana in the Vatican's Torre dei Venti, with its allegories of the winds and seasons (pre-1580); Guercino's Aurora ceiling in Casino Ludovisi (1621); slightly earlier works by Guido Reni; and Giovanni Lanfranco's *Ascension of Maria* in Sant'Andrea della Valle (1625–1628). The importance accorded to the visualization technique of perspective by late-sixteenth-century science is illustrated by Gian Paulo Lomazzo's text *Idea del tempio della Pittura*, published in 1590. Although Lomazzo strives for artistic constructions that are not purely mechanistic and thus stresses the

importance of the artist's *occhio*, nevertheless, knowledge and skillful application of the art of perspective remain per se the foundations of art.[102] From the second half of the sixteenth century until the beginning of the eighteenth, Bologna was the center of *quadratura*; particularly associated with the city are Girolamo Curti, Tomaso Laureati, the Caracci school, Giovanni Lanfranco, and Agostino Tassi. On the Bibbiena's sophisticated stages for the theater, they achieved international popularity and recognition.

The opera itself is a grand illusion. Greek tragedy may have originated from the lament on the sufferings of Dionysos and was essentially stylized peasant theater, but the Florentine Academy's attempt to revive it developed into a multisensory show aimed at even greater illusion. The arts of perspective, which created imposing constructions of space, were applied with consummate skill, and for three generations, the dynasty of the Galli and Bibbiena families ruled over this art in many Italian cities and large parts of the Hapsburg empire.[103] The complexity of their colonnaded halls and fantastic architecture, based on exact mathematical calculations, were brought to life with light reflections, cunning use of mirrors and, above all, machines that brought an entire arsenal of illusionistic effect to the stage. The Bibbienas extended the stage, creating a new kind of theatrical space, where the actors became tiny figures in endless spheres of illusion (fig. 2.13).

Image visions now began increasingly to fill the entire spaces of church ceilings. At the other end of the scale were small, elaborate illusions of space held directly in front of the eyes: peep-show boxes, or cabinets, which were greatly popular in the northern cities of the Netherlands, the most powerful European art market of the period. Only a few of these artifacts, made between 1655 and 1680, have survived.[104] They were prestige showpieces, owned by members of the upper classes of society. Their main attraction was the voyeuristic element, their direction of one's gaze through a peephole toward something that is inaccessible to others. The standard design was a rectangular box made of wooden panels; the interior was painted on all sides except for the top. For example, the Peepshow with Views of the Interior of a Dutch House, ascribed to Samuel van Hoogstraten and dating from 1663, which is now in the National Gallery in London, is in a box measuring only 58 × 88 × 63 cm (fig. 2.14). The images inside are rife with allusions to physical love: a man's clothes, sword, and feathered hat are hanging on a wall hook; at the center

Figure 2.13 Giuseppe Galli-Bibbiena, stage design, 1723. After a copperplate engraving by Johannes Birckart. By kind permission of Walter de Gruyter GmbH & Co.

Figure 2.14 Peep-show box, Interior of a Catholic church. Northern Netherlands, ca. 1650. By kind permission of the National Museum of Denmark.

of the image space is a red cushion; the middle panel shows a bed with a sleeping woman. Accessories, such as a string of pearls and a tortoise-shell comb, in this well-to-do interior evidence the common contemporary motif of virtue and sin, as found in the genre paintings by other artists of the period, such as Jan Steen or Pieter de Hooch.

Later additions were often made to the boxes in the form of staffage-like figures of people, animals, or objects (so-called repoussoirs), which do not conform to the perspectival representation and frequently look out of place. These repoussoirs detract slightly from the illusionistic effect but they are invariably positioned at points in the image that represent problem zones of perspective drawing and, thus, serve to conceal mistakes or weaknesses in the construction.

As in the later panorama, light enters the box's image space through the open top, which is not visible to the observer looking through the peephole. In the above example from London's National Gallery, light falls in through transparent oiled paper, which makes it diffuse, bathes certain parts in an indistinct sfumato, and thus perfects the illusionistic effect. The construction principle of the peep shows is the Euclidean theorem that if two straight lines meet at an angle, they appear to be continuous if viewed on the same level. Recent investigations have shown that the vanishing points in the boxes exhibit pinpricks.[105] From an imaginary viewpoint (the point where the peephole will be), needles fastened by threads were passed through the paper to the corners of the sketch and the marked paper was fixed to the panel.

Peep shows stand at the beginning of a line of development that complements the immersive spaces that envelop the full body, where the illusionistic effect results from bringing the images up very close to the eyes of the observer. Among its successors were the stereoscope, View Master, and Head Mounted Display.

Viewing with Military Precision: The Birth of the Panorama

Since the seventeenth century, Italian artists had worked in England to satisfy the demand for spaces of illusion, including Antonino Verro (Chatsworth House, 1671), Sebastiano and Marco Ricci, and their pupil, Giovanni Battista Pellegrini (Chelsea Hospital, 1721). English artists, such as William Kent and James Thornhill, mastered the technique of *quadratura*. Cipriani's parlor at Standlynch (1766), now Trafalgar House, near

Salisbury, is the first example of the modern era to dispense with the architectonic element of the frame—sixty years before the issue of Barker's panorama patent.

In the eighteenth century, Italian artists were first and foremost brilliant interior designers; masters of stucco work and fresco, who transformed many a castle and monastery hall with scenes of festivity and ceremony, they were famous throughout Europe. Bernardo Bellotto, a contemporary of Giambattista Tiepolo, the last great figure of illusionistic painting in Italy, set out on his travels with a small camera obscura and a larger portable one with a tent. His work with these drawing aids in the service of mimesis, which in him bordered on an obsession, perfected a new fusion of art and technology for small-format pictures.[106] The brothers Paul and Thomas Sandby also used the camera obscura, that apparent mirror of the real.[107] After the Jacobite Rebellion was crushed in 1746, which ended popular support for the Stuarts, the Sandbys traveled the Highlands for several months as topographical draftsmen in the service of the Military Survey of Scotland. To control the occupied territories efficiently and plan future military operations, the army was very interested in accurate drawings of the terrain, detailed panoramic vistas, and views of the landscape.[108] Only detailed cartographic data could be used effectively to play through questions of tactics, field of fire, positions for advance and retreat, and the like, so when a new pictorial technique emerged that made it possible "to be in the picture," it was soon pressed into the service of the House of Hanover's geopolitical aspirations.[109] For five years, 1746 to 1751, the young Paul Sandby worked for the Military Survey under Colonel David Watson. It is safe to assume that Sandby's ability to observe nature with precision, for which he later became famous, owed much, if not all, to the military training of his artist's eye.[110]

As a tool of visual perception, the camera obscura was the result of a long process of scientific discovery and development. Rudimentary ideas are found in Euclid; the discoveries of Copernicus and Galilei led to a realization of the physical problem that had already been described by Leonardo. Building on the findings of Johannes Kepler and Athanasius Kircher, it became possible to make the apparatus smaller, refine the coordination of the lenses, improve the reflecting mirrors, and optimize the relation of focal length and distance of the image. Finally, Johan Zahn, a monk from Würzburg, succeeded in producing a portable version.

Jonathan Crary has shown how, since the seventeenth century, the view onto reality has been gradually liberated through developments in science. The camera obscura represented a pioneering achievement in the history of cinematographic modes of perception because it introduced a restructuring of possibilities for visual experience through optical techniques. It was an innovation comparable with the discovery of perspective, and an important precondition for its development was a further stage in the process of individualizing the observer. Using it required isolation in a darkened space. This isolated situation of the observer in the camera obscura, as Crary expresses it, "provides a vantage point onto the world analogous to the eye of God."[111]

More than forty years later and five years after the first public exhibition of a circular painting by Robert Barker in London, in 1793 Paul Sandby created a "room of illusion" in just two months[112] for Sir Nigel Bowyer Gresley at his seat of Drakelowe Hall near Burton-on-Trent in Derbyshire. Sandby covered three walls with a wild and romantic landscape without framing elements. Visitors found themselves under the canopy of a blue sky, painted on the arched ceiling, and mighty trees, several meters high. Between the trees, prospects of undulating countryside, crossed by cuttings, with wide clearings and grassy banks, stretched into the distance (fig. 2.15).[113] In front of the painting was a variety of *faux terrain*, comprised of real objects: a chest-high fence was positioned a few centimeters away from the painted wall; the fireplace was camouflaged as the entrance to a grotto with pieces of minerals, ore, and a variety of seashells. Here, again, the function of the *faux terrain* was to blur the boundary between the real space and the space of the illusion.

In the painting on the fourth wall, Hermann recognizes a real Welsh landscape: "a valley; which is very Welsh in feeling and possibly represents Dolbadarn Castle in its fine setting on Llyn Peris, with Snowdon beyond."[114] The distant view and the fact that it refers to a real place[115] evoke strong associations with scenery as depicted in the panorama. One may even surmise that this room, with its view of the distance and directly immersive properties of the gigantic trees, is a reaction of illusionistic wall painting to the "new" medium of the panorama.

As a member of the Royal Academy, Sandby must have been familiar with Barker's invention. Although he had not painted room-filling frescoes before Drakelowe Hall, Sandby was well known as a faithful observer of

Figure 2.15 Landscape Room in Drakelowe Hall, by Paul Sandby, Derbyshire, Burton-on-Trent, 1793. The Victoria and Albert Museum, London.

nature and his name was firmly liked with landscape painting. Particularly his depictions of trees—nonschematic, multifaceted, delicately textured—and the fact that he distinguished between kinds of tree, generally held to be an innovation of the early nineteenth century, made his landscapes famous and Sandby a pioneer of modern landscape painting.[116] In view of Sandby's reputation, to have a whole room painted by him must have conferred considerable prestige on the commissioner of the work. In a letter dated July 25, 1794 to the Reverend T. S. Whalley, Anna Seward compares Sandby's wall paintings with the new invention of the panorama: "The perspective [in Drakelowe Hall] is so well preserved as to produce a landscape deception little inferior to the watery delusion of the celebrated panorama."[117] Although "watery delusion" may be taken as rather scathing, here a direct comparison is made between the new public panorama and Sir Nigel's private room of illusion. The similarity of the two conceptions is obvious, although at the time, the potential of the panorama to produce illusions still left a lot to be desired. The new medium of the panorama provoked the exponents of its forerunner medium into mobilizing the maximum potential of illusion that was possible.

The case is similar with the German inventor of the panorama, Johann Adam Breysig. Helmut Börsch-Supan finds a general connection between spaces of illusion and the new medium: "Breysig ... developed his idea from the tradition of interiors with illusionistic landscapes."[118] Inspired, or goaded, by the new medium, with artistic experience rooted in military precision of view, Sandby staged an evocative romantic landscape, a favorite of tourists and amateur artists. Sir Nigel and his guests had the pleasure of a journey of the eye to a virtual Wales.

Barker's Invention: Developing the Space of Illusionistic Landscapes

On June 17, 1787, Robert Barker patented a process under the name of "la nature à coup d'oeil," by which means a panoramic view could be depicted on a completely circular canvas in correct perspective. Using empirical methods, he developed a system of curves on the concave surface of a picture so that the landscape, when viewed from a central platform at a certain elevation, appeared to be true and undistorted. The application of this invention became known a few years later under the neologism "panorama."[119]

Barker was an Irishman who taught the accurate application of perspective in Edinburgh, the headquarters of British troops in occupied Scotland. A few years before his patent was granted, Barker had invented an apparatus for drawing accurate circular perspective. It was mounted on a frame with a fixed point and could swivel to take a succession of partial views, which together formed a panorama. The path leading to circular paintings had commenced about a year before with six aquatints that Barker's son, twelve-year-old Henry Aston, had made with the apparatus at the top of Carlton Hill. If Barker's intention was to demonstrate how easily, almost automatically, his system could be applied, he certainly succeeded with the choice of his son as an example. Henry's views of the landscape were first arranged on a semicircular canvas and then, using Barker's method, joined together with curved lines to produce an unbroken horizon.

However, without the material and financial support of a politician, who was also a high-ranking military officer, this new pictorial technique might never have been realized. Barker's idea caught the interest of William Wemyss of Wemyss, Lord Elcho.[120] The Guards Room of his

castle at Holyrood served as the studio. It was here that Barker made the first panorama, a 21-meter-long, 180° view of Edinburgh, which was presented to the public in the Archers' Hall at Holyrood. As a military strategist and committed parliamentarian, Wemyss was obviously interested in a new technique of perspectival representation that might be useful for military surveys and planning. Thus, the inception of the panorama was characterized by a combination of media and military history.

The panorama installs the observer *in* the picture. Although it found its way into the world partly through military interest and patronage, the notion of using the panorama as a mobile instrument of military planning was a nonstarter from the beginning. On arriving in London, it soon attracted the attention of broad sections of sensation-seeking civil society and quickly became an agent of popular taste in a society of the spectacle. On March 14, 1789, Barker exhibited the panorama of Edinburgh by dim candlelight in the Haymarket. Public response was mediocre but the art world began to sit up and take notice of the potential of this technique of visualization. Sir Joshua Reynolds, President of the Royal Academy, had at first told Barker that it was impracticable but soon changed his mind: "I find I was in error in supposing your invention could never succeed, for the present exhibition proves it to be capable of producing effects and representing nature in a manner far superior to the limited scale of pictures in general."[121]

This effect, representation of nature in the service of an illusion, was from the beginning the core idea of the panorama. Thus, it is highly likely that Paul Sandby, who was also a member of the Royal Academy, heard about Barker's invention in connection with this event and gained valuable ideas for his landscape room at Drakelowe Hall. At the very latest, he would have heard of it in June 1791 when, still in its pre-immersive phase, a semicircular view of London was exhibited with sensational success. Not yet housed in a rotunda, Barker presented to the public a view from the roof of the Albion Mills factory, near Blackfriars Bridge, in premises in Castle Street. Drakelowe Hall has been made out as a forerunner of the panoramas;[122] however, not only was it painted in 1793, but Sandby combined illusionistic landscape with a typical panoramic and distant view of a recognizable Welsh landscape as a reaction to the panorama and as a demonstration of the superiority, as yet still intact, of the older image technique.

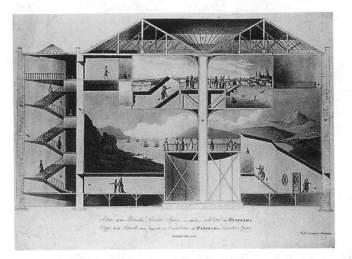

Figure 2.16 Robert Barker's Panorama Rotunda at Leicester Square, London. Cross-section, by Robert Mitchell, aquatint, 28.5 × 44.5 cm. Gebr. Mann Verlag Berlin.

Both the illusionistic landscape room and the panorama surround the observer with pictorial images and both seek to create the effect of actually being in a real landscape. Oettermann states that "In the panorama, real image spaces are created in which the observer moves around."[123] With its suite of innovations in presenting images, the panorama was able to heighten the illusion considerably and more lastingly, compared with the illusionistic landscape room. Both socially and with regard to location, the provenance of the panorama is the private houses of the nobility, the same terrain where illusionistic landscape spaces were located. This is supported by the later takeover of the *faux terrain* by the panorama, which had an important function at Drakelowe Hall, for example, as discussed above. At the beginning of the nineteenth century, the two media were at the stage of reciprocal influence.

Construction and Function of the Panorama

The world's first purpose-built rotunda opened in Leicester Square on May 14, 1793.[124] A cross-section of Robert Barker's two-storied rotunda (fig. 2.16) illustrates design and function: via Staircase B,[125] the visitor entered the viewing platform, which was surrounded by a balustrade. At this spot, the visitor was completely surrounded by the illusionistic painting that

hung on the circular walls of the building. The picture was smaller than later panoramas, covering an area of "only" 930 m².[126] The balustrade had the double function of both preventing visitors from getting too close to the picture and keeping them in a position where the upper and lower limits of the picture could not be seen. No objects extraneous to the picture were in the space that might relativize or diminish the illusion. Overhead lighting, also invisible to the visitor, illuminated the painting so that it appeared to be the source of light itself, an effect that was later perfected in cinema, television, and computer-generated images. For the observer, standing in the dark, this made it even more difficult to distinguish between an *imitatio naturae* and real nature.

Illusionistic landscape spaces had used varieties of *faux terrain*[127] since the Renaissance, but Barker's first panoramas do not appear to have made use of this device. It was first integrated into the panorama in 1830, in particular by Charles Langlois, the French specialist for battle scenes, and refined continually thereafter. Constructed on a wooden framework between the painting and the viewing platform, it was almost imperceptibly joined to the image for the visitor, who was up to fifteen meters away. The two-dimensional painting then approached the observer with a three-dimensional zone. The picture changed into an image space where the observer was physically present and was able to set him- or herself in relation to it. Apart from the *faux terrain*, Barker's patent covered virtually all the innovations that still determine panorama construction until the present day. Building on the traditions and mechanisms of illusionistic landscape spaces, the panorama developed into a presentation apparatus that shut out the outside world completely and made the image absolute.

Judged by the postulates of illusionism, these innovations in depiction and representation revolutionized the image. The panorama was located in the public sphere, and this fact, discussed in detail below, linked it to themes selected according to economic criteria and a mode of production that was industrial and international. Together, these endowed the phenomenon of illusion spaces with a new quality. Notwithstanding, its art historical origins still remain in 360° spaces of illusion.

The similarity of the concepts of the panorama and 360° spaces of illusion is also attested to by experiences with the panorama being applied to 360° spaces of illusion. In their book, *The Union of Architecture, Sculpture, and Painting of 1827*, John Britton and Nathaniel Whittock made

recommendations for heightening the effect of illusionistic landscape spaces that had been developed in conjunction with the panorama: "A painted landscape, or architectural scene, might also, with property, be introduced ... with a railing or balustrade to prevent so close an approach as to destroy the illusion. It is almost needless to remark, that such a picture should be on a semicircular wall, and painted on the principle of a panorama, strongly lighted from above, while the spot whence it is to be viewed should be in comparative obscurity."[128]

Smaller panoramas for private rooms also made their appearance, serving educational or scientific and aesthetic or atmospheric purposes. Goethe, for example, who had visited several of the large-scale panoramas, installed for a time a panorama, affixed to a circular arch, of the mountain scenery near Neuchatel in his chambers.[129] A further example of the panorama's influence on private spaces of illusion was the fashion for panorama wallpaper in the nineteenth century.[131] Confined mainly to the urban bourgeoisie, they were a relatively inexpensive industrial product. At this point, the tradition of illusionistic landscape spaces ends in the marriage of art and industry contracted by the panorama. The panorama's themes, a repertoire that targeted broad sections of society, were frequently individualized in products for the private sphere.[131] Panorama-style wallpaper was produced in the twentieth century and is still available today (figs. 2.17 and 2.18).

In his important study of the panorama, Stephan Oettermann writes: "As any new invention has its precursors, forms of art bearing some apparent relation to the panorama existed earlier, but in this case they played no direct role in the panorama's development."[132] This statement can be interpreted as the desire to postulate the position of this medium as unique. However, in view of the long and rich prehistory of the panorama and, indeed, its posthistory in the form of contemporary developments in computer-aided virtual spaces, Oettermann's statement must be viewed as relative and in need of amendment. That said, it must be admitted that there is a paucity of research on this topic. Earlier studies, which mention preforms of the panorama by Dolf Sternberger,[133] Friedrich Rupp,[134] and Alfred Auerbach[135] as well as more recent works by Sune Lundwall,[136] Edward Croft-Murray,[137] Gustav Solar,[138] John Sweetmann,[139] Silvia Bordini,[140] and Marcel Roethlisberger[141] contain only a few paragraphs on the subject. The works cited fall into the category of short compilations and do

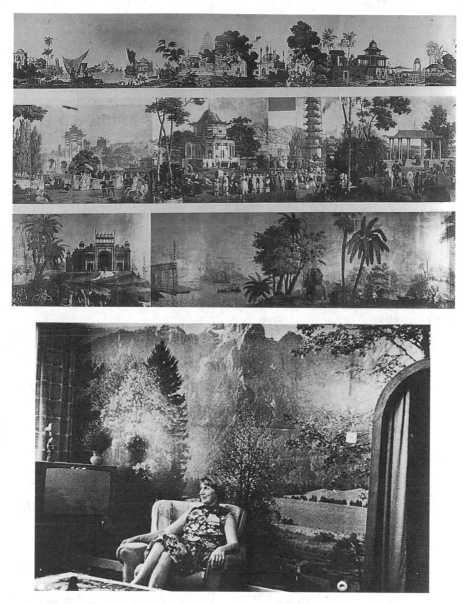

Figure 2.17　"Hindustan" Panorama Wallpaper, 1807–1820. In *Décors de l'imaginaire, Papiers peints panoramiques, 1790–1865*. Musée des Arts décoratifs, under the direction of Odile Nouvel-Kammerer, Paris, 1990; p. 306.

Figure 2.18　Panorama wallpaper. Industrial product, mountain scenery, 1970s. In *Pro Magazin*, 10/1976, p. 13, ill. 5. Author's archive.

not portray adequately the long tradition of enveloping spaces of images and illusion; moreover, their research focus is different, often unsystematic and focusing on single phenomena. However, even these findings suffice to demolish the contention that the development of the panorama is without a history. To support his argument of the singularity of the panorama, Oettermann cites the changed visual habits of the observer, from a feudal "construction in strict central perspective,"[142] as used in the Baroque court theaters, to "a gradual "democratization" of the audience's point of view,"[143] culminating in the panorama. Further, the medium of the panorama is, for Oettermann, firmly tied to the experience of the horizon, a new aesthetic experience of the eighteenth century.[144] This is a little surprising as there have been countless town- and cityscapes, coastal panoramas, and overview maps since the fourteenth century.[145] The innovation represented by the panorama does not consist in either its attempt to create an illusionary spatial image, an immersive sphere, or in the secular provenance of its themes. In the sense of an optical illusion, or trompe l'oeil, the panorama is, instead, the most sophisticated form of a 360° illusion space created with the means of traditional painting. Of spaces with illusionistic wall paintings, which surround the observer hermetically with 360° images and create the impression of being in another space than where one actually is, that is, that formulate an artificial world, many striking and important examples exist from various epochs—long before the advent of the panorama.

The Panorama: A Controversial Medium circa 1800

From the first, the panorama as an art form was controversial. Interestingly, there was less dispute about the fact that the rotundas were frequently sited near amusement districts of doubtful repute[146] or whether artistic quality was possible in pictures of this size. The real bone of contention was its outstanding aesthetic feature: the character of the illusion. Opinion was divided into two diametrically opposed camps: a minority, who criticized that there was too much illusion and saw in this a danger, and a majority, who valued the panorama precisely because of its illusionistic effect.

This "effect," which drove the representation of nature to a new level, did not leave representatives of so-called high art unmoved. Jacques Louis David, who regarded the new pictorial form with favor and often visited

the panoramas in Paris with his students, is reported to have dispensed the following advice while in a panorama by Prévost: "Si vous voulez voir la vraie nature, courez aux panoramas!"[147] John Constable was also a fan of the panorama. On May 23, 1803, he wrote to his friend John Dunthorne: "Panoramic painting seems to be all the rage. There are four or five exhibiting and Mr. Reinagle is coming out with another, a view of Rome, which I have seen. I should think he has taken his view favourably, and it is executed with the greatest care and fidelity."[148]

William Wordsworth, however, commented with irony on the efforts of the panorama to create a second reality and described the effects of its reception. The panorama of Edinburgh he characterized as "those mimic sides that ape the absolute presence of reality, expressing as a mirror sea and land and what earth is, and what she hath to shew ..."[149]

Heinrich von Kleist had high expectations of the illusionistic effect of the new image medium but was disappointed. He recorded his impressions after a visit to the first German panorama by Johann Adam Breysig, the Panorama von Rom, exhibited at Gendarmenmarkt, a square in the center of Berlin: "I say it is the first hint of a panorama, and even the idea is capable of greater perfection. For as the whole point of the thing is to delude the observer into thinking he is in the midst of nature, and nothing must remind him of the deception, then in the future, quite different arrangements will have to be made."[150]

Kleist goes on to enumerate ways in which the illusionistic effect of the new medium can be perfected: "In fact, one should stand on the painting and be unable to discover a point on any side that is not part of the painting."[151] Kleist's notion of the ideal observer's position is *in* the image and, fascinated by an image medium that sought to realize a different, second nature, he made a sketch of his plans, now unfortunately lost.[152]

A prominent critic of the panorama, Johann August Eberhard, described their effect in his *Handbuch der Ästhetik* (1805) and, regarding the question whether they were suitable as a medium of art, answered emphatically in the negative. He first targets the deceptive character of the medium: "the similarity of a copy to true nature cannot be any greater."[153] In particular, the inability of the panorama to transport transitory events and sounds, that is, a perfect illusion, results for Eberhard in a confusing conflict between "appearance" and "truth" that can even cause physical indisposition: "I sway between reality and unreality, between nature and

non-nature, between truth and appearance. My thoughts and my spirits are set in motion, forced to swing from side to side, like going round in circles or being rocked in a boat. I can only explain the dizziness and sickness that befall the unprepared observer of the panorama in this way."[154] However, the decisive factor for Eberhard's utter rejection was the impossibility of escaping from the illusion: "I feel myself trapped in the net of a contradictory dream-world, ... not even comparison with the bodies that surround me can awake me from this terrifying nightmare, which I must go on dreaming against my will."[155]

Here, we recognize a familiar polarized discourse, now in connection with the panorama, between apocalyptists and utopists: between those who see the new medium as a danger to perception and consciousness and those who welcome it as a space for projecting their fantasies and visions of fusion with all-pervasive image worlds. Shortly before, in 1800, a commission set up by the Institut de France, the most important body responsible for questions of culture in France, published its report on Barker's invention. Chaired by Antoine Dufourny, the commission unanimously applauded the panorama and its effect of "illusion totale."[156] In the commission's opinion, art had come a good deal closer to its goal of a perfect illusion through its alliance with science.[157] Unable to compare the objects in the picture with objects outside it, surrounded completely by a frameless, all-embracing image, the observer is completely subjected to the deception.[158] Moreover, the commission believed that the length of time spent in the panorama affected perception of the illusion as such: "as soon as the eye is accustomed to the light inside [the panorama], forgets the colors of nature, the painting produces imperceptibly its effect; the longer one contemplates it, the less one is persuaded that that which one sees is merely a simple illusion."[159] The commission wanted to see this illusionistic effect used in all forms of art, including—and this was new—paintings with a smaller format. They also suggested the development of an apparatus[160] to resolve the problems of transporting these huge pictures for the distribution of illusions to a mass audience—an astoundingly modern idea. In the context of this report, ideas were formulated for the first time that would become pivotal to the conception of immersion as applied to small images presented directly to the eyes.

A further characteristic opinion on the panorama was advanced by John Ruskin. He was less interested in the argument over the artistic aspects

and more in its use as a tool for education and instruction. During a visit to Milan in 1833 he wrote: "I had been partly prepared for this view by the admirable presentment of it in London, a year or two before, in an exhibition, of which the vanishing has been in later life a greatly felt loss to me—Burford's panorama in Leicester Square, which was an educational institution of the highest and purest value, and ought to have been supported by the government as one of the most beneficial school instruments in London."[161]

The step from using the panorama as an instrument of education to sharpening its mass appeal and suggestive power in the direction of mass propaganda is not a big one, even though it would probably never have occurred to Ruskin. However, it did occur very soon to military leaders in France and England. Admiral Lord Nelson, whose part in the naval battle at Aboukir was a theme of one of Barker's panoramas in 1799, was perfectly aware of its impact; Barker wrote: "I was introduced ... to Lord Nelson, who took me by the hand, saying he was indebted to me for keeping up the fame of his victory in the Battle of the Nile a year longer than it would otherwise have lasted in the public estimation."[162] Napoleon I, who was also a member of the Institut de France, fully appreciated the potential for effective publicity and propaganda using the battle panorama as a vehicle: On a visit to Thayer's panorama in 1810, he recognized that the invention could be exploited for propaganda if topical events were presented to the public in a suggestive way. He planned to build eight rotundas showing representations of his battles in the park at Versailles. If this plan had been realized, it would have been the first instance of panoramas being used as permanent monuments to military battles. In later years, there were many examples, for instance, Anton von Werner's panorama, *The Battle of Sedan*.[163] Panoramas of battles for public consumption are part of the medium's history from the very beginning.[164]

The Role of Economics in the International Expansion of the Panorama

In Europe and North America, the history of the panorama as a mass phenomenon coincides almost exactly with the nineteenth century. Particularly in the metropolises of France and England,[165] Barker's invention very quickly became a favorite medium for art, education, political propaganda, and entertainment. The rush and stress in which the panoramist

Figure 2.19 "The Traveling Panoramist." Cartoons in *Punch*, July 14, 1849 (Barker/Jackson).

composed and produced is the theme of two cartoons in Punch that appeared in 1849 (fig. 2.19). Production was speeded up; whereas in the early years, individual artists had taken years of painstaking work to produce a panorama, for example, in German-speaking countries,[166] shortly after Barker's application for his patent, panoramas were being churned out in Paris and London in just a few months. This was only possible through technically rationalized processes and de-individualized methods of painting the canvas—in short, the methods of industrial, profit-oriented production. As early as 1798, panorama production in London was so well organized that Robert Barker was able to exhibit several new paintings each year.[167]

Figure 2.20 Poole's vehicle for transporting panoramas. Photo by G.A.S. Ramschen, 14 × 27 cm.

In Paris, the second most financially powerful city after London, James W. Thayer acquired the rights to the patent for France in 1799 and his rotunda was run along similar business lines to Barker's. In Germany, the panorama was also a success at first; however, production fell off in the years 1830 to 1840.[168] Parallel to the erection of permanent circular buildings in the cities, simpler wooden rotundas were constructed, which toured the smaller towns (see fig. 2.20).

Shrewd logistics and tight business organization, often with foreign investment in the form of shares traded on the stock exchanges, characterized the economic side of panorama production. Soon, capital investment exceeded that of any other visual artistic medium, and, to minimize the risk of bad investments and check up on their competitors, companies even engaged in industrial espionage. These external economic factors determined the role of the artist. Contracts not only stipulated punctual and exact realization of the agreed concept, they also included a commitment not to create further copies for a different client. For this reason, preparatory sketches and studies usually remained the property of the company once the work was completed. Artists had no rights either to the concept or to the end product.

In the interests of profit maximization, the operators of the rotundas extended opening times[169] and developed international marketing strategies. When exhibition at the original location ceased to be lucrative, the canvas was rolled up and sent on tour to areas where people were affluent enough to be able to pay to see it. The paintings traveled thousands of kilometers and were displayed in so many different places that they were literally worn out. The *Panorama of London*, created in 1792, reached Leipzig after eight years on tour. A newspaper remarked, "The painting is so worn out and pale and all the sections so indistinct and confused that the polite Saxons must muster all their tolerance and goodwill to recognize this sorry sight as being that proclaimed by the pompous advertisements."[170] Standardization of canvas size around 1830 led to international marketing on a large scale.[171] This blatant commercialism was responsible, at least in part, for the rift that arose between traditional artists and panorama painters. The *Hamburger Nachrichten* newspaper reported from England that "An academic expert report recently decided that panorama and diorama painters should be barred from becoming members of the Academy or professors of painting."[172]

In the beginning, the rotundas were built in various forms but increasing institutionalization—later, buildings only housed panoramas with standardized measurements—resulted in a typical form of building. A new building technique utilizing a steel structure became the preferred one. The buildings concealed an apparatus of remarkable technical sophistication, although the observer inside could not see any of its features. In the late phase of panorama construction, much attention was lavished on external decoration.[173]

As they targeted a broad international audience, panorama subjects were selected for their popular appeal to the relevant sections of the public and advertised extensively in the press and on posters. With these criteria of selection, the subjects obviously did not include local interest, unknown places, or individualized, allegorical, or mythological themes. For the most part, the topic range was not driven by ideological considerations or any variety of bourgeois democratic consciousness but was shaped by the normative forces of the market. However, to a limited extent panoramas did reflect what interested the wealthier elements of society, for they were the ones who were able to afford the high entrance fees. In brief, panorama themes can be classified in a few time phases and categories.[174] At first,

there were many examples of "duplicate" cityscapes—views of the city where the panorama exhibited, such as the panorama of London from the top of the Albion Mills that was shown in London—which served to convince the observers of the illusionistic potential of the new medium. These were followed by topographical representations of national or European locations.[175] Often, the reason for choosing these particular subjects was that a place was well known or had spectacular scenery: The more exotic, distant, or remote a location, the higher the profits of the operators.[176]

The era of tourism was just beginning, and it found in the panorama, with its longing for faraway places, a versatile ally.[177] However, as panoramas brought the world to the cities of Europe and North America, for some the panoramas became an "economical surrogate for travel."[178] Many and detailed accounts appeared comparing "travels with the eye" to real travels, and quite a few preferred the former, as did this anonymous author: "What cost a couple of hundred pounds and half a year half a century ago, now costs a shilling and a quarter of an hour. Throwing out of the old account the innumerable miseries of travel, the insolence of public functionaries, the roguery of innkeepers, the visitations of banditti charged to the muzzle with sabre, pistol, and scapulary, and the rascality of the custom-house officers, who plunder, passport in hand, the indescribable *désagréments* of Italian cookery, and the insufferable annoyances of that epitome of abomination, an Italian bed."[179] Even in the more sober estimation of Alexander von Humboldt, the new 360° image medium[180] with its huge dimensions could "almost substitute for travelling through different climes. The paintings on all sides evoke more than theatrical scenery is capable of because the spectator, captivated and transfixed as in a magic circle and removed from distracting reality, believes himself to be really surrounded by foreign nature."[181]

The panorama was, to use Wolfgang Kemp's expression, "a space of presence."[182] In addition to journeys through spaces, there were soon examples of journeys through time. To this category belong the long series depicting the Stations of the Cross (fig. 2.21) at the end of the nineteenth century and the dozens of panoramas of historical battles.[183] Besides chronicles of wars, images of the rise of imperialism began to appear. Where colonial history offered spectacular events, landscapes, or battles, these were presented to the imperial power's subjects in purportedly realistic panorama images.[184]

Figure 2.21 *Panorama of the Crucifixion.* View from the visitors' platform. Altötting 1903, by Gebhard Fugel and coworkers. Photo: Erika Drave, SPA Stiftung Panorama Altötting. By kind permission of Dr. Gebhard Streicher.

The essence of the panorama was the assumption of being entrapped in the real. This game with deception was its chief fascination; whether the observer was oblivious, as in the early years, or regarded it as a source of aesthetic pleasure, as later. The other senses were addressed through the haptic element of the *faux terrain*, sound effects (created mostly on an orchestrion) and noise of battle, artificial wind, and smoke: All were used to sustain the effect of the photorealistic presentation. The *Panorama of the German Colonies*, which opened in 1885, "attempted to recreate the light, ambience, and heat-haze of the tropics in a true-to-life fashion, with mists of steam."[185] Thus, in the course of its historical development, the medium of the panorama sought to increase, or at least maintain, illusion by moving toward forms that addressed all the senses.

The panorama's claim of authenticity was based on painstaking research, often with scientific pretensions, of the locations presented. Partic-

Figure 2.22 "The Panoramist M. Tynaire Directing the Work." From *Encyclopédie du siècle. L'exposition de Paris, de 1900*, Paris, 1900, p. 313.

ularly in connection with the depiction of distant places, this had not been possible on this scale before. Moreover, these themes had to appeal to an anonymous audience of hundreds of thousands.[186] If it did not succeed in appealing to the masses, the panorama had not achieved its goal. Egalitarian treatment of the paying public was not the rule; entrance charges were often high when the panorama first opened, taking advantage of affluent sections of the market, and, toward the end of its run, the price would be reduced to cater to less well-off people. This is still a common marketing strategy today and was already in place during the entire heyday of the panorama. Whereas at the beginning of the nineteenth century, panoramas targeted only the better off, between 1840 and 1870, they addressed increasingly the middle classes. The era of truly egalitarian panorama-going only began in the 1870s in France.[187] Nevertheless, exclusivity of access for the well-to-do was still maintained through pricing policies: Prices differed according to the day of the week and the panorama. There were price supplements of up to 400 percent, which segregated the audience effectively, protecting the upper classes from rubbing shoulders with the workers.[188]

Notes

1. "A wall is no longer a tangible boundary of space but, instead, the medium of an optical idea." Strocka (1990), p. 213. See also Schefold (1952), p. 158: "With painted architectural illusions, he [the painter] takes all plastic character from the wall and fuses the imaginary space with the real one. Using only pictorial decoration, the plastic character of the wall is completely negated. The pedestal finishes with a protruding ledge, in order to support the painted columns and pilaster, and the wall appears to fall back behind them." Also, Strocka (1990), p. 214: "The rigid order of the First Style period was replaced by hitherto unavailable possibilities of pictorial representation that no longer delimited the boundaries of space but, instead, extended space and reality." See also Borbein (1975), p. 61: "There is no doubt that the vistas through the space are not merely perspectival figures; they are intended to be views into other spaces." Similarly Wesenberg (1985), p. 473, and Andreae (1967), p. 202: The "framed view of the landscape" was "inserted into the illusionistic views through the painted architecture using all possible means of deception in order to create the impression of looking through an apparent opening into the outside world."—In Pliny's *Naturalis Historia*, there is a description of Apelles's painting of Alexander. Alexander swings a thunder bolt, which, together with the hand holding it, projects from the picture and appears to hang in the observer's space.

2. This *villa suburbana* was discovered in 1909 and excavated under the direction of de Petra.

3. The illusionistic image is topped by a narrow frieze with a flowering vine and numerous erotic figures. The original ceiling has not survived.

4. For details on the cult of Dionysius and its followers, see Merkelbach (1988).

5. This interpretation was given by both Bieber and Toynbee in the late 1920s: See Bieber (1928); Toynbee (1929). See also the interpretations of Simon (1961), pp. 111–172 and Herbig (1958).

6. Hundsalz sees in this a reference to Dionysian mystics' beliefs in transcendance, where pure water was attributed with the power of reviving the dead. See Hundsalz (1991), p. 74; Simon (1961, p. 111) thinks it might have been a purification ritual.

7. Simon (1961), p. 126.

8. See Pappalardo (1982), p. 19. Pappalardo's interpretation is plausible, for Venus was indeed the patron goddess of Pompeii, which was, moreover, a city where there were only priestesses.

9. Simon (1961), p. 130.

10. See Burkert (1990), p. 38.

11. From the direction of reading the frieze with erotic imagery, which is over the architrave with meander that tops the painting, Pappalardo deduces the direction for reading the megalography: running from both sides toward the divine pair. See Pappalardo (1982), p. 19.

12. See Simon (1961), p. 162, Brendel (1966), p. 214; Grieco (1979); and Wesenberg (1991), p. 72.

13. Simon (1961) sees these representations as based on originals on parchment, which in the Second Style of Pompeii were arranged as portraits of contemporaries.

14. On-site excavations have discovered that the opening in the south wall appears to have been made at a later date. That the edges of broken fragments cut into the fresco as they fell, also implying that there may be some scenes missing, seems to support this. Boarding planks were later put up above the window and the opening facing the sea; here there are also marks made by the cutting process.

15. Simon (1961), p. 118. See also the schematic of the lines of vision in the appendix of Herbig (1958).

16. See Hundsalz (1991).

17. Only Wesenberg (1991, p. 71) is of a different opinion: Trapped in schematic notions of style, he sees in the fresco "an arrangement of large ephemeral puppets" (e.g., made of wax). Although "large, life-like effigies, in an ideal situation, cannot be distinguished from living people" (p. 72), however, they remain "non-living and isolated figures." Although Wesenberg cannot ignore the established interpretation that the image is unified in place and time, he thinks, though without offering any proof, that the figures have no relationship with each other. Neither does he explain why followers of a cult would wish to depict nonliving wax puppets instead of gods.

18. Archaeological research is aware that, despite all observations based on the images themselves, it is not possible to interpret the representation of the mysteries reliably without better knowledge of Greek panel painting. "Thus the present, utterly desolate state of a city plundered by excavation gives only the merest hint of an entire people's love of art and pictures, of which the keenest art lover now has neither understanding, nor feeling, nor need," Goethe (1899), p. 38. Goethe's remarks on Pompeii, after his visit in March 1787, are still justified.

19. After much disagreement, archaeologists have finally settled on this date; see Helbig (1969), p. 454, and more recently Ling (1991), p. 150.

20. In 1951 to 1952, the frescoes were moved to the Museo dei Termi in Rome.

21. See Gabriel (1955) for a detailed description.

22. "In this room, one fancies oneself removed to a grotto, from whence one looks out over a lush green garden ... full of birds." Andreae (1973), p. 93; and Ling (1991), p. 150: "The occupants of what was perhaps a cool dining room for summer use were clearly intended to feel themselves transported into the open air." There were other methods to transport the observer into an illusion space. For example, the Birdhouse of Varro at Casinum, of which only written records survive (De re rustica 3, 2, pp. 1ff.), used three-dimensional means. A round building, used mainly as a dining room, was surrounded by two concentric rings of columns. The space between the columns, enclosed by fine-mesh netting, was an aviary filled with numerous exotic birds. A small park surrounded the building, which was, in its turn, cut off from the rest of the world by a wall. The guests at the center of this complex had the impression of being out of doors in an exotic landscape. Under the dome of the building, a complicated mechanical apparatus showed the morning star during the day and the evening star at night. The visitor was in an extended space of illusion. See Fuchs (1962), p. 104: "Everything had the same aim, to make [the observer] forget the room where he actually was; his imagination was to carry him to another world, an idyll, incomparable with daily reality."

23. Helbig (1969), p. 355. The surviving paintings, dating from ca. 40 B.C. and discovered in the years 1848 to 1849, are now in the Vatican Museum.

24. Andreae considers it unlikely that the Odyssey frieze surrounded the entire room; see Andreae (1962), pp. 106ff. Engemann disagrees, and thinks that

other scenes from *The Odyssey* covered the other walls; see Engemann (1967), appendix I, p. 145. Ling (1991) agrees with Engemann, on p. 109: "These surviving sections were probably completed by depictions of earlier and later events on the adjacent walls."

25. See Börsch-Supan (1967), p. 59.

26. See Ling (1991), p. 108: "Their importance lies in the fact that they are the first surviving examples of 'mythological landscapes': that is, painting in which figures from myth or legend were reduced to a tiny scale and set in a vast panorama of trees, rocks, sea, and the like."

27. See Beyen (1960), p. 266.

28. Beyen sees the artist as gripped by the idea that here he could "give a glimpse into the realm of fantasy from the reality of the room."

29. For sources see Caselli (1981), p. 83, note 56.

30. See Gagnière (1965), p. 34; Laclotte and Thiébaut (1983), p. 32; Castelnuovo (1991), pp. 38ff.; and Blanc et al. (1991), p. 50, who all suggest that Matteo Giovannetti was the main artist, with possibly Pietro da Viterbo and Riccone d'Arezzo as his assistants. Previously, Benedict VII had approached Giotto, who, however, died in 1337 before he could go to Avignon.

31. Gagnière thinks that the *piscarium* is a depiction of one of the papal fish ponds. The fish in these ponds were brought to Avignon from the Saône and from Languedoc in specially fitted boats. Gagnière's idea would explain the striking coloring of the pond. See Gagnière (1965), p. 33.

32. Pochat notes that both the form and motifs of these frescoes are closer to those of tapestries, *Jagatarazzi*, than their Italian precursors. Pochat et al. (1973), p. 211.

33. See Börsch-Supan (1967), p. 220.

34. See Bek (1980), p. 35.

35. Plant (1981), p. 48.

36. Blanc et al. (1991), pp. 47ff.

37. Petrarca 1336 (1931). That Petrarch wrote this elaborate letter, which is full of allusions, not spontaneously but many years after the given date, is not even interpreted by a critic such as Giuseppe Billanovich to the effect that Petrarch might not have actually been at the summit. See "Petrarca und der Ventoux (1966)," in Buck (1976), p. 462. Groh and Groh (1996, p. 28) suggest that the real mountain as a natural object almost disappears in the web of metaphorical allusions; however, in view of the poet's detailed description, this seems rather far-fetched and does not do justice to this decisive moment in the history of Western thought. Correctly, Hans Robert Jauß points out that even "a literary fiction only increases the significance of the crossing of this boundary and the regaining of aesthetic curiosity." See Jauß (1982), p. 140.

38. Petrarca (1336 [1931]), p. 40.

39. Ibid., p. 44.

40. Ibid., p. 47.

41. Martini included a portrait of Petrarch on the frontispiece of his Servius commentary on Virgil's Eclogues. Also, two of Petrarch's sonnets mention Martini by name (77 and 78). For more on the relationship between Petrarch and Martini, see Ciccuto (1991), pp. 79ff.

42. See Mérindol (1993), particularly pp. 342ff.

43. Bek's interpretation of the room as a *hortus conclusius* is plausible, but less likely is her interpretation of the stag as a symbol of Christ, sign of love and purity. See Bek (1980), pp. 37ff.

44. See Fink's essay in Jedin (1968), pp. 400ff. Clement VI's average annual income was estimated at 190,000 golden guilders, of which 10 percent was spent on imported luxuries.

45. The material needs of the Church were met by loans, tithes, subsidies, and the considerable booty brought back from the crusades, which were not unfrequent. See Housley (1986).

46. See Cutts (1930), pp. 242ff.

47. Petrarch: "Liber epistolarium sine titulo, 6th Eclogue," in Petrarch (1925), p. 64. See also Piur's fine analysis in the same volume, pp. 49ff.

48. Ibid. "Liber epistolarium sine titulo, 6th Eclogue": "Prior Epycus ille [Boniface VIII] profanos/Lapsus in amplexus, cecinit per rura, per urbes/Quam coniunx generosa sibi. Prior ipse puellam/Nactus ad irriguos secum traduxerat hortos;/Ludibrioque habitus vivens moriensque; iacentem/Exedere canes et per-minxere sepultum."

49. Ibid., 13th Eclogue.

50. *De vita solitaria lib. II*, sect. IV, chapter 1 (Basel: 1554), here, after Piur (1925), p. 74: "Dum supervacuas et ineptas turres in novissima Babylone con-struimus ut coelotenus scandat superbia, humillimam Christi sedem non est qui tueatur aut uindicet?" Rime, no. 137.

51. Fink (1968), p. 402.

52. See Alberti (1950 [1435]). There are many examples of this metaphor. On its exceptional significance as a consequence, for example, in Dürer's work, see Elkins (1994), pp. 46ff.

53. Damisch (1987), pp. 168ff.

54. Cugnioni (1878).

55. On the restoration work, see Varoli-Piazza (1981).

56. Frommel (1961), pp. 157ff.: Peruzzi "breaks down the wall, opens up a broad landscape."

57. Gerlini (1988), p. 65.

58. Frommel (1961), p. 89.

59. See Varoli-Piazza (1987).

60. Coffin (1979), p. 103.

61. Serlio (1978 [1584]), p. 192.

62. Vasari (1976 [1568]), p. 318.

63. With reference to this point, Frommel speaks of an "imaginary image boundary, as though separated by glass walls." Frommel (1961), p. 158.

64. Ewering has investigated the mountain symbolism in the mythological frieze above the illusionistic architecture and interprets the Villa as *locus amoenus*, a "place of poets." Ewering (1993), pp. 57ff., particularly p. 61.

65. Gallus (1551), pp. 26–27: "quem claro Astraea recondit Sidere virutis rigidos conoscender montes." Cited in Quinlan-McGrath (1984), p. 104, note 83.

66. In an unpublished poem, Marcantonio Casanova writes, "Aurum Chisius [Chigi] addidit, erigitque Moles, sedibus emulas olympi, Et pictura animum loquente figit." Source: B. A. V., MS Vat. Lat. 2836, pp. 245v–246r, cited in Rowland (1984), pp. 198ff.

67. See Panofsky, "Die Perspektive als symbolische Form," in Panofsky (1980), p. 123.

68. See Clausberg (1996).

69. See Brunner-Traut (1992).

70. See Pochat (1990), p. 151. In this connection, it would be productive to examine the context and concept of "heavenly Jerusalem," but this is beyond the scope of the context under consideration here. For a recent publication on this subject, see Berriot-Salvadore (1995).

71. The inscription on the grave of the Blessed Bernardino Caimi, added in 1491, reads: "Frater Bernardinus Caymus Mediolano ... Sacra huius Montis exogitavit loca ut hic Hierusalem videat qui pergrare nequit."

72. On the origins of the Sacro Monte, see Longo (1984).

73. For a plan of Varallo, Sacro Monte, attributed to Pellegrino Tibaldi, 1570, see Kubler (1990), p. 415.

74. Longo (1984, pp. 44–58) emphasizes that the image spaces represent a visualization of Caimi's sermons, *Quadragesimale de articulis fidei* and *Quadragesimale*

de penitentia. There is a contemporary description in the British Library (C.61.e.1): Francesco Sesalli, *Descrittione del Sacro Monte di Varale di Val di Sesia...*, and by the same author: *Breve Descrittione del Sacro Monte di Varallo di Valsesia...*, Novara 1566. For more information on the Sacro Monte, see: anonymous (1591); "Descritione del Sacro Monte di Varale di Val di Sesia...," in Ravelli (1608); Fumagalli (1831).

75. Naturally, the creation of a Northern Italian surrogate for Christian pilgrims' most important destination was also intended to address poorer sections of the population who could not afford to travel to Jerusalem. On the costs of a trip to Jerusalem in this period, see Giuliano Pinto, "I costi del Pellegrinaggio in Terrasanta nei Secoli XIV e XV (dai resonconti dei viaggiatori italiani)," in Cardini (1982), pp. 257–284.

76. See Torrotti, in Butler (1928), p. 21.

77. Oettermann (1980), p. 9.

78. See Promis and Muller (1863), p. 148. Every single element of the construction had been made "ad instar locorum veri sepulcri pari distantia, pari structura, eisdemque pictuis et figuris."

79. Ibid., p. 149: "Perfecto, mi Lancine, nil vidi unquam magis religiosum, magis devotum, quod corda magis compungeret, quod caetera omnia negligere et solum Christum sequi compelleret."

80. See Ferri-Piccaluga (1989), p. 115.

81. See Kubler (1990), p. 415.

82. See Mallé (1969) and its comprehensive bibliography.

83. Lomazzo received a great deal of reliable information about Ferrari's life from his teacher, Della Cerva, who had been a pupil of Ferrari's; whereas Vasari only briefly mentions him. In his *Trattato dell'Arte e della Pittura,* Lomazzo calls for art to adhere to natural proportions, colors, and perspective and, in addition, to represent spiritual passion and physical movement, for which he coined the term *moto.* See Cassimatis (1985), p. 53. In Lomazzo's "Temple of Painting," it is Ferrari who represents this concept. See Lomazzo (1785), p. 40. Lomazzo's ideas are

closest to those of Gabriele Paleotti; in his (1582), he also appeals for painting to be "perfectly true to nature."

84. Pochat (1990), p. 151.

85. On art theory of the Counter Reformation, see Jens M. Baumgarten, "Kunst und Rhetorik in den Traktaten Carlo Borromeos, Gabriele Paleottis und Roberto Bellarminos," in Wolfenbüttler Arbeitskreis für Barockforschung (1998). Baumgarten demonstrates that a specific individualized and disciplinarian sense of the image developed in connection with Catholic denominationalism, which played a greater part in transforming early modern society than hitherto presumed.

86. "Sono dette cose di rilievo colorite, come ho detto, che paiono vere, e veri gli effetti istessi." See Zuccaro (1895), pp. 32ff.

87. See anonymous (1591).

88. See Hood (1984), pp. 301ff.

89. See Nova (1995), p. 121.

90. Ibid., pp. 119ff.

91. Ibid., p. 121.

92. The problem of representing a foreshortened projection of a figure on a curved surface correctly, in the sense of illusionism, for viewing from below, had already been solved theoretically by Leonardo. See Kemp (1990), p. 50.

93. The term *Deckenpanorama* (ceiling panorama) was coined by Hans Sedlmayr in a lecture on January 30, 1936. See Rupp (1940), footnote 1.

94. For a recent study on Pozzo, see Battisti (1996). See also the classic essay by Schöne (1961).

95. Schöne (1961), p. 152.

96. Bernhard Kerber, "Pozzo e L'aristotelismo," in Battisti (1996), pp. 33–48.

97. "Nel mezzo della fascia del pavimento è situato un marmo rotondo per indicare esattamente il punto di veduta." Pozzo (1828 [1694]).

98. "E persuadetevi, che simili opere, accioche possino facilmente ingannar l'occhio, devono avere un punto stabile, e determinato, onde siano rimarate, accioche non appariscano al riguardante quelle deformità, e storicimenti, che la curvità e irregolarità delle Volte suole far nascere, e così tutto quel dispiacere, che potrebbero cagionar nello spettatore simili lavori rimirati dal punto non suo, sarà compensato con altrettanto diletto, qualora saranno riguardati dal suo vero e unico punto. Altrimenti chi vorrà prefiggere più d'uno farà una notabile sconnessione nelle parti dell'opera e non otterrà il fine preteso, facendo rimaner vano, e senza effetto tutto l'artificio." In Pozzo (1700–1702), caption to figure 1.

99. Kerber, in Battisti (1996), p. 39.

100. See Alberta Battisti, "Die Gestaltung des Raumes bei Andrea Pozzo," in Battisti (1996), p. 51.

101. The term *quadratura* was first coined in the late seventeenth century and applied mainly to illusionistic ceiling paintings. See Sjöström (1978), p. 11.

102. See Lomazzo (1785), p. 29.

103. See Hatfield (1984).

104. See Kemp (1990).

105. See David Bomford, "Perspective, anamorphosis, and illusion: Seventeeth-century Dutch peep shows," in Gaskell and Jonker (1998).

106. See Kozakiewicz (1972), p. 59.

107. On the use of the camera obscura, see Crary (1996), especially the chapter entitled "The Camera Obscura and Its Subject," pp. 25–66.

108. See Jessica Christian, "Paul Sandby and the Military Survey of Scotland," in Alfrey and Daniels (1990), pp. 18–22. Accurate views of the landscape have a long history in connection with security interests, for example, the pictorial representation of the territory of Siena in the Sala dei Nove. See also Solar (1979),

pp. 55ff., and Wohlfeil and Wohlfeil (1982), pp. 115ff. However, the representation of topographical features in these early panorama views was inadequate for military purposes.

109. The extensive cartographic surveys of Scotland, England, Wales, and Ireland were followed in 1826 by the survey of British India, in which drawings of landscape panoramas played an important role. As early as 1810, two young officers of the East India Company had received orders to make a clandestine survey of Baluchistan and the frontier between Pakistan and Afghanistan. In the course of this secret mission they made a vast number of drawings of panoramas of the landscape. See Hopkirk (1990), pp. 39ff.

110. Thomas Paul Sandby provides an impressive account of this decisive period of his father's artistic training in Sandby (1811). Hermann (1986) mentions a number of drawings made during this period. For an account of his brother Thomas Sandby's career, which was closely connected with the army, see Charlesworth (1996). Following the Jacobite Rebellion, Thomas Sandby was closely connected with Lord Cumberland, who was brother of George III and Commander of the Hanoverian forces.

111. Crary (1996), p. 48.

112. Hermann (1986, p. 56) accepts this very short period of time for the work on the basis of Sandby's own records. Stylistic comparisons lead him to conclude that Sandby did paint the entire room on his own; however, as the room measured some several hundred square meters, it seems rather unlikely. More probably, Sandby was helped by other painters, as George Barret the Elder had been in his work at Norbury Park a few years earlier, around 1750. There, Cipriani had done the figures, Sawrey Gilpin the animals, and Pastorini the sky. This was a form of division of labor that would soon become standard for the panorama. See Oettermann (1997), p. 77.

113. The room was dismantled in 1934. Parts are preserved in the Victoria and Albert Museum, London. These are the only surviving examples of large-scale works from the oeuvre of Paul Sandby. See New Haven (1985) (exhib. catalog), p. 11.

114. Hermann (1986), p. 54.

115. In 1771, Paul Sandby toured North Wales in the company of Sir Watkin Williams-Wynn and a large group of his followers, and one of the stops was Dolbadarn Castle. Peter Huges suggests that Sandby painted the watercolor *Llanberis Lake and Dol Badern and the Great Mountain Snowdon* there, which was published in 1776. It is possible that Sandby had already visited this spectacular place. See Huges (1972), and particularly illustration 24: Llanberis Lake and Dolbadarn Castle, dated 1764. It can be assumed that a number of the drawings Sandby made in Wales served as models for Drakelowe Hall.

116. A popular volume of Sandby's landscapes was published in London in 1778: *Paul Sandby: The Virtuosi's Museum Containing Select Views in England, Scotland, and Ireland.*

117. Cited in Croft-Murray (1970), p. 62.

118. Börsch-Supan (1981), p. 164.

119. First used on June 11, 1791 in the *Morning Chronicle*, London.

120. "Pecuniary assistance" is the term used by Corner (1857, p. 5). From 1777, Wemyss raised many regiments and, as Major General, won merit for his sevices in defeating the Irish rebellion in 1795. From 1784, Lord Elcho was a member of Parliament involved in public affairs.

121. Cited in Whitley (1968), p. 106.

122. Bordini (1984), p. 41.

123. Oettermann (1980), p. 41.

124. The rotunda remained open until 1864 and exhibited a total of 126 different panoramas.

125. To accustom the eyes to lighting conditions in the rotunda, later buildings introduced a darkened pasageway that led to the viewing platform. An unusual feature was the second circular painting (Upper Circle), reached via Staricase E, which was exhibited on a second floor.

126. See Wilcox (1993), p. 30.

127. The faux terrain originated in the Renaissance and, particularly, in Baroque representations. It was used extensively in conjunction with religious ceiling panoramas, where three-dimensional elements and painted illusionism mutually heightened the effect in order to "raise the ceiling and lead the mortal sphere into the heavenly one." See Tintelnot (1951), pp. 14 and 18. On the combination of painted illusions, three-dimensional plaster figures, and stucco architecture in Baroque, see Blunt (1979), pp. 57ff. For material illusions, see Knoefli (1970); specifically for Rococco, see Schiessl (1979).

128. Britton (1827), pp. 3ff., cited in Croft-Murray (1970), p. 64.

129. See Goethe (1903) IV, 28, letters dated October 5, 1817 (letter 28, p. 270, 15); October 9, 1817 (letter 28, p. 273, 6); October 10, 1817 (letter 28, p. 276, 4); December 2, 1817 (letter 28, p. 319, 1), December 14, 1817 (letter 28, p. 330, 6). See also Goethe (1904), IV, 29, letter dated January 27, 1818 (letter 29, p. 26, 19).

130. These were miniature versions of the panorama: Papiers Panoramiques, French hand-printed wallpapers with a definite "similarity of motifs to certain famous panoramas but also to older, painted wall coverings and wall paintings." See Börsch-Supan (1967), p. 314. The most popular subjects found in bourgeois interiors were park landscapes and historical or mythological themes: "A great many of the series are based on models in the early classical style, for example, 'Views of Paris' (1814) after the panorama of 1799; 'Views of Italy' (1824) after Prevost's panorama ca. 1800." Ibid., p. 315. See also Leiss (1961), and the lavish exhibition catalog of Paris 1990.

131. A smaller group of customers preferred works with literary themes: "Arcadia" (1811); "Views of Scotland" after Walter Scott; "Telemaque" (1823) inspired by Homer's *Odyssey*; or topographical themes: "The Savages of the Pacific" (1803); "Hindustan" (1807); "The Shores of the Bosphorus" (1829).

132. Oettermann (1997), p. 5 (1980, p. 7.)

133. Sternberger (1974), note 3, p. 205.

134. Rupp (1940), pp. 72ff.

135. Auerbach (1942).

136. Lundwall (1964).

137. In his comprehensive history of decorative painted interiors in England from 1537 to 1837, in the chapter entitled "The Panoramic Room," Croft-Murray traces the tradition of panorama rooms back to classical antiquity. See Croft-Murray (1970), pp. 60ff.

138. Gustav Solar's research focuses on views of cities and topographical vistas with wide horizons taken from elevated positions. The emphasis of his prehistory of the panorama, which goes back to early modern times, is more on the aspect of the horizon and less on the 360° viewing experience of the observer. See Solar (1979).

139. In addition to examples from other epochs, Sweetmann's prehistory of the panorama stretches back to a space of illusions near El Amarneh in Egypt ca. 1370 B.C. See Sweetmann (1981), p. 10.

140. One of the most important researchers on the panorama, Sylvia Bordini, only briefly investigates its prehistory but emphasizes both the tradition of illusionary experience of spatial depth and the aspect of the enclosure of the observer by the image. Bordini (1984), pp. 37ff.

141. Marcel Roethlisberger provides a concise overview of the prehistory of the panorama, which he classifies as belonging to rooms painted with continuous landscapes. Roethlisberger (1985b), p. 243.

142. Oettermann (1997), p. 23.

143. Ibid., p. 24. For Oettermann, further proof is the fact that Barker's invention was patented (1787) and the coining of the word panorama itself in the late eighteenth century from two Greek roots, *pan* (all) and *horama* (view).

144. Ibid., pp. 7ff.

145. See Solar (1979). On depictions of the horizon predating the panorama, see Hyde (1985); the explicit critique of Oettermann's position in Gronert (1981), pp. 39ff.; and Weber's (1993) implicit critique.

146. For details, see Altick (1978).

147. Cited in Escoffier-Robida (1976), p. 7.

148. Cited in Pragnell (1968), p. 23, note 2.

149. William Wordsworth: "Mimic Sides. A Note on Panorama and Other Indoor Displays," in *The Prelude*, 1789, 1805, 1850, 1979, here the 1979 edition, cited in Shaw (1993), p. 462.

150. Kleist wrote this in a letter to his fiancée, Wilhelmine von Zenge, dated August 16, 1800. See Kleist (1800), pp. 71ff.

151. Ibid.

152. On Kleist's reflections on the panorama, see Müller (1990), pp. 239–249.

153. J. A. Eberhard, *Handbuch der Ästhetik*, Part 1 (Sechsundzwanzigster Brief), Halle 1805; cited in Buddemeier (1970), p. 173.

154. Ibid., p. 175. "Panorama sickness" was indeed a widespread phenomenon at this time.

155. Ibid.

156. See Dufourny (1937), pp. 261ff.

157. Ibid., pp. 260ff.

158. Ibid., p. 256: "Mais supposons que l'oeil, Sur quelque point de l'horizon qu'il se porte, soit constamment frappé d'une série d'images, toutes dans des proportions relatives, toutes avec les tons de la nature, et que nulle part il ne puisse saisir l'objet de comparaison qui lui est nécessaire pour asseoir son jugement, alors il sera trompé, il croira voir la nature, car elle n'est plus là pour le désabuser."

159. Ibid., p. 257: "mais à mesure que l'oeil s'habituant au jour qui l'éclaire oublie les teintes de la nature, le tableau produit insensiblement son effet, et plus on le considère, moins on se persuade que ce qu'on voit n'est qu'un simple prestige."

160. Ibid., p. 261: "Serait-il donc difficile d'isoler un tableau en sorte que les objets dont il se trouverait environné ne servissent nullement à l' oeil pour lui faciliter les moyenx de reconnâitre la petitesse, la proximité, la faiblesse du coloris des objets représentés, et le procédé employé pour la totalité et en grand dans le *Panorama* ne donnerait-il pas partiellement le même résultat?"

161. John Ruskin, "Praeterita," in Ruskin (1908), vol. 24, p. 117. Cited in: London (1988) (exhib. catalog), p. 28.

162. Whitley (1968), vol. 2, p. 108.

163. Börsch-Supan (1981), p. 170. On Napoleon's projected panoramas, see also the diary of the architect Pierre Françoise Lèonard Fontaine, December 21, 1812: "The Emperor summoned me.... He gave me to understand that he was willing to spend four or five hundred thousand francs on each panorama," cited in Robichon (1993), note 7.

164. Robert Barker, "Defeat of the French at the Nile," London, Leicester Square, 1799; Samuel James Arnold, "The Battle of Alexandria," London, Spring Gardens, 1802.

165. Barker's rotunda in Leicester soon had to compete with Ker Porter who, however, left England in 1805. In Paris, the first panoramas came into existence in 1799, in Berlin in 1800, and in Vienna in 1804, followed by other cities.

166. Marquard Wocher took six whole years for his relatively small (292.5 m²) "Panorama of Thun," which he made almost entirely himself (1808–1814); see Ganz (1963), p. 479. Johannes Michael Sattler spent five years on the "Panorama of Salzburg"; see Lundwall (1964) and Sattler (1920), p. 88.

167. The description of Henry Aston Barker's eventful journey to Constantinople (1799–1800) is a detailed and impressive account of the dangers and difficulties that panorama painters were exposed to because of the public's appetite for sensational new images. It is a hand-written diary—still awaiting publication—in the National Library of Scotland (MS 9647-8).

168. "The large amounts of capital needed to develop this interesting invention on a grand scale were not raised because entrepreneurial spirit was lacking." See Hausmann (1890), p. 257.

169. Made possible by the introduction of artificial lighting, necessary for evenings and the winter months but also an improvement in summer when there was too much sunshine. See Telbin (1900), p. 558.

170. Cited in Hausmann (1889), p. 201.

171. In France, the first standardizations of the formats were already made by the years 1799 to 1805. See Robichon (1993), p. 52.

172. *Hamburger Nachrichten*, January 22, 1833, cited in Oettermann (1980), p. 187.

173. See Bordini (1984), pp. 145ff.

174. Based on the authoritative catalog of known panoramas in Bordini (1984), pp. 325–331, which includes the information in Oettermann (1980).

175. In London, for example, there were city panoramas of Brighton (1798), Ramsgate (1800), Constantinople (1801), Copenhagen (1802), Rome (1802), Cairo (1807), and Athens (1818), among others. There was a similar development in Paris.

176. Landscapes of this kind were seen, for example, in Gibraltar (1804), Malta (1810), Spitzbergen (1819), and so on. See Bordini (1982), p. 38.

177. Bordini (1982), pp. 27ff.

178. Bätschmann (1989), p. 93.

179. *Blackwood's Magazine*, no. 15 (1824), pp. 472ff., cited in Altick (1978), p. 181.

180. "The recent perfection achieved in large-scale landscape painting (in decorative painting [including 360° frescoes], in the form of panoramas, dioramas, and neoramas), has increased the allround strength of the impression." See Humboldt (1993), p. 79.

181. Ibid., pp. 79ff.

182. Kemp (1991), p. 82.

183. There were examples of other subjects, for example, "The Triumphal Procession of Emperor Constantine in Rome," Bühlmann/Wagner, 1888; "The Last Days of Pompeii," Castellani, first shown in Naples, 1882; "Rome 1849" by Philippet in Vienna 1889; and "History of the Hohenzollern" by Fleischer, Berlin, 1892.

184. In London, for example, "The Battle of Seringapatam" (1800), "Calcutta" (1830).

185. See Siebenmorgen in Schwäbisch-Hall (1986) (exhib. catalog), p. 16.

186. See Robichon (1993), pp. 62ff., for audience statistics of French panoramas.

187. In 1860, Napoleon III decreed there must be lower prices on Sundays so that less well-off people could see Langlois's battle panoramas. See Robichon (1993), p. 56.

188. See Robichon (1993), pp. 56ff.

3

The Panorama of the Battle of Sedan: Obedience through Presence

The battle scene genre runs through the history of the panorama like a thread. In 1795, Robert Barker presented *Lord Howe's Victory and The Glorious First of June*, a panorama of a very topical subject: a sea battle against the French that had taken place only a year before. This theme was very popular with the public; indeed, Barker's panorama *The Battle of Waterloo* (1815) was his most successful panorama of all, earning in a very short time the hitherto unknown and—for the time—astounding amount of £10,000. Ker Porter (1777–1842) set new records in audience numbers with battle scenes of Anglo-French wars and his propaganda pictures of Pitt's imperial England. Indeed, the Napoleonic Wars gave rise to a great number of depictions of battles.[1] Almost without exception, the nation that exhibited the panorama had also won the battle it showed. In the entire history of the panorama the genre of the battle scene accounts for nearly 30 percent, which is a very high proportion compared to the number of smaller format paintings of the same subject. With the visualization of contemporary military engagements, the panorama established itself as an instance of the first importance for "molding political and social history according to the opinions of official and state circles of the time."[2] The former army officer Charles Langlois (1789–1870), for example, who was himself a veteran of several wars, was hugely successful with his panorama paintings of battles from the Napoleonic Wars. A number of painters active in this genre achieved international fame, including Charles Castellani, Felix Philippoteaux, and Theophile Poilpot, and particularly Edouard Detaille and Alphonse de Neuville. Public interest reached a new peak with the unveiling of the panorama depicting a battle of the Franco-Prussian War of 1870 to 1871, *The Battle of Sedan*.

From 1880, Germany became the international leader in presenting and producing panoramas. German artists worked on a grand scale for export, particularly to the United States. However, from the official state perspective of political propaganda and from the point of view of commercial interests, no panorama had more time, energy, and money lavished on it than *The Battle of Sedan* by Anton von Werner. This work, which until now has only been researched superficially, is most suitable for drawing an exemplary comparison with a contemporary computer-generated work of virtual reality.

The opening of the Sedan panorama on September 1, 1883, the anniversary of the Battle of Sedan, was a political and media event of the first

order. Throughout the German Reich, there were processions, patriotic choral concerts, school celebrations, and festivals organized by citizens' and veterans' associations.[3] Shops gave their employees the day off. The main thoroughfares, decorated with flags and bunting, were crowded with day-trippers in holiday mood. The highlight of the day was the actual opening of the panorama. Von Werner, who officiated at the ceremony, extended a welcome to almost the entire ruling elite of the German Reich.[4] The event received such extensive coverage in virtually all newspapers that public interest in the monumental art work was assured and extraordinarily high.[5] The art work was exhibited exclusively under the name of Anton von Werner; of the artists involved in its creation, only Eugen Bracht had the opportunity to talk about his landscape.[6] The other thirteen were not mentioned at all, neither by the press, nor at the opening. Media interest in this event was comparable to Christo and Jeanne-Claude's wrapping of the Reichstag in 1995—a rare occurrence indeed for a work of art. However, the gigantic painting was identified with a conception of the artist's role that had little to do with the industrial process that had created it. Although exhibited under his name alone, Anton von Werner did not contribute even a single brush-stroke.

The Kaiser, who spent one and a half hours at the panorama, was so impressed by the powerful effect of the illusion that he remarked to von Werner "I have never seen anything like it."[7] He went on to praise effusively von Werner's work of composition: "With your masterpiece, you have made the anniversary of the Battle of Sedan a living memory for the people and nurtured their understanding. And my deepest respect for this might be seen as the greatest reward for your labours."[8] Von Werner's pedagogic and psychological commission, to generate public sympathy for this military operation, had been, in the eyes of the Kaiser, successfully executed. His words of praise, embedded in descriptions of the panorama, appeared in all the newspapers the next day.

The Battle in the Picture

During the Franco-Prussian War (1870–1871), after the Battle of Beaumont where both sides sustained heavy losses, French troops massed near the fortress of Sedan on August 30, 1870. The strategy of the Prussian general, Graf von Moltke, aimed to encircle the French armies. The only route of escape to Mézières still open to the French on the morning of

September 1 was the first target of German attack. After supreme command of the French armies had been assumed by General von Wimpffen, the French attempted to break through the German lines toward the east. When the German general staff saw that von Wimpffen did not intend to break out in the direction of Mézières, they attacked the rear of the French armies. The attempt by the French cavalry to break through the closing encirclement is the subject of the Sedan panorama. Nine thousand German soldiers fell that day, and, on the French side, there were seventeen thousand dead and wounded. The panorama shows in detailed, almost photorealistic quality, the alleged situation on the battle field of Sedan at 13.30 hours on September 1, 1870.

Standing on the panorama's viewing platform, which had a diameter of eleven meters[9] and corresponded geographically to a plateau near the village of Floing, the spectator was completely surrounded by the circular painting depicting the battle field (fig. 3.1). In the foreground of the panorama, that is, nearest the spectator, German infantry of the Fifth and Eleventh Prussian Jaeger Battalions clash with the First, Third, and Fourth cavalry regiments of the Chasseurs d'Afrique. The French cavalry are attempting to breach the encirclement of their forces that had developed during the morning and open up a way out.

The raw energy of the Chasseurs' charge is stopped short by a hail of bullets from the closed ranks of the Silesian infantry.[10] The linear dynamic of the charging cavalry (mounted effectively, in terms of color, on white horses) disintegrates into a chaotic turmoil of the mortally wounded (but without wounds, blood, or gore). This is where the action of the picture is focused. A mounted bugler rears up, his instrument held high, crashing into the ranks of the infantrymen; other riders follow—exhilaration is in the portrayal, death is invisible. Von Werner had the French painted without faces, as an anonymous mass; the Prussians, however, were individualized with many portraited faces. In stark contrast to the disarray of the French cavalry, von Werner presented the Germans on the other side of a cloud of gunsmoke in disciplined, serried ranks—as if they were on a shooting range. Their commander was Captain von Strantz; he is shown with sabre raised, a giant of a man who is almost a head taller than the rest of his battalion. Like several other officers who appear in the picture, von Strantz was portraited in order to endow the scene with an aura of authenticity. The position in the composition of this figure, who, in the face

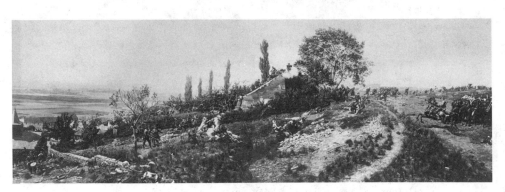

Figure 3.1 *The Battle of Sedan* panorama by Anton von Werner. Painted by E. Bracht and thirteen other painters, oil on canvas, approx. 115 m × 15 m, ca. 1883, panorama leporello of four photographs. In Ludwig Pietsch, *Das Panorama der Schlacht von Sedan*, Berlin, undated (ca. 1883).

of the cavalry charge stands his ground "cold bloodedly,"[11] is a personification of von Werner's credo: the portrayal of the overall superiority of the Prussian soldier. This is the central message of the panorama. The intention was to paint an idealized picture of the Prussian soldier and his soldierly virtues: obedient, superior, fearless, cold-blooded, disciplined, and strong—"virtues" that have been repeatedly evoked in the past and even today are still propagated as German. The moment of attack is almost exclusively initiated by the French in the picture, so that the Prussians, the real aggressors, and with them the spectators, shift to the position of being the defenders.

Behind the Chasseurs, General Marquis de Gallifet (the only Frenchman with quasi portraited features) is seen leading the cuirassiers regiments of the Division Bonnemains into battle. The Second Corps of the Eighty-second Infantry regiment advances from Floing toward the hill. To the last detail, the complexity of the troops' formation and the battle order of the milling masses is rendered obsessively in the picture. While sections of the Eightieth, Eighty-seventh, and Eighty-eighth regiments march on Illy, the horizon behind the massed French cavalry is obscured with clouds of gunsmoke. To the south, from Sedan and the adjacent fortified outskirts of Torcy, clouds of smoke rise and block the view of the burning villages of Balan and Bazailles; only that same morning, the latter had seen the massacre of its civilians by Bavarian troops. In the immediate vicinity of the spectator's position, there is hand-to-hand combat on the plateau. Here, as in the majority of panoramas of battle scenes, the ideal-typical,

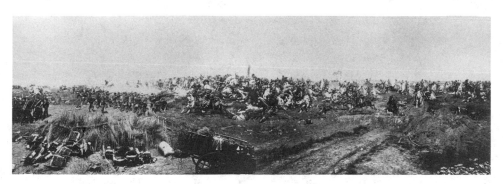

Figure 3.1 (continued)

distanced, and panoramatic view is relinquished in favor of frontal immersion in the images of a massive military encounter. The distant views of the landscape of the Ardennes toward the west present a decisive contrast to this. Below the high ground lies the village of Floing with its park, filled with French prisoners, and to one side Prussian reserve troops and munitions supply columns move up. Behind the village stretches the vista of misty green meadows of the Maas, extending far into the distance. Here there are only scattered signs of the hostilities; scattered French cuirassiers are trying to fight their way through. In the clear even light of the picture's sunny and heat-hazy late summer day (in reality, the sun did not shine there at all that day), the quiet landscape lies with its silvery ribbon of a river and builds a stark contrast to the battle. Like an anecdotal marginal note, the military band of the Prussian Jaegers is included here (who were actually supposed to be giving the infantry psychological support by playing rousing military marches). A few scattered French Chasseurs, who have managed to break through, have rounded up the musicians into a tight group. Clasping their instruments tightly in their hands, the musicians regard the cavalry with astonishment while before their eyes an infantryman drives his bayonet into a rider's side.

To the northwest, near Frénois, almost in the center of the wide valley, are two treeless elevations that border the limits of the painted space. From the southern hill, Wilhelm I with his entourage and general staff follow the progress of the battle, while Crown Prince Friedrich watches close by from the other. Although the spectator could not recognize the King in the picture, who was about six kilometers away, the fact that he was there

was known from numerous articles, reproductions, and, of course, the orientation plan of the panorama.

The Power of Illusion, Suggestion, and Immersion

In the waning years of the nineteenth century, people flocked to the panoramas in their masses. From 1870 to 1900, Oettermann gives a conservative estimate of ten million visitors[12] for the German Reich—the actual figure was probably much higher. The Sedan panorama developed increasingly and continuously into "a place of pilgrimage for narrow-minded petit bourgeois Prussian patriotism."[13] Although it had a wide audience—collective visits to the panorama by groups of school children, veterans who came to remember, tourists seeing the capital, and, particularly, the patriotic citizens "faithful to Kaiser and Fatherland"—it was an audience where ordinary working people were underrepresented because of the cost of admission. As tickets cost one mark,[14] members of the working classes could only afford it on special days when the price was reduced. On the other hand, this not inconsiderable price of admission testifies to the attraction that the worlds of illusion held for the public who, together with the images of war they experienced, also absorbed the ideology, submission, and obedience that were to lead them into the First World War.

For the company to break even on its investment—the panorama cost a total of one million goldmarks, not including interest and running costs—at least one million people would have to pay to see the picture. In effect, it was probably several million. The fact that, after 1900, the admission fee was only 25 pfennigs demonstrates, on the one hand, the declining interest in the subject and the medium of the panorama and, on the other, that the company had paid off its initial investment but continued to siphon off the profits from a segment of the market that had become financially less attractive.

For us today, accustomed as we are to adjusting our viewing habits to ever faster speeds, it is almost impossible to imagine the profound effect that the static images of the panoramas had on the audiences of the nineteenth century. The impressions created in people of bygone eras by the reception of image spaces and media constructed and conceived by them is not comprehensible by extrapolation from the present. This is not the way to gain any firm knowledge about contemporary visitors' visual experience

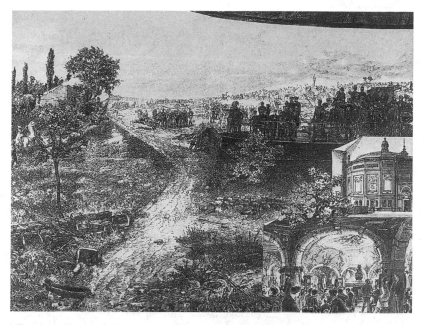

Figure 3.2 Interior of *The Battle of Sedan* rotunda, Alexanderplatz, Berlin. Panorama, rotunda, and restaurant, drawing, 1884, Gebr. Mann Berlin.

of the images in their space. If we wish to know more about the effect of the panorama *The Battle of Sedan*, then we must have recourse to the testimony of eyewitnesses: These are available in the form of press reports, but their statements can by no means be regarded as objective.[15] Obviously, there are reservations about the validity of results obtained by this method.

The visitor entered the panorama through a dark passage that led to the viewing platform where he or she was surrounded by the bright space of images, which both reflected the daylight and possessed painted light effects of their own (fig. 3.2). Without the possibility of comparison with objects external to the painting, the spectator's gaze was completely subdued by it. The light reflected by the canvas with its virtual subject appeared to the spectators, standing in the dark, to be itself the source of the real. With points of comparison and orientation to familiar objects in the panorama itself, the virtual battle succeeded in occupying the spectator's gaze by its very "luminosity." In the first few minutes, the illusion was so irresistible that the image space, as many eyewitness accounts stated, was experienced as the real presence of a second world. The news-

paper reporter for the *Neue Preußische Zeitung* described the effect thus: "The visitor is gripped immediately; he is taken completely by surprise and instinctively holds back. One is afraid of being trampled by the horses' hooves and feels the urge to concentrate on going backwards. Swirling dust and smoke seem to fill the air. Trumpets blare and drums boom. In an overwhelming onslaught, the cavalry charge. What multitudes of horse, they are the French! That's the first impression!"[16]

The illusionistic effect decreased the longer one spent in the panorama but, nevertheless, the first deep impression of feeling personally involved in what was taking place remained. Through its real effect the picture was scarcely perceived as being an actual painted picture. Moreover, *in* the picture itself the impression was extinguished that this was a finite object, separate from its observer, an experienceable picture or work of art, for everything was art. "One believes that one is standing in the surging midst of the terrible battle," insisted the *Berliner Tageblatt*.[17] Even when the spectator was conscious of confronting an illusion, its perfection seemed so consummate and above banal illusion that one still felt transported to another place, as many newspapers agreed: "the transition from art to nature is a mystery to the eye. One does not notice that one is still in the capital: one thinks one is on high ground, inexplicably surrounded by a railing, yet looking down on the battlefield of Sedan."[18] And: "It is exactly as His Majesty the Kaiser is reported to have said: It does not look painted at all; it is reality."[19]

Wilhelm I had precisely delineated the dimensions of the panorama's goal. On the basis of an illusion, specific components of a message were developed that aimed at canvassing popular support for military interventions. This was achieved through von Werner's composition of images, which thus moved into, whether through idealistic aberration or conscious falsification, the sphere of propaganda. The method follows the schematic *authenticity = illusionistic effect + idealized composition = propaganda*. In public, von Werner was obliged to reject the illusionistic element, for this connoted the odium of fakeness, of deceptive appearances with no pendant in fact, which the spectator can embrace with playful abandon. In line with the political message, he had to emphasize the documentary value and lay claim to this *second reality*, which had been produced by endless labors of reconstruction.

Figure 3.3 Anton von Werner. Photograph ca. 1900, Richard and Lindner. Author's archive.

Anton von Werner: Artist and Power Player

Anton von Werner (fig. 3.3) dominated cultural policy in the German Reich after unification. From 1870, he accompanied contemporary historical events of the newly formed state in dozens of portraits and large-scale paintings, many of them commissioned by the Kaiser.[20] Although the "official" Prussian artist Adolph Menzel took precedence over von Werner, Wilhelm I patronized this politically predictable artist and facilitated his rise to a preeminent position within the official Berlin art establishment, which his contemporaries did not only greet with approbation. Von Khaynach was perhaps the most outspoken critic: "Werner's spirit dominates in Berlin; he is, as it were, merely the artistic side of the great Prussian arsenal. Wherever the weary eye turns, there are soldiers, great and humble, flags, guns, cannons, and festivals bursting with pomp where, again, there are only soldiers. Werner has put this entire starched, blatant, dreary, petit bourgeois, feudal society onto canvas in a manner that is as thorough, embarassing, and insipid as the society itself, and that will be an

obnoxious reminder of a part of German history to the free spirits of years to come."[21] In 1875 von Werner became director of the Academy and also consolidated his influence over the Verein Berliner Künstler (Berlin Artists' Society) and the regional art commission. His position of supremacy became clear to everyone when Bismarck requested that von Werner be given overall supervisory responsibility for the German art section at the Paris World Exhibition of 1878. Von Werner was frequently at court and cultivated friendly and private relations particularly with Crown Prince Friedrich, who became Kaiser for just a few months in 1888. Through his close contacts with all three German Kaisers, von Werner succeeded in exerting a decisive influence over the art policy of the German Reich for decades, whereby he did not lack ruthlessness and censorship when asserting his own interests over people with different opinions.[22] His conception of art, which marked him as a vigorous opponent of the rise of modernism, he expounded on in a pretentious address to the Academy: "State cultivation of the arts can, in my estimation, have no other duty than to cultivate and hold fast to the idea of beauty, just as an international commission watches over the reliability and indisputability of the modern meter rule."[23] With this, he echoed the sentiments of the majority of his contemporaries. To demonstrate how the language that obtained in the debate on the normative aesthetic represented by von Werner had become radicalized, it is useful to cite from the notorious book by Julius Langbehn, *Rembrandt als Erzieher*, a work that in 1909 had already reached its 49th edition, first published in 1889: "The fate of the German nation rests on the point of a dagger, and if one may say that this dagger is called 'the German army,' then its real point is the 'General Staff'; ultimately, the fate of Germany depends on that General Staff. And as in war, so in art. At times, the politics of art will have to be a war."

The idea of exercising judgment and control over art by applying a kind of law or fixed canon was a notion that, later, von Werner would share with Wilhelm II.[24] On the basis of a style that was superficially naturalistic, which functioned above all through a massive quantity of detail, von Werner gave the impression to many—and to some until the present day—of being a chronicler, a recorder of events, an eye-witness.[25] However, a closer look reveals a host of melodramatic and engineered elements, which serve the personal elevation of the political, aristocratic, and military elite of the Reich with the intention of winning the observer of

the work over to their political aims.[26] From the outset, it was planned to realize the projected painting of the Battle of Sedan in the form of the panorama because of its popularity as a medium of images. As the theme was not merely of local importance but should address the nationalist and patriotic sentiments of broad sections of the population, the whole endeavor assumed great political significance. In the opinion of the political decision makers, Anton von Werner was the ideal choice from the beginning. His artistic style, his reputation as a chronicler who glorified the military,[27] and his standing in cultural politics made him the favored candidate for the job in the eyes of the ideologists, first and foremost the Kaiser himself. This was more than welcome to the Belgian panorama company, for von Werner was firmly anchored in the Prussian cultural landscape, and, in times of extreme national chauvinism, this fact guaranteed that a foreign investor would be safe from protectionism, whereas the choice of a different artist might have prevented the flow of profits back to the investors in Belgium.

Political Objectives

Although *The Battle of Sedan* was financed by private capital, it was promoted and controlled by the highest political offices because, for contemporary Germans, its theme was the most decisive action of the Franco-Prussian war. The defeat of France, which also resulted in the capture and abdication of Emperor Napoleon III, opened up the way to Paris for the German army. The French proclaimed the 3rd Republic, which soon capitulated. This was followed by King Wilhelm II proclaiming himself Kaiser and the unification of the southern German states with the alliance of northern German states under Prussian leadership. The first in the chain of events that led to national unity, seen by many as causal, was the Battle of Sedan. "It is our custom to celebrate Sedan Day as the birthday, as it were, of the new German Reich," wrote the *Vossische Zeitung* on the anniversary of Sedan in 1883.[28] Thus, the first of September came to be the most important national holiday in Germany.[29] For many, Sedan meant more than a military victory and political unification: For cultural chauvinists it was also the triumph of their own "superior race."[30]

From Brussels came the suggestion of to create a panorama on the patriotic theme of the Battle of Sedan, and this was greeted enthusiastically in Berlin. Not only the theme, but also the dimensions of the work and its

housing, fitted in admirably with the art policy strategy of monumental memorials, which, at the time, the political leaders of the Reich were erecting all over Germany as political propaganda.[31] In his book on the history of art in Munich, Friedrich Pecht notes: "The nation was in raptures that at last they could see their victories in a form better suited to their greatness than previous treatments and they became quite carried away. The genre of battle scenes, which had been so despised before, suddenly became the people's favorite art genre and even the poorest farmers did not shrink from journeying for days just to see the place and the battalion where their sons had fought."[32]

Although it was believed that, with the panorama, the adequate and appropriate medium had been found for the subject, Prussia was particularly bothered by the presence of large numbers of Bavarian units.[33] Thus, under the patronage of Wilhelm I, a panorama of the Battle of Sedan was commissioned that would win recognition for Prussian dominance of the German Reich. After agreement on the rough thematic outline had been reached, the Belgian company gave the Germans a free hand in the details and execution of the project. For the interests of academic research, the precise role of the Kaiser in awarding this commission still remains nebulous. Von Werner himself never alluded to any programmatic directives, but he was well known anyway for his paintings of events, seemingly with over-meticulous preservation of historic circumstances and ostentatious attention to exact detail, particularly where the effective mise-en-scène of the military was concerned. His work emphasized the specific historic moment in time and tended toward its dramatic interpretation. In the light of the well-known provenance of von Werner's earlier works, it can be assumed that by awarding the commission to this artist, it was anticipated that he would oblige with a work in the same vein. In addition, von Werner claimed to have received nods and winks from the highest offices, for example, from von Moltke, who often visited him in his studio: "I spoke with him about the projected Sedan Panorama, outlined my conception, and he gave me a lot of helpful hints for my work, which he continued to follow with lively interest."[34]

From a dramaturgical point of view, the legendary charge of the French cavalry and encircled troops under General Gallifet, which was well known from many reports and descriptions,[35] seemed to be the most suitable choice for putting the Prussians center-stage—without a doubt, for them

it was the most spectacular and glorious motif. From a military point of view, Gallifet's failure had signaled defeat for the French, who could only capitulate in view of their hopeless position. Eugen Bracht, the principal landscape painter of the panorama, commented thus on the choice of subject: "in particular, it was the magnificent cavalry charge under the Marquis of Gallifet in the direction of Floing on the Marne, which could be exploited as a motif for painters—this episode had been decided upon from the beginning."[36] Orientation on this economic and political framework was obligatory for an artist working on a Sedan panorama for Berlin.

The Panorama Stock Exchange

The Sedan panorama was not the outcome of an autonomous artist's decision. It was the end-product of a phase of multinational financial speculation, centered in this case on art. The investors in Felix Philippoteaux's panorama *The Siege of Paris* (1873), another motif from the Franco-Prussian war of 1870 to 1871, had raked in enormous returns,[37] so it was not long before competition appeared on the scene. Particularly the stock exchanges in Belgium, which were just recovering from a fall in 1879, caught panorama-fever, and stockbrokers advised speculators to invest in panoramas.[38] In Belgium alone, more than twenty panorama joint-stock companies were formed; however, the majority were bankrupt after 1885. As the majority of the panoramas they financed were exhibited abroad, shareholders and investors alike had only one interest in these projects: dividends, fast profits.[39]

In 1879, Victor Jourdain, a broker from Brussels, and his brother Louis started the Société Anonyme des Panoramas de Londres, whose shares had a nominal value of 100 Francs. One year later, under the new name of Société General des Panoramas, the shares were trading at a price of 1300 Francs. This company specialized in the financing and production of battle panoramas. Charles Castellani, who had made a considerable name for himself in this genre, was their preferred choice for these commissions, and within a short time he became a principal shareholder of the company.[40] Interestingly and contrary to the general rule, France produced many panoramas on the theme of its traumatic defeat in the war against Germany, but, undoubtedly, this helped them to come to terms with this historic episode.[41] In Germany, too, interest in pictorial representations of the war was increasing so that in 1879, Castellani was approached

by a German named "Wolf, who offered him 300,000 Francs to create a Sedan Panorama."[42] However, Castellani declined—for patriotic reasons, he claimed later in his memoirs.[43] Thus, the competition, the interest group Duwez/Maliers, founded the Société Anonyme des Panoramas de Berlin[44] in August 1879 with a share capital of 250,000 Francs. Its chairman was the architect Hanke, later director of the Sedan Panorama, and Wolf was a shareholder. Consequently, the birthplace of the panorama that became a national monument of the German Reich was, in fact, Brussels.

The companies were strictly oriented toward the marketplace with the goal of accumulating capital: Themes and target groups were selected with maximum profits in mind. In Germany, a panorama about the victorious war of 1870 to 1871 promised a good return.[45] Moreover, that the target audience of financially well off and patriotic citizens was concentrated in Berlin was obvious even without the tools of modern market research. The companies' interests were not in the least patriotically motivated. This is confirmed by the fact that both parties to the war were offered chauvinistic portrayals of events. National pride of the other side determined the profits. In May 1879, when the company was in the process of formation, Emil Hünten[46] was selected at first to execute the Sedan panorama but then Anton von Werner was approached via the new Berliner Panorama-Aktiengesellschaft, a subsidiary of the Brussels Société Anonyme des Panoramas de Berlin. Regarding the exact circumstances of the awarding of this commission, von Werner remains vague in his memoirs of 1913, entitled "Experiences and Impressions":[47] "... in the end, I was also seized by panorama-mania, which was rife at the time. A Belgian company had already erected a building in Berlin, where Emil Hünten and Simmler from Düsseldorf were at work on a painting of our Guards attacking St. Privat. Another Belgian company wanted me to take on the Battle of Sedan, and a third contacted me around the same time with the same proposition."[48]

Either von Werner did not know that Hünten worked for the same Brussels company that had two subsidiaries in Berlin, or he was trying to avoid the unpatriotic overtones of having foreign principals who would pocket the considerable profits from such a popular picture. Finally, von Werner states that "a group of Berlin financiers"[49] commissioned the work. The enormous sum of a million goldmarks[50] was allocated to erect a rotunda for the panorama in a prime location, where *The Battle of Sedan*

would be shown exclusively on a permanent basis. Thus, the responsibility for the financial success of the project lay with Anton von Werner's ability to produce an immersive version of the theme that would have a mass impact. For the artistic concept, detailed outlines, and overseeing the completion of the work, von Werner was offered the amazing sum of 100,000 goldmarks.[51]

With Helmholtz's Knowledge: "Democratic Perspective" versus "Soldiers' Immersion"

In his famous lecture of 1871, *On the Relation of Optics to Painting*, which he had given in various places and published several times, Hermann von Helmholtz summarized contemporary knowledge about optics and the physiology of perception as they related to the medium of painting. Helmholtz gave the following definition of their meaning: "The immediate purpose of the painter is, by means of his colorful panels, to call up lively visual representations in us of the objects that he is attempting to portray. Thus, it is a question of bringing about a kind of optical deception ... insofar as the artistic representation calls up in us an idea of this object, full of life and strongly perceived by the senses, as though the object were really in front of us."[52]

Helmholtz then proceeds on a *tour d'horizon* of the basic means of illusionism of his time, from the power of shadow to form contours, the finely balanced clouding of the atmosphere, the nuances in the gradation of luminous intensity, and, connected with this, the sensations of color and the contrasts elicited by adjacent hues and brightness, to the harmony of colors.[53] He does not omit to point out that a painter cannot create three-dimensional space on canvas. However, with large canvases placed at some distance from the observer, the eyes can hardly distinguish between the two images they see. Thus, the observer cannot be certain if he is looking at depth of field or a flat surface.[54] This is the physiological phenomenon that the panorama makes use of. In addition, it offers in close proximity, according to the movements of the observer, spatial changes: Objects that are closer move in relation to those that are farther away. Anton von Werner's *The Battle of Sedan* represents the sum total of contemporary knowledge in the field of the physiology of sense perception and of technical skill in the art of illusion. It is state-of-the-art illusionism and based on the findings of the great Berlin scientist Hermann von Helmholtz. It

goes without saying that von Werner knew the famous author of *Physiologischen Optik*, and it is within the realm of probability that he applied this knowledge consciously in the realization of the state project he was entrusted with.

For the observer, aesthetic reception of the panorama is bipolar: On the one hand, there is the typical panorama experience of a dominating view of the depth and expanse of the horizon. The clarity of its composition contributed to the impression of being able to follow what was going on in the battle. On the other, the *faux terrain*, the three-dimensional extension of the one-dimensional picture, had the function of integrating the observer, it came up close to the spectators, particularly in the section where hand-to-hand combat was depicted, and this strategy of virtually removing boundaries led, or rather pulled, the observer into the depths of the image space. Abandoned fieldwork tools, weapons, knapsacks, and coats, a broken-down baggage wagon, deep ruts running through the clay soil of the "terrain," grasses, shrubs, branches and stones, as well as the cap made of cloth and patent leather, lost by a Chasseur—all these properties were plastic and, as the editor of the *Vossische Zeitung* remarked, "natural enough to touch."[55] Together with the photorealism of the painting, it heightened the illusion of being in the image. The *faux terrain* served to disguise and negate the image character of the panorama and transformed the entire corpus into a space of illuminated illusion. Moreover, the boundary between picture and *faux terrain* was indistinguishable to the naked eye, as witnessed by the correspondent for the *Militärzeitung*: "the transition from reality to the painting is everywhere so cunningly contrived that only the practised eye can tell where the painting begins."[56] The actual distance between the viewing platform and the canvas was more than twelve meters. This utilized the physiological observation that humans can perceive objects spatially only up to about this distance.[57]

In applying these findings from the fields of physiology and sensory perception, which were available to illusionism in the nineteenth century, the objectives were to make the battle accessible to the observer, to break down deliberately the observer's inner distance, and to maximize the suggestive power of the representation. In connection with the panoramas by Detaille and de Neuville, Robichon reports that they evoked a strong emotional response because of their spectacular portrayal of atrocities:[58] blood, corpses, and the fixed stares of the mortally wounded in melodra-

matic postures of suffering. Although such scenes were a magnet for the voyeuristic gaze of some, they were obviously not suitable for inclusion in the Sedan panorama, for this sought to make broad sections of the middle classes identify with the soldiers and glorify soldierly virtues.

The panorama's spectators may have witnessed the greatest power of humans over the image in their day—an artificial horizon created according to the most modern scientific, technical, and economic organizational principles—but they were left entirely alone and powerless in their confrontation with the suggestive force of this enveloping, potential *totality* of the image. If we reverse the usual direction of view, from the observer to the image, then we find that, from all directions, this image apparatus fixes the observer in the center of the circular space: from its perpective, dimensions, proportions, choice of color, lighting, and *faux terrain*. The picture and the three-dimensional scenery are focused on and adjusted to the observer with the precision of illusionism and, as it also addresses the human subjects on a physiological level, they find themselves both physically and emotionally *in the picture*.[59]

In theory, the observer of the panorama has a perfect, commanding view of the painted horizon; however, in relation to the high ground where the military commanders are visible, he cannot be absolutely sure of this. The supreme commander, the king, with his sovereign view, is still above him both geographically and spatially. Although King Wilhelm was not clearly recognizable to the observer *in* the midst of the battle scene, his significance within the picture stems from his presence on the exposed faraway hilltop over the broad landscape, which frames the hill like an aura. The painted soldiers in the battle and the panorama visitors were thus all under the eye of the monarch, distant yet near, who even attained a kind of omnipresence, for it was well-known that he had been there. In contrast to this typical panoramic view of the horizon, the power of which is broken by the commanding view of the king on the high ground in the center of the landscape, is the inclusion of the observer in the direct events of the battle in the painting's foreground and the three-dimensional scenery immediately in front of it. Significantly, this section, which closely involves the observer, accounts for about half of the painting: Distant prospect and close combat have almost equal shares of the image space. The panorama "not only makes the situation clear to the observer, it draws him into the midst of it."[60] Thus, the aesthetic experience of the panorama

consisted of the sum total of these two alternating visual impressions, surveying and boundlessness, curiosity, even commanding gaze, and psychological fusion with close combat. The immersion coerced the observer into participating inwardly in the battle on the side of the Prussians, at a "moment of national importance," and in sharing the perspective of the soldiers in their dramatic fight, which triggered strong emotional responses: "One feels with these grim warriors, and what moved their souls at that time, continues to shake our own," commented the *Nationalzeitung*.[61] This was one of the main goals of the battle panoramas: suspension of the ability to relativize perception of the object and reflect on what was seen.

A further important mechanism, which contributed to the effect on the observer, was the slow "imperceptible"[62] rotation of the viewing platform, which, in less than half an hour, moved the observer past all sections of the painting. Clearly, the time allotted for reception of this work bore no resemblance to the usual time spent looking at a picture in a gallery. However, the observer's absorption was rudely curtailed: "the podium sways, vibrates from time to time, and shakes the body, which is annoying."[63] The revolving platform made it unnecessary to move and find a new place at the balustrade each time the observer wished to see a new section; once in his place, immobile, he was free to immerse himself completely in the image. Later, the cinema would perfect this freedom. The principle of releasing the observer from inner distance and conscious attitude and immersing him in a virtual otherness was the great attraction for nineteenth-century visitors to the panoramas. In the Sedan panorama, the effect was augmented synaesthetically by military marches played on an orchestrion.[64] Thus, acoustic was added to optical suggestion, and both combined to create an element of transition. Particularly the slowly rotating platform added to this impression of movement.[65]

The wave of battle panoramas was satirized in a caricature by Robida in 1882, *Le Panorama de la Bataille de Champigny* (fig. 3.4). A militant and militarized citizen, armed with an umbrella and wearing a top hat dented by a grenade, is a sarcastic commentary on the bourgeois audience at the panoramas. Thoroughly transported by the experience, he joins in the battle, which has jumped across to engulf the viewing platform. The caricature is a succinct comment on the absurdity of making war the subject of an entertainment spectacle.

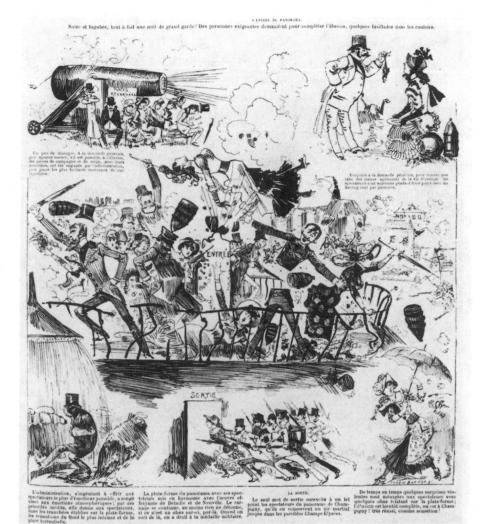

Figure 3.4 Cartoon on *The Battle of Champigny* panorama, by A. Robida, in *La Caricature*, July 15, 1882, Bibliothèque nationale de France.

In view of the propagandistic intentions of the Sedan panorama, which targeted a selected section of the public, Oettermann's characterization of its reception as egalitarian, as a "democratic perspective,"[66] is certainly a reduction and, taken to its logical conclusion, serves to idealize the panorama as a medium. Obviously, his formulation aptly describes the fact that all visitors shared the same view of the same picture, but it is unclear

why this should be linked with democracy, that is, government by the people. The fact that mixed sections of society viewed the same artifact together hardly seems to justify this attribute. Important aspects of reception, such as critical distance and selection, volition of observation, knowledge of the artificiality of the image, are not reflected in Oettermann's term, which is a biased exaltation of the panorama. If "democratic" were used to characterize the observer's position vis à vis the medium, then there would be no need to discuss *interaction*, that is, the effect of the observer on the medium and the content it conveys.

Like the majority of battle panoramas, *The Battle of Sedan* aimed to "educate" through a powerful model—not of democratic thinking, but of unquestioning obedience. This "soldierly virtue" was seen as the basis of success, and it was glorified by the most monumental image the Reich possessed. Oettermann's analysis treats the aesthetic experience of immersion, which is seminal to the conception of the panorama, only marginally, and does not acknowledge its central importance: The power of immersion to deprive the human subject of the right of decision cannot be reconciled with the ideal of the overall, horizontal view. Yet the suggestive and emotional effect of immersion has always been the hallmark of the panorama's aesthetics as a medium, and this reached its zenith in the genre of the battle panorama. Recalling Panofsky, Oettermann defines the panorama as the "pictorial expression, 'symbolic form' of a specifically modern, bourgeois understanding of nature and the world."[67] This is, at best, an incomplete characterization of the aesthetics and phenomenology of the panorama. Since the reappearance of these circular paintings in the 1980s in countries with notoriously authoritarian regimes, for example, China, North Korea, Iraq, and Egypt,[68] as a medium for glorifying military actions significant from the viewpoint of national policy and history, this analysis is questionable. To equate a "symbolic form" of the configuration of the medium panorama with a specific intellectual position is, in view of the differing forms of political system that employed and still employ it, untenable. Recent research on the panorama also takes this view; for example, Streicher is of the opinion that to classify the panorama with the group of " 'new media' of a society moving towards democracy is a too one-sided view."[69] Rather, the medium has the power to endow an image with an enduring effect, irrespective of the social system of the society that exhibits it. The question arises whether the horizontal views and awe-

inspiring landscapes that are common to most panoramas, regardless of subject—townscapes, faraway places, battles, or seascapes—originate from a "bourgeois view" or whether the configuration of the panorama image machinery itself invokes such motifs, that is, whether they are inherent to the medium. The panorama is clearly suited to the portrayal of bright landscapes. Dark, confined spaces, as frequently encountered in the diorama, would be unconvincing as an illusion if depicted on the panorama's convex screen with its overhead lighting. It may be concluded that the range of themes is invoked by the medium.

Oettermann's attribute of "democratic" with reference to the panorama dissolves completely when Michel Foucault's analysis of the Panopticon is considered. The design of Jeremy Bentham's model prison—Foucault called it "power's laboratory"[70]—arranges the cells in a panoramatic circle around a central observation tower. Behind bars, the prisoners are subject to total observation by the prison guards, and this total control, according to the theory, would be the means of their reformation. In the panorama, the prisoners are replaced by the picture, but this offers nothing more to the observer, who is hermetically sealed off from everything extraneous to the picture, than an illusionary total view: Were it not hermetic, there would be no feeling of presence or virtuality. Boundaries between picture and observer were deliberately removed within a controlled and structured situation in order that, in the words of the *Reichs-Anzeiger*, the image would be "indelibly etched on the soul."[71] The situation of Bentham's Panopticon is reversed in the Sedan panorama: The observer is the object of political control.

The horizontal view is an aesthetic device that cloaks the observer's absorption into the "omnipresent" panorama image, and thus the intellectually creative mechanism of distance is threatened by the immediate proximity of the panorama. Arnheim also emphasized the role of selective, focused perception in qualitative reflection: Active selection is essential for observation, and indeed, for exercizing intelligence in general.[72] However, it is impossible to select any art object in a total image, for everything is image.

The Sedan panorama did not satisfy all tastes. There were frequent clamors for a more realistic portrayal of war, that is, more blood. For the relatively high price of admission (one deutsche mark, which corresponds to about forty to fifty Euros today), many people wanted to see more of

the spectacular horrors and carnage of war.[73] Von Werner's reaction: "I remarked to His Majesty that the public finds there is not enough turmoil of battle and slaughter in the painting, whereupon the Kaiser replied that there was quite enough; indeed, almost more than enough, and it was the truth."[74] The "analytical" aspect of this "true" painting, distilled from general staff reports, eye-witness accounts, technical representation of the scenery, study of the infantry battalions' movements and the way gun-smoke disperses, was sanctioned and established on the authoritarian strength of the Kaiser's word. The fact that neither he nor von Werner had actually seen the battle was of scant relevance and did not detract from the assertion that it was a "true" picture. The technical analysis substantiated the painting's claim to be a *vera icon* and front-page press coverage spread this message throughout the country.[75]

It is indeed interesting that they avoided showing the slaughter of real battle in the picture almost entirely. As mentioned above, the reason undoubtedly lay in the fact that the picture was designed to arouse, or even create, nationalist and patriotic feelings in the audience. An orgy of blood and carnage, which immersion would have trapped the audience in, would have been counterproductive. Also, it would have been damaging to the careful mise-en-scène of a superior Prussian "art" of war and made no contribution to strengthening national pride.[76] The portrayal of violence is confined to narrow limits, which—like the entire panorama—were calculated to have an effect that was not too repellent.

The Sedan picture had a double premiere. Until the official day of inauguration, it was kept hidden from the public eye. After the ceremonial first viewing by the highest dignitaries of the Reich, it was officially elevated to the status of a true and accurate reproduction of the historic event. Then it was opened to the public, who were permitted to enter this political space, displaying the appropriate deferential manner. Thus, a ritual staging the social order of the Reich was enacted in connection with the painting. Obviously, it was different to that connected with the *Villa dei Misteri*; however, the elaborate ceremonial is common to both. The "state painting" is the focal point of classical mechanisms that operated in the cults around images[77] long before the "age of art": *vera icon*, charged with an aura through concealment, and here augmented through the effect of the dark passage leading in, the new illusion option of total immersion

and the utilization of the image by state authorities, orchestrated by the echo of the print media.

Strategy and Work of the Panoramist

The central element of the Sedan panorama concept was to create a painting that produced an authentic—in the sense of true—impression of the battle. Moreover, the composition had to be clear and portray the German troops as exemplary. Anton von Werner acknowledged these goals in his speech at the opening of the panorama, which the *Neue Preußische Zeitung* reported thus: "He has attempted to embody in his work the calm, determination, and sense of duty that inspires our army."[78]

After accepting the commission, Anton von Werner, who had not spent even a single day at the front, was faced with the task of covering a canvas measuring over 18,500 ft^2 with a realistic rendition of the Battle of Sedan to a schedule of just one and a half years. The first step was to organize the requisite material and set up a timetable as quickly as possible; then to recruit a team of competent artists, to coordinate and supervise their work. It was usual for the panoramist to assemble a number of specialists, artists specializing in landscape and figures, as well as a team of assistants, often students from the Academy of Arts. To organize the work process and work out administrative problems were von Werner's main tasks.

As mentioned above, von Werner himself did not paint a single brushstroke of *The Battle of Sedan*.[79] He was responsible for the composition: to select the viewpoint of the observer according to the given guidelines and to devise the most authentic-looking reconstruction of the historical moment possible. Further important experts were taken on board in the preliminary stages: the art critic Ludwig Pietsch, who in 1870 had been the correspondent in the German general staff headquarters at Sedan and with whom von Werner wanted to work out the exact reproduction of the historical situation; the landscape painter Christian Wilberg, who assumed responsibility for the execution of the landscape; and Wilhelm Gentz, academy professor and genre artist. Finally, von Werner had the not inconsiderable task of presenting himself to the public as the author of a political artwork of mammoth dimensions.

The draft architectural plans for the rotunda were completed on February 9, 1882. At the end of May, von Werner went to Paris with the

architect Böckman to meet with Pietsch and Wilberg, who had been there since April, to study the new panoramas *Battle of Vionville-Mars-la-Tour* and *Battle of Villiers-Champigny* by Eduard Detaille and Alphonse de Neuville, both motifs from the war of 1870 to 1871. Having no previous experience as a panoramist, von Werner intended to gather as much information as possible about composition, mise-en-scène, and the mechanisms of their effect on spectators of modern battle panoramas from studying the famous circular paintings by de Neuville and Detaille and from talks with Detaille.

A few days later, the project team traveled on to Sedan, leaving Wilberg in Paris, who had fallen seriously ill. Their visit was kept secret, for recently, panoramists had caused diplomatic complications.[80] The main object was to select a suitable position for the standpoint of the observer. In theory, once this was determined, the content of the picture was automatically fixed. As panorama painting was held to be the search for the perfect reproduction of the theme at hand and therefore the painter was not free to exercise any influence on the given landscape, the choice of the observer's standpoint assumed great significance. However, as their program of time and place was determined before they even set out, von Werner's only task was to find a spot for the observer angle from where all components of their program could be combined satisfactorily: "On the high ground above this place [*Floing*], from this vantage point, one had a clear view of the entire panorama of the Maas valley, its peninsula of Iges, to the north Calvaire d'Ily, to the southeast the fort of Sedan with Torcy, and the hill where King Wilhelm and Crown Prince Friedrich Wilhelm had stayed until the evening. It was here that I found the position which seemed to me the most suitable for the portrayal of the decisive moment of the battle and with regard to artistic considerations."[81]

In this way, von Werner was able to combine conceptually the panorama-immanent aesthetic dimension of the broad horizontal view with his main objective: the presentation of "the decisive moment of the battle," namely, the French defeated by the Prussian lines immediately before the eyes of the observer. According to Eugen Bracht, contemporaries saw in this scene the "meaning of victory."[82]

On this occasion, von Werner made only rough sketches of the terrain as a background for the position and composition of the masses of figures; later, the landscape painters took photographs of it. Their work at the site

of the battle was finished. The delegation traveled on to Brussels where they read of Wilberg's death in Paris in the newspapers.[83] On June 4, the group met with more experienced panorama painters: Schaumpelheer, de Haas, de Groth, and Wouters. Privy Councillor Günther from the German Ministry of War was also present at this meeting,[84] but his precise function is another point that von Werner remains silent on in his memoirs. After a final visit to the panorama of the Battle of Waterloo, the team returned to Berlin on June 8. Von Werner quickly filled the vacancy left by Wilberg's sudden death with the landscape artists Eugen Bracht and Carl Schirm. It is characteristic of the medium of the panorama that replacing Wilberg was more a problem of organization than of artistic conception. Any artist working on the panorama relinquished his individual style for the normative form of this medium and, therefore, was always interchangeable.

After accepting the commission on July 18, Bracht and Schirm traveled immediately to the panoramas in Paris to study the combination of landscape painting and *faux terrain*. Afterward, they went to the Maas valley. Bracht worked mainly on studies in oils and Schirm took photographs of the battlefield secretly with a special camera from the position that von Werner had chosen. They made sketches of fragments and details of the landscape at Dinant for later use in the panorama so that they would not have to stay too long at the actual battle site. Bracht described this difficult work in a letter to his wife: "We have to find terrains and objects that correspond to the given ones, both with regard to the uphill and downhill situation as well as the prescribed light conditions. This is very difficult and so far, we have found only a few things that are really suitable."[85]

Particularly in the area of taking pictures, technology was rapidly advancing to prominence. Mechanical reproduction already had a long tradition. The camera obscura was followed by a number of inventions that simplified and rationalized the taking of landscapes, which could be used without prior knowledge of perspective and with only basic drawing skills. These included: the Panoramagraph (1803), which had been developed to assemble single drawings into a whole with correct perspective; the camera lucida (1806), which by means of a prism projected a virtual image onto paper so that the outlines could be traced; there was also the Diagraph. Daguerrotypy and photography perfected this development. The first panorama daguerrotypes appeared in 1841. Subsequently, other inventions

followed in quick succession that introduced improvements, particularly to the shooting angle/angle of acceptance and the transport of the pictures.[86] Together with the normative pressure of economic considerations that demanded speedy production, the axiom of the greatest possible imitation of reality led to the continual development of new technical tools, which made the process of picture-taking increasingly autonomous. It also subjected the landscape painter to a process that allowed hardly any individual artistic expression.

Painstakingly, Anton von Werner worked his way through a further suite of procedures in order that the panorama would appear as a quasiscientific reconstruction of events and maximize the impression of authenticity. After the portrayal of events had been more or less fixed by determining the time and the observer's position in the picture, von Werner started work on the reconstruction of the battle situation, the basis of the work. Studies of sunlight and color were made, and dozens of portraits of officers, who had seen action that day, were painted from ordered photographs. The young artists Carl Röchling, Georg Koch, and Richard Friese, working on the premises of von Werner's villa in Wannsee near Berlin, produced studies of horses and soldiers in a wide variety of poses, for which purpose he arranged for "a complete arsenal of weapons and uniforms, both French and German"[87] to be moved out there. There was a visit to military maneuvers at Belzig on September 17 to study the formations, movements, and actions of entire sections of infantry and artillery. Of particular interest was the "study of the volume or spread of heavy artillery gunsmoke at varying ranges" and the "picture made by the Jaegers in trenches fending off the enemy with rapid fire."[88] Here, as always, von Werner received the full support of the military, which he had enjoyed for years, and the gunners were given orders "to blaze away and not be too sparing with the ammunition."[89]

Beside the exact replication of the landscape topography, the authoritative official foundation on which von Werner based his claim that his was a true picture of events was the report given in the *Generalstabswerk*, which had been written over a period of seven years by the *Kriegsgeschichtlichen Abtheilung* of the *Großen Generalstabes* (Department of Military History of the General Staff). However, this report does not give an exact description of the cavalry charge and resulting confusion of action: "It is

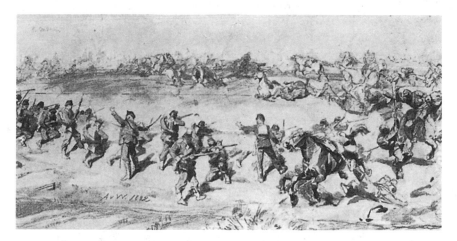

Figure 3.5 Anton von Werner, *The Charge of the Cavalry*. Preliminary sketch for *The Battle of Sedan* panorama, 1882. In *Anton von Werner: Erlebnisse und Eindrücke 1870–1890*, Berlin: Mittler 1913, p. 352.

impossible to give an accurate report of the details of the wild tumult of fighting, which raged for about half an hour in waves up and down the western edges and slopes of the high ground."[90]

Von Werner copied this passage down word for word in his notes together with a complete list of the regiments involved.[91] His first sketches attempted to convey the "wild tumult": the lines of the Prussian Jaegers appear ragged, their commanding officers wield their sabres in the midst of their men, all are of the same stature, and the solid thrust of the French attack has disintegrated into a number of independent skirmishes (fig. 3.5). Ultimately, he simplified his composition to a linear structure, which arranged the repulsion of the cavalry charge in a way that is comprehensible to the observer. In spite of all the research and quasi-scientific reconstruction, the panorama remained a composition, an ideal. This did not deter von Werner in the slightest from claiming it to be authentic, supported by the testimony of numerous eye witnesses in the form of veteran officers: "[I] received the most valuable hints from the officers of the regiments that had directly engaged with the French cavalry and they furnished me with a wealth of details about the fighting that they had witnessed personally."[92] Although, naturally, the soldiers had only "seen what was in their immediate vicinity,"[93] and it proved impossible to reconstruct exactly which company was where at the time in question,[94]

von Werner settled on a formulation that covered the eye witness accounts with a veneer of trustworthy facticity: "However, by comparing the occurrences they recounted to me—albeit after making numerous changes to my composition—in the end I succeeded in creating a picture that gave military clarity to the tumult mentioned in the General Staff report."[95]

Begun in December and completed in January in his studio, von Werner's composition of the charge of the French cavalry was drawn to a scale of $1:10$. This picture that the artist created went far beyond the content of the written source material and the fragmentary and subjective reports of eyewitnesses; moreover, it bore no resemblance to the original sketches.[96] On January 10, Crown Prince Friedrich came to the studio to see for himself how work was progressing. According to Bracht, in the early stages of the project the Crown Prince—who later stayed away from the panorama completely—had tried to change its program. He suggested the "Capture of Bazaille" for the panorama's subject, because then he would certainly have been included in the picture. This, however, was not an option for Prussian Berlin because of the overproportional participation of Bavarian contingents in this battle. Additionally, civilians had been massacred at Bazaille in a veritable "blood bath" so that this was not a "suitable object for portrayal."[97]

Von Werner's composition presents the turmoil of battle to the observer in a way that is easily comprehensible and thus prepares the ground for a suggestive appeal to patriotism and warlike instincts. At the panorama's opening, the *Berliner Tageblatt* commented: "Pictures of war and battle panoramas . . . also stir up the sparks of national honor in every man who is fit for military service."[98] The panorama's claim to represent the truth stood in contradiction to von Werner's composition, which served the principle aim of demonstrating the alleged superiority and discipline of the Prussian soldier.

L'Art Industriel

In the tradition of the workshop, panorama production involved a series of different painters and specializations. There were painters who covered large areas of canvas, draughtsmen for the minute details, and specialists for landscapes, genres, and figures. Bracht and Schirm were responsible for the landscape, and Friese, Röchling, and Koch painted the figures as composed by Anton von Werner. A further nine artists, brought in mainly

from the academies in Berlin and Karlsruhe, supported these two groups during the eight months that the panorama took to complete.[99] On February 10, 1883, painting began in the half-finished rotunda. Von Werner spoke afterward of an "extraordinary effort."[100] A movable tower made it possible to work on different levels of the canvas at the same time. As a rule, there was a daily quota of work that had to be accomplished. Each of the many people contributing to the canvas had strictly delineated areas of work. Thus, the work process had an industrial character, not in the sense of producing a large number of objects but in the monotonous, standardized nature of the work, which resulted in eradicating all personal style of the "workers." The primacy of illusionism and immersion, to which all else was subject, did not allow a personal artistic style, for otherwise the panorama would not have achieved its purpose. The economic principle that governed the production was likewise at the cost of the individual.

The dimensions were truly gigantic.[101] At the end of the nineteenth century, the norm for panoramas was around 2000 m^2 and the paint used amounted to several tons.[102] After the canvas had been divided into squares, a rough outline of von Werner's 1 : 10 sketch was transferred onto it, the work being divided among the artists (fig. 3.6). For the Sedan panorama, they succeeded in hanging the canvas straight at the first attempt, without the customary bulges. This made the process of transferring the sketch much easier,[103] for usually the rounded and convex surfaces created many problems for the artists with regard to perspective: in order to draw a line that would be perceived as straight from the observers' platform, the artist was continually obliged to work and then stand back from the canvas. The panoramist Bohrdt described some of the problems confronting the artist: "Close up to the canvas, the artist is helpless. He cannot even assess a straight line and when he has drawn one, it looks wrong."[104]

The lack of distance, including physical, to the work was an obstruction to a smooth and conscious work process for the artist and, additionally, precluded forming an overview of the whole work. According to Hausmann, the artist found himself in a difficult situation: "the horizontal architectural features have to be painted as curves, the vertical elements in the foreground have to be drawn with a considerable gradient."[105] After each section, the artist had to move back several meters to check the effect. As this procedure would have complicated the work, slowed it down con-

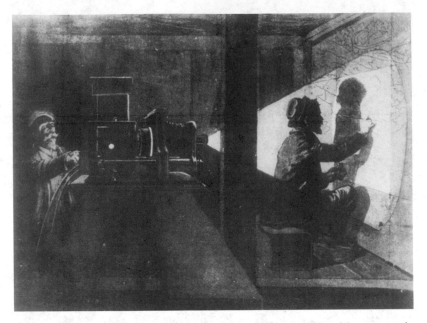

Figure 3.6 Projection of a photographic plate is used to create the 1:10 outline of the panorama of Madagascar, 1900. By kind permission of Silvia Bordini.

siderably, and did not make sense from an economic point of view, the artists transferring the rough outline to the canvas were guided by directions from the observation platform: "That the drawing pencil took on incredible proportions, the reader can well imagine. We had a bamboo pole, which was about five meters long."[106] Thus, in this panorama, not only was the traditional unity of artistic conception and realization split up, but a further production stage was inserted into the industrial process. The artists were relieved of the control over what they had created, and this was institutionalized in the person giving directions. For Wolfgang Kemp, it was the "enormous quantitative expansion, that transformed the workers in front of the canvas into mere hands and the instructor in the middle of the round space into a mere eye. Here, it was not a process that was dissected, it was people that were split up into partial functions."[107] Reduction to the status of a mere performing agent alienated the artist from his work; he could follow only partially his own creative process.

In addition to the technical apparatus for taking pictures described above, further technical aids were employed to apply the sketches to the

canvas. The panoramas had been created according to this system: Using projection, the photographs of the landscape were transformed into a preparatory sketch of 1 : 10, which was then distorted according to the rules of descriptive geometry.[108] A picture was then taken of this, and the sketch thus obtained became the final model, which was then projected onto the panorama canvas. The artists only had to trace the lines with charcoal. The methods of projection were, from about 1860 onward, very much improved through stronger sources of light. In 1863, Claudet developed a process whereby artists were able to work on the projected drawing directly on the canvas.[109] Thus, the stages in the production of the panorama were: photography—drawing—photography—projection —drawing—painting. Although this standard procedure was almost certainly followed in the Sedan panorama, the precise method of transferring the images to the canvas is not explicitly mentioned by the historical sources.

The degree of alienation that obtained in the panorama, particularly with respect to the graphic artist, was relativized by work on details. Yet although the artist was able to develop a feeling for the fragment he was working on, its execution still had to conform rigorously to the dictates of illusionism. Von Werner insisted on absolutely sharp detail throughout the gigantic painting: "... the practices of subordination, sketching, or outlining, which are admissible for easel painting, cannot be used here. I realized very quickly that, for example, sketchy outlines of the troops located around two kilometers away from the observer's position would not suffice because, as mere patches of color, they appeared closer to the observer and only receded when painted in such careful detail that they stood up to scrutiny through an opera glass."[110]

The mechanically aided transfer of the outline to the canvas together with sharpness of detail and realistic color ruled out all possibility of personal artistic expression and characteristic style. Von Werner continued: "In addition, masses of foliage in the mid- or foreground painted with broad strokes of the brush proved to be impossible because the effect was not natural but just 'painted.' So Eugen Bracht was compelled to paint a great walnut-tree in the foreground leaf by leaf ...".[111] Here, von Werner uses the language of an artist to express the normative mechanism of the panorama medium in similar terms to those used by the scientist Hermann von Helmholtz in 1871.[112] To produce the illusion of nature demanded

the relinquishment of characteristic artistic style and the depersonalization of the artist. For the *faux terrain*, which the panorama artists also created after the picture was finished, the same method was applied. Here, too, all traces of the individual artist were obliterated in order to maximize the effect of the illusion and immersion.[113] For this work, which was possible only through the concerted efforts of many people working together and the utilization of technical instruments, von Werner assumed not only the role of deviser of the conception but also those of director and supervisor. Frequently, von Werner was obliged to seek the advice of experienced panoramists, such as Piglheim, Detaille, and de Neuville,[114] but he still does not appear to have been very competent at his job. Eugen Bracht's judgment is scathing: "I suffered a great deal because of A. von Werner's obsession with changing things—the best sections were destroyed and redone many times over because they did not conform to the proportions he had set for himself."[115]

Von Werner had an attack of fatigue while in the panorama on June 4. What caused this is not known, so one can only speculate: It is possible that the official responsibility for a project of these dimensions weighed heavily on him; it is also possible that it was a further element in the construction of a myth—the artist gives his all to realize a work of monumental importance, which takes a heavy toll on him. During the project, von Werner's manner and conduct prefigured to a certain extent the type of director who developed later with the advent of cinema, who operated surrounded by assistants and technical apparatus of all kinds. As we have seen, in the panorama a complex system intervened between the artist and the artwork. The final result depended solely on the smooth operation of all components, and the end-goal of total illusion, of seeming to conserve a historic, aureoled moment in time, could be achieved only through rigorous and precise coordination.

The Rotunda

For the time, the total cost of the panorama—one million goldmarks—was astronomical. The architects Ende and Böckmann, who had supervised the building of the national panorama two years previously, were awarded the contract for the rotunda after their design won third prize in a public competition (fig. 3.7).[116] Designed as a national memorial of the monu-

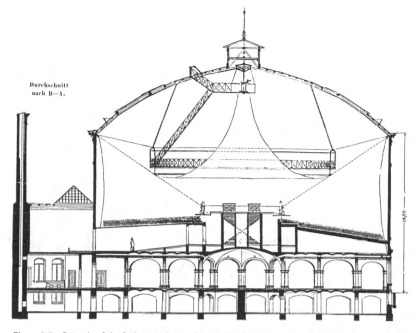

Durchschnitt
nach B—A.

Figure 3.7 Rotunda of the Sedan panorama. Cross-section, design: Ende and Böckmann. In *Deutsche Bauzeitung*, December 26, 1883, p. 613.

mental variety, the external decoration[117] was representative and costly: sgraffito-like paintings by E. Ewald, a plaque inscribed with passages from the proclamation of Wilhelm I of July 25, 1870, and a Prussian eagle against French flags on a background of gold-leaf. Further, the brick building was an eye-catcher by virtue of its position alone: in splendid isolation in the Panoramastrasse on the west side of the new road junction at the Alexanderplatz urban railway station.

Modeled on contemporary industrial exhibitions, the ground floor housed a spacious and decorative restaurant where the surrounding "humoristic murals ... which depicted military life in peacetime"[118] appealed on a burlesque level to the guests after their visit to dioramas and the panorama. Via a mezzanine story, where there were two bas relief maps of the battlefield and a short ramp with a few steps, one reached the top floor and the panorama itself. Technically, the construction of the panorama was complex and, for its time, very modern. There were two notable innovations: First, the outer circle of the viewing platform, which was 1.5 meters wide,

revolved, powered by a 45 horsepower engine. The speed could be varied according to the size of the crowd, allowing the visitors between 15 and 40 minutes to be transported past the 115 meters of painting and *faux terrain* with its cardboard soldiers. Second, the Siemens and Halske Company supplied the artificial lighting. Arc lamps, used in the evenings and in winter, together with heating, made it possible to visit the panorama until 11 P.M. The lighting produced such subdued effects that the colors retained their full effect, even at night.[119]

The rotunda also housed dioramas. In contrast to the panorama, which was dedicated to the rank and file, the dioramas focused on military leaders. As von Werner put it, they complemented the representation of this "historical event of world importance,"[120] and completed the program of the political space represented by the panorama. Three events of the day, spaced at five-hour intervals, are captured in the dioramas. The first, entitled "General Reille delivers Emperor Napoleon's letter," takes place at 7 P.M.; the second, "The capitulation at Donchery" at midnight; the third, "Bismarck meets with Napoleon," at 5 A.M. Here, the immersive medium of the panorama meshes with successive images of a passage through time, a device that Gaudenzio Ferrari had already utilized in his Stations of the Cross at Sacro Monte. Each diorama foregrounds a different figure of the Prussian military leadership: The first is dominated by Wilhelm I; the second—the night of France's capitulation—by von Moltke. Nearly all the French generals are portrayed as bowed figures who are unable to withstand the penetrating gaze of the towering von Moltke, whose stern features are accentuated by painted light effects. Von Werner's mise-en-scène of the vanquished French was more extreme in the final diorama than in his preparatory sketches. The tendentious nature of the piece was confirmed by his contemporary Rosenberg: "Then the artist decided that at least in his composition, there would be a balance between the two opposing sides, although he left no doubt as to which side possessed the greater spiritual and material substance."[121]

In the third diorama, Bismarck is similarly idealized: In an attitude of unapproachable hegemony, he has come up to the captured Emperor Napoleon on horseback. He looks down from his mount on the sick emperor, who is portrayed in foreshortened perspective and appears small by comparison. Napoleon has descended from his carriage, he appears

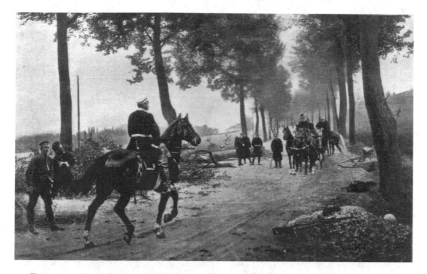

Figure 3.8 Bismarck's meeting with Napoleon. Diorama in *The Battle of Sedan*, oil on canvas, whereabouts unknown, photograph of the original. In Adolf Rosenberg, *Anton v. Werner*, Bielefeld: Velhagen and Klasing 1895, p. 91.

lost and is encumbered by a walking stick, positioned between the horse-drawn vehicle and three young soldiers on the road (fig. 3.8). The compositional strategy, to portray the military leaders in a position of "Blicküberlegenheit"[122]—superior command of view—vis à vis the battle landscape, which was by definition not possible in the panorama, is revealed in full in these dioramas. All three, Wilhelm I, von Moltke, and Bismarck, who had seen the work in progress on visits to von Werner's studio, were featured in superior isolation:[123] Wilhelm I confronts the battlefield, von Moltke the French generals, and Bismarck the defeated emperor. Although the Prussian faces did not actually display the infamous "Sedan smirk," nevertheless, in all these pictures they are literally looking down on the French. This is a further example of a politically slanted statement masquerading as authenticity.

In spite of the claim that these representations of the battle were true, von Werner's composition work resulted in a product that was distorted and laden with antipathy. The intention was that this specific historic moment, the defeat of the "traditional enemy" and the "birth of the Kaiserreich," should be indelibly etched on the collective memory of the public by this monumental work, which left the impression that one had

been there oneself. This was the essence of official state interest in the panorama. The effect produced by the vast immersive image space was linked with that of the dioramas, which functioned as portraits of military commanders, and were complemented by the genre paintings in the restaurant. The message had differentiated facets: The panorama was suggestive and gripping; the dioramas in their darkened rooms exuded an aura of reverence; and the simple pictures of soldiers in peacetime operated on a lighter, burlesque level. The latter, which were artistically undemanding, fulfilled an important function in the overall effect, for in recollection, the panorama and dioramas stood out even more effectively against these sentimental genre paintings.

Although the Sedan panorama was unique,[124] and therefore tied to one particular location, the methods used in its production make it difficult to distinguish it from an industrial product. At the same time, the panorama is both structurally and essentially no different than any other work of art that is material and not ephemeral. The outward appearance of this man-made work is that of an object. Leaving aside its destruction or deterioration over time, the materiality of the idea that gave rise to the work is the concept of lending existential form to a temporal phase within a space. With the aid of painting, three-dimensional objects, and architecture—additionally, often sound effects, sometimes steam or odors—the panorama is not only an element of all three art genres; it also realizes, unknowingly, Wagner's conception of a *Gesamtkunstwerk*, or synthesis of the arts, which results from the complex interplay of these components.[125]

To imagine a haptic dimension, to have the impression that it is possible to touch the cardboard soldiers or intervene in the battle, is the core of the concept of immersion. However, as the visual character of this production was of seminal importance, the haptic effect of the material receded into the background. Obviously, the individual visitor's reception of the Sedan panorama changed over time, yet the postulated illusionistic effect barred any interpretation of it as an "open work of art."[126] For only in its material entirety and illusion-maintaining intactness did it constitute the panorama form. If a part were missing or changed in a way that detracted from the illusion, it would no longer be the work that had been commissioned, created by the artist, and executed by his assistants. Further, any idea of change by the observer was leveled at the very founda-

tions of the panorama concept. Similarly, changes wrought by the passage of time were also unwelcome, for these reduced the impression of illusion. It was only possible to perceive the panorama as a work, in the sense of a discrete object, outside the rotunda; once inside, once *in the picture*, the sense impression of a distant work, separated from the observer, disappeared. In the homogeneous image space, everything was the work. Consciously, or unconsciously, the observer perceived the space of the illusion; however, this image space was not recognizable as an object, as an artwork.

Following Walter Benjamin's concept of the "aura," which is connected to the nonreproducible authenticity of a unique original,[127] the specific effect of a work may be subject to strong fluctuations because of shifting sociopolitical coordinates. *The Battle of Sedan* is an illustrative example: through its connotations of being labeled as the historic truth by artist and Kaiser and of being a very expensive and powerful reference to a political event, the Sedan panorama gradually faded into obscurity as the battle receded into the past and the military protagonists of the dioramas passed away. Official interest in its continuation waned, and its decline in popularity with the public was undoubtedly due in part to the new medium of film, which heightened the transitory illusion effect and thus made a stronger appeal to the audience. No alternative use was found for the rotunda and it was demolished in 1904. The panorama was finished. Its symbiotic linkage with the *presentation apparatus* of the rotunda[128] meant that it had to be destroyed the moment that further exhibition was no longer profitable. For the medium of the panorama functioned in the same way as film, slides, or computer programs, that is, only in conjunction with its presentation apparatus. Its enormous dimensions were prohibitive for disposal on the private art market, and this sealed its fate. Its scale also made integration into another medium or a museum impossible. Museums did not have the prerequisites for displaying panoramas, and the few that have survived have done so in their rotundas.[129] The course of media history and the limited political interest of later generations led to the breakup of the Sedan panorama. After the rotunda was pulled down, it is said that the complete canvas was handed over to Kaiser Wilhelm.[130] In 1928, the National Gallery put the rolls into storage, but since World War II, all trace of the panorama has been lost.[131]

Notes

1. In London, e.g., the Battle of Aboukir (1799), Trafalgar (1806), Waterloo (1816); in Paris, the Battle of Wagram (1810), among others.

2. Streicher (1990), p. 19.

3. See, for example, *Deutscher Reichs-Anzeiger und Königlich Preußischer Staatsanzeiger* no. 206, Berlin: September 3, 1883, evening edition, p. 2; and *Norddeutsche Allgemeine Zeitung*, 22nd year, September 1, 1883, p. 2.

4. Apart from Kaiser Wilhelm I himself, the following persons were among those present: "General Field-Marshal Count Moltke, Prince Radziwill, Count Lehndorff, Count Pückler, Count Perponcher, Count Eulenburg, Prince Reuß, the Generals von Willisen, von Winterfeld, von Oppeln-Bronikowski, von Faber du Faur..., the President of the Reichstag von Levetzow, the Chairman of the City Council Dr. Straßmann, the Ministers von Puttkamer, von Bötticher, Dr Friedeberg." See von Werner (1913), p. 374.

5. Reports appeared, for example, in: *Berliner Tageblatt*, no. 409, September 2, 1883, p. 1 (first supplement); *Deutscher Reichs-Anzeiger und Königlich Preußischer Staats-Anzeiger*, no. 206, Berlin: September 3, 1883, pp. 2–3; *Germania, Zeitung für das Deutsche Volk*, no. 200–13th year, Berlin: September 2, 1883, p. 3; *Militärzeitung*: "Das Panorama der Schlacht von Sedan," no date (Secret State Archives, I. HA, Rep. 92, 8, nos. 280–295); *Nationalzeitung*, no. 410, 36th year, September 2, 1883, p. 2, and no. 411, September 2, 1883, p. 2 (first supplement); *Neue Preussische Zeitung—Kreuzzeitung*, no. 205, September 4, 1883, p. 1; *Norddeutsche Allgemeine Zeitung*, 22nd year, Berlin: September 1, 1883, p. 1; *Die Post*, no. 240, 18th year, September 3, 1883, p. 1; *Tägliche Rundschau Zeitung für Nichtpolitiker*, no. 204–3rd year, September 2, 1883, pp. 2ff.; *Vossische Zeitung*, Berlin: September 2, 1883, pp. 2ff.

6. Indeed, the landscape found such favor that, almost immediately after the opening, Bracht was appointed Royal Professor in a patent of September 18. See *Jahres-Bericht der Königlichen akademischen Hochschule für die bildenden Künste zu Berlin* for the academic year October 1883–August 1884, Berlin: 1884, p. 3. In the Archive of the HdK, Berlin: Bestand 6, 129.

7. Von Werner (1913), p. 374.

8. Ibid., p. 376.

9. To enable spectators to gain a clearer impression, the position of the objects in the painting were aligned according to the points of the compass on an orientation plan which was available to all visitors.

10. With considerable pathos, Pietsch writes in his guide to the Panorama of the "heroic death-ride, in which the cavalry regiments knowingly sacrificed themselves." See Pietsch (ca. 1883), p. 2. Glorification of the defeated enemy was intended to enhance still further the glory of one's own victorious side.

11. "Kaltblütiger Haltung": Rosenberg (1895), p. 75.

12. Oettermann (1980), p. 192.

13. Streicher (1990), p. 17.

14. In 1800, the average wage for workers in industry, trade, and transport in Germany was 545 marks per year; see Honorst et al. (1975), p. 107. Thus, the average monthly wage was around 45 marks, which explains why the admission price of 1 mark was prohibitive for a worker's family.

15. As described above, this panorama was a political event of the first order. Its patriotic subject—which was in effect the legend underpinning of the foundation of the German Reich—plus the fact that it was sanctioned at its opening by almost the entire political and military elite meant that press reports on the panorama and its intention of creating an illusion were hardly likely to be negative.

16. *Neue Preussische Zeitung—Kreuzzeitung*, no. 205, September 4, 1883, p. 1 (no author).

17. *Berliner Tageblatt*, no. 409, September 2, 1883, p. 1 (first supplement).

18. *Neue Preussische Zeitung—Kreuzzeitung*, no. 205, September 4, 1883, p. 1; see also other newspapers that corroborate this impression, e.g., *Tägliche Rundschau Zeitung für Nichtpolitiker*, no. 204–3rd year, September 2, 1883, pp. 2ff.; *Vossische Zeitung*, Berlin: September 2, 1883, pp. 2ff.; *Berliner Tageblatt*, no. 409, September 2, 1883, p. 1 (first supplement); *Die Post*, no. 240, 18th year, September 3, 1883, p. 1. The *Militärzeitung* wrote: "It is as though one is really watching the battle

from an observatory," in the article entitled "Das Panorama der Schlacht von Sedan," no date, p. 3 (Secret State Archives, I. HA, Rep. 92, 8, nos. 280–295).

19. *Neue Preussische Zeitung—Kreuzzeitung*, no. 205, September 4, 1883, p. 1.

20. See Bartmann (1985); Berlin (1993) (exhib. catalog).

21. Von Khaynach (1893), p. 28.

22. Langbehn (1909), pp. 264ff. See also Mai (1981a), pp. 458ff. and Paret's (1980) study on von Werner's art policy in Berlin.

23. Von Werner (1896), p. 42.

24. Without directly mentioning names, Wilhelm II clearly disapproved of impressionism and other modern trends in art: "Whosoever breaks away from the law of beauty, the feelings of aesthetics and harmony that fill every human breast whether he can express it or not, and views the main objective as a particular solution of more technical problems, that man sins against the primary wellsprings of art." Wilhelm II, cited in Seidel (1907), p. 15; as quoted by Mai (1981a), p. 462.

25. Paret compares von Werner's role as a collector of details to that of a photographer: "and indeed Werner's function at Versailles was that of a highly privileged cameraman, who mingled with his subjects on terms of equality." See Paret (1988), p. 167. Bartmann also takes up this aspect: "the photographic accuracy of his style contributes to his works being regarded as sources." Further: "Frequently this disguises propagandistic intentions, which, due to masterly suggestion, admit of only one conclusion: Yes, that's just how it must have been!" In Berlin (1993) (exhib. catalog), p. 9.

26. See Gaehtgens (1990).

27. In Rosenberg's words: "He is able to portray things in a popular and vivid manner, to reproduce with military accuracy all details of uniform and weaponry, which is the reason why particularly soldiers contemplate with special pleasure his otherwise rather sober images." Rosenberg (1883), p. 730.

28. *Vossische Zeitung*, Berlin, September 2, 1883, p. 1, morning edition.

29. Nipperdey (1992), p. 260.

30. In this connection, the following is of interest from Hermann Glaser's sociocultural study, *Die Kultur der Wilhelminischen Zeit*: "According to a remark of Benedetto Croce, it was above all German professors who, after 1871, encouraged German philistines with a so-called Sedan-smirk on their faces in this feeling of superiority over other nations, in their contempt for the decadent and already degenerate Latin races, for their moral corruption and wretched parliamentary fights." Glaser (1984), p. 233.

31. Independently, Louis Braun had already created a Battle of Sedan panorama for Frankfurt in 1880, also on behalf of a Belgian company, which had created a sensation. See Siebenmorgen in Schwäbisch Hall (1986) (exhib. catalog), pp. 11ff.

32. Pecht (1888), p. 416.

33. The interpretation suggested itself that "one was looking at a battle between the French and the Bavarians, as the rest of the German troops fade right into the background behind these courageous brothers-in-arms: a little bit of local patriotism, without which the picture would make an even better impression." In *Zeitschrift fur bildende Kunst* (1881), pp. 745ff.

34. Von Werner (1913), p. 332. Prince Wilhelm also visited the panorama rotunda on May 28 and 29 to see for himself how work was progressing.

35. For a militaristic account, see the journal *Vom Kriegsschauplatz. Illustrierte Kriegszeitung für Volk und Heer. Illustrierte Geschichte des Krieges von 1870/71 für Volk und Heer*, no. 23, Stuttgart 1870/1871, p. 8 (ill. 33).

36. Theilmann (1973), p. 106.

37. See Robichon (1993), p. 59, footnote 11.

38. See Leroy (1993), p. 74.

39. In order to maximize returns and attract further investors, for example, in 1879 the panorama of the Battle of Tétuan was opened to the public even before it had been completed.

40. Castellani's first works for the Jourdains' interest group were the panoramas of the Battle of Waterloo (1878) and the Battle of Ulundi (1879), a military encounter from the recent colonial Boer War in South Africa.

41. See Robichon (1979, 1985).

42. See Leroy (1993), p. 75.

43. Charles Castellani, "Confidences d'un panoramiste," Paris, undated, p. 229; cited in Leroy (1993), p. 75.

44. Leroy (1993), p. 80, appendix table 1.

45. Pieske has shown that a great demand existed in Germany for pictorial representations of all kinds of this war: paintings, prints, illustrations in books and journals. See Pieske (1993), pp. 163ff.

46. Leroy (1993), p. 80, appendix table 1.

47. This source must obviously be treated with some caution, for von Werner was more interested in constructing his own legend than providing candid information.

48. See von Werner (1913), p. 277.

49. Ibid.

50. *Centralblatt der Bauverwaltung*, March 22, 1884, p. 116.

51. Of this, 20,000 goldmarks were designated for Bracht and Schirm, the artists responsible for the landscapes.

52. Helmholtz (1903 [1871]), p. 96.

53. Ibid.

54. Ibid., p. 100.

55. *Vossische Zeitung*, September 2, 1883.

56. See *Militärzeitung: Das Panorama der Schlacht von Sedan*, no date (GStA, I. HA, Rep. 92, 8, nos. 280–295), p. 3.

57. Helmholtz (1903 [1871]), p. 100.

58. Robichon (1979, 1985).

59. One approach in the aesthetics of reception that suggests itself is proposed by Wolfgang Kemp and follows recent methods of literary criticism. However, its notion of the empty space, the *Leerstelle*, does not cover the image strategy of immersion that is effective in the panorama. See Kemp (1992), pp. 7–27.

60. *Nationalzeitung*, vol. 36, no. 411, September 2, 1883.

61. *Militärzeitung*, no date (GStA, I. HA, Rep. 92, 8, nos. 280–295), p. 2.

62. *Vossische Zeitung*, September 2, 1883.

63. Ibid.

64. Musical accompaniment was a tradition in battle panoramas. As early as 1802, Samuel James Arnold had used the involving power of music in his panorama of the Battle of Alexandria in London.

65. This was the first attempt to simulate movement in a rotunda panorama. In the *Moving Panorama*, ca. 1820, a concealed mechanism unrolled images on strips that were several meters long in front of the stationary observer. In 1834, the first double-effect dioramas made their appearance. Images were painted on both sides of a transparent canvas, for example, with a view of a location by night and by day. This was lit using an apparatus by reflectiona and refraction, which created the effect of time passing.

66. Oettermann (1980), p. 26.

67. Ibid., p. 9. See Gronert (1981), p. 44, for a critique of Oettermann's thesis and Blumenberg (1989), footnote 12. The term "symbolic form" is found in Erwin Panofsky's essay "Perspektive als 'symbolische Form,'" in his (1980), p. 99. Panofsky, in turn, draws on the discourse with Ernst Cassirer and Cassirer's lecture "Der Begriff der symbolischen Form im Aufbau der Geisteswissenschaften," pp. 11–39 in Saxl (1923).

68.　*The Battle of Stalingrad*, Wolgograd 1962, UdSSR; *Battle of Al-Qadissiyah*, Al-Mada'in 1968, Iraq; *Panorama of the Liberation of Pleven*, Pleven 1977, Bulgaria; Battle at Teschou, Pjongjang, no year (after 1987), North Korea; *Panorama of Arab-Israeli War*, Cairo 1988, Egypt; *Battle at the Bridge of Lo Gou on 7 July 1937*, Peking 1988, China. See Hyde (1988), pp. 200ff. and Comment (1993), p. 107. The *Bauernkrieg-Panorama of Bad Frankenhausen* is not included here since it is not a panorama in the strict sense of an illusionistic, temporally and spatially homogeneous picture.

69.　Streicher (1990), p. 18.

70.　Foucault (1977), p. 263.

71.　*Deutscher Reichs-Anzeiger und Königlich Preußischer Staats-Anzeiger*, no. 206, Berlin: September 3, 1883, p. 3.

72.　Arnheim (1972), pp. 29ff.

73.　The lack of ruins and destruction was felt to be almost unrealistic. The *Vossische Zeitung* wrote: "The buildings and villages between Floing and Sedan ... look almost suspiciously intact and decorative, like on Sundays. . . ." See *Vossische Zeitung*, Berlin, September 2, 1883, p. 2. The editor of the *Militärzeitung* objected, in the same vein: "We were delighted to see the excellent, disciplined troops going into battle, some with a turnout more immaculate than we have seen in this perfection at parades in peacetime." *Militärzeitung*, no date (GStA, I. HA, Rep. 92, 8, nos. 280–295), p. 3.

74.　Von Werner (1913), p. 403.

75.　See *Nationalzeitung*, vol. 36, no. 410, September 2, 1883, p. 2.

76.　A more realistic account of the soldier's experiences in battle is recounted by a contemporary combatant, Pflug Hartung in his *Kulturgeschichte des Krieges von 1870–71 Krieg und Sieg*:

The majority of the wounds are hidden by clothing; superficially all that can be seen is a small hole from which blood flows and thus these do not make a strong impression on the observer. However, there are other sights: one man's stomach has been ripped open by a shell splinter, he holds his intestines back with his

hands and screams like a wounded animal. Another lies on the ground, his lower jaw shattered and his tongue hanging out of a pulp of blood, flesh, and bone; he is covered in blood and mucous from which only his eyes stare, white and terrible. Someone is spewing masses of blood in pumping gushes, and next to him, another man pleads that he cannot stand the pain any more; someone should kill him quickly, please quickly! It is fortunate that the comrades are usually on the move and very occupied with other things; otherwise, the effect on their morale would be unfavourable. (Hartung 1895, pp. 45ff.)

77. See Belting (1990).

78. *Neue Preußische Zeitung*, Berlin, no. 205, September 4, 1883, p. 1.

79. Sternberger (1974 [1938]), p. 18.

80. Louis Braun, who had completed a panorama of Sedan for Frankfurt a few years before, had been picked up in the area by the authorities and spent a few days in a French gaol. On the other side, the German authorities had refused Detaille and de Neuville permission to work on the panorama of the Battle of Metz in Germany. Von Werner did not even apply to the French authorities to do on-site research. See Grosskinski (1992), p. 66, footnote 157.

81. Von Werner (1913), p. 340.

82. Theilmann (1973), p. 106.

83. Ibid.

84. GStA, I. HA, Rep. 92, 5, 108.

85. Bracht's papers I, C-8; letter to his wife Maria, July 30, 1882, cited in Grossinski (1992), p. 38.

86. See Stolze (1909) and Stenger (1911).

87. Von Werner (1913), p. 345.

88. Ibid., p. 349.

89.　Ibid.

90.　Generalstabswerk (1874–1881), p. 1239.

91.　See GStA, I. HA, Rep. 92, 6ff., 158 as well as the list on pp. 159ff.

92.　Von Werner (1913), p. 354.

93.　Ibid.

94.　Ibid.

95.　Ibid.

96.　Von Werner worked on this sketch at least until January 30 (see GStA, I. HA, Rep. 92, 5, p. 121.).

97.　Theilmann (1973), p. 107. Bock (1982, pp. 113ff.) has proposed that von Werner's modified composition imitates Franz Adam's painting, *Kampf bei Floing in der Schlacht von Sedan*. A very popular work in its time, Adam's work was awarded a gold medal at the Berlin World exhibition of 1874—von Werner must have known it.

98.　*Berliner Tageblatt*, September 2, 1883, p. 1.

99.　These were: Otto Andres, Walter Busch, Victor Freudemann, Rudolf Hellgrewe, Carl Keinke, Adolf Schlabitz, Richard Scholz, Paul Söborg, and Carl Wendling.

100.　See GStA, I. HA, Rep. 92, 5, p. 121.

101.　Labédollòere gives a precise estimate of the total area of the eighteen panoramas produced by Prevost at 86,667 m2 6 cm2. See Labédollòere, "Histoire du nouveau Paris," Paris, no date, p. 30, cited in Benjamin (1983), p. 660. His ironic note—panoramas over 2000 m2 are unknown—refers to the increasingly gigantic dimensions of these circular paintings.

102.　Hans Bohrdt, himself a panoramist, noted the changed dimensions with a trace of melancholy: "Poor painter, in your quiet studio you squeeze a little paint

from the tube onto your palette; how will you feel when you are confronted with a barrel of white paint weighing several hundredweights?" Bohrdt (1891), p. 123.

103. Oettermann (1980), p. 208.

104. Bohrdt (1891), p. 122.

105. Hausmann (1890), p. 262.

106. Bohrdt (1891), p. 122.

107. Kemp (1991), p. 89.

108. From 1850 on, this function was fulfilled by so-called *perspecteurs* who specialized in this. See Bordini (1984), p. 75.

109. Bordini (1984), p. 78.

110. Von Werner (1913), p. 372.

111. Ibid.

112. "Even the most skilful perspectival representation is not of much use where irregular forms are concerned, for example, the dense foliage of overlapping tree tops." See von Helmholtz (1903 [1871]), p. 101.

113. Sternberger compared von Werner's work to create an illusion with the attempt to produce a second reality: "It was really black magic or alchemy, what von Werner was doing. An art where natural and artificial elements were mixed and combined—and its goal was not art or even beauty or the enjoyment of beauty, but the creation of a new and different nature, made by humans." See Sternberger (1974 [1938]), p. 17. To this end, for example, the effect of lighting and the materiality of the military band's weapons and music instruments was heightened by first modeling and then applying gold and silver plating (see Sternberger 1974 [1938], p. 17).

114. See GStA, I. HA, Rep. 92, 5, p. 121.

115. Theilmann (1973), p. 117.

116. Ende and Böckmann were renowned for their monumental buildings: in addition to tendering for the Hamburg Town Hall, the Reichstag, the Cathedral, the Zoological Gardens and Ethnological Museum in Berlin, they were particularly involved in Japan where they completed several large buildings.

117. The Sedan panorama was also celebrated as an architectural success in specialist journals, for example, Richard Rönebeck, "Das Sedan-Panorama am Alexanderplatz in Berlin," in *Centralblatt der Bauverwaltung*, April 1884, pp. 114–116; *Deutsche Bauzeitung* December 26, 1883, pp. 613–616, and June 25, 1884, p. 302.

118. *Deutsche Bauzeitung*, December 26, 1883, p. 615.

119. Ibid., p. 614.

120. Von Werner (1913), p. 353.

121. Rosenberg (1895), p. 82.

122. Warnke (1992), pp. 72ff.

123. Ibid., p. 73. Warnke refers to this effect in von Werner's picture *Moltke bei Sedan*, painted in 1884.

124. Piglheim's *Panorama of Jerusalem and the Crucifixion of Christ*, painted in 1886, is a rare exception. In only a few years, it was copied no fewer than nine times. See Oettermann (1980), p. 216.

125. Richard Wagner advocated that art be true to life, popular, appeal to all the senses, and utilize multimedia; in this way, all the arts would be united. The innovations of darkened auditorium, "surround-sound," and the revival of seating arrangements as in ancient Greek amphitheaters would intensify the immersive captivation that ensued from events that addressed the audience polysensually. See "Das Kunstwerk der Zukunft," in Wagner (1887), vol. 3, pp. 42–177.

126. Umberto Eco placed high expectations in the ambivalence and contradictions that a plurality of interpretation options open up for a work. Eco terms an art work "field of possibilities," which "initiates a communicative relationship that does not sink into chaos ... but is balanced ... between the intention of the

author intends and the answer of the recipient." Eco (1973), p. 159. Further: "An open work of art sets itself the task of giving us an picture of discontinuity: it does not narrate it, it *is it*." Ibid., p. 165. The authoritarian formulation of the panorama's images is diametrically opposed to ideas of this kind.

127. Benjamin (1974 [1936]), p. 476.

128. See Kemp (1991), p. 91.

129. *The Battle of Champigny* panorama (Paris 1882, 120m × 15m) was an exception. Like *The Battle of Rezonville* panorama (Vienna, 1884), it was cut into pieces and sold from 1892 to 1896. See Saint-Omer (1978) (exhib. catalog), p. 5.

130. Letter from Dr. Dominik Bartmann to the author dated August 5, 1996.

131. Admiral von Uslar's enquiry as to its whereabouts received the following answer from the National Gallery, dated February 25, 1935: "Dear Admiral von Uslar, *The Sedan Panorama* was given to the National Gallery in 1928 for safekeeping. Due to its great size, it was delivered in rolls.... Heil Hitler! The Director." Archive of the Nationalgalerie (NG), Gen. 15, vol. 12, journal no. 374/35.

4

Intermedia Stages of Virtual Reality in the Twentieth Century: Art as Inspiration of Evolving Media

The desire *to be in the picture*, in both the metaphorical and nonmetaphorical sense, did not disappear with the panorama but lived on in the twentieth century. In this chapter, I shall follow the ways in which 360° images continued and entered developing new media and art trends. Further, I shall look at how visions or utopias, that is, the desire to produce art, interweave with actual attempts to realize new media for illusions.

In connection with its commission on the panorama, in 1800 the Institut de France suggested developing a smaller-scale apparatus, which would also create a panorama-type illusion and shut out distractions of the environment. The stereoscope, invented in 1838 by Charles Wheatstone and improved in 1843 by David Brewster,[1] was an apparatus that fulfilled these criteria. It utilizes our physiological ability to perceive depth of field: Two eyeglasses arranged as far apart as the eyes, the binocular parallax, allow the combination of two images taken from viewpoints a small distance apart. The stereoscopic view results from a system of mirrors and gives the observer an impression of space and depth. In 1862, Oliver W. Holmes and Joseph Bates began to market an inexpensive model of the stereoscope, and by 1870, it had become a standard piece of furniture in middle class homes. Modernized versions were available well into the twentieth century (fig. 4.1).[2]

Monet's Water Lilies Panorama in Giverny

It is perhaps surprising that modern painters intent on abstraction should have utilized image spaces encircling the observer to reduce the distance between image and observer. Claude Monet, for example, spent decades searching for ways to fuse the observer and the image. The triptychs, Iris, Saule pleurer, Agapanthus, and Nuages, painted between 1915 and 1917 and each measuring 12.75 m by 2 m, created "the illusion of a single continuous canvas":[3] a complete panoramic view of Monet's water lily lake (fig. 4.2). To begin with, Monet planned Nymphéas as a proper panorama for a garden rotunda lit only by daylight from the glass roof. However, its first public exhibition in 1927 was as eight series of images displayed in two rooms of an orangery at Giverny, the Musée Claude Monet.[4] Although this mode of display also aroused associations in contemporary visitors of being "submerged" in a lake,[5] Monet's original concept intended to avail itself of the far more effective illusion medium of the panorama. Monet's water lilies, floating on the wind-ruffled water that reflects the changing

Figure 4.1 Achromatic stereoscope. 90 × 120 cm, ca. 1860. Smith, Beck, and Beck, London. By kind permission of Gerhard Kemner.

colors of the sky, have lost almost all distinct contours. The artist's intention was to locate observers within the watery scene, not "submerging" them in water, but immersing them in an image space with an indeterminate perspective: *floating* above the water's surface, without distance, confronted on all sides by the 360° images.[6]

By 1904, Monet had already removed the banks of the lake, the imaginary viewpoint of external observers on *terra firma*, thus bringing the pond's surface closer. The fragmentary depiction fills the paintings entirely. Monet, who used to sit only 15 to 20 cm away from the canvas when painting, succeeds in transferring his own view to the observers. He forces them out of a secure inner distance, blurs the perspective, forms, and colors of the homogeneous images, obscures the familiar view of near and far, and encourages them to glide into the exclusiveness of a water landscape. The synthesis of natural environment and mental impression puts the

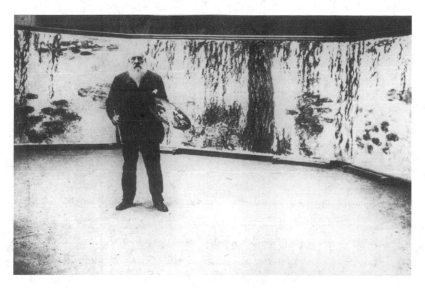

Figure 4.2 Claude Monet In Atelier 3 in Giverny, 1922. By kind permission of Karin Sagner-Düchting.

observer in a bird's-eye view position that overcomes the laws of gravity in the image space; in a certain sense, it is disembodiment. The linking of a nondistanced impressionist interpretation of a natural scene with the mechanisms of suggestion found in the image apparatus of the panorama suited the artist's intentions perfectly. Thus, one year after Monet's death and fifty years after his *Impression, soleil levant*, a late example of modern art reached the changed artistic landscape of the late 1920s, transported in a derivative of *the* mass medium for images of the nineteenth century.

Prampolini's Futurist Polydimensional Scenospace

In an entirely different social and aesthetic context, Enrico Prampolini (1894–1956), probably the most prominent member of the second generation of Futurists,[7] was also fascinated by the idea of using all available technical means to remove the boundary between observer and image space. In his manifesto on Futurist scenography (1915), the twenty-year-old Prampolini called for the immediate and radical removal of all static, painted scenery and its replacement by dynamic electromechanical scenic architecture of luminous plastic elements in motion. Prampolini was not interested in replicating natural elements of the world; he wished to dynamize the dramatic action on the stage, convinced that this would lead

to corresponding effects on the minds of the audience. The actors, whose performance he assumed would be much more intense on such a dynamized stage, he later rejected entirely. It is interesting that Prampolini applies the fantasies of fusing different elements into one, typical of the Futurists, to the theater stage. Contemporaneously, Filippo Tommaso Marinetti was extending his theory to include cinema. In his Futurist Cinema Manifesto of 1916, Marinetti declares cinema to be the most dynamic of all human media of expression because of its ability to compound traditional forms of art and media. Futurist cinema will demolish the limitations and structures of literature through its images, through a realm of images augmented by appeals to the other senses deriving from other art forms.

Prampolini continued to work on his new concept for the theater, and in 1924, he proclaimed the polydimensional Futurist stage. The traditional, box-shaped horizontal stage, seen from one direction only and with a clearly delineated area for the audience's attention, was to give way to "spherical expansion." The stage would contain "new vertical, oblique, and polydimensional elements" that are set in motion electromechanically. These would enlarge the perspectival view of the horizontal, which, in concert with the light elements, would move "in simultaneous penetration toward a centrifugal irradiation of infinite visual and emotional angles of scenic action."[8] The distanced overview does not feature in this concept: Prampolini's goal is a paradoxical amalgam of a synthetic and dynamic image space, which creates a sharp contrast between strict contraction and absolute expansion in order to communicate spiritual moments of eternity.[9]

Prampolini was not the only one thinking in this direction. Although following different artistic and political goals, a short time later Bauhaus artists were also directing considerable efforts toward the union of stage and audience. The sociopolitical perspective is a different one, but notions of a totality are also found in the theories of László Moholy-Nagy, in Theater der Totalität, and in Walter Gropius's *Totaltheater* (1927), written for Erwin Piscator. In his essay, "Theater, Zirkus, Varieté," Moholy-Nagy wrote: "It is high time to develop activities, which will not allow the masses to remain mute spectators, which will not only move them inwardly but seize them, make them participate, and in the highest transports of ecstasy, allow them to enter the action on the stage."[10] He called

for a new type of expanded stage including other media, which would level out the way theatrical space is organized, and the introduction of a system of separate, moveable surfaces fastened to a wire frame.[11] Moholy-Nagy reinterpreted certain ideas of Richard Wagner's: He reduced the importance of the spoken word and envisioned a synthesis of space, movement, sound, light, composition, and abstract artistic expression, enhanced by technical apparatus.

In 1919, Kurt Schwitters, who inspired the Dadaists, also conjured up visions to eradicate barriers with a multimedia work of art: "I demand Merz theater. I demand the complete mobilization of all artistic forces to create the *Gesamtkunstwerk*. I demand the principle of equal rights for all materials, equal rights for able-bodied people, idiots, whistling wire netting, and thought-pumps. I demand inclusion of all materials, from double-track welders to three-quarter size violins. I demand conscientious modernization of technology until complete implementation of molten melting-togetherness.... I demand revision of all the world's theaters according to the Merz idea."[12]

The Futurist conception of a *spazioscenico polidimensionale futurista* centered on blending observer and mechanodynamic image space. Prampolini was convinced that this would open up "new worlds for theatrical magic and technique."[13] The more powerful the suggestive potential of the seemingly *living* theatrical images became, the more logical it seemed to the Futurists that the actor was a useless element in the action. For since the Renaissance, the actor on the traditional stage of a theater represents a relative viewpoint, the spectator's opposite number, and this endangers the immediacy of the new images and their efficacy. Prampolini's position on the actor is much more radical than, for example, Gordon Craig's of a few years earlier; he even regards actors as "dangerous for the future of theater"[14] because of their unpredictability and ability to interpret: "I consider the intervention of the actor in the theater, the element of interpretation, to be one of the most absurd compromises for art in the theater."[15] Without going into detail here, it does seem remarkable that the core motivation of Prampolini's ideas for the theater is religious and spiritual; every spectacle was, for him, a *mechanical rite* of the eternal transcendence of matter, a magical revelation of a spiritual and scientific mystery.[16] Prampolini saw the theater as "a panoramic synthesis of action, a perfectly mystical rite of spiritual dynamism. A period of time for

the spiritual abstraction of the new, future religion,"[17] and he translated Futurism's well-known visions of merging humans with machines into a state of permanent dynamism on stage. He wanted to amalgamate this image, now mechanized and "totalized," with the spectator. Without actors, it would be possible to revolutionize the spectators' perception and direct their thoughts toward a spiritual state, which would prepare the ground for a new religion. To this end, Futurist scenospace theater creates a virtual and dynamic sphere from which the spectator cannot escape.

Film: Visions of Extending the Cinema Screen and Beyond

It is now more than seventy years ago that Rudolf Arnheim set out to classify film as art, armed with an entire catalog of aesthetic concepts.[18] After the intense debate on cinema[19] and writings by Walter Benjamin,[20] Erwin Panofsky,[21] and others published shortly afterward, this appeared to mark a pause for reflection and thoughtful review after the turbulent early days of this young medium, which had been largely spectacular. From the limiting frame of the screen, the absence of the space-time continuum, movement of the camera, to slow motion and and many other parameters besides, Arnheim (who studied art history in Berlin) fans out his aesthetic vocabulary of film. Although the artistically creative subject is threatened with near-liquidation by the complexity of organizing the machinery of film production, Arnheim interprets the medium as being free for artistic utilization. In his view, the time was past when film was under the influence of its precursor media—diorama, panorama, pleorama, mareorama, and so on—which meant first and foremost illusion and immersion. Arnheim emphasizes the difference between filmic reality and human perception primarily in order to better analyze the directors' possibilities for artistic intervention, yet the career of cinema as an image medium began because it appeared capable of fulfilling the unkept promises of its suggestive precursors, whose effects and affects no longer had the power to captivate the urban mass audiences.[22] The consciously reflected universe of images was penetrated by the visuality and particular nature of the film and first scientific studies presented their findings. Just as today the dynamic images produced with the aid of high-performance computers are regarded as a turning point in the evolution of images and a challenge to theorists, at that time film was perceived as a dramatic and decisive event. To approach a fuller understanding, however, is possible only through

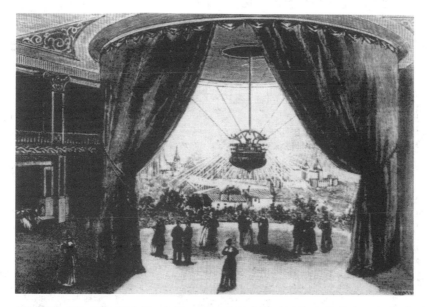

Figure 4.3 View of Charles A. Chase's *Stereopticon*, 1896. In *Hopkins Magic*. By kind permission of Silvia Bordini.

the relativization of a historical appraisal. Arnheim was fully aware of this, when, nearly a centenarian, he stated: "In pondering the future we are tempted to limit our attention to the curiosity about the inventions and discoveries awaiting us. This, however, would be narrow-minded. What is needed is a wider view encompassing the coming rewards in the context of the treasures left us by past experiences, possessions, and insights."[23]

Many and diverse were the ways in which the film became the successor to the mass medium for images that was the panorama. Much less well known are the developments that culminated in this new medium. In 1894, the stereopticon was presented to the public, an apparatus that used sixteen slide projectors working in rapid succession to project circular pictures (fig. 4.3). For a short time, the panorama united with the new technology of cinematography in the *Cinéorama* (fig. 4.4). First presented at the 1900 World Exhibition in Paris, it was a hybrid medium: Ten 70mm films were projected simultaneously to form a connected 360° image.[24] In fact, the walls of older panorama rotundas were often whitewashed and used as presentation spaces for the new cinematic version.[25]

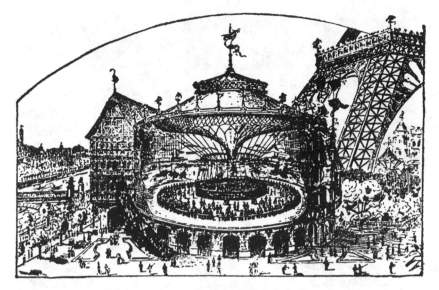

Figure 4.4 The *Cinéorama* at the 1900 World Exhibition in Paris. Cinematographic panorama, constructor: Raoul Grimoin-Sanson. Pen-and-ink drawing in *Le Cinema*, by G. A. Auriol et al. By kind permission of Georg Olms Verlag.

The history of the World Exhibitions has not yet been written, but these mammoth trade fairs are closely linked with the development of new media of illusion. Even a cursory glance reveals their concerted attempts to provide the millions of visitors with images that conjured up visions of the future. In this respect, Paris 1900,[26] with the giant panorama, *Le Tour du Monde*, dioramas of colonies, panoramas of Madagascar and the Congo, Cinéorama, and mareoramas, was no different than the New York World Exhibition in 1939. Under the motto "Building the world of tomorrow," new designs for urban development were on show as large walk-in models; inside the exhibition symbol, a sphere measuring 60 m in diameter, visitors could enter a cityscape entitled "Democracy." However, the real expression of the American vision was created by Norman Bel Geddes and sponsored by Chrysler: the Futurama. It depicted a journey through an automobile-friendly city of 1960, thus offering a simple direction for consumer optimism after the recent Great Depression (figs. 4.5 and 4.6). Thousands of model cars flowed along a freeway—later, the stereotyped image of urbanity par excellence—past high-rise buildings stretching as far as the eye could see and occupying the horizon. The visitors sat in

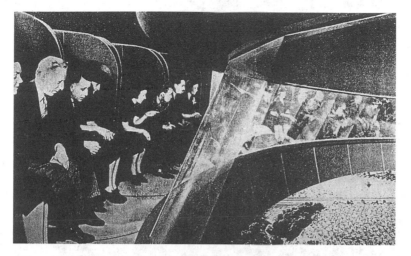

Figure 4.5 *Futurama*, 1939 World's Fair, New York. In *The World of Tomorrow*, ed. L. Zim, M. Lerner, and H. Rolfes, 1988, p. 112. By kind permission of Herbert Rolfes.

darkened cabins, arranged in a circle and hanging several meters above this model world. At the World Exhibition in Osaka of 1970, which attracted a record number of visitors, the Pepsi Cola pavilion presented a playful artificial sphere that addressed the senses with dry ice, interactive laser effects, stroboscopes, and music. The result was a confusion of the senses that approached synaesthesia. Colors and sounds mix, shapes have taste, you can describe the color, shape, and flavor of someone's voice or music, the sound of which looks like "shards of glass." A technopoetic composition designed by the legendary group Experiments in Art and Technology (EAT), it revamped the appearance of something now familiar to urban societies around the world: the polysensory environment of the discotheque. The vision of a media society informed the World Exhibition EXPO 2000 in Hannover. Both the pavilions of corporations, such as Bertelsmann's 100 million mark *Planet m*,[27] and national pavilions, such as Germany's[28] (fig. 4.7), took the visitors to bright worlds full of multimedia images, often accessed by dark tunnels filled with low-pitched sound. In the "longest cinema in the world," Jean Nouvel used dramatic light effects, spatial sound, and powerful emotional and nostalgic images to create an apotheosis of *Mobility*.[29] The long, dark passageways between the incalculably moving images also produced a feeling of immersion, not so much in an explicit image space but rather a lasting feeling of

Figure 4.6 *Futurama*, 1939 World's Fair, New York. Interior, worker with model of a building from the Vision of a City, 1960. By kind permission of Herbert Rolfes.

Figure 4.7 Expo Hannover 2000. Themenpark: *Mobilität*, architect: Jean Nouvel.

suggestive image spaces. The scenography adhered closely to the concepts of EXPO 2000's management. In a theoretical article on scenography published before the Hannover exhibition opened, Martin Roth, director of the theme park, stated that in Hannover, the content of the visualizations is characterized by a relationship of competition to their modeling by new projection techniques. Referring to Buckminster Fuller, Disney, and El Lissitzky, among others, he wrote: "It is within this tension that the true dynamic and dramaturgical momentum of the exhibition is realized."[30] The architectonic designs of the pavilions' interiors, where materiality, complexity, and expression are barely recognizable, retreat behind the surfaces used for projecting worlds of images. The visitors find themselves in dark caves, which—like IMAX cinemas or virtual art installations—transport meaning only through moving pictures. The architectonic structure is merely a vehicle for the images, and this allowed variability in what could be shown. Each World Exhibition has introduced new image experiences to the public using the most advanced media technology of the day. Their aim is to create a credible and irresistible vision of the future, and this can be achieved most readily by employing large format images that enclose the visitor.

Today, contemporary accounts of first film shows by those pioneers of cinematography, August and Louis Lumière, read like a blend of legends, anecdotes, and sensational journalism. *Arrivée d'un train en gare le ciotat* (1897) was, as R. M. Hayes has pointed out,[31] actually the first 3-D film to be screened in public, although it is unlikely that the optical aids really did enable the images to be seen in three dimensions. Like the panorama before it, film began by replicating what could actually be experienced to establish its potential as a medium. The audience reacted to the approaching train in this film, its "brutal reality,"[32] with screams of panic, by running away, and, according to many contemporary sources, by fainting.[33] These reactions resulted from the fact that for the first time, the camera lens angle and the observer's eyepoint corresponded. James Gibson has described this effect and its influence on film in his outline of an ecological theory of perception.[34]

The immersion experienced by early cinemagoers is described by Siegfried Zielinski: a "darkened room, where the spectators, like Plato's cave-dwellers, are virtually held captive between the screen and the projection room, chained to their cinema seats, positioned between the large-size

rectangle on which the fleeting illusions of motion appear and the devices that produce the images of darkness and light. Cinema as an environment for the enjoyment of art, for immersion in traumatic experiences, for hallucination, for irritation of real experience; and, what is more, with films constructed in deliberate opposition to the experiences of those who pay to enter the dark womb and be at the mercy of the play of light and sounds."[35]

Early cinemagoers' reactions to silent black and white films tax our imagination and seem explicable only in terms of the novelty of the medium of illusion and its then unknown potential for transitory suggestive effects. Film greatly affected an audience whose perception was unprepared and not habituated to processing moving, simulated images. However, this effect must be regarded as relative in view of the similar drastic reactions of the public to the first panoramas and the long historic chain of innovations in illusionist image production. At first, the audience is overwhelmed by the new and unaccustomed visual experiences, and for a short period, their inner psychological ability to distance themselves is suspended. This contention needs to be tested by comparative research on immersion, which as yet is only just beginning. The connection between innovations in technologically produced illusions and putting the inner ability to distance oneself under pressure, may, for a period of time (the length of which is dependent on the illusion potential of the given new medium) render conscious illusion unconscious and confer the effect of something real on that which is merely appearance.[36] When a new medium of illusion is introduced, it opens a gap between the power of the image's effect and conscious/reflected distancing in the observer. This gap narrows again with increasing exposure and there is a reversion to conscious appraisal. Habituation chips away at the illusion, and soon it no longer has the power to captivate. It becomes stale, and the audience are hardened to its attempts at illusion. At this stage, the observers are receptive to content and artistic media competence, until finally a new medium with even greater appeal to the senses and greater suggestive power comes along and casts a spell of illusion over the audience again. This process, where media of illusion and the ability to distance oneself from them compete, has been played out time and again in the history of European art since the end of the Middle Ages.

Film, or cinema, is such a heterogeneous media complex that it resists being subsumed under a general definition. Here, I shall follow the Russian director Andrey Tarkovsky's characterization of film as "emotional reality," which allows the viewers to experience a "second reality."[37] Cinema is intended for direct sense and emotional perception, and this inevitably gives the director "power" over the feelings of the audience, even leading some filmmakers into the aberrant self-deception of being a demiurge. For Tarkovsky, these highly sensitive and suggestive components of film that, for a period of time, allow the audience to believe in an artificial reality created by technology, impose a heavy responsibility on the director.[38] This perspective, Tarkovsky's iconic understanding of film, allows us to interpret and comprehend the recurrent forays attesting to film's polysensory aims. Their basic trend is toward extending the system of illusion beyond the visual to include the other senses. Essentially a reproductive and psychological art form, the medium of film has seen many attempts in the last century to advance beyond two-dimensional screen projection in order to intensify its suggestive effect on the audience.

Teleview (1921) introduced the 3-D film to the United States.[39] Colorful light projections, viewed with two-color glasses, created impressions of space and depth.[40] Like the panorama, the subjects of these films were distant and, for the average urban American, exotic places: a Hopi camp in Arizona, scenes from the Canadian Rockies, or a main feature entitled *M.A.R.S.* Abel Gance also planned to include 3-D sequences in his epochal film *Napoléon* (1926–1927). However, at private previews, the 3-D scenes were felt to be too overwhelming, even more powerful than the panoramic effect of three simultaneous screen projections. Gance decided to remove the 3-D sequences in order not to risk compromising the effect of the rest of the film, which was in 2-D.[41] Zeiss-Ikon put their 3-D color *Raumfilm* system on the U.S. market at the end of the 1930s, but, apart from a few short films, it was hardly used during World War II.[42] For the cinema newsreel Wochenschau in Germany and the lavish color productions of the German UFA film company, the standard format in the latter war years remained 2-D.

Sergei M. Eisenstein was one of the visionaries of new media of the art of illusion (fig. 4.8). In the late 1940s, he described a symbiosis of art and utopian technology. An influential Soviet film director and theorist, he interpreted the history of art as an evolutionary process inseparable from

Figure 4.8　Sergej Eisenstein. ⟨http://www.fdk-berlin.de/forum98/gesichter.html⟩.

the development of technology. From the perspective of the 1940s, Eisen-
stein considered film the most advanced developmental stage of art. In his
essay *"O Stereokino"* (1947), he stressed the long continuity in the dia-
lectical relationship of art, science, and technology.[43] The ultimate syn-
thesis of all art genres would culminate the imminent realization of
Stereokino, stereoscopic cinema,[44] which Eisenstein believed humankind
had been moving toward for centuries and represented a further expression
of a deeply human urge to create images.[45] Then, the image, experienced
as "real three-dimensionality" (Eisenstein offered no technical details about
stereoscopic cinema) would "pour" from the screen into the auditorium.[46]
Further, stereo sound would be "absolutely essential."[47] This would enable
the director to "capture" the audience and the audience to "immerse
themselves completely in the powerful sound."[48] Stereokino would have
the power "for the first time ever, to 'involve' the audience intensely in
what was once the screen and to 'engulf' the spectator in a manner no less
real and devastating with what was formerly spread across the screen."[49]
Eisenstein is not sketching a blueprint of virtual reality here, in the sense

of panoramatic images; his reflections revolve around rendering images so powerful, with plasticity and movement, that they can tear the audience psychologically out of their actual surroundings and deliver them into the environment of the stereoscopic film. His use of language, such as "immerse," "engulf," "capture," and so on, is a clear indication of what lies at the heart of this idea: the expectation of soon having a medium at his disposal that, at an advanced technological level, would have the capability to amalgamate image and spectator psychologically. These film images would have a suggestive power with hitherto unknown potential and effects: "That which we were accustomed to see as an image on a screen will suddenly 'swallow' us in the distance that opens up behind the screen, which has never been seen before, or 'get into' us through a 'tracking shot,' which has never been realized before with such expressive power."[50]

Obviously, Eisenstein is not looking to facilitate inner distance in the spectator or to construct an arena of manageable, controlled reception and subjectivity. He saw Stereokino as a tool for "getting into" the audience and "sucking them into" the images.[51] The essay "About Stereoscopic Cinema" documents Eisenstein's will to take possession of this future high-tech medium of illusion as an instrument for exercizing a great deal of control over the emotions of the audience. He seeks to infer the inevitable development and phenomenology of this medium of illusion from art history and anthropology:[52] Stereokino is rooted in the ritual union of actors and audience, an archaic urge to reconcile "show and mass audience" to form "an organic whole."[53] Eisenstein saw this new image machinery as the goal of a teleological development and justified his intention to utilize it with arguments invoking art history and anthropology. It goes without saying that he desired to further the aims of Socialism in this way.[54] Yet his formulation of the intent to control audience emotions and his supporting arguments did not proceed from any Communist party directives. These visions and arguments are the product of an analytical thinker and went far beyond what the Party expected of filmmakers. Irrespective of how one judges the politics, they are a true reflection of Eisenstein's personal endeavors as a politically thinking artist and aesthetician.

Of the many projects to expand the Silver Screen in the United States during this period, Fred Waller's Cinerama, with its 180° screen (fig. 4.9), occupies a salient position. Compared with the idea of 360° images and the short-lived attempts at projecting circular images at the turn of the

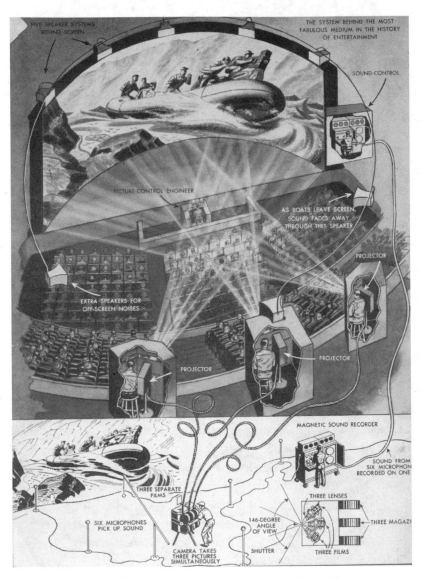

Figure 4.9 The Cinerama. From the private collection of John Mills.

century, Cinerama represented a step backward; however, it was commercially successful. In company with several other large-scale image projection apparatus, Cinerama originated from an attraction exhibited at the 1939 World Exhibition: the Vitarama, a product of Waller's experiments in the late 1930s for the U.S. air force to improve their flight simulators. At the height of its popularity in the early 1960s, Cinerama films were screened in their own specially equipped cinemas of which there were about one hundred around the world. The films were shot with three cameras and presented with stereophonic sound. Cinerama occupies a paradigmatic place within successful 3-D entertainment cinema of the 1950s and 1960s.[55]

In the same period, Morton L. Heilig developed a far more radical vision of the immersion idea: the Cinema of the Future, offering illusionary experiences to all of the senses, including those of taste, smell, and touch.[56] The screen would not only fill 18 percent of the spectator's visual field, like CinemaScope in 1954, or 25 percent, like Cinerama; Heilig's declared aim was 100 percent: "The screen will curve past the spectator's ears on both sides and beyond his sphere of vision above and below."[57] *The Cinema of the Future* would, Heilig felt, even outdo the "Feelies" envisioned by Aldous Huxley in *Brave New World* and represent an image medium with a unknown suggestive potential: "it will be a great new power, surpassing conventional art forms like a Rocket Ship outspeeds the horse and whose ability to destroy or build men's souls will depend purely on the people behind it."[58] In Heilig's opinion, an artist's powers of expression would benefit considerably through knowledge of the human sensory apparatus and perception—a simple idea, yet remarkable for the period. Along with so many other projects, the Cinema of the Future was destined to remain a futuristic vision. However, its motivation and orientation continued to drive aspirations in the realm of technical development, though tempered by the fact that these are always subject to economic viability and prevailing political interests.

Heilig's pioneering research focused exclusively on immersive image apparatus for the rapidly expanding medium of his day: television. In 1960, he patented the "Stereoscopic televison apparatus for individual use" (fig. 4.10). This consisted of stereo glasses with two miniature TV screens that produced 3-D images and combined the principles of the stereoscope with the technology of television.[59] Only two years later, he developed

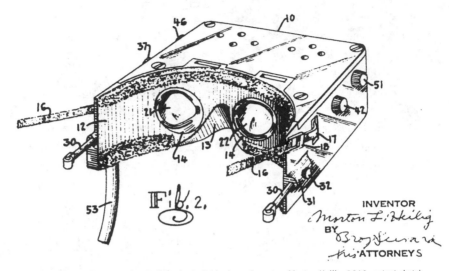

Figure 4.10 Stereoscopic television for individual use. Inventor: Morton Heilig, 1960, patent sketch. Author's archive.

the Sensorama Simulator (fig. 4.11),[60] which soon made its way into the entertainment sector. In addition to 3-D CinemaScope images and stereophonic sound, the audience in the Sensorama were subjected to vibrations and smells simulated by chemicals.[61] The Sensorama was not interactive, but it did succeed in addressing four of our five senses: sitting on an imaginary motorcycle, the spectator saw the streets of, for example, Manhattan whiz past, heard the noise of traffic and the streets, smelled petrol fumes and pizza from snackbars, and felt the vibrations from the road. In this case, the objective of polysensory experience of images is clear. In the 1960s, the Sensorama was found mainly in amusement parks in California but hardly anywhere else.[62]

Besides 3-D cinema, a constant phenomenon but one that never exerted a determining influence on mainstream film production, many other attempts were launched to enhance cinema with tactile elements or smells. Films such as *Earthquake* (Robson 1974) and *The Tingler* (Castle 1959) included haptic sensations: The audience sat in special seats that shook. *Polyester* (Waters 1981) included smells: With the entrance ticket came a card strip which the cinemagoer rubbed during the appropriate film sequences releasing corresponding smells.[63]

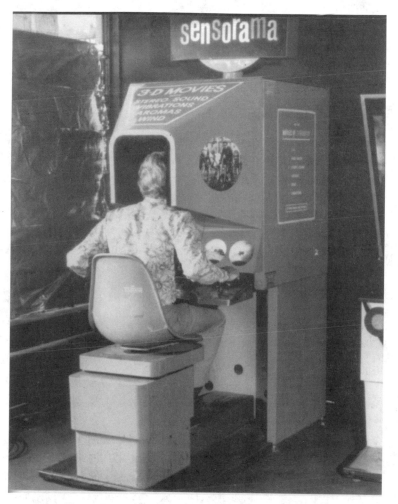

Figure 4.11 Sensorama Simulator. Inventor: Morton Heilig, 1962
⟨http://www.cinemedia.net/CCP/data2.htm⟩.

Parallel to these developments in filmic art, popular and spectacular versions of virtual spaces existed as amusement park and fairground attractions in the 1970s and 1980s, particularly in the form of small immersive circular cinemas. At regular intervals, new concepts were advanced, and some even realized, of how to enhance immersive experiences in the cinema, for example, Omnimax cinema's spherical projection (fig. 4.12).[64] James Gibson has defined these endeavors in terms of the urge to extend the view by banishing all forms of frame from the field of vision:

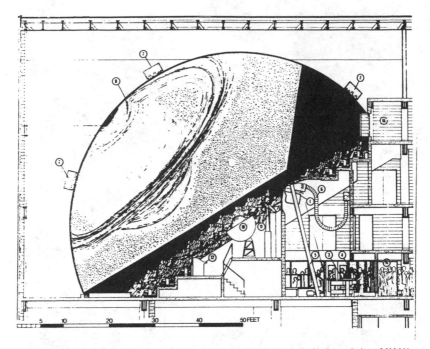

Figure 4.12 Omnimax Theater, 1984. Precursor to the IMAX Dome. By kind permission of IMAX Corporation.

"With a Cinema screen, the virtual window may sample as much as 160° of the ambient array, instead of the mere 20° or 30° of the usual movie theatre, and the illusion of locomotion may then be compelling, uncomfortably so."[65] From the point of view of illusion, IMAX (Image Maximization), introduced in the 1990s, represents the state of the art. This U.S. company has installed over 150 of their spectacular cinemas in more than 20 countries. With curved screens of up to 1000 m^2, spectators are literally in the images. For 3-D IMAX films, the audience wears special glasses with lenses that are opened and closed in rapid succession by high frequency infrared light. Each eye sees the images of the two film projectors separately and the brain combines the slightly different images into one, producing an impressive effect of spatial depth. Commercially, the IMAX cinemas are highly successful;[66] thematically, the films' subjects follow a pattern prefigured by the panorama: IMAX takes the spectators to inaccessible, far-off foreign places. Today, this means the depths of the oceans, the wreck of the Titanic, the summit of Mount Everest, or outer

space. The distant places that beckon us now have shifted to the most extreme zones the planet has to offer. Frequently, IMAX films show spectacular locations, such as the Grand Canyon in the United States, which are of such vast dimensions that the human eye cannot take them in at a glance. With edited sequences of takes from inaccessible angles, IMAX expands natural spectacles, and it is to this effect that it owes its millions of visitors.

Highways and Byways to Virtual Reality: The "Ultimate" Union with the Computer in the Image

Ever since the early days of the computer during World War II,[67] there have been attempts to connect, synchronize, or analogize this universal machine with human beings. One of the first to see computers in relation to humans was Vannevar Bush, adviser to Franklin D. Roosevelt and, in his capacity as director of the Office of Scientific Research, decisively involved in the development of the atom bomb. In a classic, highly influential article written in 1945, "As We May Think" for *Atlantic Monthly*, he referred to the computer as a "mind machine." Further, he discussed ideas for the collection, storage, and accessibility of information in a world based increasingly on efficient data processing. Norbert Wiener followed suit in 1948,[68] and Alan Turing in 1950.[69] They both saw analogies between the work processes of humans and computers and thus laid the foundations for later theories of robotics, cybernetics, and research on artificial intelligence. Wiener defined cybernetics as the science of conveying messages between humans and machines. This remarkable conceptualization derived from an idea that later formed the basis of all concepts of interaction and interface design: communication between humans as the model for communication with or between machines. In 1960, when the successful launch of Sputnik into space had also sent shock-wave visions of similar technology in conjunction with nuclear devices through the military establishment, J. C. R. Licklider, who worked on computer networks in defence, sketched a vision of symbiosis between humans and computers.[70] Licklider was interested in simplifying exchange of information between human beings and computers, which would make it possible to give orders and pass them on quickly in wartime, for as he said laconically, "Who can direct a battle when he's got to write the program in the middle of the battle?"[71] As director of the U.S. Defense Department's

Advanced Research Projects Agency (ARPA, later DARPA), which was mainly involved with funding defense-relevant projects rapidly and unbureaucratically, Licklider supported research that led to development of interaction with computers and, ultimately, to the personal computer. For Licklider, the computer was an intelligent partner, which needed to be equipped with attributes of reactive behavior. Then, in 1964, Marshall McLuhan appropriated the term *symbiosis* to describe the future relationship between humans and machines.[72]

Ivan E. Sutherland made probably the most decisive contribution to the human–machine interface in his doctoral thesis, "Sketchpad" (1963), which was supervised by Claude Shannon at the Massachusetts Institute of Technology (MIT). Sketchpad was the first graphical user interface, and it reformed computer graphics. In 1951, the Whirlwind computer had been developed, which allowed direct manipulation of data on a cathode ray monitor—at the time, still a rarity. It was the first dynamic and interactive display. However, Sketchpad enabled the user to draw directly onto the monitor with a hand-held lightpen[73] and thus offered the option of manipulating images directly on the screen: the basic prerequisite for interaction with virtual realities. Sketchpad was the precursor of graphics programs such as Adobe Illustrator or MacDraw, which replaced the abstract *word*-commands, that is, syntax, interface with the interface of pointing at *icons* with a device, that is, physical action, which was also much easier to use.

Sutherland's ideas for an "ultimate computer display" of 1965 were also revolutionary. This display would have the capability to rearrange physical laws optically in "exotic concepts" and even visualize these through computed matter.[74] One remarkable passage recalls Alberti's use of the window metaphor: "One must look at a display screen as a window through which one beholds a virtual world. The challenge to computer graphics is to make the picture in the window look real, sound real, and the objects act real."[75] Sutherland's article, published in the proceedings of a science meeting, opened up a new space for futuristic speculations about this new computer-based medium, which radicalized as-if scenarios. In such an image space communicated directly to the senses, handcuffs can restrain and a shot can kill,[76] depending entirely on the programming. Sutherland's ideas went far beyond mere illusion; the simulation potential of the system

ought to have material results, for example, violence, and produce a perfect oneness with the machine-made virtual image.[77]

From 1966, Sutherland and his student Bob Sproull worked on the development of a head-mounted display (HMD) for the Bell Helicopter Company, in retrospect, an important place where media history was written. The HMD represented the first step on the way to a media utopia: a helmet with binocular displays in which the images on two monitors positioned directly in front of the eyes provided a three-dimensional perspective. When connected to an infrared camera,[78] the apparatus made it possible for military pilots, for example, to land on difficult terrain at night. This helicopter experiment demonstrated that merely by using "camera-eyes," a human being could immerse in an unfamiliar environment and be *telepresent*. At one point, a test person panicked when his HMD showed pictures taken from the top of a skyscraper of the street far below, even though he was actually safely inside the building. This amply demonstrated the immersive psychological potential of the technology. In 1966, Sutherland replaced the photographic film images with computer graphics. These were updated many times per second in real time by the system and thus the concept of interactively experienced virtual reality was born.

In 1968, with ARPA funds from the U.S. defense budget,[79] Sutherland developed the first computer-aided HMD. It showed 3-D computer images, and sensors inside tracked the user's head movements,[80] a process known as *headtracking*: "The fundamental idea behind the three-dimensional display is to present the user with a perspective image which changes as he moves."[81] However, the aim of this HMD was not the total simulation of artificial environments; in contrast with today's headsets, visual access to the outside world was uninterrupted. Using two miniature cathode ray tubes, the computer images were projected over the images of the actual environment. The user saw both real and computer images simultaneously, which enabled its utilization as a targeting device.

Sutherland's early virtual spaces were very simple scenes, consisting of at most 200 to 400 polygons. Headtracking and biomechanical feedback produced an impression of immersion. Regular updating made the computer images appear changeable and capable of reacting to the user's movements, limited only by the program's scope: the principle of interaction.

For the first time, the observer was partly responsible for generating the resultant 3-D images. This new potential of the observer's role went so far beyond that of the panorama or Cinerama that they hardly bear comparison.

This new relationship to machines, that is, computers, soon appeared in theoretical discussions of film art. In his book *Expanded Cinema* (1970), Gene Youngblood proposed widening the definition of cinema. Citing many examples, mainly from performance art and the Intermedia movement in the 1960s and 1970s, Youngblood showed that the cinema's two-dimensional screen had entered into a whole range of symbioses with other imaging elements and techniques. Although these were rarely illusionist, they were often multimedia, multisensory, and exclusive, conceived as near-totalities.[82] For example, the Cerebrum, an multimedia event space in late 1960s New York was a mixture of gallery and club, with a psychedelic light show and music, where visitors wore the same uniform of simple white clothes, an uninhibited atmosphere in which to live out "personal realities and anonymous psychodramas."[83] Other contemporary Intermedia artists combined large-format, often abstract film projections with sound effects and sensory stimuli. Particularly innovative were the one-off performances that required audience participation. Jud Yalkut (*Dream Reel*, 1969), for example, used a parachute suspended above the observers as a projection screen for his film images. At the University of Illinois, John Cage and Ronald Nameth (*HPSCHD*, 1969) surrounded the audience with 52 loudspeakers, 8,000 projected slides, and 100 films in an event lasting five hours. Milton Cohen (*Space Theatre*, 1969) projected a mixture of light effects, film, and slide images onto a rotating assemblage of mirrors and prisms. His aim was also "to free film from its flat and frontal orientation and to present it within an ambience of total space."[84] The term "expanded cinema" encompassed video, computers, and lasers, that is, holograms. Well versed in contemporary models of artificial intelligence research,[85] Youngblood envisioned the future human as an amalgamation of organism and computer, a cyborg.[86] With regard to the future development of image production, which he also referred to as expanded cinema, Youngblood projected onto the computer the utopia of a medium where thoughts and mental images would immediately translate into image worlds without interposing processes of communication or code. Theoretically, this predicates a *brain interface*. Youngblood's vision of 1970

was still diffuse, and the consequences were not thought through; nevertheless, he concludes. "the ultimate computer will be the sublime aesthetic device: a parapsychological instrument for the direct projection of thoughts and emotions."[87]

Youngblood's concept of expanded cinema described a trend in the visual arts that sought to extend abstract, technical images and involve as many of the senses as possible for its aesthetic effect. Its ideal was a corollary of the all-inclusive panoramic effect, to which end it was necessary to overcome the traditional boundaries of the film screen. In the future, Youngblood imagined that the relation between observer and fleeting, technologically produced images would be replaced by a physical symbiosis of human and computer image in an ultimate state of osmotic interpenetration. The idea is reminiscent of Sutherland's notion. It is the old idea of merging the human being and the image, but reinvigorated for the computer age. Many of Youngblood's ideas appear to mark him as a utopian, but he was one of the first art theorists with the clarity of insight to point out that the computer would enable the most radical innovations in image illusionism currently possible.

Particularly at MIT, researchers worked intensively on designing immersive computer interfaces. Already in 1970, Nicolas Negroponte[88] had declared that their goal was to combine the visual capabilities of film with computer processing. In 1972, Negroponte stated his vision of a creative human–computer relationship in an even more radical way. Following his argument to its logical conclusion, he declared in his manifesto-like book *The Architecture Machine* that in the future his own profession would be superfluous: The primary functions of an architect could be carried out just as well, if not better, by a computer.[89] By implication, the idea that using a computer can turn an inexperienced user into an architect is applicable to many professions and creative activities. In 1976, the Architecture Machine Group at MIT, also funded by ARPA, focused on the spatial, or hierarchical, distribution of data as an organizing principle.[90] One of the researchers, the psychologist Richard Bolt, supported the idea of an interface that targeted the senses and wrote an account of this research in his book, *The Human Interface*, published in 1984. In company with the majority of treatises on new media technologies, Bolt also tries to ground the principle of spatial distribution of data in established traditions of art history, citing no less an authority than

Francis A. Yeates and her distinguished book *The Art of Memory*[91] in this endeavor.

Computer scientists, who also considered themselves artists, were already something of a tradition: In 1965, Michael Noll and his colleague Bela Julesz organized the first U.S. exhibition of computer graphics in the Howard Wise Gallery. In Europe, Frieder Nake and Georg Nees had done the same in Stuttgart the year before. Jasia Reichardt's London exhibition, Cybernetic Serendipity, was a milestone in the early history of computer art, which began in the 1950s as a chance by-product of the work of programmers, such as Ben Laposky on the oscillograph. It was the first showcase of creative work with computers in the fields of music, graphics, film, and poetry.[92] In Germany, the exhibitions Computerkunst—On the Eye of Tomorrow and Impulse Computerkunst in the Kunstverein in Munich followed in 1970. This was also the year that computer art became an integral part of the Biennale in Venice, which enhanced the international status of the genre.

In the early 1970s, the computer scientist Myron Krueger began work on developing other forms of integrating human mind and interactive computer images. Krueger experimented with reactive installations, and his work paved the way for interactive, psychologically communicative environments. His oeuvre—he also thought of himself increasingly as an artist—reflects the search for a system where the observers, or users, understand themselves as part of a community of programmed beings and where the artist is a composer of computer-generated space communicated in real time. Krueger called this a "responsive environment." His main work, *Videoplace*, is driven by this idea; the first version dates from 1970 and he developed it further in subsequent years. *Videoplace* is a two-dimensional graphic computer environment; a classic closed-circuit, which records the observer on video and projects his or her digitally manipulated silhouette onto a wall-sized screen. The program offers many levels of interaction, involving the observer in a dialogue-like structure.[93]

In the 1980s, the metaphor dominating interaction with the computer changed radically: Modern graphical interfaces, such as Xerox PARC used in Apple Macintosh computers, began to replace the word-based commands.[94] The metaphor of the desktop created an illusion of a manipulable discretionary symbolic environment on the screen. In essence, virtual environments are an extension of this metaphor into a third dimension,

which can be observed and manipulated from exocentric and egocentric perspectives.

In addition to Sutherland, the most important pioneers in the development of virtual reality systems were undoubtedly Tom Furness and Scott Fisher. From the mid-1970s, Furness worked on targeting devices for the U.S. Air Force[95] and founded the Human Interface Technology Lab (HIT) at the University of Washington in 1989. Fisher began working at MIT on stereo optical apparatus and, along with many other researchers, moved to Atari's R&D department in Silicon Valley in 1982.[96] Thomas Zimmerman, who had invented the prototype of the data glove in 1981,[97] was one of the computer scientists who joined him at Atari.[98] There, Zimmerman met Jaron Lanier and together they founded the firm VPL Research. In cooperation with NASA, VPL refined the data glove, which originated from the two-dimensional mouse interface. The data glove became a highly specialized sensor, which registers and transmits the position of the fingers, thus enabling movement and navigation in a virtual space.[99] In most cases, the glove uses optical fibers that run along the fingers from the wrist. The given flexing of the fingers modulates light transmitted through the fibers and the information is relayed to a computer via diodes. The user can touch or move computer-generated objects with the glove. However, feedback effects or tactile obstructions are still difficult to simulate. Sensors positioned on the body allow spatial coordination in the data space and the manipulation of computer-generated objects.[100] Lanier and his company VPL Research were the first to market commercial applications of the data glove and VR. The Atari Lab closed down in the mid-1980s and Fisher moved to the NASA Ames Research Center,[101] where a stereoscopic HMD system with a liquid crystal display (LCD) was constructed within the framework of the VIEW Project (virtual environment workstation). These virtual image spaces allowed up to six users at one time to interact with virtual objects.[102]

NASA was also responsible for further developing the technology of telepresence.[103] Telepresence, for example, allows a user to direct a distant robot's movements by remote control. The user moves in a computer-simulated representation of the robot's actual physical location. Simultaneity of user action and robot reaction together with the graphical representation of the robot's location creates an impression of being present in a different physical location.[104] Thus, telepresence extends the

connection between body and machine one step further. It cannot be stressed enough that this is a far cry from "abolishing the body." The goal of telepresence research is to address the senses in a very precise way in order to achieve all-around illusionary deception of the user. In 1988, Scott Fisher and Elisabeth Wenzel succeeded in realizing the first spatiovirtual sound, which, even when the user's coordinates changed, remained located in its own position in the simulated space—a further device for enhancing the illusion. The fastest computers of these years, such as the Hewlett-Packard 9000, were able to render solids, like cubes, more plastically, with shadows on their surfaces in real time. Before, these could be represented only as wire mesh models.

The Rhetoric of a New Dawn: The Californian Dream

When William Gibson published his novel *Newromancer* in 1984, a gentle satire on utopian dreams, the idea of simulated experiences in computer-generated spaces, in cyberspace, was fast becoming popular. Gibson's understanding of cyberspace was a series of networked computer image spaces, a matrix, which as a "collective hallucination" would attract billions of visitors daily.[105] The subculture that rapidly formed around virtual reality appropriated this new word in the late 1980s. Gibson was rather surprised by the attention scientists and techno-believers paid to his book and the utter seriousness with which his visions were debated and discussed.[106]

In the same period, the price of high performance computers dropped drastically, resulting in a rash of new companies and first commercial uses of virtual reality.[107] Garage firms, such as Autodesk,[108] VPL-Research,[109] Sense8,[110] and W. Industries, with just a few employees,[111] and magazines of the new computer subculture, such as *Mondo 2000*, *Virtual*, *Whole Earth Review*, and *Wired*, plus a series of cyberspace festivals, first spread across California and later to the computer scenes of other industrialized nations. The mood was predominantly euphoric but accompanied by a lot of hype. The conviction that soon there would be a medium capable of spawning image illusions never before experienced gave rise to diffuse individual utopian visions in its protagonists and a collective imagination: the new Californian Dream.[112] Visions of a network spanning the world like a technoid skin, which would allow experience of 3-D space, spread quickly from the subculture to the tabloid press whose reports conformed by and

large to their sensationalist credo. Serious business journals were not left untouched by these technological flights of fantasy. An unprecedented investment fever swept the Stock Exchange, and billions of dollars gave a new direction to the worldwide economy.[113] When Jaron Lanier coined the term "virtual reality" in 1989, this was also an attempt to package heterogeneous areas of research on the human–computer interface with different labels together with utopian dreams in one, albeit paradoxical, buzz word with a strong appeal to the public imagination.[114] Terminological fuzziness widens the scope of the imagination and feeds dynamics of development. Rhetoric of this kind often heralds utopian imaginings that are located in a spatiotemporal distance with an appointed redeemer.[115] The hopes placed in a future, as yet nonexistent, technology indicate the presence of religious motifs. Strikingly, expectations are not placed in anything human or divine but in an artificially created apparatus, an artifact.[116] In the mid-1990s, certain Republican intellectuals in the United States discovered cyberspace as a place for projecting the old "westward ho" ideology, which led not only to the conquest of the Wild West but also to the genocide of native Americans. They proclaimed that America's future would lie in the networks.[117]

Virtual Reality in Its Military and Industrial Context

The new alliance of art and technology embodied by virtual reality and its image culture cannot be considered as an isolated phenomenon; it is an integral part of revolutionary developments in the economy and military technology. According to the German ministry of economic affairs (Bundesministerium für Wirtschaft), contemporary developments in new information and communications technology are radically changing both the economic and technological spheres to a degree "that is comparable with the transition from the agrarian- to the industrial-based society, with all accompanying changes."[118] The computer is transforming entire sectors of the economy, production, planning, administration, military operations, and leisure time: Virtually all areas of life are changing rapidly. The degree to which society is dependent on functioning telematic networks and information infrastructures is also increasing rapidly, for which the near-panic concerning the year 2000, or "Y2K," serves as an impressive demonstration. The diversity and speed of communication now possible is influencing the education system, speeding up and expanding the production

Figure 4.13 Moore's Law. Reprinted by permission of Intel Corporation, copyright 2001 Intel Corporation. ⟨http://www.intel.com/research/silicon/mooreslaw.htm⟩.

of information, and transforming the structures of knowledge. The welfare state and legislature strive to keep up with developments. In brief, in the space of relatively few years, the computer has engineered massive transformations, and the pace is accelerating, rather than slowing down.

For decades now, the price of graphics hardware has reduced annually by a factor of 4, while performance increases 20 to 100-fold. For example, a supercomputer today can process one thousand million instructions per second (1000 MIPS). If a human were to read just one instruction per second, he or she would take 32 years, without sleeping or resting, for the same amount of data. The popular formula expressing this development is Moore's Law; in 1965, Gordon Moore predicted that the number of transistors per integrated circuit would double every 18 months (fig. 4.13). If this exponential rule still holds, then it will only be a matter of years before the computing power is available to realize high-definition spaces of illusion.

At the beginning of the new millennium, it appears that the computer will amalgamate with telecommunication in a new synthesis, a hyper-medium:[119] As soon as the Internet is able to handle greater quantities of data, image spaces will be available in a quality that is currently achieved only in expensive installations, stand-alone systems, at festivals or media

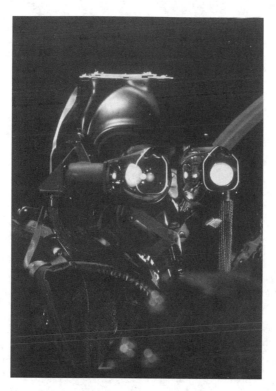

Figure 4.14 A pilot in the Tornado OFT wears a CAE helmet-mounted display. *Military Systems & Trainings News,* no. 1 (fall 1999/winter 2000): p. 7.

museums, which are, on their own admission, future models for the Internet. The majority of exhibitions of interactive art use systems of this kind. However, a precondition for telepresent access to virtual reality applications via the networks is new cables, for example, glass fiber, worldwide.[120] Further, new tools for data compression and standards for bandwidth are needed, as both are important for speed of data transmission and image quality. Currently, telecomunications companies are investing large sums of money to achieve these goals. To put networks in place that will enable high-speed exchange of data on wide bandwidths, companies in the United States, Japan, and Europe have already committed themselves to investments of several hundred billion U.S. dollars.

This close-knit fabric of economic and technological interests, sensation-seeking, and escapism has all but banished the military origins of this

Figure 4.15 Octagon of Aachen cathedral. Photomontage of 20 fisheye shots taken by Dr. Rolf Dieter Düppe. Institut für Photogrammetrie und Kartographie der TU Darmstadt.

technology from public consciousness. To cite but two examples: In the 1980s, the McDonnell Douglas Corporation developed an HMD, which enabled pilots to double their quota of "kills."[121] The U.S. Air Force has used flight simulators for years in pilot training, and even back in 1991, these were capable of such realism that the pilots' adrenalin levels were higher in the simulators than when flying real missions during the Gulf War (fig. 4.14).[122] In addition to this staple application in military aviation, simulation models were also developed for the navy and the army by Bold Beranek and Newman Inc., largely supported by funds from the defense budget: The SIMNET network allows U.S. forces to simulate battles in which over 1000 tanks are deployed. Before combat in the Gulf War and the intervention in Somalia, the armed forces practiced simulated maneuvers. A similar network was installed for the U.S. Air Force, the Aircrew Combat Mission Enhancement Network (ACME). The German Bundeswehr uses the AGPT system, which provides simulations after the manner of SIMNET but with better quality graphics. Installed in mobile containers, it can be transported to anywhere in the world.[123] The U.S. Army works with virtual reality environments for tens of thousands of participants with simulations that are highly realistic.[124] In addition to

investments by the military complex and the space industry, in the early 1990s, particularly the electronics and information sectors of civil industry invested heavily. Of particular interest were applications for developing prototypes faster, simulating industrial production processes, constructing walk-in simulations of the built environment from the past, present, and future (fig. 4.15), visualizing scientific research results,[125] and simulation-aided research.[126] Many commercial companies have their own virtual reality research departments that are tailored to their specific requirements. This does not only include telecommunications and software firms[127] or the giants of the entertainment industry, such as Disney, Nintendo, and AOL Time Warner, but also traditional industries, such as automobile manufacturers and civil aviation. Medicine uses the new technological applications in a wide variety of fields. Further, hitherto inaccessible sections of the market are being opened up, not only in more remote regions, by the introduction of e-commerce.[128] Producers and consumers are brought together on a global scale, with all the positive and negative effects for disparate economies that ensue from these encounters. The entertainment sector was the first to develop marketable virtual reality applications.[129] Almost without exception, the leading finance and economics journals have published reports on virtual reality technology; the general drift being that there is hardly an area where this polysensory medium cannot be utilized. R&D of virtual computer worlds has become a globe-spanning project, and a list of the institutes, companies, and organizations involved would fill an entire chapter of this book.[130] Therefore, I shall present a few examples of leading institutes where artists are involved in research, have developed new forms of interaction and interface designs for virtual spaces and telepresence models, and are working on the future of the Internet: a network that will allow access to immersive spaces of illusion.[131]

Art and Media Evolution I

In the mid-1980s, artists of interactive works, such as Jeffrey Shaw, Lynn Hershman, Grahame Weinbren, and Myron Krueger, worked for the most part alone. By comparison, virtual art developed at first in a few research institutions that were equipped with the necessary, very expensive technology. Thirty years after C. P. Snow introduced the idea of two cultures,[132] the distinct contours of the boundaries between technology and

art began to break down. Today, a global network of artists work in privileged research institutes on the development of virtual realities.

In the early 1990s, when lower-cost high-performance computers came on the market, it became possible to depict naturalistic three-dimensional bodies with up to 500,000 polygons. Silicon Graphics Workstations introduced the possibility of real-time operations, which also allowed interactive simulations.[133] Installations were created that not only put the observer more intensely *in the image* but, through elaborate interactions, involved the observers in the actual creation of the work itself. Artists working at well-equipped research institutes, such as Monika Fleischmann and Wolfgang Strauss, Christa Sommerer and Laurent Mignonneau, Charlotte Davies, Ulrike Gabriel, Agnes Hegedues, Knowbotic Research, Peter Weibel, Paul Garrin, Christian Möller, Edmond Couchot, Jean-Louis Boissier, and Toshio Iwai, achieved international recognition.

As early as 1991, the Banff Center for the Arts in Canada decided to let artists develop and open up virtual reality technology actively. The result was a program, scheduled for two years, for realizing sections of artistic projects. From 1991 to 1994, virtual installations, such as *The Placeholder* by Brenda Laurel und Rachel Strickland, *Inherent Rights* by Paul Yuxweluptun, and *Archeology of the Mother Tongue* by Toni Dove and Michael MacKenzie, were among the artworks created within this framework.[134]

One of the most important research institutions for virtual reality is Carnegie Mellon University's SIMLAB. Under the directorship of the late Carl Eugene Loeffler, virtual environments were developed that could be experienced simultaneously by several users, for example, via telepresence, "inhabited" by artificial agents, and controlled by A-Life programs. Loeffler enriched technology with artistic concepts as, for example, in the installation *Virtual Ancient Egypt*.[135] In collaboration with the Egyptologist Lynn Holden and the Center for Creative Inquiry team of Carnegie Mellon University, Loeffler created the simulation of an ancient temple, the installation *Virtual Ancient Egypt: Temple of Horus*. According to Holden, this was the first module of a large-scale project, *Virtual World of Antiquity*. Using the latest photographs of the excavations, they reconstructed the 60-foot-high walls and pillars of the Temple of Horus, including the many chambers. By clicking on certain points on the walls, the user could activate animations and in the innermost shrine a statue revealed the chamber's secrets to background music of Egyptian chants.

In 1967, Gyorgy Kepes, a friend of Laszlo Moholy-Nagy, founded the Center for Advanced Visual Studies (CAVS) at MIT, which aimed at high-level cooperation between art and technology. Having worked at the New Bauhaus, Kepes was firmly committed to interdisciplinarity. This is also reflected in his six-volume work *Vision and Value*, where he outlines an attempt to overcome the specialization of the modern age through integration and synthesis of art and technology. Kepes's intention was to develop a language of vision. To this end, he included findings from biology, experimental psychology, anthropology, communication theory, linguistics, engineering, and relational mathematics. However, the technology-centered Architecture Machine Group at MIT soon eclipsed the CAVS model, both in standing and securing research grants.[136]

Internationally, the University of Geneva's MIRALab, directed by Nadia Magnenat-Thalmann, holds a top position in the field of 3-D animation. This applies particularly to applications such as the simulation of naturalistic body movements in realtime, facial expressions, and the highly complicated animation of materials and objects.[137] Present research focuses on constructing virtual environments populated by avatars, which can be accessed from distant locations via high-performance networks.

In 1986, the Japanese telecommunications corporation NTT and the Japanese government in Kyoto founded together the Advanced Technology Research Institute (ATR) for the purpose of developing virtual reality technology for telecommunication.[138] In the institute's artist in residence program, Christa Sommerer and Laurent Mignonneau work on the design of new interfaces and innovative forms of interaction. Programmatically, the president of the ATR laboratory, Ryohei Nakatsu, stresses that the cooperation of art and technology is focused on developing highly complex methods of communication, including sensitive, nonverbal interaction. In his address at the opening of the ATR-Science-ATR Congress in May 1996 in Kyoto, Nakatsu stated that "It is indispensable to study the mechanism of interaction and to develop technologies that can realize highly human-like communication by integrating communication and interaction technologies as well as interactive arts."[139]

When they applied virtual reality technology to architecture and urban planning, the Berlin association ART+COM, founded in 1988, broke new ground.[140] In addition to interactive installations, such as *Zerseher* (1991) by Joachim Sauter and Dirk Lüsebrink,[141] the same year saw Monika

Fleischmann and Wolfgang Strauss' first virtual reality work, *The Home of the Brain*. In Germany, virtual reality research is concentrated mainly in the Fraunhofer Institutes in Stuttgart (FhG-IGD, IAO), the Zentrum für Graphische Datenverarbeitung (ZGDV)[142] in Darmstadt, German Aerospace in Oberpfaffenhofen (primarily telerobotics research), and the Fraunhofer Institut in Sankt Augustin near Bonn.[143] Fleischmann, who works closely with Strauss, became artistic director of the GMD's Institut für Medienkommunikation in 1992, where the main research focus is to develop interactive virtual scenarios and innovative interface design for human-machine communication.

Roy Ascott, one of the foremost pioneers of interactive art,[144] founded the Centre for Advanced Inquiry in the Interactive Arts (CAiiA) at the University of Wales in Newport, where he established an international joint research program, CAiiA-STAR, which allows media artists to gain a Ph.D. A significant number of internationally important media artists participate in this program, artists who normally work in high-tech institutes on the development of new interfaces, interactive models, and visual strategies and who are playing a decisive role in the design of the high-performance future of the Internet.[145] His position as director of this program, which attracts so many leaders of cutting-edge research in media art, confers on Ascott the role of *spiritus rector*, who gives the younger generation of visualization developers of the new millennium a wealth of new impulses, consolidated further in the series of meetings entitled Consciousness Reframed initiated in 1997 by Ascott.

In addition to the artist in residence programs of the research laboratories, there are the important festivals that have nurtured and promoted interactive art—events such as Ars Electronica,[146] Interactive Media Festival, Siggraph,[147] Imagina,[148] and the Biennales of Kwangju,[149] Lyon, Nagoya,[150] and St. Denis.[151] In Germany, media art has received suppport since the 1980s. With the foundation of the new Kunsthochschule für Medien (KHM)[152] in Cologne, the Hochschule für Graphik und Buchkunst in Leipzig, the Institut für Neue Medien[153] in Frankfurt, and particularly the Zentrum für Kunst und Medientechnologie (ZKM)[154] in Karlsruhe, Germany, along with Japan, is among the foremost pioneers of media art. Japan's institutions include the InterCommunication Center (ICC)[155] in Tokio and the International Academy of Media Arts and Sciences (IAMAS)[156] in Gifu.

Notes

1. See Wheatstone (1838).

2. See Witasek (1910), pp. 167ff.; Kemner (1989); Tokyo (1996b).

3. See Sagner-Düchting (1985), pp. 55ff.

4. Monet worked on this theme for many years, and in 1921, he had over 50 waterlily paintings in his atelier that could be combined in a variety of ways.

5. Dezarrois speaks of visitors being "plongés dans un aquarium lacustre," in "Les Nymphéas de Claude Monet à l'Orangerie des Tuileries," *Illustration*, March 21, 1927, p. 548, cited in Sagner-Düchting (1985), p. 61.

6. "Le panorama se déroule d'une façon interrompue, en cercle autour du spectateur." See M. Elder, *A Giverny chez Claude Monet*, Paris, 1924, p. 79, cited in Sagner-Düchting (1985), p. 60.

7. For the artistic policies of the Futurists, see Falkenhausen (1979).

8. See Prampolini (1924), p. 7: "Questa nuova *costruzione teatrale* per la sua ubiacazione permette di fare sconfinare e *l'angolo visuale* prospettico oltre la linea d'orizzonte, spostando questo al vertice e viceversa in simultanea compenetrazione, verso una irradiazione centrifuga di infiniti angoli visuali ed'emotivi dell'azione scenica."

9. Ibid.

10. See L. Moholy-Nagy, "Theater, Zirkus, Variete," in Wingler (1985), pp. 54ff.

11. Ibid., p. 55.

12. See Schwitters (1973–1981), vol. 5, pp. 39ff.

13. See Prampolini (1924), p. 7.

14. Ibid.

15. "Ritengo quindi che l'intervento dell'attore nel teatro quale elemento di interpretazione, sia uno dei compromessi più assurdi per l'arte del teatro." Printed in boldface in the original, ibid., p. 7. In his *Magnetic Theatre*, Paris 1925, Prampolini replaced the actors with light effects.

16. "Ogni *spettacolo* sarà un *rito meccanico* dell'eterna transcendenza della materia, una rivelazione magica di un mistero spirituale e scientifico." Ibid.

17. "Una sintesi panoramica dell'azione, intesa come un rito mistico del dinamismo spirituale. Un centro di astrazione spirituale per la nuova religione dell'avvenire." Ibid.

18. Arnheim (1933), pp. 129–133.

19. See Kaes (1979).

20. Benjamin (1974). Panofsky had already raised the issue of reproduction in 1930 in his essay, "Original und Faksimilereproduktion." He wrote a critique of Benjamin's ideas, first published in the Hamburg journal *Der Kreis*, long before the Nazi movement began to gain in strength. See Panofsky (1930).

21. Panofsky (1936). On this subject, see "Regine Prange, Stil und Medium," in Reudenbach et al. (1992), pp. 171–190.

22. Nevertheless, all his life as a researcher, Arnheim believed that the tendency of increasingly perfect film images, as a technical illusion that covered the view of our world, possessed a threatening character for the sphere of art. See Arnheim's preface to the revised 1974 German edition of his (1933).

23. See Arnheim (2000), pp. 167ff. This essay was, as Arnheim put it in our correspondence, "already written with a view to the new millennium, so I was thinking of the coming generation and of your generation." Letter written in Ann Arbor, dated August 5, 2000, private archive of the author.

24. Friedberg (1993), pp. 84ff.

25. See Bordini (1981), pp. 101ff.

26. For an impressive list of the panoramas shown at the World Exhibition Paris 1900, see Malkowsky (1900), pp. 28, 131–132, 238–240, 474–475.

27. An advertisement for EXPO 2000 reads: "The journey into the fascinating world of the media 'Planet m—media for people' begins with a ride in the largest elevator in the world. The 'Space Lift' will take you and 200 other visitors into the inside of the planet. In a Multivisions Show you will experience the development of the media speeded up, from cave paintings to the Internet." See ⟨http://www.expo2000.de / cgi-bin / db4web_c / ibis / sdocs / tn / docs / tn_index.mth?spr_id=2&filter_id=4&tn_id=301028⟩.

28. The description of the EXPO contains the following: "Canvases, above, below, right, left, in front, behind: films in 2 × 360 degrees. Six bridges allow access to the space. Bridges with symbolic character: 'bridges to the future'.... The film shows pictures from recent German history; however, mainly from the present and the future. The starting point is a neighborhood party in the courtyard of Berlin apartment building. Germany is be experienced 'at close quarters'.... The 720-degree film event 'Deutschland mittendrin' was designed by the Stuttgart Agency of Mila and Partner, in cooperation with KuK Filmproduktion, Munich." See ⟨www.deutscher-pavillon.de/cont2.html⟩.

29. See Roth et al. (2000), vol. 1, pp. 88ff., and Nouvel (2000).

30. Roth (2000).

31. Hayes (1989), p. 3.

32. Monaco (1980), p. 348.

33. See Brownlow (1997), p. 26; Toeplitz (1979), p. 18; Toulet (1995), p. 17. For a different viewpoint, see Loiperdinger (1996). Maxim Gorki, who had been to shows at the Cinématograph Lumière in Novgorod in the summer of 1896, wrote: "A railway train appears on the screen. Like an arrow, it streaks directly towards you. Watch out! It seems to be heading exactly for the darkness where you are sitting, to turn you into a shredded bag of skin, full of squashed flesh and splintered bone, to reduce the room to ash and rubble, and destroy the building." See I. M. Pacatus, "Brief notes, Nizegorodskij listok, Niznij-Novgorod," no. 182, July 4, 1896, cited in *KINtop*, 4 (1995): 13. Decades later, the effect on people who were confronted with the medium for the first time hardly differed. For example, in

1931, a dozen farmers were injured in the Romanian village of Goerovesti in the panic that broke out during the first film show.

34. "The beholder is apt to identify himself with a protagonist to whom he feels sympathy, and this means he puts himself at the point of observation of the protagonist as I have described." Gibson (1986), p. 295.

35. Zielinski (1999), p. 92.

36. At the Paris World Exhibition of 1900, the Lumière brothers revisited the panorama. They exhibited the photorama, where projected images replaced the painted pictures: a panoramic slide projection of a film strip, about 90cm long and 11cm high, in the form of a cylinder approximately 29cm in diameter. Twelve lenses combined with mirrors revolved around the slide and projected the picture piece by piece onto the screen at such speed that the impression of a complete circular image was created. See Zglinicki (1979), p. 106.

37. "A film is an emotional reality, and that is how the audience receives it— as a *second reality*. The fairly widely held view of cinema as a system of signs therefore seems to me profoundly and essentially mistaken." In Tarkovsky (1986), p. 176.

38. Ibid., p. 172.

39. Before the advent of the stereo film, slides were projected in three dimensions. With the laterna magica, these images spread all over the world from the seventeenth century onward. See Robinson (1993); for a more recent view, see Klaus Bartels, "Proto-Kinematographische Effekte der Laterna Magica," in Segeberg (1996), vol. 1, pp. 113–147.

40. See Hayes (1989), p. 5.

41. Ibid., p. 9.

42. Ibid., p. 11.

43. During Eisenstein's lifetime, only a short passage from this essay appeared in the Russian magazine *Iskusstvo kino* (Art of the cinema), 1948, no. 2: 5–7.

44. "To doubt that stereoscopic cinema has its tomorrow is as naïve as doubting whether there will be tomorrow at all." See Sergei Eisenstein, "Über den Raumfilm," in Eisenstein (1988), p. 196. (English translation Eisenstein 1949.)

45. Ibid., pp. 197ff.

46. Ibid., p. 199.

47. Ibid., p. 235.

48. Ibid. Already in 1940, Eisenstein had the idea of surrounding the audience in the cinema with loudspeakers. In the same period, Walt Disney realized this aesthetic effect for his film *Fantasia*.

49. Ibid., p. 207.

50. Ibid., p. 201.

51. Ibid., p. 210.

52. Eisenstein mentions historical attempts (Richard Wagner's multimedia conception of the *Gesamtkunstwerk*, is not included) to remove the barrier between spectator and theatrical action: *The Monodrama* (1910) by Jewreinov, for example, tried to convey the feelings expressed on the stage to the audience as absolutely as possible through an intermediate device, in this case, a moving chorus (pp. 240ff.). Its function as a link is reminiscent of the *faux terrain* of the panorama. Eisenstein emphasizes that this idea is found in many cultures: In Japanese Kabuki theater, for example, there is the *hana michi*, the flower path, which functions as a bridge between the audience and the actors. At decisive moments in the drama, action moves to the *hana michi*. Through bringing his face in close up to the audience, the actor can use this proximity to get through to them; ibid., p. 226.

53. Ibid., p. 208.

54. Shortly before, Eisenstein was awarded the Stalin Prize for the first part of *Ivan the Terrible*. However, in 1946, the Central Committee of the Communist party banned screenings of Part II on ideological and aesthetic grounds.

55. There are dozens of examples; see Hayes (1989).

56. See Heilig (1992).

57. Ibid., p. 283.

58. Ibid., pp. 284ff.

59. See also Comeau et al. (1961).

60. See Halbach (1994a), pp. 231ff.; (1994b), pp. 190ff.; and the detailed account in Lipton (1964).

61. See Fisher (1991), p. 103; Burdea (1994), pp. 5ff. Burdea's view, that the Sensorama marks the beginning of virtual reality's prehistory, is in my opinion too narrow.

62. Krueger (1991a), p. 66.

63. For a detailed history of olfactory cinema, see Anne Paech, "Das Aroma des Kinos: Filme mit der Nase gesehen: Vom Geruchsfilm und Düften und Lüften im Kino, 1999," at ⟨http://www.uni-konstanz.de/FuF/Philo/LitWiss/MedienWiss/Texte/duft.html⟩.

64. See Max (1982).

65. Gibson (1986), p. 184.

66. The IMAX cinema at the Technisches Museum in Munich counted over a million visitors in 1997, and in the same year, the IMAX cinema in New York was the most successful cinema worldwide. See Wolf (1998); and Donna Cox, "What can artists do for science: Cosmic voyage IMAX film," in Sommerer and Mignonneau (1998a), pp. 53–59.

67. On the early history of the computer, see Pierre Lévy, "Die Erfindung des Computers," in Serres (1994), pp. 905–944, and the excellent exhibition catalog Steyr (1993), used by many histories of the computer as a reference work. For general information on the computer's military origins, see Coy (1994).

68. Wiener (1961).

69. Turing (1950).

70. Licklider (1960, 1968).

71. See R. M. Fano, CBI Interview OH 165, interviewer Arthur L. Norberg, April 20, 1989, Cambridge, Mass

72. McLuhan (1964).

73. Ivan E. Sutherland, "Sketchpad: A Man–Machine Graphical Communication System," MIT Lincoln Lab, TR 296 (Jan. 1963); also available at ⟨http://www.realtime-info.be/encyc/techno/terms/81/83.html⟩.

74. Sutherland (1965), p. 508.

75. Ibid.

76. Ibid.

77. Michael Noll, who had worked at Bell Telephone Laboratories since 1961, published in the same year his proposals for 3-D computer films: Noll (1965a), p. 20, and Noll (1965b). Noll had already recognized the possibility of calculating the spatial coordinates for films with 20 images per second without time lag. See also M. Noll, "Computers and the visual arts," in Krampen et al. (1967), pp. 65–79.

78. Head-mounted electromagnetic sensors had already been used by the Philico company in a telepresence system in 1961: See Comeau et al. (1961).

79. Shocked by the success of the USSR's *Sputnik*, ARPA was given the power and means to take fast action in support of projects that would regain the technological lead for the United States in the arms race between the Superpowers. See also Woolley (1992), p. 53.

80. Charles Seitz had just developed the ultrasound sensor at MIT's Lincoln Lab.

81. Sutherland (1968), p. 757.

82. Additionally, there were Wolf Vostell's *Electronic Happening Room* (1968) and Aldo Tambellini and Otto Piene's *Black Gate Cologne* (1968); see also Henri (1974b). In her study of Jeffrey Shaw's work, Söke Dinkla sees his early inflatable

Corpocinema (1967) as belonging to this movement. The *Corpocinema* was a walk-in polyvinyl environment with slides, film, and light projected onto its skin; see Dinkla (1997), pp. 98ff. and Anne Marie Duguet, "Jeffrey Shaw: From Expanded Cinema to Virtual Reality," in ZKM and Klotz (1997), pp. 21–33.

83. See Youngblood (1970), p. 361.

84. Ibid., p. 371.

85. Ibid., pp. 187ff.

86. Ibid., p. 52.

87. Ibid., p. 189.

88. In 1964, the young student of architecture, Nicholas Negroponte, had the idea of developing a machine that would optimize architects' planning operations and thus would need to be in close interaction with the user. In 1967 he founded the Architecture Machine Group at MIT, from which the MediaLab developed later. Their early research made important contributions to the development of CAD technology and other areas in the development of sensory interfaces.

89. See Negroponte (1972).

90. See Negroponte and Bolt (1976).

91. Bolt (1984). Yeates argues that the basis of all memory is the imagination's organization of space, i.e., spatially organized memory, such as in a temple or a theater. Moreover, memory spaces assume the presence of the rememberer or thinker *in* the memory. On the early link-up of the computer with psychology, see Hersh and Rubinstein (1984).

92. Reichardt (1969).

93. See Dinkla (1997), pp. 76ff.; Myron Krueger, "Responsive Environments," in Korfhage and Isaacson (1977), pp. 375–385; and Krueger (1983).

94. See D. C. Smith et al., "The star user interface: An overview," pp. 1–14 in *Designing the Star User Interface*, at ⟨http://jupiter.information.umn.se/nijsow/

ucipd/smith.html⟩. See also ⟨http://www.cs.cmu.edu/~amulet/papers/uihistory.tr.html⟩.

95. Under Furness's direction, the technology was developed at the Wright-Patterson airbase. The result was the first VCASS system (Visually Coupled Airborne Systems Simulator) in 1982. See also T. Furness, "The Supercockpit and Its Human Factors, Challenges," in Perlman et al. (1995), pp. 38–42.

96. The Atari Lab, whose philosophy was to develop technological visions for the next two decades, assembled at this time researchers such as Brenda Laurel, Michael Naimark, and Erich Gullichsen, some of whom, e.g., Laurel and Naimark, later made themselves a name as artists.

97. See T. Zimmerman et al., "A Hand Gesture Interface Device," in Carroll (1987), pp. 189–192.

98. Brenda Laurel was quick to see the computer's potential for staging virtual experiences in artificial spaces in real time. See Laurel (1991). Laurel's book is already a classic that summarizes contemporary ideas on the interface and interaction.

99. The data glove is basically the further development of the mouse. The input medium could be, for example, a video camera.

100. Their predecessors, today in general use, are the graphic user interfaces (mouse, windows, and menus), which were developed by Doug Engelbart among others in the early 1970s at the Palo Alto Research Center (PARC) and the Stanford Research Center, supported by ARPA grants. Another forerunner of the data glove is the pointer that Daniel Vichers developed for the HMD.

101. On the work of this institution, see Ellis (1991).

102. Fisher and McGreavy et al. (1986).

103. Marvin Minsky envisioned a telepresence system in his (1980).

104. See (1992), pp. 109ff. Potential applications are research and work in dangerous or inaccessible places, such as in space, on the seafloor, the battlefield, and so on.

105. See Gibson (1990 [1984]).

106. Gibson said in an interview, "it never occurred to me that it would be possible for anyone to read these books and ignore the levels of irony." Cited in Guilliatt (1989).

107. In the vicinity of Los Angeles, Autodesk was founded in 1982; VPL Research in 1984, in 1990, Sense8 and the VR game manufacturer W-Industries in England.

108. See Walser (1988); Walker (1988), pp. 9ff.; Bricken (1989).

109. See Lanier (1989).

110. See Gullichsen et al. (1989).

111. According to a report in *Business Week*, October 5, 1992, VPL and Sense8 together employed a mere 33 staff members, a figure that demonstrates the miniscule proportions of these firms compared with the armaments and space industry.

112. Analyzing this new medium, the media theorist Gene Youngblood remarked with millenarian rhetoric: "The 'wonder' before which we stand is not the urban space but the dematerialzed space of electronic sociality in which we shall move at the speed of light. Any praxis that does not set itself the task of investigating this space does not deserve the predicate 'avant-garde.'" In Youngblood (1989), p. 83. Youngblood continues with Futurist jargon: "Entering virtual space is clearly future-oriented and dedicated to the praise of future generations. The new avant-garde is striving to bring about a new Renaissance—a new civilization," ibid., p. 84. In a similar vein, Morgan Russel prophesied a new image of the human being: "Once we human, all too human, beings begin spending much time in VR, we will become new creatures. As we mould ourselves in a way which may not even be discerned until we have already become something manifestly different from what we are now." Russel, "VR everywhere," in Linz (1990) (exhib. catalog), vol. 2, p. 217. Jaron Lanier of VPL expected technological innovation to end racial discrimination: Virtual reality for him means the absolute abolishment of class and racial differences as well as all other forms of pretext for all forms are changeable. See Lanier, "Was heißt 'Virtuelle Realität,'" in Waffender (1991), p. 83. See also Walser (1990, 1991). And the "drugs guru"

of the 1970s, Timothy Leary, managed to hit the headlines once again with similarly drastic ideas: "In the cyberworld, you'll be having competitions, love affairs.... Everybody will more and more be communicating with the global language of icons. Literacy will be as quaint as baby talk." See "Timothy Leary in an interview with *UPSIDE*," David Sheff, in Linz (1990) (exhib. catalog), vol. 2, p. 250. These ideas also surface in movies, such as *The Lawnmower Man* by Brett Leonard (1992); *Strange Days* (1995); *The Net* (1995); *Virtuosity* (1995); *Johnny Mnemonic* (1995); and *The Matrix* (1998), all published on the Net. This list is not exhaustive; dozens more could be added.

113. For example, the report in the *Wall Street Journal*, Jan. 23, 1990, pp. 1 and A9.

114. Myron Krueger's term "artificial reality" was less successful; see Krueger (1991).

115. Still of interest in this connection is Doren (1927).

116. An invocation of the age-old myth of creating artificial life; see Bredekamp (1992a).

117. See Alvin Toeffler et al., "Cyberspace and the last American Dream: A Magna Carta for the Knowledge Age," ⟨www.townhall.com/pff/position.html⟩, p. 7, and Toffler and Toffler (1995).

118. Bundesministerium für Wirtschaft, *Info 2000: Deutschlands Weg in die Informationsgesellschaft*, Bonn, February 1996, chap. I.1.

119. Coy (1994), p. 37.

120. See Borchers (1998).

121. See *Aviation Week and Space Technology*, August 15, 1988, pp. 94–96, and Thompson (1987).

122. See *Manager Magazin*, October 1991.

123. Thompson (1993), pp. 142ff.

124. See Macedonia (1994).

125. Gigante (1993a), pp. 8ff.

126. Molecular structures and their specific features, for example, can be simulated as an aid in speeding up research in chemistry and physics.

127. Cf. the activities of Microsoft: ⟨http://research.microsoft.com/vwg/⟩; for an overview, see ⟨http://www.acm.org/sigchi/hci-sites/COMPANIES.html⟩.

128. Mirapaul (1998b).

129. Brill (1993); Johnson (1995), pp. 22ff. The goal of a "totally immersive, visual and audio experience" is being pursued in Japan particularly by Sony, Blockbuster, and Sega (see Johnson 1995, p. 22).

130. See *The National Research Agenda for Virtual Reality*, supported by ARPA, the Air Force Office for Scientific Research, Army Research Laboratory, NASA Armstrong Laboratory, NSF, NSA, among many others. See also Durlach and Mavor (1994); IEEE (2001).

131. See Negroponte (1995). This is also the vision of Bill Gates, who is, financially, the most powerful human today; see Gates (1995), pp. 194ff.

132. Snow (1960).

133. Silicon Graphics product literature, Silicon Graphics Inc., Mountain View Calif., 1991; and ⟨http://www.sgi.com/virtual_reality⟩.

134. Moser et al. (1996), pp. 267–328.

135. Loeffler, "The networked virtual museum," in Loeffler (1994), pp. 31–37; and Loeffler, "Virtual Pompeii," in Breit (1996).

136. Today, MIT has the Media Arts and Sciences Program.

137. See ⟨http://miralabwww.unige.ch/⟩; Magnenat-Thalmann (1992), Thalmann (1994); and P. Volino, M. Courchesne, and N. Magnenat-Thalmann, "Versatile and efficient techniques for simulating cloth and other deformable objects," in Cook (1995), pp. 137–144.

138. See ⟨http://wwwatr.co.jp⟩. The shareholders, who raise an annual budget of 50 million U.S. dollars, are mainly from the telecommunications industry: NTT, NEC, Hitachi, Toshiba, etc.

139. See Sommerer and Mignonneau (1998a), p. 15.

140. ⟨http://www.artcom.de/⟩.

141. This installation, recipient of several awards, gives the user's gaze an iconoclastic dimension: When the user gazes at a particular point, the initially sharp contours begin to blur and gradually disappear. Technically, this is achieved by a camera within the image that tracks the user's gaze; the computer responds in real time and eliminates the particular sections the user is looking at. See ⟨http://www.artcom.de/projects/zerscher/welcome.cn⟩.

142. See ⟨http://www.igd.fhg.de/⟩. For more about the work of this institution, see the Kongress VR '94 and Jörg Vogel, "Haptic Interfaces and Force Feedback in MIS-simulators," at ⟨http://www.robotic.dlr.de/Joerg.Vogel/Medicine/hi.html⟩.

143. ⟨http://www.gmd.de⟩.

144. Roy Ascott has shown at the Venice Biennale, Electra Paris, Ars Electronica Linz, V2 The Netherlands, Milan Triennale, Biennale do Mercosul, Brazil, European Media Festival, and gr2000az at Graz, Austria. He has been Dean of San Francisco Art Institute, California: Professor for Communications Theory at the University of Applied Arts, Vienna: and Principal of Ontario College of Art, Toronto. He is on the editorial boards of *Leonardo, Convergence*, and the Chinese language online arts journal *Tom.Com*.

145. CAiiA-STAR is a multidisciplinary institute that encompasses the following areas: performance, immersive VR, music, transgenics, A-Life, technoetics, telematics, telerobotics, mixed reality, architecture, and other emergent art forms, behaviors, and genres. Artists of international repute who are Ph.D. graduates include Dew Harrison, Joseph Nechvatal, Jill Scott, Bill Seaman, Miroslaw Rogala, and Victoria Vesna; others, who are Ph.D. candidates, are equally well known: Peter Anders, Jon Bedworth, Donna Cox, Charlotte Davies, Elisa Giaccardi, Gromala, Gilian Hunt, Pamela Jennings, Eduardo Kac, Kepa Landa, Jim Laukes, Dan Livingston, Kieran Lyons, Simone Michelin, Laurent Mignonneau, James

Norwood, Marcos Novak, Niranjan Rajah, Gretchen Schiller, Thecla Schiphorst, and Christa Sommerer.

146. ⟨http://www.aec.at⟩.

147. ⟨http://www.siggraph.org/s98/⟩.

148. ⟨http://www.ina.fr/INA/Imagina/imagina.en.htm⟩.

149. ⟨http://www.daum.co.kr/gallery/kwang/han/index.html⟩.

150. ⟨http://www.tocai-ic.or.jp/InfoServ/Artec/arte⟩.

151. ⟨http://www.labart.univ-paris8.fr/index2.html⟩.

152. ⟨http://www.khm.de⟩.

153. ⟨http://www.inm.de⟩.

154. ⟨http://www.zkm.de⟩. For an overview, see ZKM (1997).

155. ⟨http://www.ntticc.or.jp/⟩.

156. ⟨http://www.iamas.ac.jp/⟩.

Virtual Art—Digital! The Natural Interface

Charlotte Davies: *Osmose*

Many virtual environments reduce the observer to a disembodied state within a Cartesian space that is clear for miles around and often quite empty. Although Charlotte Davies's virtual environment *Osmose* (1995) has been exhibited only six times in North America and Europe,[1] it has received more attention in the international discussion of media art than perhaps any other contemporary work.[2] Only a few thousand visitors have actually experienced the installation, but many times that number of art aficionados have avidly followed the debate on aesthetics, phenomenology, and reception of virtual art that has homed in on this particular work. Moreover, *Osmose* cultivates the user-interface—a central parameter of virtual art—at a level that is still unequaled; an independent treatise could be written on this aspect alone. *Osmose* is a technically advanced and visually impressive simulation of a series of widely branching natural and textual spaces: a mineral/vegetable, intangible sphere. Nothing recalls the grainy, jittery, polygonal images of virtual art's early years; in the data space of the Canadian Charlotte Davies, phosphorescing points of light glimmer in the dark in soft focus. *Osmose* is an immersive interactive environment, involving head mounted display (HMD), 3-D computer graphics, and interactive sound, which can be explored synaesthetically.[3] On a second level, the installation offers visitors the opportunity to follow the individual interactor's journey of images through this simulacrum of nature. With the aid of polarized glasses, they watch his or her constantly changing perspectives of the three-dimensional image worlds on a large-scale projection screen. The images are generated exclusively by the interactor, whose moving silhouette can be discerned dimly on a pane of frosted glass. The solitude of the interactor is intentional, for it intensifies the individual experience of the virtual space. The structure of the installation, a combination of a stand-alone system and a darkened auditorium with a screen, is reminiscent of a studio theater or cinema (fig. 5.1).

Like a diver, solitary and weightless, the interactor first glides out of a grid of Cartesian coordinates into the virtual scenarios (fig. 5.2): a boundless oceanic abyss, shimmering swathes of opaque clouds, passing softly glowing dewdrops and translucent swarms of computer-generated insects, into the dense undergrowth of a dark forest. Passage from one scenario to the next is smooth, fluid. Whereas early virtual environments utilized portals that rendered transitions abrupt, in the image world of *Osmose*

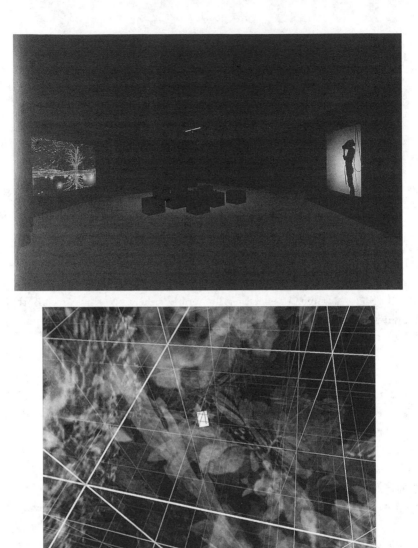

Figure 5.1 Charlotte Davies, *Osmose*, 1995. Setting, Virtual Reality Environment, Montreal. By kind permission of the artist.

Figure 5.2 Charlotte Davies, *Osmose*. Detail: forest and grid. By kind permission of the artist.

Figure 5.3 Charlotte Davies, *Osmose*. Detail: rocks and roots. By kind permission of the artist.

the observer experiences osmotic transitions from one sphere to the next, seeing one slowly fade before it amalgamates into the next. Naturally, this means that the two image spaces have to be generated simultaneously. The HMD stereo monitors immediately in front of the eyes allow the interactor to pass into subterranean earth, encountering there vivid rocks and roots (fig. 5.3), and, finally, to enter the microcosmos of a tree's glistening, opalescent leaf.[4]

At the center of this data space stands a leafless tree in a clearing, representative and isolated. Its trunk and branches gleam like crystal, entirely transparent and permeable to its very center. *Osmose* is both a solid mineral and a fluid intangible sphere, a non-Cartesian space. A symbol of life, fertility, and regeneration in almost every culture, the tree's iconography can be traced through all cultures and epochs. Now it grows here: the tree of virtual worlds. Looking down from the top of the digital tree, in which the biological process of osmosis is mysticized, aureoled, and merged with

the technical images, the tangled network of roots appears to resemble a distant galaxy, yet as the observer approaches, it evokes a microcosmos. Two textual worlds serve as parentheses around this simulacrum of nature: The 20,000 lines of program code for the work are visible in the virtual environment, arranged in colossal columns; and a space filled with fragments of text—concepts of nature, technology, and bodies, all penned by thinkers, such as Bachelard, Heidegger, and Rilke, whose ideas were untouched by recent revolutionary developments concerning the image. The fact that the computer program is visible does not detract substantially from the immersive experience; it reveals in part the binary foundations of the image spaces and, in this way, makes the observer aware of the origins of the illusion. The ensemble of virtual spaces in *Osmose* is structured as follows:

Movements produced by breathing

	Code			
	Text			
	Cloud			
Forest	Clearing	Pond	Leaf	
	Subterranean earth	Ocean depths	Tree	Forest
	Code	Microorganisms		
	Text			

Movements produced by inclining body/HMD

The illusion emerges from the high-capacity memories of three Onyx2 Infinite Reality Silicon Graphics workstations. Formerly, these supercomputers were used for military simulations and film sequences, and in 1995, they still cost more than a million U.S. dollars.[5] Most of the enormous program was written by John Harrison (VR software), who had already created the custom software for Brenda Laurel's virtual reality environment *Placeholder* at the Banff Center, and the computer graphics are by George Mauro. The program enables registration of the motion-capture

devices, the real-time computation of the images,[6] and control of the sonic architecture, designed and programmed by Dorota Blaszczak. The sound was composed and programmed by Rick Bidlack. Although a vast amount of complex equipment was utilized, the project remained a manageable process. It is not unusual for ten programmers to work simultaneously on a virtual environment, but *Osmose* was created in a mere six months by three people who produced the concept, design, and program. As with most virtual artworks, for example, *The Home of the Brain*, the majority of drafts were rejected: "We first tried many tests to try and get soft and luminous effects. Along with this were experiments in various sorts of navigation using breath and balance, which culminated in the system we now use. For each new idea that we used in *Osmose*, perhaps 10 to 20 ideas were thrown away."[7]

Char Davies began her career as a painter and filmmaker. From 1973 to 1978 she studied liberal arts in the United States and Canada and, from 1987, she concentrated exclusively on the visual potential of the computer. She joined the startup company Softimage in Montreal, which, at the time, had a workforce of three, and has been one of the driving forces in the creative development of complex computer graphics software ever since. In this period, her artistic works were mainly in the area of computer graphics for which she received several awards from major festivals.[8] By 1994, Softimage employed over 200 people and Char Davies was its vice president. When the company's programs brought the dinosaurs in Jurassic Park to screen life, an amazed world took note of these pioneers and the software giant Microsoft bought Softimage for 130 million U.S. dollars. It was a strategic acquisition, strictly in line with Bill Gates's vision of the infrastructure of the future: a vastly speeded-up Internet combined with virtual image spaces. Under Microsoft, Davies held the privileged position of artistic director. In 1998 she became independent again and founded her own firm, Immersence. She is also a Ph.D. fellow with Roy Ascott—in company with many other prominent computer artists—at the Centre for Advanced Inquiry in the Interactive Arts (CAiiA) at the University of Wales College, Newport. With her close relationship to the development of advanced graphics techniques, Char Davies is one of the driving forces of creative development of complex computer graphics programs.

The Suggestive Potential of the Interface

Char Davies's objective, to develop a natural interface, is a groundbreaking one. The user-interface is the point of contact where humans and machines meet in order for exchange to take place. It can take many forms. It is at the interface, which must be used by the active observer according to the rules of the particular illusion world, that the structures of the simulation designed for communication meet up with the human senses. Thus, the interface in virtual reality functions pervasively as the key to the digital artwork and molds both the perception and the dimensions of interaction. The observer, whom Davies refers to as "the immersant," controls navigation through this virtual reality installation by means of a vest filled with sensors. This is donned before the journey can begin, and it tracks each breath and each movement of the torso and relays this information to the software. Then the corresponding virtual image effects, which create the impression of moving through the image space, follow in real time. Although the heavy HMD actually only supplies the visual field with images, it creates the suggestive impression of full-body immersion in the virtual environment. The feeling of being *in* the images, produced by the spatially enveloping visual impression, is thus amplified. Like a scuba diver, the observer floats upward with lungs filled with air, whereas regular breathing produces a calm and balanced state. Divers are well acquainted with the feeling of immersion, the physical experience of being completely enveloped and slowly floating through the watery element. Not surprisingly, it was being underwater that gave Char Davies (who is a passionate diver) the inspiration for this finely gauged, physically intimate synthesis of the technical and the organic. Because the interface technique of *Osmose* utilizes intuitive physical processes, the observer's unconscious connects to the virtual space in a much more intense way than with a joystick or a mouse.

In virtual reality, the interface is key to the media artwork and defines the character of interaction and perception. The effect is a profound feeling of embodied presence, which, in the course of the "immersion," results in an emotional state of being that is heightened still further by the music. Each zone has its own localized sound; in fact, sound in general plays a decisive role in generating the feeling of presence.[9] It accentuates the visual impressions, where expansive space alternates with microcosmic proximity, increasing the density of the natural phenomena. The sonic ar-

chitecture is expressly designed for each image world space: The observer associates frogs croaking and birdsong and hears repeated bass tones that evoke meditative effects. Although many people who have experienced the fifteen-minute immersion in *Osmose* are convinced that they heard musical instruments and the sounds of insects, the sound is based on the sampling of a male and a female voice. Reponses from many of the several thousand "immersants" mentioned "contemplative, meditative peace," "fascinating, awe-inspiring depth," and feeling "gently cradled." These impressions are confirmed almost without exception if one looks at the relevant discussion groups on the Internet or the comments in the visitors' books at the exhibitions where *Osmose* was on view.[10] The book of visitors' comments from the Barbican Art Gallery in London contained the following: "I had a vertigo when looking down ..."; "After the initial panic, it was amazing and relaxing ..."; and "What a relief to get a go! That was truly the most mind-expanding piece of art I've ever been a part of ..." A number of participants even claimed they had been put in a trancelike state. Although the choice of words is reminiscent of esoteric rhetoric, it does reflect a cardinal effect of virtual reality: The suggestive presence *in* a totality of images gives rise to a mental—in *Osmose*, meditative—absorption. The psychological power of this new art of illusion becomes apparent in this work as in no other of the genre.

This physically intimate design of the human–machine interface gives rise to such immersive experiences that the artist speaks of reaffirming the participants' corporeality; Davies even expresses the hope that a spatio-temporal context is created "in which to explore the self's subjective experience of 'being-in-the-world'—as embodied consciousness in an enveloping space where boundaries between inner/outer, and mind/body dissolve."[11] She relates this to "archetypal aspects of nature and to interior psychological space simultaneously."[12] Prerequisite to the attainment of this goal is immersion experienced in solitude, a subjective experience *in* the image world. In this space, the images of other immersants' journeys, avatars, or "subjective" agents would only distract the participant from the suggestive/absorbed state.

Osmose offers a totally new reality, a cascade of alternative realities that, through physical and mental presence in the image world, effect a fusion and a moment of transcendence—this applies to nearly all historical spaces of immersion. Although *Osmose* creates contemplative impressions, even

meditative effects, this type of art reception does represent a significant innovation. The body is addressed polysensually and immersion is produced with the techniques of illusion. This full-body inclusion demands—irrespective of the gender of the immersant—that the observer relinquish distant and reserved experience of art and, instead, embrace eccentric, mind-expanding—or mind-assailing—experience of images. Thus, the character of immersive art is revealed as located within a bipolar field of tension. Like the Villa dei Misteri or the battle panoramas, the maximized, suggestive potential of the images aims at ecstatic affects, and this also includes regressive effects. In a number of theoretical texts, Davies has outlined her artistic intentions and view of immersive virtual space: "I think of immersive virtual space as a spatio-temporal arena, wherein mental models or abstract constructs of the world can be given virtual embodiment in three dimensions and then kinesthetically, synaesthetically explored through full-body immersion and interaction. No other space allows this, no other medium of human expression."[13]

The more intensely a participant is involved, interactively and emotionally, in a virtual reality, the less the computer-generated world appears as a construction: Rather, it is construed as personal experience. Before *Osmose*, this realization was applicable to simulated air battles, but since the advent of this work, it has become clear that slow and gentle navigation of image spaces can also produce a high degree of potential power of visual suggestion. The manner in which Osmose realizes "virtual reality" is the work's strength; at the same time it nourishes reservations and presentiments concerning possible future manipulation of observers' emotionality via images. Although it is a technical illusion, visually *Osmose* suggests a biosphere that functions in such a way that, for example, persons who would normally avoid being underwater have phobic reactions: "I, however, experienced several of the worlds in the piece as an occasion for panic. Like many asthmatics, being underwater makes me deeply and instantly afraid. Evidently, even when the water is symbolic, I experience it viscerally as water and as everything smothering that water means to me...."[14] Apparently, the new medium of virtual reality reactivates a mechanism of suggestion that historically has been present in all new media of illusion, whether the panorama or the film. Yet it is not the aim of the artist to create a substitute for nature. Her representations of the

organic do not conjure up the chimera of digital realism, nor are they abstract. Rather, it is the old artistic trick of *sfumato*, which deceives the eye and facilitates multifaceted associations.

Summarizing the discussion centered on *Osmose*, two basic, polarized trends can be identified. First, the work promotes a new stage in an intimate, mind-expanding synthesis with technology[15]—this is a comforting argument, an old variant of uncritical faith in machines. Second, *Osmose* confirms the opinion of those who see in the ideology of the *natural interface* a new level in the history of ideas and images of illusionism,[16] or who dismiss *Osmose* as virtual kitsch.[17] The adherents of virtual reality, who have often reiterated their claim that immersion in virtual reality intensifies their relationship with nature,[18] might ponder the following question: Why the immense technological effort in order to return, after a gigantic detour, to the real? Does not the quest for nature using technical means resemble the plane curve of a hyperbola pretending to be an ellipse?

It will soon be possible to access image spaces that depend on huge amounts of data, like *Osmose*, via the Internet through ongoing speed-up and new techniques of file compression. Just as in 1800 the Academie Française envisaged that the panorama would lead to the development of easily accessible and cheap technology, Davies also hopes that progress in media technology will bring her image worlds to a far wider group of users.[19]

All elements combine to endow *Osmose* with a flowing and coherent quality that envelops the participant totally. As mentioned above, the totality of the effect is strengthened further because it dispenses with the use of portals and clearly defined boundaries between the image worlds in favor of osmotic transitions. For example, the immersant appears to move through a luminous digital tree. For Martin Buber, contemplating a tree was an occasion to reflect on conscious experience: "It may so happen, by grace and will combined, that I, in contemplating the tree, become enclosed within the relationship to it and then it is no longer an It. The power of wholeness has captured me."[20] All is unified, indistinguishably: "Image and movement, genus and example, law and number."[21] An aesthetic impression of immersion is a primary characteristic of virtual reality. However, being enveloped in a cocoon of images imposes profound limitations on the ability for critical detachment, a decisive hallmark of

modern thought that has always played a central role in experience of and reflections on art.

Aesthetic Distance

When actually immersed in a high-resolution, 360° illusion space, it is only with great difficulty that an observer can maintain any distance from the work or objectify it. It is well-nigh impossible to perceive it as an autonomous aesthetic object. If media competence results from the faculty or learned ability to objectify a given medium, then this mechanism is diminished in virtual installations. The designers use all means at their disposal to banish this from the consciousness of the recipients. At best, the medium of virtual reality can be objectified through knowledge and critique of the image production methods and an understanding of their technical, physiological, and psychological mechanisms, for *everything* is an image.

As the interfaces seem to dissolve and achieve more natural and intuitive designs so that the illusionary symbiosis of observer and work progresses, the more psychological detachment, the distance from the work vanishes. Without it, a work cannot be perceived as an autonomous aesthetic object. Inside the "omnipresence" of virtuality, any mechanism of knowledge acquisition will be affected and influenced. In virtual environments, a fragile, core element of art comes under threat: the observer's act of distancing that is a prerequisite for any critical reflection. Aesthetic distance always comprises the possibility of attaining an overall view, of understanding organization, structure, and function, and achieving a critical appraisal. This includes searching for hypotheses, identifications, recollections, and associations. Notwithstanding the longing for "transcending boundaries" and "abandoning the self," the human subject is constituted in the act of distancing; this is an integral part of the civilizational process. As Adorno expressed it: "distance is the primary condition for getting close to the content of a work. It is implicit in the Kantian notion of disinterestedness, which demands of the aesthetic stance that it should not seek to grasp the object.... Distance is a phenomenon of works of art that transcends their mere existence; their absolute proximity would mean their absolute integration."[22] Michel Serres points out that it is only in the fixed artwork whose elements the onlooker "sets into motion" does

the spatial configuration become a vivid sensory event.[23] And in Arnold Gehlen's view, "direct emotionality of experience is held to be alien to art, and rightly so,"[24] and both Hans Jonas[25] and Hartmut Boehme advance arguments against an aesthetics where distance is absent. Both thinkers stress the subject-constitutive, epistemological quality of distance, which Boehme expresses thus: "All happiness is immersion in flesh and cancels the history of the subject. All consciousness is emancipation from the flesh to which nature subjects us."[26]

The more "natural" the interfaces become, the greater the danger—not only that most of the "technological iceberg" will be inaccessible to the user who is unaware of it—that there will be an illusionary disappearance of boundaries to the data space. Increasingly powerful computers increase the suggestive potential of virtuality, which, particularly through the ideology of a "natural interface," is beginning to unfold its full psychological and manipulative influence. Against the backdrop of virtual reality's illusionism, which targets all the senses for illusion, the dissolution of the interface is a political issue.

In addition to things based on the familiar, computer-generated virtual reality allows the creation of aesthetics that are no longer bound to physical laws and which will become, with faster computers, more real, gripping, and involving. The potential option of perception will be weightlessness, that is, floating through image worlds, touching and transforming computer-generated matter, changes of surfaces and textures, spaces of gigantic and awesome proportions, experienceable individually or collectively, vertiginous heights and depths, speeds that produce euphoria or paralysis. It is within the realm of probability that the "shock," which Walter Benjamin diagnosed as being film's aesthetic innovation, will undergo renewal and intensification—with far more sophisticated means. The most obvious symptom of this loss of distance will be a voyeuristic, dissecting penetration of representations of objects and bodies.[27] In conjunction with the attempt to generate the feeling of real presence, these impressions, which run counter to habitual perception according to nature's laws, may result in problems of perception that should not be underestimated. The serious contradiction between corporeal reality and artificial image illusion is likely to be at a level that almost precludes rational access. Confirmation of this is provided by first results of research

conducted on "simulator sickness": impairment of motor control, vision, and gastric functions; apathy, disorientation, migraine, indisposition, and vomiting have all been diagnosed as physical effects.[28]

Osmose is an art work whose status is gradually emerging. Notwithstanding the rather polemic references to kitsch and esotericism, *Osmose* does represent a signpost in the history of the media, like the films of the Lumière brothers or the early panoramas, not least because of its aesthetic utilization of new technologies of immersion and illusion.

At first glance, Davies most recent work, *Ephémère* (1998), appears to be its twin: a virtual space that generates reactive image worlds in real time. Like Osmose, *Ephémère* has also stirred up scientific and academic discussion.[29] Yet whereas Osmose was deeply embedded in a spiritual conception of nature, the image worlds of *Ephémère* include organs of the body, bones, and the circulatory system. In place of *Osmose*'s many natural worlds, *Ephémère* has a clear three-part division: landscape, earth, and inside the body. Significantly, this installation introduces the dimension of time to Char Davies's virtual art: the three zones undergo successive changes from daylight to night, from pale winter to the bright colors of spring and the deeper shades of summer, which are perceived in the rocks, grasses, and images of the body. The only constant element is a stream: It changes, according to zone, into a river, an underground stream, or blood coursing through the network of arteries. When asked, Char Davies says that *Ephémère* is inspired by an actual place in her native Quebec and, in a certain way, symbolizes a lament, an elegy, a remembrance space for the passing of nature as we have known it.

The Concept of "The Work" in Processual or Virtual Art

The concept of a "work of art" has always been subject to historical change. One form would be privileged and achieve the status of paradigm for a time before being replaced by another. Any object declared a work of art and thus, by inference, deemed worthy of being remembered, is subject to the constructions of social groupings, as Maurice Halbwachs[30] has demonstrated. An artwork symbolizes and focuses a particular artistic view of the world. Aside from all genre-specific differences, it fixes concept, ideology and hypothesis, aesthetic preferences and norms, and, consciously or unconsciously, follows social constellations. Hegel's ideal work of art

was a complete, closed unit, an autonomous original, representing the form of truth as it appears to the senses, a "soul-filled unit of the organic," a world in itself, a microcosm, an analogy of the whole world. As Wolfgang Thierse has shown, the social and ideological expression of this notion culminated in the protection of artifacts by copyright, which was introduced in the eighteenth century.[31] Much later, Dewey continued to uphold the idea that the work detaches itself from the human conditions that gave rise to it,[32] and he reaffirmed the linking of work and its author, who inscribes him- or herself in the work as guarantor of its individual shape or gestalt.

The crisis into which this concept of "the work" has now plunged is a sign of developments in art over the last hundred years. The most radical attack was launched by the avant-garde, who rejected the notions of originality, identity, authority, and purposelessness or l'art pour l'art, in an attempt to overcome the dichotomy between art and life and change experience of life through aesthetic means. Action art, performance, and happenings of the 1950s and 1960s mark the point where, at the very latest, the concept of a work of art as a discrete entity starts to break down. Ephemeral interactions with the audience attempted to allow contradictions, layers of meaning, and chance elements to enter into the work. Great expectations were initially placed in this pluralism, the "virtuality of possible orders," as evidenced by Umberto Eco's essay "Opera Aperta." In "Opera Aperta," the work of art is no longer a sort of encoded or enciphered message, viewed from the inside of production, to be deciphered by the observer using a repertoire of keys. Instead, it is an arrangement of possibilities; according to Eco, an ensemble of forms of organization, where many are entrusted with the initiative of the interpreter.[33] According to this view, an image is the sum of possible narratives, histories, or interpretations that it allows. It is not predetermined, as was the classical artwork, for the substance of the interpreter is bound inseparably to arrangement of material. In Eco's words: "The task of an open artwork is to give us a picture of discontinuity; it doesn't tell of it, it is it." For Allan Kaprow, who gave the word "happening" its new meaning in the late 1950s, art is an ever-changing "work in progress," a narrative created by audience participation. Happenings were nonlinear events and encouraged the trend toward dissolving the fixed spatial and temporal limits of a

work, dislocating the central position of the author, and enhancing the work through harnessing the imagination of the participating spectators.

The development of cybernetic control processes since the mid–twentieth century was the innovation that provided the basis for inter-action with computers and made possible works that the author did not define exclusively any longer. Like her predecessors Popper, Davis, Good-man, and Sakane,[34] the art historian Söke Dinkla locates the origins of the idea of interaction in the classic period of the avant-garde, specifically Futurism and Dada, with Marinetti's Variety Theatre Manifest and Max Ernst's exhortations to participate of the 1920s. Further lines of this de-velopment continue in happenings, cyborgart, 1960s reactive environ-ments, and closed circuit technology.[35]

Any concept of a work that seeks to give an idea an existential form for a definite period of time in space diverges categorically from the onto-logical appearance of a work of virtual reality. These ephemeral image spaces, which change within fractions of a second, achieve the effect of existing only through a series of computations in real time, 15 to 30 per second. The image is constituted as a spatial effect, via the interposing program and HMD, only on reaching the cerebral cortex;[36] thus it leaves its medium in a twofold sense. Recently developed laser scanners can project virtual reality images directly onto the retina; in this case, the category "image" does not disappear altogether—if the retina will suffice as a medium—but this must surely constitute the most private form of image currently imaginable: an image that is seen only by the observer, who triggers or retrieves it through actions or movements. Moreover, these virtual images will be seen only once by one person before they disappear forever—something that is entirely new in the history of the image.

There are certain parallels with the cathode ray tube, still an essential component in the majority of existing television and monitor screens, for there, also, a complete picture never exists. A ray of light scans the lines, causing luminescent bodies to emit light for a fraction of a second. It is the sluggishness of the human eye, the so-called retinal afterimage (inves-tigated by Goethe in his Farbenlehre)[37] that produces the effect of a com-plete picture on the screen. In this serial image production, which is invisible to the naked eye, images continually appear and disappear for good in fractions of seconds. To construct a work using photons is de facto the immaterialization of the work, although the equipment used to create

it is far from immaterial. It is this immateriality that represents the pre-requisite for the highest degree of variability possible and the basis for interaction. Materiality—if one wishes to call it that—is limited to the individual pixel. The ontological character of a work of art as defined by Heidegger[38] and others no longer obtains in the aesthetics of computer-aided virtual reality. For this reason, such works are defined increasingly in terms of their processual nature, which stresses their unfinished or open quality and locates art within a framework of communicative social relations.

Material works of all epochs have served as points where memories and recollections are crystallized, whether gravestones, medals, paintings, or other artifacts—even film. Memories change over time and according to the given state of knowledge, society or social class, whether dominant or dominated. The strength of material works of art, both past and present, lies principally in their function as illuminating and vibrant testimonies of the social memory of humankind. For only fixed artworks are able to pre-serve ideas and concepts enduringly and conserve the statements of indi-viduals or an epoch. An open work, which is dependent on interaction with a contemporary audience, or its advanced variant that follows game theory—the work is postulated as a game and the observers, according to the "degrees of freedom," as players—effectively means that images lose their capability to be historical memory and testimony. In its stead, there is a durable technical system as framework and transient, arbitrary, non-reproducible, and infinitely manipulable images. The work of art as a dis-crete object disappears. Computers may be the best repository of all time for information—as long as the operating system or storage medium is not out of date—but they are unable to record or reproduce the sensual pres-ence of a material work of art. Unlike the qualities of material works of art, games and arbitrary interaction do not qualify the computer as a medium for memories and recollections.

Notes

1. 1995: Ricco/Maresca Gallery: *Code*, New York; Musée d'art contemporain de Montréal: *Osmose*; Laing Gallery: *Serious Games*, Newcastle-upon-Tyne, England. 1997: Museum of Monterrey: *Virtual Art*, Mexico. Barbican Art Centre: *Serious Games*, London. 2000: San Francisco.

2. More about this work: Porter (1996); Wertheim (1996); Rutledge (1996); Davis (1996); Davies and Harrison (1996); Lunenfeld (1996); Borsook (1996); Carlisle (1997); Grau (1997); Kac (1998); Davies (1998a); Heim (1998), pp. 162–168, 171; exhibition catalog, Arte Virtual Realidad Plural, Museo de Monterrey, Mexico Monterrey 1997. See also: ⟨http://www.softimage.com/Softimage/Content/Projects/*Osmose*⟩.

3. *Osmose* uses the following hardware configuration: *SGI Onyx Infinite Reality Engine2* with R4400 150 Mhz Prozessor, 2 RM6's, plus 128 MB RAM, DAT drive, 2GB Hard Disk, CD-ROM drive. A Macintosh computer, receiving commands from an SGI computer, controls various MIDI applications, sound synthesizers, and processors. Image and sound, as well as position sensors, are contained in an HMD with a Polhemus tracker and a motion-tracking vest. There is also a data-beamer and a digital stereo amp with speakers.

4. The texture of the leaves was scanned from real objects.

5. In the early development phase an *Indigo2* was used.

6. John Harrison wrote a prototype of *Osmose* in Softimage's *Sapphire Development Kit*, a program that allows static models to be computed efficiently under real-time conditions. See Sims (1996).

7. See Porter (1996), p. 59, where he quotes Char Davies.

8. For example, SIGGRAPH 1991 and 1992; IMAGINA 1991 and 1992; International Symposium on Electronic Art (ISEA) 1992. In 1991 she won the *Prix Pixel Image* at IMAGINA and received an award for *The Yearning* at Ars Electronica in 1993.

9. In Davies's own words: "And perhaps most importantly, a lot of the emotional impact of the piece comes from the haunting melodies and soundscapes throughout." Quoted in Porter (1996), p. 60.

10. From the *Osmose Book of Comments* of the Museum of Contemporary Art, Montreal (owned by the artist), some comments written in the period August 19, 1994 to October 1, 1995: "Sublime, an experience that is embodied, spiritual and esoteric …"; "An almost religious experience, certainly a meditation, very close to yoga …"; "I discovered in myself a fascination for the depths. I am surprised and

eager to understand the deep sense of my own being in this real unreal space. RJ";
"*Osmose* is a reconciliation with nature through technology, a reconciliation with
technology also contrary to what we're used to, gentle and peaceful. . . ."

11. See ⟨http://www.immersence.com/immersence_home.htm⟩.

12. Quoted in Robertson (1994), p. 19.

13. Davies (1998a), p. 67.

14. See Morse (1998), p. 209.

15. Davies (1998a), pp. 56ff: "*Osmose* is a powerful example of how techno-
logical environments can simulate something like the old animist immersion in
the World Soul, organic dreamings that depend, in power and effect, upon the
ethereal fire. . . . *Osmose* also reminds us how *intimate* we are with electronics, in
sight and sound, in body and psyche."

16. I attempted to locate this within the history of illusion in a lecture enti-
tled "Into the Belly of the Image: Art History and Virtual Reality," at the Eighth
International Symposium on Electronic Art (ISEA) at the Art Institute Chicago,
September 22 to 25, 1997.

17. D'Amato (1996), pp. 35ff.; or the critique of BIT: "Perhaps Char could
take her naive naturenostalgia and contrived technoblindness, her jungle of quotes,
and marry Mr. unabomber technodemonizer, pledge troth in concomitant deafness
to the integrate social possibilities that cut through the machinery of capitalism
and living, make little virtual bomb babies." See Bureau of Inverse Technology
(BIT) (1995), p. 13.

18. See Lanier (1989), p. 119.

19. "One of the things we are doing with *Osmose* is to port it onto new tech-
nology as the technology comes along, maybe eventually we will get it onto to
something relatively small. And we are hoping to do that with the new work
[*Éphémère*] too. It is my insistence on transparency (in real-time) that necessitates us
using such high-end equipment. If I could do it with just a wooden brush and oil
pigment I would—but then you could not be enveloped in the created space,
which is what drove me into this medium in the first place, and may keep me

here, even for all the technical complexities." From a letter from Davies to the author, February 4, 1997.

20. Buber (1984), pp. 13ff.

21. Ibid., p. 14.

22. Adorno (1973), p. 460.

23. Serres (1981), p. 152.

24. Gehlen (1986), p. 60.

25. Hans Jonas, "Der Adel des Sehens: Eine Untersuchung zur Phänomenologie der Sinne," in his (1973), pp. 198–219.

26. Böhme (1988), p. 221.

27. See Grau (1994), pp. 21ff. It is already possible to experience holding a simulated beating heart in your hand, and then putting your hand inside it.

28. See Kennedy et al. (1992), pp. 295ff. To date, little research has been done on mental effects. However, one recent work is Kolasinski (1996).

29. Wertheim (1999); Anders (1998); Brew (1998), p. 79; Davis (1998), pp. 56–57; Gagnon (1998); Goldberg (1998); Heim (1998), pp. 162–167, 171.

30. Halbwachs (1925).

31. W. Thierse, "Das Ganze aber ist das, was Anfang, Mitte und Ende hat. Problemgeschichtliche Beobachtungen zur Geschichte des Werkbegriffs," in Barck et al. (1990), p. 397.

32. John Dewey, "Art as Experience," in Dewey (1987), vol. 10, p. 8.

33. Eco (1973), p. 28.

34. Popper (1975, 1993); Davis (1975); Goodman (1987); Sakane (1989).

35. See Dinkla (1997), p. 25.

36. See Zell and Hübner (1994), p. 164.

37. Goethe (1988), pp. 67ff.

38. Heidegger (1990), p. 21: "Im Werk der Kunst hat sich die Wahrheit des Seienden ins Werk gesetzt. 'Setzen' sagt hier zum stehen bringen.... So wäre dann das Wesen der Kunst dieses: das Sich-ins-Werk-Setzen der Wahrheit des Seienden." Only if one concedes that the "truth of what is" exists in its transience does this quotation from Heidegger still have validity today.

6

Spaces of Knowledge

Knowbotic Research (KR+cF): *Dialogue with the Knowbotic South*

Since their formation in 1991, the Austro-German artist group Knowbotic Research (Yvonne Wilhelm,[1] Christian Hübler,[2] and Alexander Tuchacek[3]) have developed hybrid models for digital representations of knowledge. Knowbotic Research have received many awards for their work,[4] and in 1998, all members of the group were given a professorship at the University for Art and Design in Zurich. Their virtual installation *Dialogue with the Knowbotic South* (*DWTKS*) (1994–1997), which has been exhibited at several exhibitions,[5] processes scientific data from research stations' networked data bases to create a changing abstract representation of Antarctica. It visualizes and maps this deserted, yet scientifically well-documented, continent in a virtual scenario, but does so in a totally nonmimetic way.[6] In *DWTKS*, the data from the networks is visualized as changing starbursts of pixels on large projection screens in a dark room. The data is collected and activated by software agents, the knowledge robots or "knowbots." The image space consists of complex dynamic fields where exchange and interaction take place between the human visitors and the knowbots and poetic software machines. The data, arranged in the virtual space like constellations of stars, are pulled together, as if attracted by a magnet, and then burst apart again, like supernovas. The installation also presents the physical topology of several research and monitoring stations in the Antarctic on a plastic film on the floor. The artificial space can be experienced both virtually and abstractly; the user navigates by moving a touchwand, an interface reminiscent of the joystick. Wearing a headset with a mini-monitor, the "private eye," in front of one eye, the visitor explores the glowing, rotating data fields and correlated metallic sounds, which produces an extraordinary feeling of space. Currents of conditioned cold air, the temperature of which derives from data recorded by meteorological stations on the sixth continent, is blown into the installation space. It is a polysensory environment that the visitor encounters in *DWTKS*. This combination of physical and virtual components that represent the multiple layers of the real was created years before hybrid artworks of this kind appeared in the discussion as "mixed realities."

It took two years to develop *DWTKS*; the group received some support from the hardware producers who lent their machines, and invested 50,000 U.S. dollars of their own money in the project. For young graduates, this was a considerable sum and also the limit of what they could

raise. Although Knowbotic Research were expert in the most important programs, such as C+ and Java, for *DWTKS* they also had to rely on the help of professional programmers for exceptional software solutions. When artists employ professionals, who work for much less than they would get in the commercial sector, they have to mobilize considerable skills of persuasion for art's sake.

In the hypothetical space of *DWTKS*, the knowbots are the units that structure, visualize, and establish contact with the artificial space. The users enter into contact with these virtual software agents and use them to access the data live from the electronic networks of the Antarctic research stations. Theoretically, this happens in real time; practically, the data is updated every three hours. The knowbots condense the information dynamically and allow the users to access it. Using a wand—an interface that is neither "intuitive" or "natural"—the users can log in via knowbot to the swirling data fields and intervene. The knowbots function as nonrepresentational interfaces between programs and active users; they are visualized, abstract representations of knowledge that is undergoing permanent change. However, communication with these early forms of agents is confined to moving through the data fields and activating correlated sounds. The knowbots appear to the user in the form of local swirls of data, and, when activated, they visualize keywords of the given collaborating research project (for example, diving robots), and the user can also activate with his or her gaze accompanying fragments of sounds. In the image space, these are combined faster by a knowbot the closer the user's gaze is to the agent.

When Alexander von Humboldt returned from his field trip to South America, he proposed the construction of a panoramic space of images depicting a highly complex and foreign reality for visitors. This is not the aim of Knowbotic Research: They invite the user to explore and interrogate interactively an abstract, self-organizing system. The visitor is not offered immersion in an illusionistic artificial Antarctic landscape but a plunge into an image space filled with abstract scientific data, a space of constant metamorphosis: This is the intention of the artists.

Following Giambattista Vico, who asserted that we can only understand what we have created ourselves, *DWTKS* enables scientific data, that is, columns of figures, from Antarctic research stations to be translated into three-dimensional audiovisual representations and temperature-controlled

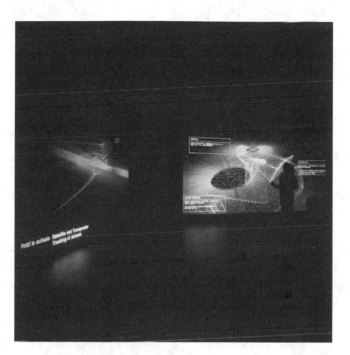

Figure 6.1 Knowbotic Research, *Dialogue with the Knowbotic South*, 1995. Interactive real-time installation. By kind permission of the artists.

air streams. This multiperspectival perception, which is communicated on various levels, including the mini-monitor and panoramic view on large projection screens (fig. 6.1), raises questions about traditional mimetic concepts of computer art. Although Knowbotic Research operate within the context of the virtual reality discourse, also working with the total effect produced by sounds and images, they choose to represent complex, chaotic, and abstract systems in a form diametrically opposed to that of the mimetic approach. *DWTKS* allows the user to witness actively how science models and simulates Antarctica, a continent not fully explored, with extreme natural and climatic conditions and scant history of civilization: computer-aided nature.[7] Their visualization of scientific data does not create an artificial space of illusion but, instead, an abstract dynamic knowledge space that is capable of representing changes over time, for example, the constant movements of icebergs. The artists' computer-aided approach, however, does not conform to the view of some scientists that the computer can construct and represent anything and everything.

In scientific research, visualization models work increasingly with abstract, complex data structures that are relying less and less on mathematical code. There is an increasing need for an aesthetic structuring of knowledge, which will allow the data to be presented in a form that is transparent, manageable, and manipulable. Knowbotic Research's concept for *DWTKS* also raises questions about the hope of science to represent nature in its entirety and, with their artistic deconstruction, they draw attention to the ideological dimension of science that seeks to represent what is seen as it is intended it should be seen.[8] Art and science are both part of a wider culture, and, in the context of this understanding of culture, it is clear that science cannot be purely objective.

With *DWTKS*, Knowbotic Research formulate an alternative model to the dominant immersive and realistic works of virtual art, which are oriented primarily on illusion. A representation of complex, chaotic, processual systems could hardly be anything other than abstract; nevertheless, it is more than apparent that the artists consciously distance themselves from the paradigm of illusionist virtual reality. *DWTKS* implements scientific strategies of gathering knowledge as a medium of perception, and thus it interrogates the ever-changing definition of nature from the standpoint of contemporary linkage of science and nature. The complexity and original form of the data collected make new demands on coding systems, which result in making landscapes visible. This artistic visualization and presentation of scientific data can also be interpreted as a highly elaborate, abstract model of the world, in spite of the fact that there are no similarities with illusionist representations of landscapes. By means of the private eye display, which supplies only one eye with images, the total view seen by the other eye is disrupted and a stereoscopic immersion effect frustrated—intentionally. The user remains in the image space, but the perspective is distanced and bifocal. This organization of perception must be construed as a countermodel to image worlds that address all the senses to form a sphere of illusion and, with the aid of intuitive interfaces and anthropomorphic agents, curtail the inner distance of the observer. Yet a certain suggestive effect does remain, for which the moving and glowing image fields, the darkened room, the interaction, and the soundscape suffice.

In their images, Knowbotic Research have developed an aesthetic that is not content to remain on the surface of the monitor, as many graphics programs do. Their approach aims at using the artist's repertoire to visu-

alize the internal processes of computer technology and the data streams in the telematic networks in order to reach beyond the genre of simulation media, which in the course of its history, art has brought forth time and again.[9] The artists use the systems of scientific data production to high-light an interpretation of the world that is determined by specific methods, not as a cipher denoting objectivity. Objectivity remains immanent to the system. This also leads to their critique of immersively communicated models of nature produced by virtual art, whose ideology is to pretend that digital events are experiences of nature. Computer-aided nature occupies a diametrically opposed position, which presents unmistakably the digital basis of image worlds and, through the knowbots, allows the observer to enter dialogic action spaces with myriad abstract models of natural phe-nomena. Knowbotic Research offer visual layers in an image space filled with scientific symbolism through which the user's guides are the know-bots: themselves an incorporation of the search, focusing, and modeling of research.

In several interviews, Christian Hübler has declared the aims of Know-botic Research to be the creation of a space for action, ideas, and thought where diverging concepts can collide. For Hübler, the task of an artist is to construct a framework where users can generate abstract and poetic events: "We advocate experiments, which do not design new systems or structures, that develop transient situations and specific nonlocations through moving across the overlying strata of physical and electronic processes. Nevertheless, I would still term what we are working on as being 'machine-based,'"[10] that is, not human-based. This is Knowbotic Research's answer to the apocalyptic visions in the style of Vilèm Flusser or Jean Baudrillard. The latter fear that, when confronted with virtual image machines, people will "prefer to renounce their creative powers in order to exercise and enjoy them through the mediation of machines first. For what such machines offer is, above all, the spectacle of thought and, in their dealings with machines, people opt for the spectacle of thought rather than thought itself."[11] *DWTKS*, however, represents a machine that induces thought.

The Virtual Denkraum I: *The Home of the Brain* (1991)

A further example of how artists attempt to distance themselves from pure illusionism while making extensive use of its mechanisms and techniques

is *The Home of the Brain—Stoa of Berlin*, an electronic space of communication by Monika Fleischmann and Wolfgang Strauss. This immersive and interactive environment is experienced audiovisually by using data glove and HMD.[12] Developed in 1991 at the ART+COM institute for research and development in computer-aided design in Berlin, it won the first prize—the Golden Nica—in the Interactive Art category at the *Ars Electronica* Festival in Linz, Austria, in 1992. Any adequate description and analysis of this work necessitates close adherence to the 3-D, dynamic, and interactive image space of its virtual reality. Photographs, slides, or video can give at best only impressions of movement or texture because these media fix their subjects and, in the case of video, recordings are linear. As it is the observer who triggers or selects the images seen in virtual artworks, neither video nor Quicktime files can capture or convey the new aesthetic qualities of virtual reality, such as interaction, spatial effects, immersion, interface design, and the sensory impressions that result.

Monika Fleischmann and Wolfgang Strauss, born in 1950 and 1951, respectively, both studied at the Hochschule der Künste (Academy of Art) in Berlin. In 1988 they helped to set up the ART+COM institute[13] for interdisciplinary research and the development of new techniques of computer communication and design, which was founded by the Berlin government and Telekom-Berkom. Like many computer artists, Fleischmann has a multidisciplinary background, having worked in fashion design and the theater. In 1993, she was appointed artistic director of the Institute of Media Communication[14] at the Forschungszentrum Informationstechnik (GMD) in Sankt Augustin and, together with Strauss, founded Media Art Research Studies (MARS)[15] there in 1997. Their aim was to use artistic methods to develop virtual spaces, new forms of interaction between humans and computers, better rendering of movement, and creative interfaces. Fleischmann is a permanent member of GMD's research staff and a professor at the Hochschule für Kunst und Gestaltung in Zürich, the first woman and the first artist to hold these posts simultaneously.

Wolfgang Strauss is an architect who has experimented mainly in the field of installations and performance art. Since joining GMD in 1993, he has worked on a variety of solutions to interface problems.[16] In 1995, he became professor for Media Art and Design at the Media Lab of the Hochschule für Bildende Künste, Saarbrücken. Fleischmann and Strauss are among the best-known media artists of today. They have exhibited

at venues all over the world, including the Intercommunication Center Tokyo (ICC), the Museum für Gestaltung in Zürich, the Haus der Kunst in Munich, Centre Pompidou in Paris; MOMA, New York and festivals, such as Ars Electronica, the Biennale in Venice, Siggraph, the International Symposium on Electronic Art (ISEA), Imagina in Monte Carlo, and many others. Their numerous lectures and publications have brought them many invitations to serve on important committees, including the Goethe Institute and EXPO 2000, and conference selection boards, such as the influential ACM and ISEA.

In *The Home of the Brain*, a data glove[17] and sensors in the HMD relay commands to the system, which consists of a Crimson Silicon Graphics Workstation and a software package.[18] In real time, which in the early years of virtual art was accompanied by jumpy movements, the computer responds with sections of images and sounds triggered by the wearer's movements. Only one person at a time can wear the HMD and experience immersion; other visitors view the images generated on a screen, roughly 9 m^2,[19] in a semidark room, about 20 m^2, and are invited to comment at will. The user of the environment is seen as a shadow behind a pane of glass. The structure of the installation, which dates from 1992, is an arrangement that can be changed or extended at any time by modifying the program or interface: It is a work in progress.[20] Many visitors said that they experienced the decoding of the image program and the possibility of discovering connections as a game. Like many other virtual reality artists, Fleischmann and Strauss are correct in interpreting their work as an attempt to make sensory experience possible in virtual worlds as well: "We are turning the theory on its head that man is losing his body to technology. In our opinion, the interactive media are supporting the multisensory mechanisms of the body and are thus extending man's space for play and action."[21]

The Home of the Brain represents a totally new form of public space— that of the global data networks. In Strauss's words, it is a "morphological simulation space, in motion,"[22] which can be experienced polysensually and interactively. The architectonic shell of this digital archive for different media theoretical approaches is modeled on Mies van der Rohe's Neue Nationalgalerie (New National Gallery) in Berlin.[23] It is a modern version of the ancient Greek *Stoa*, which offers a simulated, highly symbolic, space of thought and information, where a metaphorical discourse on the ethical

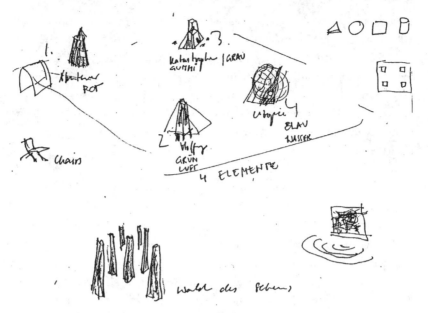

Figure 6.2　M. Fleischmann and W. Strauss: Concept for the VR installation *The Home of the Brain*. Felt-tip pen, 1991, unpublished. By kind permission of the artists.

and social implications of new media technology takes place. The project's declared intention was to transport reflections and information on these questions into the public domain. To this end, the image space contains a selection of commentaries illustrating fundamentally different intellectual positions in the debate (fig. 6.2).

The image space of the virtual Neue Nationalgalerie displays black conical forms like treetrunks, flat flooring elements, and walls covered with white archaic runes. Four houses, arranged in the form of the points of a compass, are grouped around a central labyrinth. These are inhabited by four computer scientists and media philosophers who engage in a symbolic discussion of the ethical and social impact of new media technologies. At that time, Fleischmann and Strauss were very dissatisfied with the public attention these questions were receiving,[24] which, in the early 1990s, revolved around cardinal questions relating to the technical revolution in image production, the creation of true-to-reality virtual spaces, the quest for artificial intelligence (AI), and the consequences for people and society. The four experts selected to inhabit the houses are: Joseph Weizenbaum and Marvin Minsky, computer and AI specialists, and the

philosophers Paul Virilio and the late Vilém Flusser.[25] Looking back now, more than a decade later, the artists' choice of these four was both wise and far-sighted, for although they were not exceptionally well known at the time, in the meantime they have become classics of media theory.

The four are represented visually in grainy photo portraits like large placards inserted via texture mapping into the image space, their names in large type, a leitmotif that is assigned to each, and by citations on banners. These chains of thought float like Möbius strips, winding around the virtual objects—a combination of image and words. On entering one of the houses, the interactor also hears spoken citations that have been selected by the artists. By moving, the interactor can compile an individual collage of polylogical statements.

Each of the four thinkers is assigned an element—fire, air, earth, or water—a color, and a sound. Significantly, all these categories share the number four. It is not possible to catalog the iconography of the design in detail here, but it is important to indicate the scope and breadth of cultural reference of the work's conception: four elements,[26] thinkers,[27] stereometric spatial forms,[28] colors,[29] and leitmotifs[30] add up to a compelling association with models of the world according to Plato's doctrine of the elements. The use of this system in the work's formal construction provides a cultural and historical foundation that affirms its provenance in Western culture. It was Plato's *Timaeus* that first identified the four elements with the geometric shapes of tetrahedron, cube, icosahedron, and octahedron. Apart from the icosahedron, which is replaced by the sphere, *The Home of the Brain* adheres to the platonic system. Moreover, each geometric shape has a multitude of other historical and cultural connotations, and the number four, the *divina quaternitas*, the number linking the elements, humours, seasons, and cardinal virtues, among other things,[31] also has an intercultural dimension.[32] In Fleischmann's words, *The Home of the Brain* is a "world of archetypes,"[33] a reference to C. G. Jung's concept of the collective unconscious: Archetypes, or in Greek "original images," represent in Jungian psychology the inherited structure of the personality that preserves the accumulated past experience of the human species. These universal dispositions of the human imagination are always present in the collective unconscious and surface or enter the conscious state in particular situations, such as dreams, fantasies, visions, and also in myths and fairy tales, in the form of symbols.[34]

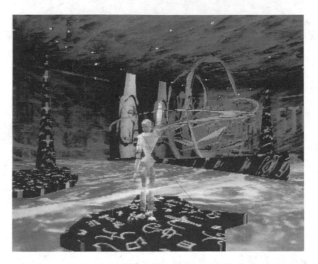

Figure 6.3 *The House of Catastrophe* of the philosopher Paul Virilio. In the foreground, *Modulor*, screenshot from *The Home of the Brain*. By kind permission of the artists.

Positioned between the poles of the quaternary arrangement in the virtual image space is an abstract, steel-gray human figure whose pose and proportions are reminiscent of Le Corbusier's *Modulor*. Standing on a black platform this figure provides the observer with a reference point, a reminder of human scale within the virtual space (fig. 6.3). The labyrinth at the center, defined by the doctrine of the elements as the location of quinta essentia, is not planar but fans out and grows into the surrounding space in torsional movements. The 3-D labyrinth, which undergoes multi-faceted changes of direction both horizontally and vertically, is an illuminating metaphor for the collage-like reception that results from putting together the statements of the four thinkers.[35] Moreover, it represents the ambivalence of navigating the installation's possibly endless path and the utopian goal at its center. It refers to the dialectic discourse that the visitor can construct using the four thinkers' widely divergent views.

The work's full title, *The Home of the Brain—Stoa of Berlin*, also proclaims its cultural and historical links. The *Stoa poikile* was a building in ancient Athens, an elongated, rectangular, and colonnaded hall, and its name referred to the paintings it housed. It was a center for communication, and in 300 B.C., Zenon of Kition gathered his followers there and founded the philosophical school of the same name, the Stoa or Stoic phi-

losophers. Interestingly, Fleischmann and Strauss interpret the openness of the Stoa of antiquity as a model for public discussion, for example, like the Open Source movement. The Stoics' explanation of the cosmos followed the doctrine of the elements[36] whereby the idea of a human being as a holistic, mental, and physical unity who is part of ubiquitous God-Nature occupied a central role. The concept of *oikeiosis*, the basis of Stoic ethics, denotes this relationship in the teachings of Zenon, as Pohlenz demonstrates: "From birth onwards, external perception is connected to inner perception, or synaesthesis, which is consciousness of the self, and it is from this self-perception that the first active motion of the spirit arises.... It consists of turning toward one's own being, which one experiences as belonging to and to which one 'dedicates' oneself. This is *oikeiosis*."[37] Significantly, another key concept is that everything real is understood as corporeal.

Programmatically, the four thinkers' citations describe the challenges facing contemporary society: What are the political, cultural, and social implications of the Internet? What will be the effects of true-to-reality image spaces and experiences in them? Is the creation of AI possible? Is it desirable?

A core element of Marvin Minsky's thought, one of the most prominent representatives of "hardcore" AI research, is the reproduction and artificial optimization of human mental faculties. His work at the Massachusetts Institute of Technology (MIT) involves the attempt to decode the bauplan of the human brain. He has advocated the creation of a so-called Mentopolis, where human brain structures will survive their owners' biological death in digital form. Here Minsky continues a long tradition, which compares humans to the very latest machines, either already in existence or under development: The brain is a machine that only has a trillion parts, which perhaps one day will not seem very many. We now use the word "mechanical" to express disdain. One day, however, we will use the terms "lifelike" or "like the human brain" to mean boring and limited and of no further interest.[38] To the question, how machines might prolong life, he replies, We will reconstruct ourselves. We will find those parts of our brains that think, feel, and learn, and we will transfer these structures to new parts that are not made of easily destructible matter.[39] In another interview, when asked "In other words, you mean to change the human mind, for example, by building computers in the brain. Is that a consequence of

AI?" Minsky replied, That is the consequence of research into intelligence. When you know how the brain works, you can build a new one.[40] The religious and mystic roots of these ideas are even more apparent in the work of neognostics, such as Hans Moravec, who has taken up Minsky's position and projected it into the future.[41] Here, technological utopias converge with religious ideas. Moravec, professor at Pittsburgh's Carnegie-Mellon University and founder of the world's largest program on robotics, has predicted that if computer speeds continue to increase exponentially, the next twenty years will see the development of robots with greater capabilities of thinking and feeling than humans. These robots will be able to self-replicate and will colonize outer space, thus overcoming the limitations of time and space. However, because they will be far superior to mere mortals, these androids will precipitate the extinction of the human species. For in the history of evolution, Moravec says, no species has ever survived the confrontation with a superior competitor. Faced with this impending apocalypse, humankind's only option for escaping extinction will be to download itself. Through a digital copy of each individual, with memory, consciousness, and intelligence, which will be released from the "superfluous" body, those formerly known as human beings will be free to create a community of minds in the electronic data networks of the future.[42]

In the installation, Minsky is associated with the element of water, the geometric shape of the sphere, and the color blue (fig. 6.4). Around his House of Utopia twist bands of thoughts, such as "Can you imagine, that they used to have books, which didn't talk to each other?" "There is no difference between dream and reality," and "Thinking is like a house." These replace the artists' original selections: "Future generations of computers will be so smart that we will be lucky if they even keep us as pets," or "We are merely an experiment on earth and we should be proud of it."[43]

Joseph Weizenbaum, Minsky's long-standing antipode, who also taught at MIT, believes that ethical thinking in the natural sciences needs to be strengthened. The installation includes Weizenbaum citations, such as "Humans are quite simple" and "The so-called powerlessness of the individual is perhaps the most dangerous illusion one can harbor." Weizenbaum rejects the idea that computers can acquire intelligence of the human kind and insists on the fundamental difference between humans and computers.[44]

Figure 6.4 The House of Utopia. Screenshot from *The Home of the Brain*. By kind permission of the artists.

Weizenbaum views AI's mechanistic concept of human intelligence as simplistic and limited, and he is highly critical of "artificial intelligence's perverse grand fantasy."[45] In his opinion, it is not possible to sythesize intelligence. Intelligence involves the capability to form associations, make abstractions and transpositions, and includes contextual knowledge—something entirely lacking in the computer, for it cannot construct semantic relationships with things.[46] In the virtual space, Weizenbaum lives in the cube-shaped House of Hope; he is assigned the element of earth, with its whispering of trees, and the color green. A new wave of human-machine utopias, sparked by Moravec's text *Mind Children*, this time with beings "that are superior in capability to humans by a factor of a million million million million million (that's 10^{30}),"[47] prompted Weizenbaum to update his critique of the more extreme variety of AI.[48] The focus of his criticism is the installation of a "divine order," which places computers above humans.

Vilém Flusser, whose ideas have been particularly influential in Europe, predicted that the technical image would unleash a cultural revolution

of unimaginable proportions.[49] Rapid advances in computer technology would obviate the necessity for humans to work and think for themselves, turning them into cerebral appendages of the worlds of technical images, into mere players.[50] Flusser advocated the development of a new anthropology modeled on computer thinking: "So-called life cannot only be analyzed in terms of particles or genes, to take but two exciting examples, but thanks to genetic engineering, these can be recombined to create new information and to produce 'artificial life forms.' Or, computers can synthesize alternative worlds, which they project using algorithms, that is, symbols of mathematical thinking, and which can be just as concrete as the environment around us."[51]

Radical in his thinking, which is often framed in unconventional language, Flusser projects the consequences of his vision of the future onto the "superfluous body:" "As soon as the body brings itself into play by exhibiting irreparable defects, it is the task of medicine to shut it down as smoothly as possible."[52] These apocalyptic conclusions lead Flusser to his new form of anthropology: "Not only a new ontology but also a new anthropology is being forced upon us. We must understand ourselves—our self—as one such digital scattering.... We, too, are 'digital computations' made up of buzzing possible pixel constellations."[53] Flusser's contention that the difference between the self, or being, and the dynamic digital image of pixels, or appearance, has been abolished is essentially a modern version of the belief in icons, which concedes that the image, like the body, possesses a real quality, something of the real.

Flusser was fascinated by computer-generated image worlds, and just as he saw the barriers between humans and technology disappearing, he also declared the boundary between art and advanced technology to no longer exist. However, in his opinion, the structures by which technical images are communicated "lead 'automatically' to a fascist[54] society,"[55] which Flusser warns us about. For his own discipline, philosophy, he foresees "mathematicization of the philosophical discourse and, vice versa, the philosophization of technology—the true goal of our thinking."[56] His is the House of Adventure, dedicated to his vision of flowing space, and he is assigned the pyramid, the color red, and the crackling sound of the element fire. Möbius strips proclaim "Sounds are memories," and "Telematics will become more sensual," while the visitor hears the words, "Technology can only get better but the human will probably get worse."[57]

Not surprisingly, Flusser's counterpart is Paul Virilio, whose media theory postulates humankind as the victims of the tremendous process of acceleration that has transformed transportation and telecommunications, which steals the space of time from us antiquated and slow humanoids. "If time is history, then speed is merely its hallucination."[58] Virilio is the philosopher of speed, of "dromology"—a field he has established that combines the history of technology, military strategy, urban studies, aesthetics, and physics. According to Virilio, all forms of transportation and communication differ from their predecessors in that they are faster; development of media culture leads to ever faster production of stimuli and processes of perception, whereby military technology and techniques of illusion are the driving forces. Strauss and Fleischmann's virtual environment contains the following key statements by Virilio: "At the present time, we are still living in extensive time, of cities, history, memory, archives, and the written word, and in intensive time, of the new technologies. This is a program of absence—it is only a program, our absence definitive. For we will never be present in the billionth parts of seconds."[59]

For Virilio, the speed of new media technologies threatens the entire sphere of politics, and his perception of this danger leads him to insist they must be reformed and related to the space of speed.[60] A banner winds its way around his House of Catastrophe with the words "Aesthetics of disappearance," the title of one of Virilio's most famous works in which the philosopher bids a melancholy farewell to difference, which is produced by spatial distance: "The reconciliation of nothing and reality and the suspension of time and space by high velocities replace the exoticism of journeys with a vast expanse of emptiness."[61]

In the early 1920s, Aby Warburg had already described the process of the disappearance of cultural differences because of the introduction of new media. The loss of distance, the increasing "smallness" of the world due to modern systems of transport and the telecommunication of information, Warburg saw as endangering the space for thought in the natural sciences and cultural awareness: "Telegrams and telephones destroy the cosmos. Mythical and symbolic reflection creates space for meditation or thought in the struggle for spiritual links between man and his environment, but this is murdered by split-second electrical connections."[62] The installation associates Virilio with yellow, the octahedron, the element of air, and the sound of approaching storms. Further citations include "Today one can die

Figure 6.5 Screenshot from *The Home of the Brain*. By kind permission of the artists.

in a labyrinth of signs; before, one died because there were no signs" and "The violence of speed annihilates."

In summary, these thinkers were chosen because of the polarity of their positions, and this is reflected in the polarity of design of the artwork. The artists do not attempt to synthesize the experts' statements. That is left to the visitors, who navigate and interact with the various spheres of images.

Back in 1991, *The Home of the Brain* (fig. 6.5) visualized in a remarkable way an overview of the new paradigm of communicating via technical images. Further, it was a metaphor for the new public space of telematics, an entirely new kind of public forum, which developed rapidly through the Internet and its associated technologies. Because of its digital form, reception of a work that is on the Net can take place anywhere in the world: Theoretically, it is "nonlocatable." Something of this quality adheres to the real building on which Fleischmann and Strauss modeled their virtual *Stoa*, the Neue Nationalgalerie by Mies van der Rohe, completed in 1967. It is based on older plans of an office building for the Bacardi Company to be erected in Santiago de Cuba. The building in Berlin is in fact a "steel-frame version of the Bacardi building."[63] The original building was never built, for Fidel Castro and the Cuban Revolution intervened.

At the same time, this virtual gallery, which is the scene of the four-sided discourse on the recent media revolution, represents a vision of virtual art that is nonlocatable, or at least very difficult to locate, symbolizing

the relationship between a composition and the entire Net whose channels enable its reception and make interaction with it possible. It is an imaginary memorial spatial image, in the sense used by Frances Yeates, which transports concentrated, complex information. In the labyrinth, in the interplay of the theorists' positions, the individual interactor's collage of meanings creates a space of thought, which is technically immaterial and a concentrated compound of information without linear continuity. It is this mechanism that reveals the work's intention to inform and enlighten.

As outlined above, *The Home of the Brain*'s design makes extensive use of the number four, the *divina quaternitas*, in constructing a vivid metaphor of the world, which refers to cosmological models indebted to Plato's doctrine of the elements. These models stood for unity and humankind's place in the totality of the natural order. The installation reflects a historical and intellectual concept that, on the one side, utilizes the rigid doctrine of the elements and, on the other, digresses from it to create disparity and a wide range of associations. Virtual reality, a product of advanced technology, is connected here with theories that, for people of today, belong to a far distant past. Although they propose a holistic view of nature, including humans, they are nevertheless permeated by an aura of obsolescence and hermetic inaccessibility. This practice of coupling elements of historical art and cultural production, which are highly evocative and auratic, with the very latest technological developments has become such a common trend that it exhibits features of a strategy. Virtual reality models, for example, of a host of historic buildings attempt to graft the new onto the old and are widely used for the purposes of advertising (fig. 6.6).[64] Moreover, the linking of the doctrine of the elements with Jung's concepts of archetypes and the collective unconscious can be seen as an attempt to establish the medium of virtual reality as part of a continuum with deep cultural and historical roots. For Jung, the historic procession of successive images were all variations of archetypal symbols or "thematic frameworks" for discovering images. In particular, the symbols of totality, ellipse, circle, or mandala represent in Jungian terms a perennial, fundamental optical figure that articulates repressed, sublimated, or desired oneness of mother and child, man and woman, human and world, ego and God, and so on, and appears time and again in magical and mystical contexts.[65]

Here, high-tech illusion, virtual reality, is combined with a suite of important theories concerning the holistic relationship between humans

Figure 6.6 Advertisement, *VIRTUAL REALITY Special Report*, fall 1994, vol. 1, no. 1.

and nature that all belong to the past. The iconography of holism enriches this medium of illusion with cultural roots that, however, were the product of entirely different ages, dimensions, and contexts. The implication of combining the theory of archetypes with virtual reality, that virtual reality facilitates the bond of humankind and nature, as the Stoics understood it and as a recurrent theme of the doctrine of the elements, is highly problematic for a number of reasons.

Essentially, virtual reality stands for the complete divorce of the human sensorium from nature and matter. In the history of illusionism in art and media, virtual reality constitutes the greatest challenge so far to the human senses and their relationship with the environment, which produces, sustains, and permeates them. The interactor inside the image space recognizes that what is visible is an illusionist environment where the perceptions of the organs of sense and the quantities of time and space have become variables. It is highly questionable in this art how concept, as a matter of course, the ancients' elements, or matter, make their comeback; how computed material things, perhaps soon to even be experienced haptically, pass over into the digital sphere, immaterial but upholding the deception of being material. Apart from doubts as to whether models of the world based on Plato's elements doctrine, which disappeared at about the same time as alchemy, are either timely or meaningful, it is questionable whether virtual reality is an appropriate medium of reference for the real world. Materially, virtual reality image worlds are nothing, disregarding the technical equipment used to create them, and thus the excessive preoccupation with these worlds appears somewhat paradoxical, if it cannot find a new direction.

The Home of the Brain, limited by contemporary technology, was not a highly immersive installation,[66] but it did achieve interaction with 3-D images. The limitations of the optical illusion were compensated at the conceptual level by an image program that stressed the whole in its wide-ranging design. Development of virtual reality technology was then still in its infancy, so the full potential of the work's concept, with its narrative, playful, generative, and even dionysian elements was not able to develop. Nevertheless, *The Home of the Brain* was one of the first truly remarkable expressions of virtual image culture and displayed visionary qualities.

The Virtual Denkraum II: *Memory Theater VR* by Agnes Hegedues (1997)

In the Renaissance, neoplatonists constructed virtual temples of memory, memory theaters, which were spaces of thought, memory storage spaces for the assembled knowledge of their time, where multilayered, theoretically infinite associations between the displayed objects and memory spaces were possible. In the imagination, the mind could navigate through spaces that facilitated combinatory processes: *ars combinatoria* was the fruitful principle

of these memory theaters, including that of Giulio Camillo, circa 1550.[67] The aim was to take the knowledge of the *ars memorativa* stored in the cultural medium of the book, animate and give life to it, transform it into a vision that provided access to the already panoramic body of knowledge of the Middle Ages. The Hungarian artist Agnes Hegedues has taken up this historic concept of the memory theater, as Bill Viola had done a few years before,[68] but with the difference that she offers the visitors to her virtual spaces a dynamic structure with intermedia elements, thus expanding the historic mnemonic techniques with contemporary media.[69] In this piece, virtual art operates close to the current widespread trend of staging knowledge, inspiring and forcing rejection of the desktop metaphor in favor of dynamically generated spatial visualizations.

In *Memory Theater VR* (1997), Agnes Hegedues invites the visitor into a panorama rotunda. A circular screen marks the boundary of the virtual reality environment, forming a virtual theater (fig. 6.7). At the center stands a pedestal with a Plexiglas model of the panorama architecture in which the visitor moves a 3-D mouse, the Mini Bird, in order to navigate. The coordinates of the mouse are relayed to the computer, which responds in real time with image worlds on the panoramic screen. Similar to Camillo's arrangements, which were always constructed as a theater, Hegedues's compositions of images can be displayed on four levels, each above the other. The visitor can construct a film on the history of spatial illusion and control its projection, which is ingeniously staged by doubling the situation through the interface. The work cites very heterogeneous concepts of virtual reality, such as works by the architect Daniel Libeskind, Ivan Sutherland's HMD, or Lewis Carroll's *Alice in Wonderland*. The principle of the historical *Wunderkammer* is also represented.[70] Hegedues's panorama formulates a rich array of associations, leading the visitor through the history of art and media, including mannerist, futurist, and deconstructivist virtualities. It represents a distillation of decisive historical intellectual turning points, or media emblemata, which are configured before the inner eye in changing combinations, allowing the visitor to form individual memories of the images.

For most visitors, the collage is a stimulating intellectual experience. The interactive structure nullifies any compulsory interpretation, such as the hermetic cosmology obtaining in Camillo's memory theater, and through its variety of historical citations, it becomes an actively experi-

Figure 6.7 Agnes Hegedues, *Memory Theater VR*, 1997. VR installation. By kind permission of the artist.

enced space for reflection. Although Hegedues makes conscious use of virtual reality imaging techniques in her memory theater, her interpretation of the immersion concept does not focus on sensory experience that leads to diminished inner distance. Hers is an experiment with creative, active immersion that encourages rapid combinatory interaction between the associative fields of images and promotes playful exploration of epistemological processes. It is an attempt to allow active production of memory through the juxtaposition of disparate, heterogeneous, even deviant elements, in spite of total sensory immersion in the media construction. Perhaps this method can point a way for the virtual spaces of the new media to actively encourage and support reflection and awareness. In this sense, Agnes Hegedues is not part of that substantial trend in media art which, with increasingly simple navigation of virtual spaces and adaptation of interfaces to the physiological disposition of the human senses, constrains

Figure 6.8 Daniela Plewe, *Ultima Ratio,* 1999. Interactive installation. By kind permission of the artist.

the individual imagination and further enhances the tendency toward passive consumption. In her memory theater, Agnes Hegedues shows us how art, in alliance with databases, can enrich our own memories through associative combinations of stored image and sound documents.

Ultima Ratio: For a Theater of the Media

In the longer-term perspective, the concept of utilizing interactivity to develop our creativity and our awareness is one of the most promising avenues that could lead to a new aesthetics of interactive computer art. A remarkable work that points the way is *Ultima Ratio* (1997–1998), by the German media artist Daniela Alina Plewe (fig. 6.8).[71] Plewe has studied at media art schools in Germany and abroad; currently, she studies philosophy, literature, and anthropology in Berlin and film and video in Paris. Her work *Ultima Ratio*, which has been exhibited in Europe, Japan, and the United States[72] and has received distinctions and awards,[73] succeeds in communicating not only the multilayered dimensions of its content through interaction, but also the form and expression of one's own reception, the manifestation of the individual user's dealings with the work in

the work. It offers reception, creative action, and strategic learning in conflict situations: a rare opportunity to expand one's self-image.

In dramas, novels, or artworks we often encounter serious conflicts, dilemmas, contradictions, and moments of ambivalence that, when concentrated within one character, serve to introduce irresistible suspense into the plot until, finally, the conflict is resolved in some way, for example, by making a fatal choice. In *Ultima Ratio*, the visitors stand under a disk-shaped projection screen with a radius of several meters—rather like a ceiling panorama. There, the interactor sees his or her options of pro and con arguments projected as abstract diagrams in real time. Visitors can expand the existing database by voicing new arguments, facts, or assumptions. Conflicts are reduced to logical structures and a modified decision-support system from AI research implemented.

The basic aesthetic experience of *Ultima Ratio* is conflict. Once involved, the visitor must make a choice, actively and creatively, to deal with an ambivalent situation. For example, a visitor involved in a well-known dramatic situation is asked, Should Hamlet kill Claudius while he is praying? Hamlet wants to avenge the assassination of his father, an argument for, but contemporary beliefs said that if one was killed while at prayer, one would go straight to heaven—an argument against. Pro and con arguments are visualized, can be weighed or automatically evaluated. *Ultima Ratio*'s databank stores various types of conflicts from life and literature plus the input from the installation's visitors. It is a flexible system of interactivity of theoretically limitless complexity, which is expanded by the discourse and modifications of the users. Justifiably, Plewe has suggested her model as an appropriate tool for the representation of knowledge in general on the Internet.

With *Ultima Ratio* Plewe is pursuing an ambitious goal: the attempt to generate a visual language for argumentation as demanded by a particular situation, which particularly represents the logic and internal arguments of the protagonists on which future action will rest. Plewe's visual language translates options for actions into images of arguments, which produces logical semantics and, thus, transcends the traditional concept of rationality. This is why concepts of neuronal networks or emergence play no role in Plewe's work. The choices based on words are visualized as 3-D diagrams in the virtual space. As yet, this possible iconic argumentation is at a rudimentary stage: The arguments appear as fragile and abstract bodies

in space, which represent their conditions, conclusions, and inner dynamics. An eyetracker is the interface to the virtual theater of strategic imaged arguments, which follows the visitor's gaze and enables the diagrams to be distorted according to any change in the observer's perspective.

Ultima Ratio's databank either suggests a selection of models to avoid conflict or, if desired, delivers argumentations appropriate to the specific conflict situation. Additionally, the system is capable of combining different dramatic motifs and generating new, synthetic characters to enter the action, ones that Shakespeare didn't include. The feature that accomplishes this is the "Crossovers—Tracing Motifs" mode. For example, the revenge-rule may lead from Hamlet to Medea, where also a rival-rule exists, as it does in *Casablanca* as well. "Cascades of Doubt" represents the characters' internal monologues, "Change Agent" and "Change World" allow the user to assume a new identity or enter a new game world, while "Reasoning Running Wild" reveals the ubiquity of possible doubts. Some of the other modes are "Inversions—Negations," "Modeling Virtues," and "Global Ponderer": The latter model allows the visitor to remain passive and watch *Ultima Ratio* run on its own. The mixture of all these playful components makes *Ultima Ratio* a fascinating work to experience, though some visitors may find it a complex and hermetic work. The transcultural and trans-media associations it evokes of being chained in our imagination to a drama in which we are but pawns in a game is strong and not easy to shake off, in spite of all interactivity and jumps through time and space. What *Ultima Ratio* offers is a first glimpse of an open system of theater, which allows the audience to participate interactively at a high level of abstraction and dramaturgy in the solution of open conflict. It is a vision of a future media-aided theater.

Exegetes of the Panorama: Benayoun, Shaw, Naimark

A war-torn landscape, ruined buildings, soldiers, tanks, debris, the wounded: Under a lowering sky of dark clouds, we move through a landscape scarred by death and destruction and pervaded by an apocalyptic atmosphere. Armed only with a camera, we are in a panorama of news pictures of many different armed conflicts—a universe of anonymous violence (fig. 6.9). Using a joystick, we navigate around soldiers of many countries and epochs. They stand like Potemkin villages in a kaleidoscopic

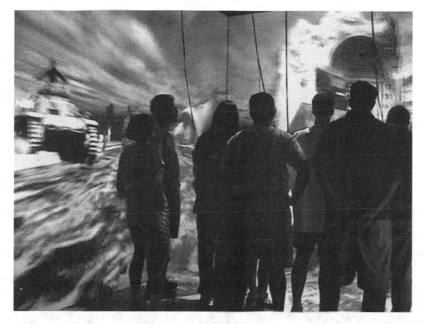

Figure 6.9 Maurice Benayoun, *World Skin*, 1997. Interactive CAVE installation. By kind permission of the artist. ⟨http://www.benayoun.com⟩.

pattern; stationary and lifeless images of war. The further we penetrate into the image sphere, the more we recognize how endless it is.

This disturbing work by Maurice Benayoun, *World Skin*, uses CAVE technology to transport the visitor into a virtual battle panorama[74] and won the coveted Golden Nica in the Interactive Art category at the Ars Electronica in 1997. The award of this highest distinction in computer art also recognized Benayoun's long-standing engagement with digital techniques and whose first success came in 1995 with *The Tunnel under the Atlantic*, an installation with great public appeal. Visitors to the Centre Georges Pompidou in Paris embarked on virtual journeys through space and time to meet with visitors to the Museum of Contemporary Art in Montreal in an image space.

Born in 1957, Maurice Benayoun cofounded Z.A. Production in Paris, a company of which he is still art director. His international reputation is documented by over forty awards and prizes and also by his appointment as communication consultant to the French government. *World Skin* is

Figure 6.10 Maurice Benayoun, *World Skin*, 1997. By kind permission of the artist.

viewed in a cube, an almost hermetically enclosed space, where the walls and floor are projection screens and only the entrance side remains open. It admits several visitors at a time to experience the images that cover the walls. Seen through Liquid Crystal Glasses, these appear in 3-D immediately in front of the visitors in the CAVE. Databeamers outside this area back-project the real-time pictures onto CAVE's semitranslucent walls so that inside, the graphics flow seamlessly leaving no areas blank, which produces the effect of being physically present in the images. This fulfills the essential requirement of all virtual art: enclosure of the observer within the image space—here in CAVE—to elicit a greater or lesser feeling of immersion and separation from the outside world. Thus, Maurice Benayoun reveals himself as an exegete of the panorama, who, using the latest image technology, takes up the idea and aesthetics of the panorama again and develops it further.

The installation's image space is a composite of pictures from many theaters of war, which are formed into a virtual panorama by a Silicon Graphics machine (fig. 6.10).[75] Within this panorama, the visitors take

pictures with a camera. Here, however, photography is a weapon of anni-
hilation: Whatever is "shot" exists for nobody any longer, for the fragment
photographed disappears from the image space, leaving a monochrome
area with black silhouettes, and a print of the image fragment is given to
the visitor on leaving the installation. In this way, the colored images dis-
appear completely and all that remains is a white section of screen.[76] The
portrayal of war by the media, which for the visitor is at first overshadowed
by the experience of immersion, becomes apparent through taking photo-
graphs. "Here the viewer/tourist," says Benayoun, "contributes to an am-
plification of the tragic dimension of the drama. Without him, this world
is forsaken, left to its pain. He jostles this pain awake, exposes it."[77] Fur-
thermore, it is the visitors who destroy the virtual space by taking pic-
tures: "First by our aggression, then feeling the pleasure of sharing, we rip
the skin off the body of the world. This skin becomes a trophy and our
fame grows with the disappearance of the world."[78] The camera becomes a
weapon: The synaesthesis of exploding flashlights and rising staccato of
gunfire mutually enhance the effect of the other.

In the history of technology, the camera has many associations with
weaponry of annihilation, from Etienne Jules Marey's photographic gun to
today's remote-controlled cruise missiles, whose constant stream of relayed
images ceases only with the destruction of the enemy and its images. In
the early years, image production had difficulty keeping pace with ballistic
techniques, but with the advent of cinematography and video, image
speeds began to approach those of the missiles, which in turn increasingly
assumed the function of cameras. Humans are getting farther and farther
away from the battlefield. Inventions that utilize telepresence are only the
latest vanishing points of a development that has been going on now for
decades. The real experiences of battle, such as those shown in the Sedan
panorama in its own particular pictorial language, are increasingly a rarity.
Modern warfare is telewarfare, waging hostilities from a distance, and
media warfare, experienced as a game to test all conceivable variations
of strategies in simulations. This critical analysis represents Benayoun's
approach to the panorama. The experience of war through images is inter-
fered with, destroyed, by the medium of photography in *World Skin*. It is
about the role of images in our perception and appropriation of the world.
Terrible real events are reduced to "significant surfaces" (Vilém Flusser).
Although the news pictures are of real events, they do not allow us access

to this tragedy without end. The violence inherent in the act of rendering reality flat, false, of reducing it, is commonly held to be characteristic of photography. In *World Skin*, the ubiquity of the photographic images creates a second visual skin that blankets reality and, in our memories, replaces it. Bit by bit, *World Skin*'s panoramatic collage of image fragments is erased, neutralized. The actions of the visitors cause a clean and nonsymbolic data space to appear: They tear the skin off the image space and leave in its stead—nothing. To Maurice Benayoun, photography represents death, and here he is in agreement with Vilém Flusser, for whom photography and war are both means of eradicating events from history: "Like war, like photo: time stands still in both."[79]

In *World Skin*, sound plays a seminal role in creating the effect of immersion. Jean-Baptiste Barrière's composition[80] reflects the topography of the image space, both in its texture and by characterizing its potential. Total immersion is achieved only through the synaesthesis of these effects, for not only does the sound enhance the immersed state, it also encourages the visitors to destroy the image part of the immersion: What at first sounds like a camera shutter when the visitor takes pictures soon transforms into the sound of gunfire. According to how often the camera is used, the sounds increase until they resemble the rapid fire of an automatic machine gun. The behavior of the visitor parallels that of machine-gunners, first observed in World War I, who were unable to take their fingers off the trigger of their weapons once they had begun to fire. The visitors hear a rising crescendo of gunfire, which gets louder as the images are destroyed, until the extent of the damage is so apparent that they are jerked out of their immersed state.

Jeffrey Shaw, who has many years of experience with immersive media, consciously takes up the tradition of the panorama in *Place* (1995), which combines photography, cinematography, and virtual reality. Since its creation, there have been several versions of this installation, which cites the older medium of the panorama within the new one of virtual reality.[81] The first *Place* surrounds the visitor with a 360° panorama screen and allows him to move through the landscape projected onto it,[82] in which further photographed panoramas in cylindrical form are embedded. The total arrangement of these different elements constitutes the panorama. From a central rotating platform, the visitor uses the zoom on a video camera to focus on particular zones in the virtual space. This interface facilitates

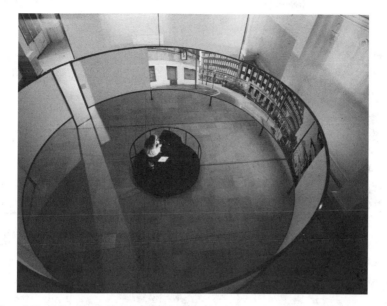

Figure 6.11 Jeffrey Shaw, *Place Ruhr*, 2000. Interactive panorama landscape. By kind permission of the artist.

navigation and allows the visitor to enter the individual cylinders, which were photographed using a panorama camera in places such as Bali, France, Japan, and La Palma. Shaw arranged these panoramas on a line drawing of the Sephiroth, a sign from the Cabbala, which is also visible in the viewfinder of the camera. The original design of *Place* encompassed many world locations, but the system is highly flexible and Shaw modified it in 2000 for the exhibition Ruhr-Vision in Dortmund, Germany, to focus on landmarks and locations that represent and document the economic and social history of the Ruhr (fig. 6.11).[83]

Jeffrey Shaw was born in 1944 in Melbourne, Australia. From 1963 to 1965 he studied architecture at Melbourne University and then art at the Accademia di Belle Arti di Brera in Milan and St. Martin's School of Art in London. Since the late 1960s, he has been regarded as one of the pioneers of media art. He is currently a professor at the Hochschule für Gestaltung in Karlsruhe and director of the Institute of Image Media at the ZKM in Karlsruhe. Experimentation with immersive image spaces is a hallmark of Shaw's oeuvre, from his early work in the Expanded Cinema movement (in his classic work, *The Legible City*, which was also modified

and varied many times, visitors explored several square kilometers of a virtual urban environment made up of letters of the alphabet), to his *Extended Virtual Environment*, EVE, and his latest installations, like *Place Ruhr* 2000, which are utilizable in multicultural contexts. In this version, the configuration is expanded to include film sequences, and visitors can experience immersion in twelve places in the region, such as coal mines, ruined industrial buildings, and the panoramic view from the top of a gigantic slag-heap. Once inside an image space, the stills come alive as a film sequence runs. Shaw does not use programs with agents or evolving image spaces to achieve his impressive effects, as evidenced by *Place Ruhr 2000*, but traditional methods enhanced by interactive elements. One can "enter" a wide variety of places that demonstrate the profound transformation that this region, once entirely dominated by heavy industry, has undergone, for example, a cemetery with the graves of ninety-four miners who were killed in an explosion caused by firedamp; a coking plant, once one of the world's largest; the velodrome in Hoesch Park, built in 1939 under National Socialism as a job-creation measure. Experienced in immersion, these places leave a melancholy impression of a region indelibly marked by industrialization; the velodrome, where workers once spent their free time, is now derelict and trees push their way up through the concrete. *Place Ruhr 2000* creates a space that is a memorial to the people and culture of industrial society of a particular region but at the same time resembles so many others around the world that have been radically changed by industrialization and are today moving in new directions.

In March 2001, the Taliban blew up several colossal statues of the Buddha, which dated from pre-Islamic times, in the remote mountain valley of Bamian. Massive international protest in the run-up to this act of destruction was to no avail, and a part of world cultural heritage is now gone forever. The Buddha statues were not even well documented—not that photographic images could in any way make up for the loss of the unique works of art that the iconoclasts destroyed. But would awareness of cultural treasures be greater, perhaps, if more people could travel to UNESCO-listed sites of world heritage, at least with their eyes? This faint hope is the starting point of Michael Naimark's work *Be Now Here*, created in 1994 with support by the UNESCO World Heritage Centre, Paris for the Center for the Arts Yerba Buena Gardens in San Francisco (fig. 6.12).[84] *Be Now Here* is an immersive environment, consisting of a large 3-D video

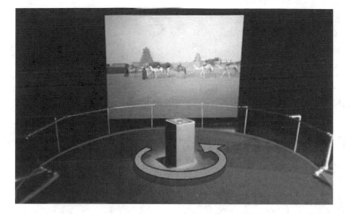

Figure 6.12 Michael Naimark, *Be Now Here*, 1995. 3-D panorama installation.

projection screen and quadrophonic surround-sound with, like the old panoramas, a rotating platform at the center for the visitors from where they can interact with the environment. Its design is not dissimilar to Jeffrey Shaw's *Place*; in fact, the two works were created at about the same time. In the best tradition of the panoramists of yore, Naimark traveled to out of the way heritage sites to take his panoramic views. Using a special camera, he wanted quality images that would both document and appeal to an audience. Dubrovnik, Croatia, Timbuktu in Mali, and Jerusalem are included in Naimark's panorama of world culture, as well as Angkor in Cambodia. He used a 35mm 3-D camera, developed by himself and his colleagues at Interval Research Corporation, which has two wide-angle lenses and is powered by special motors that can take 60 exposures per minute. Mounted on a motor-driven tripod, the camera takes less than one minute to revolve 360° and then a high definition 3-D panorama is "in the can."

Michael Naimark was born in 1952 and has taught at several world-famous institutions, including San Francisco State University, California Institute of the Arts, and MIT. His international reputation has brought his invitations to join the editorial boards of *Leonardo EA* and *Presence*, the foremost specialist journal of virtual reality research. Throughout his entire artistic career, Naimark has worked on and experimented with various forms of immersion. A pioneer of the first generation, along with Krueger and Shaw, he has been associated with computer art and related research

since his youth. After studying at MIT, in the late 1970s he developed the first interactive laser videodisc while in Nicholas Negroponte's Architecture Machine Group. For this project, the city of Aspen was filmed by taking shots at intervals from a car that was driven along all possible fixed routes. The result was the legendary *Aspen-Moviemap* (1978–1980). The history of the vision, to document places without losing any image definition, drives both this book and another project Naimark was involved in the late 1980s, when plans to rebuild The Globe Theatre in London were underway.[85]

The leitmotif of Naimark's oeuvre is immersion, which he defines simply as the feeling of being inside rather than standing outside.[86] Unlike the individual experience offered by installations such as *Osmose* or *The Home of the Brain*, Naimark concentrates mainly on public space immersion, where several people at a time can share a media environment. He regards immersion driven by computer graphics critically and has remarked that few practitioners in this field have any sense of the aesthetics of field work. Naimark sees his own panoramic landscapes as belonging to the tradition of landscape painting, ethnographic field work, and cinéma vérité.[87]

Naimark is a world traveler, a man who has not only explored and researched the new horizons of the new media but has also journeyed to the farthest corners of the earth to immerse himself in different human societies. In the mid-1980s, he visited the Ifuago tribe in the mountains of the northern Philippines, at the time, a people almost untouched by Western media culture. The Ifuago, known for their ancient cultivation of rice on terraces, head-hunting, and, according to Naimark, their firm belief in dreams, adopted Naimark as a son into the family of a shaman. The trip was also part of a research project that had originated from discussions at the Atari Research Lab, where Naimark then worked, concerning what are the basic questions people ask that could be answered by a hand-held computer. For this project, Naimark traveled a very long way indeed. Without being aware of it, Naimark did the same as Aby Warburg had done with the Navajo Native Americans: He visited a remote people to pose an anthropological question, to find answers to the latest riddles posed by his own civilization. At that time, the future development of the Internet was unimaginable and hand-held computers with Net connections only a vision, but for Naimark it was not in the least absurd to

ask the inhabitants of a remote region which questions such a device should be able to answer. Today, the technology exists, and global media, video, TV, satellite dishes, and the Internet have changed the culture of the Ifugao radically. In 1992, Naimark continued his Moviemap studies with a 3-D panorama camera at the Banff Centre for the Arts in Canada and laid the foundations for his panorama of world culture, *Be Now Here*.

Mixed Realities

Discussions of so-called mixed reality, a catchword that is still new and trendy, currently center on connecting real spaces, including their forms of cultural and social action, with image processes of virtual environments.[88] One advantage of mixed realities is that in general, the observer is not obliged to wear an oppressively heavy HMD or forced into the computer-generated body of an avatar; mixed realities make orientation easier while still allowing interaction with new fields of action. Thus, the hermetic image strategies, as represented by the HMD or CAVE, have now been joined by a concept of hybrid spaces, part real and part virtual. They are dialectical connections of physically and media-communicated image spaces,[89] where usually a darkened space is linked to a large format screen to form a mixed reality.

Since 1998, Monika Fleischmann, Wolfgang Strauss, and their team have been working at GMD to modify their *The Home of the Brain* installation and transform it into a viable Internet VMRL (virtual reality modeling language) application, within the framework of the eRENA Project, which is supported by European Union funds. *Murmuring Fields*,[90] as the work is now called, is an attempt to create a hybrid space, a combination of projection screen and a viewing room, which does not alienate the observers from their own physical perception (fig. 6.13). The artists state that the goal of their strategy is to emphasize the body and its materiality and integrate its dynamics into virtual action spaces.[91] This declared intention distances their concept from strategies of unconscious immersion and evidences their aim to promote awareness in interactive and communicative spaces.

Murmuring Fields can be shown in a CAVE or, as has been the case at festivals so far,[92] on a screen with databeamer projection. A black-and-white camera positioned on the ceiling of the installation's real space tracks the actions and movements of two visitors (maximum), registering

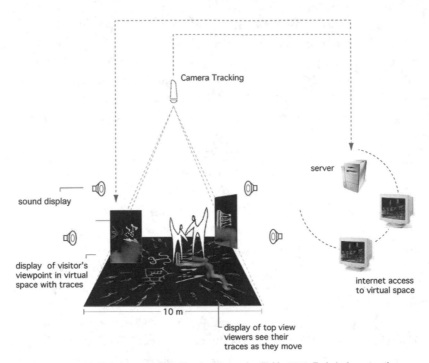

Figure 6.13 M. Fleischmann and W. Strauss, *Murmuring Fields*, 1999. Technical construction. By kind permission of the artists.

them as mobile, dark forms against the bright background of the floor. This is mapped onto the images of the virtual space, where the visitors are embodied as rudimentary avatars, represented by traces of colored dots that move in the two-dimensional image space according to each movement or step of the visitors. The eMUSE[93] System for *Murmuring Fields*, which was developed in the MARS Laboratory, combines VMRL and Java technology, which in theory allows Internet users to intervene in the work in process and contribute to the production of the mise en scène. In *Murmuring Fields*, the stage, an audiovisual playground, is empty except for murmuring sounds that accompany the visitor's footsteps. The visitors feel their way toward the source of the sounds like blind persons and, step by step, develop an idea of what the virtual data space is like. On a second level, the sounds are depicted as visual symbols and projected onto the floor for the visitors' orientation. Experience with the installation has shown that the graphic symbols disorient some visitors. However, the

majority find this visual solution stimulating, in spite of the slow framerate. When a visitor navigates the sound space, the tracks of their movements are stored by the computer to build up and depict a spatial plan of their actions. There is no pregiven "story" but, instead, a dynamic cycle of action and perception. For example, while moving through a field of abstract sketches on the screen representing one fragment of the thought space *The Home of the Brain*, a visitor can activate a corresponding field with acoustic elements. This is the basic concept of the mixed reality stage: a virtual space full of information, which is activated, revealed, reorganized and recombined, added to and transformed as the user navigates the real space. The soundscape promotes the aesthetic and intuitive relationship to the environment, which depends particularly on the "natural" full-body interface that cannot be seen or touched. The idea is to enhance awareness of one's own body and develop the concept of the avatar as a channel for communicating by movements and gestures that is an extension of one's own body.[94]

However, this may not necessarily be the case. In HMD or CAVE installations, whose image worlds have rather more complex representations of the user as avatar, the body is active only within the limits imposed by the particular installation and there is little reason to suppose that there the user is less aware of his or her body than in a mixed reality environment. The decisive issue remains the suggestive quality of appeals to the senses and the nature of the interface, the distance resulting from a nonintuitive connection to the world of sensory input. Thus, mixed realities are not of necessity nonimmersive, as some claim; in most cases, their design promotes the tendency to sink into the suggestive space of images. When, as in *Murmuring Fields*, the visitors remain in a dark space (fig. 6.14) and concentrate visually on a brightly lit reference scene of their actions, their attention is not directed toward the dark room with one's body in it but rather, as in cinema, is drawn out of the real space inexorably toward the screen.

Obviously, mixed realities form an integral part of the prehistory of media evolution described here. Their combining of elements of physical and virtual spaces is leading to the emergence of a new cultural technique. The prologue is being written by artists, such as Fleischmann, Strauss, Sommerer, or Pleve, whose installations have the ability to mobilize

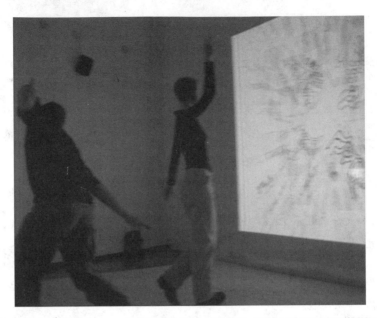

Figure 6.14 M. Fleischmann and W. Strauss, *Murmuring Fields*, 1999. Mixed realities installation. By kind permission of the artists.

emotions. They are making an important contribution to expanding the boundaries of visualization and the possibilities of visual intelligence, to differentiation of the degree of possible complexity and, thus, to amelioration of the bittersweet side of immersion. This may help virtual spaces cast off their reputation as surrogates sooner than expected and to aid their development toward a new role as augmenters of experience in the physical world.

Virtual Reality's Dynamic Images

Compared with traditional images and their fixed materiality, digital or virtual images are categorically different. In many ways they no longer resemble what used to be called a picture; unlike a photograph, for example, a computer image—an implosion of the image, the real, and the imaginary—is nonreferential. It may well be based on a source image; however, this does not necessarily have to be the case (fig. 6.15). From this principle and the construction process of its origins described above, it follows that a computer image represents truth no more and no less than

Figure 6.15 3-D scan, 1999, scanned with a Cyberware scanner. Scan datasets obtained at SIGGRAPH '99. Courtesy of Cyberware.

any other work of art, regardless of form, whether a painting, a mosaic, or something else. On the one hand, a property of the image is its visible appearance, which is concrete; on the other, its basis in numbers, or code, is an abstraction. Therefore, a digital image, stored in electronic form, is an oxymoron. Although the image is experienced with the eyes, the observer is a long way off from being able to program it on the basis of its appearance alone.

With the exception of evolutionary image processes, the concept of "the original" is foreign to the computer. With regard to the data, there is no difference between an original and a copy, for the machine's system protects the structure from any intentional or unintentional modification. Thus, there is no original to be protected from copying. Software and its supporting hardware configuration can be reproduced at will, whereby no difference can be ascertained between the new environment, the copy, and its original model. Furthermore, the reproduction of an original work, if it is recognizable as such, serves to promote the aura of the original.[95]

For an artwork of virtual reality, which knows no original, connotations of the cult of uniqueness, in the sense used by Walter Benjamin, do not obtain. In digital art, the aura originates through artificial inaccessibility or deep, immersive contact with the work—for example, when observers

are obliged to travel long distances to a festival to see a stand-alone installation of a much-discussed virtual work that is rarely on show owing to the expense involved. In theory, it would be possible to replicate this work any number of times, but in practice, it is seldom to be seen in its spatially polyvariant form and the image worlds it generates differ each time it is viewed.

Digital form permits almost infinite variability of the image, but this bears no resemblance to the manipulation of photographs or video recordings. Although it will not be detectable later, all individual elements of the image can be changed, pixel by pixel, as well as its totality, for example, by changing the color or contrast scale.[96] In good light, humans can distinguish between about 10,000 shades of color. The latest generation of computers, which can produce 16.7 million colors through finely adjusted combinations of the primary colors of light, red, green, and blue, exceeds by far what humans are physiologically capable of distinguishing. However, it is still not possible for computers to create true colors reflected by solids.

The appearance of images rarely reveals any information about the code on which it is based. Although storage conventions determine precisely what kind a certain file is, vastly different quantities of data may exist without affecting the appearance of the image in any way. One line of programming, for example, is sufficient to determine the size and position of a hatched square. However, if we define each single line, then the same shape requires a data file of enormous size. The code is invisible at the surface, so it is impossible to say anything about the structure of the code, which may be chaotic and "dirty," or organized and "clean." Conversely, the code will not tell us anything at all about the complexity of the image.

Digital imagery is not tied to a particular carrier medium, and thus their manifestations can have many different formats and types (fig. 6.16). Experienceable in real time and transformable, they can appear on a miniature LCD monitor in an HMD, on a cathode-ray tube monitor, or in large dimensions from data-beamers projected in a CAVE. Only through a series of real-time calculations, which produces the fleeting interplay of light rays and luminescent bodies in a monitor for only a fraction of a second, can the effect of an existing entity be created on the retinal afterimage, already described by Goethe in his *Farbenlehre*. The ontological status of the image is reduced to a succession of light beams. Real-time calculations are also the foundation of the image's apparent changeability,

Figure 6.16 HyPI-6: 6-Sided-Cave. Fraunhofer-IAO; IAT University Stuttgart CC Virtual Environments 2001. By kind permission of Oliver Stefani.

the possibility of entering it, and, consequently, these types of interaction with the observer. The image sphere constitutes itself, both technically and aesthetically, only in conjunction with the actions of an audience; however, this can influence the work only within the program's framework, according to the method of multiple choice.

In virtual reality, 3-D images are projected in HMD monitors as two 2-D images. The spatial effect results from stereoscopic vision and is formed in the observer's cortex. Thus, the images leave their media in a twofold sense: a 3-D image, which has no physical existence except, perhaps, in the excited neurons of the brain, forms a constitutive unit together with the observer and is nonseparable from him or her. Recently developed laser scanners can now beam virtual images directly onto the retina. Although such pictures still belong in the category of images, if the retina suffices as a medium, these are the most *private* of all images imaginable so far: The ontological dimension of the image dissolves for laser images. In this age of dynamic images based on calculations, the question arises whether the term "image" is still an appropriate characterization, or whether the virtual image should be interpreted instead as a neural category.

Virtual imagery proposes "as-if" worlds. In a potentially infinite, additional space, it develops extensive representations, which connect largely with the appearance of experienced reality, developing it or overwriting it, and the dynamic capability of genetic algorithms appears to bring it to life. Virtual images rely on the ability of computers to copy real or model imaginary worlds while at the same time referring to a utopian space of what is possible. Nevertheless, these representations of complex environmental systems are still based on intelligible formulae and the illusion on logical comparisons. Virtual space is an automatic illusion of hard- and software elements, a virtual image machine that is based on the principle of real time.

Integrating a representation of the observer's body into the image sphere can augment the immersive function of virtual image spaces. Like a marionette, this avatar is dependent on the physical movements of the observer.[97] Via hard- and software interfaces, the sensory and the communication systems of the body can couple to all imaginable forms of simulated existence. Incorporated in the imagery as one or more multifaceted artificial bodies, the observer experiences conscious phenomena deriving from this situation: Each artificial identity has its own perceptions, moves in a specific environment, and possesses an individual reality.[98] The feeling of *being inside the image space* is intensified still further when it includes "agents," representations of artificial beings that behave in a subjective way and seem to coexist with, or to react to, the observer in the virtual space.[99] Agents were developed from programs that filter and process vast amounts of information.[100] In simulated environments, they are often part of anthropomorphic[101] or animal-like systems, where they behave predictably, meet their individual fate, and influence the future development of the environment.[102]

In worlds of virtual images, many forms of the image merge with elements addressed to sense organs other than the eyes.[103] Added to the 360° form, this results in the tendency of the image to negate itself as an image. Media history now confronts an illusion of a dynamic virtual image space where image and image space have been transformed into a variable sphere. It translates sensory intervention into image fields or image spaces, creates them in the first place through interaction, or they are "brought to life," changed unpredictably and unrepeatably by evolutionary image processes. Real-time calculations expose the dynamic image to modification

Figure 6.17 Visualization of the geography of the Internet, September 1998. Internet connectivity graph by Bill Cheswick and Hal Burch. © Lucent Technologies. Published in: *Wired Magazine*, December 1998. ⟨http://cm.bell-labs.com/who/ches/map/gallery/wired.gif⟩.

that is potentially unlimited. Perhaps in the near future, intuitive, natural interfaces will succeed in removing the last vestiges of a boundary between them and the observer who will be able to interact with subjective software agents inspired by biological processes. Dynamic image worlds will possess an as yet unimaginable potential of suggestion; images, out of control and apparently recreating themselves, ever changing, containing information that will soon outstrip the resolution capacity of the human eye. The threshold on which we stand, to open, interactive, evolutionary image spaces, heralds not only a "culture of the moment," but also the loss of the image's historical status as "witness." The mnemonic function of an immutable and fixed work capitulates to arbitrary manipulation of the image where recapitulation is impossible and will ultimately fall victim to system frameworks that last for perhaps only a few years. The image is in danger of becoming a transitory phenomenon.

In computer images, a manifest form has disappeared, and the worldwide transport of data via networks marginalizes the existence of any actual location for them. When image worlds transfer to the Internet and are accessible globally, as is envisaged, we may see virtual dynamic images coupled with other virtual spaces in complexes, transformed by

intercultural exchange, and developed, in the sense of emergence (fig. 6.17). Currently, the vanguard of virtual reality on the Internet is represented by the panorama-type formats *Quicktime VR* and *Virtual Reality Modeling Language* (VRML), which expand Internet images into the third dimension.[104] VRML is a file format for mainly static scenes on the Internet, which can visualize 3-D images. One needs only a standard PC, for example, to enter buildings and move through landscapes, interacting naturally. VRML was not developed by computer scientists but is the product of a mainly California-based subculture of computer enthusiasts who, in the late 1990s, were all influenced by cyberspace hype and shared the vision of William Gibson. These prostheses appear to be clear expressions of the desire to create a world of illusion on the Net. Illusions, which are at present still much more effective on stand-alone systems, will probably relocate to the Internet as soon as bandwidth, speed of data transfer, and compression software allow. Then virtual reality, the grandchild of the panorama, will be implanted in the Net.

Although it is theoretically possible to preserve virtual images and their programs forever without the slightest change being perceptible, it is impracticable for they are dependent operating systems and storage media, which are being replaced at an ever-faster rate.[105] It would take a great deal of expense and energy to transfer artworks to new forms of storage because of their individual and technical complexity, and thus, technical progress leaves them behind. The example of NASA is often cited in this connection: It is no longer possible to read the data collected by the Saturn mission of 1979; all the tapes still exist but the hardware to read them does not. Changing media and consigning art created for them to the scrap heap are elements of the same mechanism that led to the decline of most European panoramas a century ago: The operating systems of today are the protective rotundas of yesteryear. An entire decade of virtual art production threatens to be lost, for until now, this art form has not been integrated into the art market, despite its tremendous success at exhibitions, and museums have not acquired the necessary conservatory competence or technological requirements to collect and display these works. In the main, museums have neglected to secure works of computer art for their collections, and long-term concepts for collecting virtual art, for example, in collaboration with computer centers, museums of technology, and manufacturers, simply do not yet exist.

The Computer: Handtool or Thinktool?

Any characterization of the role of the artist in virtual reality must interrogate the status of the computer. Is it really comparable with a tool? With a paintbrush, for example, an extension of the artist's hand that is dependent on his or her skill and the imagined work, which transfers information of the artist's hand analogically?[106] In the work process, a dialectical confrontation does not arise, or only to a minor degree, between the artist's conception and the tool at hand; yet the skillful wielding of that tool is primarily a result of practice. Tools invoke a specific kind of knowledge based on experience that is formalizable only to a limited extent. By contrast, a computer, or at least one that is part of a network, with its hard- and software configurations is an apparatus capable of transforming the artist's conception through dialogue and options arising in the course of the work process. The possibilities are, however, finite: artistic processes and ideas alike are constrained by technological limits. At the beginning of the 1990s, the linkage of creative artistic processes with computers was still regarded with skepticism. One standpoint, representative of this way of thinking, spoke of this "media work" making the artist totally redundant and utterly disempowered: "In principle, these processes are developing in a direction that will gradually absolve humans from all active participation in the process of production and, if necessary at all, grant them the status of mere observers."[107]

However, in view of the complex work of research and planning, which is essential for selecting the optimal software to realize the artistic conception, and the dialogic nature of the process of discovery and selection, this assessment is problematic. Theoretically, if the computer metamorphoses into a *universal translating machine* for sensory impressions, then it should be considered a thinktool. The artist realizes a conception in a dialogue with a system while seeking what is possible. Traditionally, the tool is regarded as a "witness" of the work[108] and is gradually used up or worn out in the process. Although such terminology as "tools," "toolbox," "programmer's workbench," and so on is common usage in connection with the computer, the concept is inadequate. The computer offers the artist options such as rectifying errors, duplication, randomly generated combination and recombination, continual feedback, reversibility, and visual-polysensory design of effects that can be selected from a palette of options. Graphics programs are based on the simple atomistic binary code

of 1 and 0, or true-false values, but the variety of formal elements, in forms, words, sounds, and movements, they can describe is astronomical. Once programmed, saved, linked to menus or files, and labeled by pictograms, it is possible to create any number of different forms. The structure of the program's data characterizes the given software: What you can do with a program, what it looks like, and how it "feels," depends on the abstractions on which it is based. To put it briefly, the structure of a program's data organizes symbols for a specific purpose. Graphics programs, like *Freehand*, can produce filigree lines through particular organization of complex data, but cannot be modified easily for animation or software–user interfaces, for example. This might seem trivial to some programmers or users, but it is a fundamental difference from traditional tools and from the computer artist who works mainly in an object-oriented way, processing abstract models, interpretations, and formalized laws.[109] Many computer operations are neither continuous nor linear; the process of creation more closely resembles a dialogue. For many years, the only mode of operation was the question and answer dialogue, an abstraction that effectively created a considerable distance between artist and work, before menus and the graphic user interface (GUI) became standard. Although this allows the artist to retain a certain distance from the work and the material, it does entangle him or her in a method of operation defined by dialogue, with numerous although a finite number of directions. Thus, attention and creative thought are bound, to a large extent, to the interactive features of a program.[110]

The metaphor of the tool evokes associations of human sovereignty over tools and material, but digital media require the artist to relinquish a part of this sovereignty in exchange for new and effective means of design. Conversely, the artist now operates within the force field located between the domination of the tool utilized and emancipation from the normative power of the tool, that is, its domestication.

Computer work is characterized by standardization: continual repetition of the program, copying fragments of images, processing, pasting, collaging them, and so on. This subjects the artist to a kind of algorithmic automatism, which at times renders creative work independent and automatic: Even unplanned, chance products can be generated that deviate extremely from the original model. Particularly genetic algorithms, combinatory aleatory processes that initiate an evolution of the image, allow

today's artists to create objects or landscapes with a precision and surrealism that is hardly possible to realize with imagination and drawing technique alone.[111]

How does creative work with programs affect the results in the sense of a creation that is intellectually controlled by the artist? On the one hand, there is the interplay between active design and accumulating notation, and on the other, the "active" participation of the computer, of the medium:[112] An artist can immerse himself in the creation of an artificial world and develop spatial models, design artificial agents, and define polysensory feedback or genetic algorithms. With experience and technical skill, it is also possible for the artist to estimate the visual potential of the program elements and imagine possible combinations. Like the game of chess, masters distinguish themselves from amateurs by their ability to predict, to *see* in advance the appearance of the decision trees of combinatory processes. Yet ultimately, it is the intellectual vision, transposed into the work step by step with technology as its reference, that remains the core of a virtual work of art.

Additionally, the computer is a medium for archiving and communicating.[113] At the very latest, when one considers how this information and communication medium with its worldwide electronic networks produces dialogic, dynamic, transmutable images that are totally immaterial, it becomes clear that the metaphor of the tool is inadequate. Through the Internet, global access to programs and image data sources has expanded in immense and incalculable ways (fig. 6.18). Artists from anywhere in the world can now participate in the creation of a work. Groups of artists separated geographically by vast distances, who might never have encountered or even heard of each other, can now collaborate, in structures similar to e-business, at the same time on various continents, in shifts, at different times, theoretically day and night. These open systems, connected by networks, open up endless and unimagined possibilities for distributed co-authorship. This fundamental extension of the radius of work and the possibility of strolling, like Walter Benjamin's *flaneur*, through networked virtual spaces one day, when the capacity of the digital networks has increased, will demand a profound shift from local cultural horizons to transcultural artifacts; in other words, to global production and representation of knowledge.[114]

Figure 6.18 *AlphaWorld*. Satellite maps of the urban development by Roland Vilett (December 1996–August 1999). Activeworlds.com, Inc. ⟨www.activeworlds.com⟩.

Notes

1. Born in 1962, Yvonne Wilhelm studies communications design in Munich; as a video-artist she has exhibited at many international festivals of media art.

2. Born 1962 in Loeben, Austria, Christian Hübler studied at the Kunsthochschule für Medien (Academy of Media Arts) in Cologne and has received grants from several European institutions.

3. Born 1962 in Vienna, he studied electronic music. In the late 1980s, Alexander Tuchacek developed interactive software for improvised music. In 1992, he worked on the Electronic Café for the Dokumenta IX in Kassel.

4. Hermann Claasen Prize for Media Art and Photography 2001; International Media Art Award ZKM Karlsruhe 1997; August Seling Award of the Wilhelm Lehmbruck Museum 1997; Prix Ars Electronica, Golden Nica 1994 and 1998.

5. The installation was realized in cooperation with Detlef Schwabe, Markus Brüderlin, and Peter Sandbichler of ARTEC in Vienna and sponsored by the KHM and Hamburg's Department of Culture. It exhibited, e.g., at ISEA 1994, MCA Helsinki, Kunstraum Vienna 1995, Kunstverein Hamburg 1997, DEAF 1997, and the Wilhelm Lehmbruck Museum in Duisburg 1999.

6. See Knowbotic Research (1994, 1996, 1997).

7. KR+cF were given access to data from the U.S. National Science Foundation and the Alfred Wegener Institute for Polar and Marine Research in Bremerhaven, which they visited on a weekly basis. Norway, New Zealand, and Russia also provided data. However, they were unable to get satellite data less than two weeks old except for the online data provided by the Alfred Wegener Institute.

8. See Galison (2001); Kemp (2000).

9. See Hans Ulrich Reck, "Computer Aided Nature: Knowbots und Navigatoren: Ein Gespräch u.a. über Kunst, Wissenschaft und korrespondierende Realitäten zwischen Hans Ulrich Reck und Knowbotic Research," in Reck et al. (1996), p. 4.

10. See Hans Ulrich Reck, "Sprache und Wahrnehmung an Schnittstellen zwischen Menschen und Maschinen," in Kunst und Ausstellungshalle der Bundesrepublik Deutschland (1998), pp. 244–271, citation p. 257.

11. Baudrillard (1989), p. 123.

12. *The Home of the Brain* was exhibited between 1991 and 1992 at the Architekturforum in Zürich, at the Soft Target exhibition in the Künstlerwerkstätten in Munich, at Ars Electronica in the Landesmuseum in Linz, and at the New Realities—Neue Wirklichkeiten II exhibition in the Museum für Gestaltung in Zürich.

13. ⟨http://www.artcom.de⟩.

14. Institut für Medienkommunikation.

15. ⟨http://www.viswiz.gmd.de/VMSD/PAGES.en/mia/f_mars.html⟩.

16. Responsive Workbench—Spatial Navigator, for *The Home of the Brain*—Virtual Balance, for *Skywriter*—Touch Interface, for *Liquid Views*—Interface for Distance and Approach for Rigid Waves—Interface for Movement (Camera tracking) and Dynamic Gesture (Theremin).

17. VPL-Dataglove with the software VPL BodyElectric.

18. Radiosity Software, an ART+COM in-house development, OS CD-ROM, and IRIX Development CD-ROM.

19. The screen measures 2.9m × 3.2m and the projector is a Sony Databeamer 3CRT.

20. Strauss in an email to the author, December 15, 1998. More recently, the artists explained their idea as follows: "The audience in front of the screen functioned as the choir in Greek tragedy and thus had a different role to the usual viewer for they comment on the navigation and interaction of the cybernaut: 'Please go back to Flusser's red corner.'" Email to the author, May 27, 2001.

21. Email to the author, May 27, 2001.

22. Wolfgang Strauss and Monika Fleischmann in *film und arc* 1, December 2–5, 1993, Graz, Austria.

23. Originally, Fleischmann and Strauss conceived *The Home of the Brain* as a discursive event for the theater. The idea was inspired by Berlin's Schaubühne Theater production, *Rudi* (1986), at the Filmhaus Esplanade, directed by Klaus Michael Gruber. However, the nonavailability of their protagonists of choice obliged the artists to transport the event into the virtual sphere.

24. Monika Fleischmann: "There are many people here [in the virtual Neue Nationalgalerie] whose opinions should be canvassed and heard because technological developments and their effects on our real world are not the exclusive concern of computer scientists." Unpublished draft dated November 22, 1991, author's personal archive.

25. Flusser died in a road accident just before the project reached completion.

26. See Böhme and Böhme (1996). In the Middle Ages, the doctrine of the elements was reinterpreted according to Christian theology and the neoplatonic

school of Marsilio Ficino gave new life to Plato's cosmology. The four elements were given a secular meaning and served as an analogy for the theoretical structures of contemporary philosophers. In his work *Iconologia* (Rome 1603, p. 123), Cesare Ripa presents a referential framework for depicting the four elements. Alchemy also took up the tradition of the four elements. On the iconography of the elements, see also Frey et al. (1958), pp. 1256–1288.

27. The four debating philosophers is a motif that also has medieval associations: See Esmeijer (1978), ill. 26.

28. Some examples of studies on the history of constructions, ideas, and significance of stereometric spatial forms: the pyramid—Hermann (1964), and Schmidt (1970); the cone in the Middle Ages—Baltrusaitis (1960), and in the nineteenth and twentieth centuries, Sedlmayr (1939/1940). On Ledoux and Boullée in particular, see Reudenbach (1989), esp. pp. 50ff. See also Vogt (1969), pp. 294ff. On the connections between mathematics, optics, philosophy, and art, see Richter (1995).

29. The selection of colors in *The Home of the Brain* does not derive either from Plato or Alberti's four *veri colori*, which assigned ash gray to the earth (Albert 1975), or from Leonardo's six colors (see Leonardo da Vinci 1882, p. 274).

30. These are catastrophe, hope, utopia, and adventure. The system of philosophical leitmotifs faintly recalls Goethe's *Farben-Tetraeder* (color tetrahedron) of 1816/1817 (ill. 90), which associated the colors blue, yellow, green, and red with understanding, reason, sensuousness, and imagination. This is a similar arrangement.

31. For a detailed description, see Esmeijer (1978), pp. 59ff.

32. On the intercultural aspects of quaternity, see Jung et al. (1968), pp. 73ff.

33. See Fleischmann and Strauss in Fleischmann (1992), p. 100.

34. Dreams and myths led Jung to formulate the theory that only part of the human psyche is unique, subjective, and personal. In contrast to this acquired individual unconscious, the *collective unconscious* is common to all and characterized by archetypes, in particular by the images relating to gender of the *animus* and the *anima*. Jung thought that nature and the psyche were linked not only causally, but

also in terms of meaning, transcending the boundaries of time and place. See Jung (1926, 1928).

35. The sound recordings used in the installation come from video recordings or television programs: Weizenbaum and Minsky from the program *Chips statt Fleisch im Kopf*, Sat 1 (German TV channel), 11/91; Flusser's words from an interview, given during the symposium aussenräume innenräume of the Gesellschaft für Filmtheorie in the Museum of Modern Art, Palais Lichtenstein, in Vienna, in November 1991. On labyrinths, see Santarcangeli's erudite (1967) study, and the vast collection of historical labyrinths in Kern (1982). See also Doob (1990).

36. Pohlenz (1992), pp. 71ff.

37. Ibid., p. 114. Oikeiosis "ultimately encompasses all of humanity" (p. 115).

38. See Minsky (1991), p. 12.

39. Ibid.

40. Minsky (1990b), p. 103; see also Minsky (1988).

41. Moravec (1996).

42. Not surprisingly, Moravec is further of the opinion that bodies will be transformed into matrices in cyberspace and "the coarse physical processes of change will be replaced by a wave of faster, imperceptible cyberspace-transformations until, finally, everything becomes a bubble of mind expanding almost at the speed of light." See Moravec (1999), p. 257. At the same time, "the boundaries of personality will be very fluid—in the end even random and subjective, since strong and weak relationships between various bodies will arise and then dissolve again," ibid., p. 258.

43. Unpublished draft by Fleischmann and Strauss, early 1992, author's personal archive.

44. "Man is not a machine. I shall argue that, although man most certainly processes information, he does not necessarily process it in the same way computers do." Weizenbaum (1976), p. 203. Penrose criticizes the fundamental precept of hard AI from a mathematical perspective, viz., "The idea is that mental activity is simply the carrying out of some well-defined sequence of operations, frequently

referred to as an *algorithm*." Penrose (1989), p. 17; see also the critique of Dreyfus (1972), and more recently Dreyfus (1992).

45. Weizenbaum (1976), p. 203.

46. Weizenbaum (1992), p. 169.

47. Moravec (1988), p. 74.

48. Weizenbaum (1992).

49. Flusser (1985), p. 9.

50. Ibid., p. 123.

51. See Flusser (1991a), p. 155.

52. Ibid., p. 160.

53. Ibid., p. 156.

54. In the sense of concentration.

55. Ibid., p. 68.

56. Ibid., p. 153.

57. These are taken from the interview cited above.

58. Virilio (1992a), p. 49.

59. "On vit encore le temps extensiv des ville, de l'histoire, des memoirs, des archives, des écrits, et le temps intensiv de nouvelle technologie. C'est ça le programme d'absence—Ce n'est qu'un programme ... notre absence definitive. Parce qu'on ne serait jamais là dans les milliardes des secondes."

60. "Il faudrà réaventer un politique qui soit lié a l'espace vitesse."

61. Virilio (1986b), p. 122.

62. Warburg (1995 [1923]), p. 59.

63. See Schulze (1986), p. 311. The original design of the Bacardi building also proposed a construction of steel, but when the architect visited the site this was abandoned in favor of a concrete structure because of the high salinity of the air (p. 309).

64. Exhibitions such as Die vier Elemente at the Mediale Festival in Hamburg 1993 and First Europeans in Berlin 1993, or Holden and Loeffler's work *The Networked Virtual Reality Art Museum*, are further examples.

65. In this connection, Peter Sloterdijk's (2000) study on the history of the sphere in cultural contexts is a valuable resource.

66. Fleischmann and Strauss commented in an email on May 27, 2001: "The installation was highly illusionist, like no other work has been since, because of our Radiosity Program. It was not our primary goal to create a space of illusion but rather to experiment with the possibilities of interactivity and an interface that reacted with the human body."

67. See Camillo (1550); also Yates's classic (1966), pp. 192, 205, 231ff.; on the renaissance of the memory theaters in the computer age, see Matussek (2000).

68. In his *Theater of Memory* (1985), Viola associates the electrical processes in the brain involved in memory with the electronic processes of video technology; the more recent work by Emil Hrvatin, *Drive-in Camillo* (2000), explicitly uses the metaphor of the memory theater to refer to early modern times.

69. Hegedues produced this artwork at the Institut für Bildmedien at the ZKM in Karlsruhe, which is directed by Jeffrey Shaw. Gideon May was responsible for the software and Bas Bossinade for the hardware (SGI Maximum Impact); Christina Zartmann assisted with the computer graphics.

70. For a detailed account of the art- and wonder-cabinets, see Bredekamp (1995).

71. See Dotzler (2001); Plewe (1998); Plewe's essay in Dinkla and Brockhaus (1999); Shikata (2000); and Minato (2000).

72. 1999 at Ars Electronica, the exhibition Connected Cities in the Wilhelm Lehmbruck Museum in Duisburg, and at Canon ArtLab in Tokyo; 2000 at a presentation at UCLA by invitation of Victoria Vesna and Bill Seaman.

73. *Ultima Ratio* won an award in 1998 at the Comtecart in Dresden; in 2000, it was nominated for the Ars Viva Prize of the cultural section of the Bund Deutsche Ingenieure (Association of German Engineers); and in 2001, it received an honorary mention in the new category Artistic Software at the Transmediale in Berlin.

74. Benayoun and Barriere (1997); and Godé (1999).

75. The work runs with 2 SGI Onyx Reality Engines, the shots are taken with a camera with Polhemus sensors and 3-axis computation of coordinates and a program that computes the corresponding frame in relation to the scene and time of the shot. The software was developed principally by Patrick Bouchaud, Kimi Bishop, and David Nahon.

76. Raphael Melki created the computer graphics for this new technique of excerpting image fragments.

77. Benayoun and Barriere (1997), p. 313.

78. Ibid.

79. Flusser (1998), p. 242 and also his (1989b, 1985).

80. Born in Paris in 1958, Jean-Baptiste Barrière studied music, philosophy, and mathematical logic. In addition to composing, in 1981 he became the first researcher at Ircam/Centre Georges Pompidou in Paris to work on crossover projects like *Chant* (synthesis of the singing voice with computer) and *Formes* (control of synthesis and composition with computer) projects.

81. *Place* was produced under the auspices of the Neue Galerie am Landesmuseum, Johanneum Graz and, among other venues, exhibited at Trigon Personale 95, Neue Galerie am Landesmuseum Johanneum, Graz, Austria. 1996: Under Capricorn, Stedeljik Museum, Amsterdam, Netherlands; Artifices 4, Saint Denis, France; La Vilette, Cittè des Sciences et de l'Industrie, Paris, France. 1997: Arte Virtual—Realidad Plural, Monterrey, Mexico. 1998: Surrogate Karlsruhe,

Germany, *Place—A user's manual Wellington*. See Stedelijk Museum Amsterdam (1996), pp. 76–77. See also ⟨www.lebart.univ-paris8.fr/Art-04/index.html⟩.

82. The software was developed by Adolf Mathias, the hardware configuration by Huib Nelissen and Bas Bossinade.

83. Blase and Kopp (2000), pp. 94–103. It was also shown in Poland at the exhibition *WRO2000@kultura* in Wroclaw.

84. *Be Now Here* was exhibited at San Francisco Film Festival (in collaboration with SFMOMA), 2001, Tech Museum of Innovation, San Jose, 1998–1999; Rotterdam Film Festival, 1998; Art at the Anchorage, New York, 1997; Siggraph, New Orleans, 1996; Center for the Arts Yerba Buena Gardens, San Francisco, 1995–1996.

85. Others involved were: Rob Semper, Exploratorium, and Larry Friedlander from Stanford University; Apple Multimedia Lab.

86. Naimark (1995).

87. Ibid.

88. Fleischmann and Strauss (2001); Ohta (1999). See also Broll (2001).

89. Peter Lunenfeld, "Unfinished business," in his (1999), pp. 6–22.

90. The concept by Wolfgang Strauss and Monika Fleischmann was realized by Jasminko Novak, Frank Pragaski, Christoph Seibert, and Udo Zlender.

91. Wolfgang Strauss, "Imagine space fused with data: A model for mixed reality architecture," in Fleischmann and Strauss (2001), pp. 41–45.

92. Various versions of the system have been tested at GMD Schlosstag '98 and '99 in St. Augustin, Transmediale '99 in Berlin, and Fidena '99 in Bochum.

93. Electronic Multi User Stage Environment.

94. See Fleischmann and Strauss (1999), p. 93; Billinghurst et al. (1999).

95. Bredekamp (1992b).

96. See Mitchell (1992)

97. Damer (1998b).

98. See Ascott (1997), p. 35.

99. See Heeter (1992), pp. 264ff.

100. In network communication, more and more programs are being developed that use these autonomous agents, or "knowbots," without any visual representation. Knowbots use methods related to biological mechanisms for collecting information. They communicate autonomously with other programs and even work in teams, if appropriate. See Dieng et al. (1994).

101. In the field of naturalistic animation of human movement and physiognomy based on behavior, again it is military research that has made considerable progress. At the Center for Human Modeling and Simulation, one of the main objectives is to communicate with agents using voice commands: The ultimate goal is to be able to direct them in a simulated battle. See Badler et al. (1995).

102. See Maes (1990), pp. 49ff.; and Thalmann (1994).

103. See Weibel (1994b).

104. See Kloss et al. (1998).

105. Moreover, storage media such as tapes are not durable but undergo an aging process. Over time, the adhesive that binds the magnetic coating to the synthetic tape degrades.

106. See Gehlen (1957). For a general overview, see Spalter (1999).

107. See Zec (1991), p. 103.

108. "Tools retain and indicate the *changeable* aspects of the materials." Bahr (1983), p. 168.

109. McCullough points out that "the non-technician should note: here, in what is fittingly known as object orientation, is the very root of one of the biggest

advantages of digital media, namely the ability to operate on abstractions as if they were things." McCullough (1996), p. 98.

110. According to William James, the binding of the attention functions as follows: "It is the taking possession of the mind, in clear and vivid form, of one out of what seem several simultaneously possible objects or trains of thought. . . . It requires withdrawal from some things in order to deal effectively with others." Cited in Preece et al. (1994), p. 100.

111. See Kusahara (1998), p. 114.

112. See Schelhowe (1997), p. 182.

113. See Esposito (1995).

114. See Coy (1995) and Mitchell (1995b).

Telepresence: Art and History of an Idea

Telepresence Now!

At an exhibition organized by German Telekom in the autumn of 1991, an early, fragmentary version of *The Home of the Brain* was transmitted via ISDN from the ART+COM institute in Berlin to Geneva in Switzerland. A user in Geneva, equipped with data glove, was able to navigate the data set from Berlin without being visible. This was an experiment in telepresence, reception of digital artworks, and interaction with them over large distances. The classic position of an observer directly in front of a material work of art was replaced by a participatory relationship that surmounts great distances but still appears to be immediately present in the work. *The Home of the Brain* was an early glimpse of the epistemic innovation represented by telepresence, where in its reception the work loses its locatability. The observer does not go to the work, the painting, the panorama, the film, and so on, and the work does not come exclusively to a particular observer. Telepresence also represents an aesthetic paradox: It enables access to virtual spaces globally that seem to be experienced physically while the same time it is possible to zap from space to space at the speed of light and be present simultaneously at completely different places.

Telepresence art,[1] which began to develop in the early 1990s before the World Wide Web boom and can be considered as the successor to telematic art, was strongly influenced by two artists in particular: Eduardo Kac from Brazil and Ken Goldberg from California. Kac's and Goldberg's approaches have less to do with immersive environments and more with aspects of telecommunication: teleaction using operators and robots. Kac, who has exhibited all over the world and received many important awards,[2] achieved international recognition in the 1980s as the pioneer of Holopoetry. In the 1990s, he turned to works that combine biological processes with telematic structures. In the Ornitrorrinco Project, a collaboration with Eduardo Bennett exhibited at SIGGRAPH 1992 in Chicago, users controlled the movements of a remote robot located at Kac's workplace, the School of the Art Institute in Chicago, via telephone line and the buttons on the set. He continued to explore the aesthetics and epistemology of telepresence in following works, such as *Ornitorrinco in Eden* (1994), *Rara Avis* (1996), and *Uirapuru* (1999), a networked installation, which was first shown at the ICC Biennale in the InterCommunication Center in Tokyo.[3] The uirapuru is both a real bird and a mythical creature in a legend from the Amazon, and this quality of being at once local and

remote is reflected in the design of the installation. The exhibition space in Japan had a stylized rainforest inhabited by colorful telerobotic flying fish—the "Uirapuru" in Kac's version of the legend—that could be controlled by a local interface and by distant users of the Web. Visitors to the gallery moved the flying fish and saw the forest from the fishes' perspective. Sensors tracked the fishes' movements and the data was streamed live on the Web. Web users could interact with the avatars of the fish in a virtual space. Kac's design merged the perception of the fish with that of the Net users and gave imaginary presence in the mega city of Tokyo to a fabled bird of the Amazon, which, according to belief, is animated with the souls of the dead. The artificial Amazon at the ICC exhibition was connected via the Web to servers in the Amazon, which transmitted the songs of real Amazonian birds live to Tokyo. There, small "pingbirds," telerobotic birds, received the data from the Amazon over the Net and transformed it into birdsong. Thus they both received the information and gave it expression. The *Uirapuru* installation combines in a twofold manner communication between different species in a common environment and organizes its physical and virtual digital representation telematically halfway around the world.

Kac's installation brought magic and exoticism to the metropolis by means of networked computers. A few years earlier, Goldberg had drafted a concept of a telegarden, which was widely discussed and finally installed in 1995 (fig. 7.1). Since 1996, the *Telegarden* is on show at the Ars Electronica Center in Linz. This miniature garden is watered by the arm of a robot fitted with a webcam controlled by users of the Web. The virtual gardeners, who may be logged in thousands of kilometers away, maneuver the $40,000 arm through visual feedback over the Net, and, by simply clicking on a website button, pour water over the living plants in a small trough.[4] Web users thus had the power to make a symbolic landscape of the world flourish or wither and die. After every hundred hits, the users were given the option of planting more seeds in the earth with the robot arm. The public resonance of this installation was quite remarkable. By the end of the first year, over 9000 telepresent visitors to the site had helped to cultivate the garden and created a joint work in worldwide cooperation. Anyone could look in, but in order to water the telegarden or plant a seed, the users had to register at the site and use a password. Up to this point in time, Goldberg had likened the culture of the Web as typical

Figure 7.1 Ken Goldberg, *Telegarden*, 1995. Telematic installation. By kind permission of the artist.

of that of hunter-gatherers. However, the telegarden was a symbolic model for a postnomadic society that anonymously and collectively tended plants on a miniscule piece of the earth. The members of this group, who never actually came face to face, communicated with each other, or were even aware of how many other virtual gardeners were logged in, were using the most modern medium of the time for this. Goldberg's work was a collective, intercontinental cultural production. The idea is faintly reminiscent of Roy Ascott's telematic artwork *La Plissure du Texte* (1983). At the Paris exhibition Electra, Ascott connected sixteen speakers from all over the world with each other by ARTEX technology, assigned each a role, and the result was a collective fairy tale.[5] The technology of the time did not allow reception of this art event by a large audience, so *La Plissure du Texte* is comparable only in a very limited way with the *Telegarden* and its unknown number of anonymous viewers and artists. Also, Ascott's concept of telematic art at that time consciously renounced, even negated,[6] the character of an artwork as an object, insisting on its processual nature. By contrast, Goldberg's *Telegarden* allows the object to return to telematic

Figure 7.2 Paul Sermon, *Telematic Dreaming*, 1992. By kind permission of the artist.

art, although it is an object undergoing a process. Kac's and Goldberg's pioneering works, which provoked much theorizing on the implications of telepresence for the concepts of art and cognition, made it possible for users to intervene from a distance; but they were not concerned with putting users in an immersive environment or enhancing an imaginary connection with an artificial space through sensory feedback.

Paul Sermon, born in 1966, is a British artist from Roy Ascott's school, whose work integrates immersive aspects within the framework of telematic art. He became well known for his telematic installations at the beginning of the 1990s and now teaches at a number of art schools in England and Germany. He uses video-conferencing to link people in different places, which allows audio communication plus mime and gestures and results in encounters that are astonishing in their near-intimacy. In *Telematic Dreaming* (1992) (fig. 7.2), a live telematic video installation linking two sites first exhibited at the legendary Koti Exhibition in Kajaani, Finland, a bed is the medium for high-definition images: images of a partner, perhaps many thousands of kilometers away, live and in close proximity. The clear projection of another person, who can react almost in real time to the other's movements on the bed, is so suggestive that to

touch the body's image, projected onto the sheet, becomes an intimate act. Sermon's declared aim was to expand the user's sense of touch; obviously, it was not possible to touch the other virtual bedmate, but one experienced the suggestion of touching through rapid and vigorous or tender and reflective movements. Many observers found this a contemplative moment; a sensory impression achieved synaesthetically where hand and eye fuse. This quality distinguishes this work and others created in subsequent years in collaboration with Andrea Zapp. Their techno-aesthetic language is unique and has brought this artist duo great popularity. The traditional rhetorical technique of hyperrealism is capable of addressing other senses through the faculty of vision. The images of another person in close proximity have such a strong effect that the visual impression stimulates a suggestion of tactility. This is a mechanism employed by art throughout the ages, and we encounter it here again in the phenomenon of telepresence.

In Sermon's *Telematic Vision*, which was created at almost the same time, the visitors find themselves in the situation of watching television. Sitting comfortably on a sofa in front of a large-screen monitor, we see not only full-size images of ourselves but also of visitors to the second site of the installation who, via ISDN videoconference link, are sitting on the sofa with us. Here again, a feeling of astounding nearness and familiarity arises. As actions have no actual consequences in the divided image space, many visitors seize the opportunity for uninhibited mischief and make virtual seductive advances, indulge in intimacies, or even come to blows. Sermon is one of the few artists who uncovers this quality of virtual art: The restraints that reality imposes on us are lifted and the actual consequences of our actions removed; we can experiment, play with, or overturn the established boundaries of social intercourse, but only—at least this is the artist's intention—in order to experience and discover more vividly its subtle distinctions.

The powerful social aspect of Sermon's work is visualized in the site-specific installation *A Body of Water* (1999), created for the exhibition Connected Cities,[7] which has an atmosphere that borders on the eerie. In a chroma-key room set up in Duisburg's Wilhelm Lehmbruck Museum, visitors mingle virtually with visitors to the second location of the installation: a miners' changing room, the "Waschkaue," at a disused mine in Herten. Projected onto one side of a gauzy pyramids of a water screen, images of the Duisberg visitors become concrete and realistic presences in

the Waschkaue, while on the other side is projected historic film material of miners showering. The installation recalls a telematic art classic, *Hole in Space* (1980) by Kid Galloway and Sherrie Rabinowitz. They connected two large screens in Los Angeles and New York, a kind of video telephone of enormous dimensions, a tunnel through space. Initially, it was used quite spontaneously by passers-by, but as the exhibition progressed it inspired highly imaginative telecommunication: parties, family reunions, even showing the latest addition to the family to far-off relatives. This strategy of confronting groups of people who are geographically far apart attains an explosive sociopolitical dimension when people from radically different cultures or social backgrounds encounter each other, almost intimately, in an image space. In the darkness of a derelict industrial building, Paul Sermon created a work whose effect was both evocative and vivid, an imaginary space for remembering generations of miners who, after toiling underground, washed the coal dust from their hard-working bodies there. Thus, Sermon adds a dimension of social critique to his visual strategy in this installation with its disturbing intimacy.

Since the late 1990s, the work of the Australian media artist Simon Penny has linked the concepts of telepresence and immersion. Penny, who lectured for several years at Carnegie Mellon University's Robotics Institute, attempts in his project *Traces* to network several CAVEs in different locations to create a single electronic image space. In 1998, he received the Cyberstar award of WDR, one of Germany's biggest television stations, for this concept. Realized in a rudimentary form at GMD in Sankt Augustin in 1998 (fig. 7.3), *Traces* marks an important stage in the development of telepresence art. It does not offer worlds of computer graphic images or navigation interfaces. Instead, users enter virtual image spaces to interact with gauzy traces of light that represent the dynamics and volumes of human bodies (fig. 7.4). Penny envisages that "interactions will take the form of real-time collaborative sculpturing with light, created through dancing with telematic partners."[8] Users will see large virtual spaces, hear spatially distributed sound, and experience the vibrations of the floor. The ultimate technological goal is to get away from all traditional forms of interfaces and visual displays. Four infrared stereo cameras transform in real time the users' contours into three-dimensional representations, which Penny envisages will be seen thousands of kilometers away in polysensorialy expanded image spaces. Continual and rapid changes of the cameras' angles build a

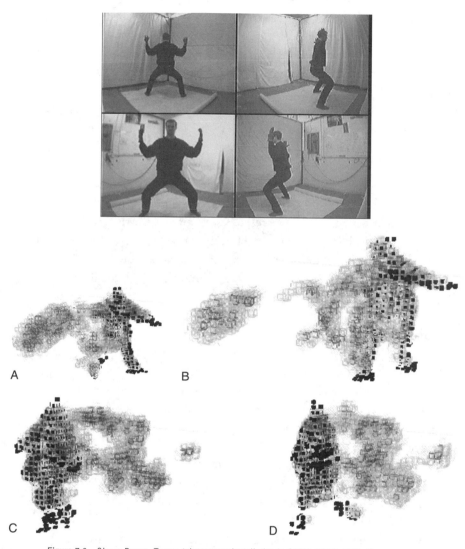

Figure 7.3 Simon Penny, *Traces*, telepresence installation in CAVE, 1999–2001. Programmer: Andre Bernhardt. By kind permission of the artist.

Figure 7.4 Simon Penny, *Traces*, 1999–2001. Detail, programmer: Andre Bernhardt. By kind permission of the artist.

real-time body model of a visitor inside a CAVE, so-called smart video switching. For example, the image of a user in Tokyo can be seen in a CAVE in Berlin, or vice versa. It is also planned to add individualized spatial sound, which will be based on the user's behavior, and will entail creating a technique to attach dynamic sound behaviors to moving virtual objects. *Traces* dispenses with HMDs, tracking sensors, joysticks, and screens; neither does it use buttons or mouse clicks. The aesthetic goal of this complex of networked installations, possibly distributed all over the world, is to focus users' attention on their own bodily behavior over a longer period of time. It is solely the bodies in motion that constitute the real-time graphics and sound.[9] For the first time, this work formulates interaction with traces of remote bodies of individuals: the appearance of the "dispersed body" (in the sense of being virtually in several locations at the same time) that was introduced by the telepresence debate.[10]

The separation of mind and body is immediately recognizable as a dualistic concept of the human being and also implies a devaluation of corporeality, as in the Gnostic tradition. According to this notion, mind is understood as entirely incorporeal, tending increasingly toward simulation, and the body, in its function of sensory appropriation of the external world, whose largest and perhaps most intense sensory organ is the skin, is repressed. In the place of a biophysical body with its neurosensory experience we have an arbitrary, machine-mediated experience whose elements can, theoretically, be stored in digital form.

Subhistory of Telepresence

Telepresence is an amalgam of three technologies: robotics, telecommunications, and virtual reality. Telepresence expands the radius of human actions and experiences. The motivation that drives researchers and users to explore this path is, on the one hand, simple curiosity as to what may lie behind the horizon, in the sense of expanded powers of experience and effects. On the other hand, it can be interpreted as stemming from religious motives in the broad sense; as part of the tradition of "playing God." Robotics, telecommunications, and virtual reality feed into the history of the idea of telepresence—three areas that from their inception have featured repeatedly interpretations of the given technical stage of development charged with mythological/magical or religious overtones. The user of a virtual environment, for example, can intervene in the environment

via telecommunication and a remote robot and, in the opposite direction, to receive sensory feedback, a sensory experience of a remote event: Telepresence succeeds in making virtual that which physically experienceable existence actually possesses. Thus, telepresence maps onto three long-term projects in the history of ideas, including their mythical, magical, and utopian connotations. These are, first, the dream of *artificial life* and *automation*; second, the tradition of *virtual realities* in art; and third, the occult prehistory of *telecommunication*, which operates permanently within structures of ideas for leaving the body. Similar to the level of technology, these three separate strands in the history of ideas now begin to converge and consolidate into a projection of a utopian dream. The history of technology has always been the history of its myths and utopias, a revelation of human yearning, and a prerational reference base. Ever since Plato, *mythos* has stood for the Other of *logos*. Myths do not aspire to a scientific basis; they are to be believed for they are representatives of existence. History has shown that the Age of Reason's conscious treatment of myths has not guarded against their often unconscious reappearance. Furthermore, often the answers provided by myths are in fact open questions or something that has not yet come to an end.[11]

Yet, the idea of leaving the body in order to be seemingly present and active somewhere else is not a qualitatively new idea, neither in the history of religion or in the history of art. Any prehistory of attempts to achieve presence in distant places (that is, telepresence) cannot circumvent the status of images. Let us recall that, before the "invention of art," the image was understood as invested with occult powers, which connected us to remote objects and beings. We can see this in the German word for image, *Bild* and its etymological Germanic root *bil*. *Bild* represents less the specifically graphic and more something that is permeated by an irrational, magical, and spectral power, which cannot be fully understood or controlled by the observer; an artifact that has the power to leave the body and possesses a life of its own.[12] The quality of telepresence found in cult images reveals itself as evidence of their "life": blood, tears, and working miracles are attributed to them.[13] In belief systems that rely especially heavily on images such as voodoo, for example, images and effigies are credited with the power to work miracles and magic over great distances. Images allow mortals to interact directly with the gods and procure presence and power for that which is represented.[14] This function of the image

was joined in the Middle Ages and early modern era by the idea of achieving immediate presence at another place, traveling through space, by using mirrors: Under certain physical conditions, a person could see his own image hovering in the air. With the aid of catoptrical mirrors, wrote Agrippa of Nettesheim in 1529, one can form any kind of image in the air as far away as one wants.[15] A universal mystery allows seers and clairvoyants to see far-off events and things to come in mirrors.[16] According to legend, mirrors had the power to destroy entire fleets of ships by fire or make them visible when below the horizon. A mirror belonging to Pythagoras was even said to be able to make anything written on it in blood appear on the moon's surface.[17] It is hardly surprising that metaphysical qualities were also attributed to mirrors, in that the soul and mirror image were felt to have a deep affinity with each other. Sick people were supposed to cover their mirrors so that their souls would not take flight to another plane of existence. In the eighteenth century, it was widely believed that, with the aid of mirror cabinets, one could escape to artificial spheres—an idea similar to virtual reality and immersion. However, mirrors also have the property of focusing light so that with their help new things can be discovered. This does not only apply to the telescope:[18] In 1646, the Jesuit polymath Athanasius Kircher described a cylindrical mirror, which would allow him to project the ascension of Christ as though floating on air.[19] Like Agrippa, Kircher was fascinated by the idea of transmitting written messages over distances. His projections with apparatus using sunlight achieved distances of up to 500 feet, and he hoped, with larger apparatus, to transmit writing over a distance of 12,000 feet.

Modern versions of this idea include the *Cinéma Telegraphique* (1900) and Thomas Alva Edison's Telephonoscope (1879) (fig. 7.5), but these, too, remained media utopias. Long before the invention of movies, these projects envisioned the transmission of moving pictures. In a technical vision of things to come, a British couple at the turn of the nineteenth century was said to be able to communicate with their daughter on the colonial British Island of Ceylon by means of a large format screen that they hung over their fireplace instead of a painting.[20] Other visualizations, printed in contemporary newspapers, displayed the faces of terrified observers, who were transported into the middle of a distant battle via telematics. Although these devices could not be manipulated by their users,

EDISON'S TELEPHONOSCOPE (TRANSMITS LIGHT AS WELL AS SOUND).

(*Every evening, before going to bed, Pater- and Materfamilias set up an electric camera-obscura over their bedroom mantel-piece, and gladden their eyes with the sight of their Children at the Antipodes, and converse gaily with them through the wire.*)

Paterfamilias (*in Wilton Place*). "BEATRICE, COME CLOSER, I WANT TO WHISPER." *Beatrice* (*from Ceylon*). "YES, PAPA DEAR."
Paterfamilias. "WHO IS THAT CHARMING YOUNG LADY PLAYING ON CHARLIE'S SIDE?" *Beatrice.* "SHE'S JUST COME OVER FROM ENGLAND, PAPA. I'LL INTRODUCE YOU TO HER AS SOON AS THE GAME'S OVER?"

Figure 7.5 Edison's Telephonoscope. Magazine illustration 1879. In W. *Herzogenrath*, et al., eds., 1997, *TV Kultur: Fernsehen in der Bildenden Kunst seit 1879*. Dresden: Verlag der Kunst.

they did receive sensory impressions from afar. And Christian Riess's vision of a "seeing machine" in 1916—it was no coincidence that the timing coincided with World War I—is a precursor of the webcam (fig. 7.6). Riess connected a camera to a machine that could send electric image signals over the telephone lines to be retranslated into an image at the other end.[21]

By the 1930s, the notion of telecommunication had merged with the notion of artificial life to form a powerful new vision of a disembodied human self. Italian Futurists envisioned a metallic body that would gain vitality through mechanical impulses. In this way, Marinetti wanted not only to overcome death but, with the aid of radiophony (a form of wireless telegraphy), to increase the body's sensory perceptions to a massive degree as well. Taste, touch, and the sense of smell were to be amplified to the point where they would be capable of receiving stimuli over long distances.[22] Here the idea of the automaton combines with the mythical power and utopian vision of *electricity*, whose roots lie in the Age of

Figure 7.6 *Sehende Maschinen* (seeing machines). Cover of the book by Christian Riess, Munich, 1916.

Enlightenment and which would, some imagined in the United States, eradicate the evils of industrial society by fusing nature and technology.[23] Lewis Mumford's early work and Marshall McLuhan's fantasies of transcendance projected onto electricity are other examples. In his book *God and Golem* (1964), Norbert Wiener envisioned the possibility, in principle, of translating the very essence of humankind into code and transmitting it over telephone lines. Time and again, we project our image of humankind onto the most current, as yet uncharted, and seemingly limitless potential of the latest stage of technological development. In search of the substance of the human, we hope to realize the essence of life in projections of utopian technologies.

Apart from sober considerations of how to optimize the conquest of space, since McLuhan's dictum, "the extensions of man," the utopia (or dystopia, according to one's standpoint) of a global information shield has made its appearance, which envisages the evolutionary development of an emerging gigantic collective intelligence. This "infosphere," also referred to as a "noosphere," of ubiquitous cyberspace will be laid over the brittle and increasingly impaired sphere of the earth, an infinite nirvana. It will be pure connectedness, a "smart sphere" as it were, that engenders a collective soul. This and other ideas of cyberculture's representatives, which appear to be original at first glance, when viewed from a historical perspective are found to follow common patterns, as in Pierre Lévy's statement: "as the future source of human consciousness, [there will be] a transcendental 'collective intelligence,' a 'meta-language,' that originates in global, direct communication."[24] At symposia of visionary virtual image culture, instances of overt religious rhetoric are not uncommon. For example, according to Marc Pesce, the co-inventor of virtual reality modeling language (VRML): "The deterritorialization of the self is the essential feature that marks human entry into cyberspace. In the universe of infinite connection and possibility the only possible ontology is magical; . . . The techniques of magical will, quintessentially linguistic, require a conscious mastery of the relationship between word and world. At the end of history comes the Word."[25]

What is being preached is the phantasm of union in a global net community, cybergnosis, salvation through technology, disembodied as a posbiological scattering of data that lives forever. Perhaps the most radical exponent of this school is Hans Moravec.[26] The foundations of this thinking

are not rational, nor is it even good science fiction (as in the quality and perceptive writings of Bruce Sterling, for example); rather, it is Gnostic. These thinkers seek programmatically to leave world, matter, and corporeality behind them, which, in view of the dramatic threats that nature and humankind face today, represents an irresponsible escapism into irrational and religious realms that one believed superceded and a thing of the past. Here, one seeks in vain for any kind of contribution to solving present-day problems or ameliorating existing misery; instead, one is offered futuristic transcendental visions, lacking in rigor and highly problematic in their implications—an opiate. In the present phase of technological upheaval and radical change, the idea of ubiquity is being invoked unconsciously: a longed-for state of transcendence, a variant of gnosis. It is a sign of insecurity that myths are resurfacing again. The idea of overcoming the body, of a transcendental escape from the flesh, derives from religion, as in the ancient notion of the transmigration of souls found in Buddhism and the Upanishads, the involution of spirit in matter, metempsychosis or reincarnation, of which Krishna speaks.[27] However, the return of religious motifs does not manifest itself in connection with systems of beliefs or the institutionalization of any religious organization but is characterized by lifting elements of various religions out of their dogmatic context. What we observe are hyperzealots of a new technoreligion running wild, zapping, excerpting, and floating in cyberspace.

Religions, esoteric doctrines,[28] parapsychology, and sects preaching the imminent apocalypse all regard the human being as a transitional phenomenon on its way to a state of pure spirit. Probably the oldest passage in Hebrew literature to mention the idea of ascension is the so-called Ethiopian Book of Henoch. In ancient Greece, the first ideas concerning the astral nature of humans appeared in the second half of the fifth century B.C. Plato's writings also contain references to the continuing existence of the soul after death,[29] and in the writings of Hermes Trismegistos we find "You see, O son! How many bodies we must pass through ... before we reach the one and only God."[30] Mysticism propagates the existence of another, transcendental reality, compared to which the material world sinks into meaninglessness. Meister Eckhart taught that "According to the manner of my unborn being, I have always been, am now, and will be for ever."[31] However, similar passages also appear in the Apocrypha and orthodox scriptures. The idea of the transmigration of souls runs through

Western thought, with varying degrees of weight, from Giordano Bruno to Swedenborg,[32] Lessing, and others. It is an ideology that conflicts with the ideas of the Enlightenment. In the context under discussion here, it is interesting that many religions and esoteric doctrines imagine the part of a person that lives forever as an *illusory* body made of some kind of fine nonmaterial, intangible yet visible at times under certain conditions—from the *ka* of the ancient Egyptians to the *astral body* of the Theosophists[33]—a disembodied existence.

"Telepistemological" Implications: Presence and Distance

Telepresence encompasses three areas that are prone to the projection of visions: artificial life, the fusion of visions with infinite virtual image worlds, which these present as factual, and the transformation of the self into digital data before death, its despatch through space, and reconfiguration in a form different than the original one—not like being beamed up in *Star Trek*. These utopian notions converge in the idea of telepresence, which enhances still further their specific content. Telepresence also combines the contents of three archetypal areas of human aspiration: automation, virtual illusion, and a nonphysical view of the self. These notions converge in the concept of telepresence in that it enables the user to be present in three places at the same time: (a) in the spatiotemporal location determined by the position of the user's body; (b) by means of *teleperception* in the simulated, virtual image space (the point to which attempts in art history have led thus far to achieve virtual reality); and (c) by means of *teleaction* in the place where, for example, a robot is situated, directed by one's own movements and providing orientation through its sensors.[34]

The media-driven epistemology of telepresence appears to be a paradox. Telepresence is indeed a mediated perspective that surmounts great distances; however, perception will soon be enriched in the virtual environment. The seeming assurance of what is seen by appropriate haptic impressions or smells enhances the credibility. The threefold nature of telepresence raises fundamental questions in telepistemology,[35] that is, for our understanding of the way distance affects our capacity for knowledge and discovery. Through networking any number of robots or technobodies, telepresence facilitates the multiplication of possible spaces of experience. Additionally, these spaces of telepresence can be arranged contrarily to evoke contradictory experiences. This paradoxical situation becomes even

more so by the fact that it will be possible to move in different realities and different illusory bodies. Reality, as stated by quantum physics, is always a product of perception. Distance and closeness will coincide through a technical set up in real time and create the paradox of *I am where I am not and I experience sensory certainty against my better judgment*.

The phenomenon of telepresence transforms spatial experience as we know it, which was hitherto determined by physical experience. The direct experience of location, dependent on the body, is primarily responsible for epistemic experience, but then gives way partially to a telepistemology that is without a subject. However, inner and visual distance are essential prerequisites for the experience of art and the world in general. Since the eighteenth century, aesthetic theories have regarded distance as a constitutive element of reflection, self-discovery, and the experience of art and nature. These stressed that the inner distance of an observer must be finely balanced so that the view of the whole and the details are equally accessible. The experience of distance does not reject sensory experience or emotions per se, as does religion or myth, but it relies on their relative integration in the entirety of human experience. Experience of propagandistic, orgiastic, or pornographic elements is in direct contrast to conscious experience grounded in aesthetic distance. Here, distance is understood as gaining an overview and not merely in the sense of physical separation from the object. More than perhaps any other thinker, Ernst Cassirer reflected on the power of distance for intellectual productivity and creating awareness. In *Individuum und Kosmos*, Cassirer proposes that distance constitutes the subject and is solely responsible for producing the "aesthetic image space" as well as the "space of logical and mathematical thought."[36] Two years later, Aby Warburg stressed the intellectual, awareness-heightening power of distance and placed this "original act of human civilization," in the introduction to his *Mnemosyne-Atlas*.[37] The result of this physical and psychological distancing from the phenomenon is a conceptual space, or *Denkraum*: the precondition for awareness that an object is distinct and separate from the conscious subject. It seemed to Warburg at the beginning of the twentieth century that this was already threatened by the sudden proximity created by the invention of the telegraph.[38]

Paul Valéry's view is diametrically opposed to Warburg's. In his essay, with the programmatic title "The Conquest of Ubiquity," Valéry predicted that the near future would see the reception of artworks transmitted

from afar by electricity. In some ways the spiritual father of McLuhan, Valéry envisioned a medium that would convey polysensorial stimuli and be on tap everywhere, like electricity or water: "Works wherever there is someone and a suitable set of equipment.... We [will] find it completely natural ... to receive these extremely swift mutable images and oscillations from which our sensory organs ... will compose all that we know. I do not know if there has ever been a philosopher who dreamed up a company specializing in the free home delivery of sensorialy perceptible reality."[39] If we did not know this was written in 1928, it could be describing contemporary telepresence art.

With the imminent possibility of theoretically infinite numbers of new spaces of experience created through telepresence, the question arises whether this really will revolutionize the foundations of our basis of knowledge. Will we see this machine-mediated telexperience as the loss of experience of the world, like Albert Borgmann and Jeff Malpas,[40] or will we agree, at least in part, with Hubert Dreyfus, who sees teleoperations via camera (thus not actually polysensory virtual reality), although they use reduced sensory input, as an expanded cognitive process of sensory perceptions and direct participation in distant events?[41]

However, it is not unlikely that distanced awareness and formation of opinion à la Cassirer will make way in some form for visually and tactilely mediated perception, which evokes the own body via polysensorial interfaces (Valéry). Perhaps we shall see the conception of human beings as fixed in one location change. It appears as though the polysensorial connection of users to virtual image machines will be able to suggest intimate physical proximity to the remote users. With the speed of light, the user will be "present" in the animated image via robots, perhaps even in several places simultaneously. Martin Jay has doubts that perfected, imperceptible virtualization is viable because of the time lag in transmission and reception of messages that always exists in telecommunication. This latency undermines the illusionary effect of interaction and, though hardly detectable, even affects the light medium. Jay claims that indexical traces, comparable with those left by light on photographic plates, remain when virtual reality is transmitted telematically: "indexical traces survive in both virtual reality and telerobotic technologies and ... each resists complete virtualization."[42] In principle, Jay is correct, but, as far as the physiology of perception is concerned, this problem is disappearing as the speed of

data transfer increases. In the end such traces will be detectable only by machines, not by the users of telepresence systems.

Telepresence has far-reaching consequences for the areas of work, culture, jurisprudence, and politics. Where, for example, does the legal responsibility lie for actions commanded electronically or carried out by robots? What if the virtual image world displays an action to the person commanding it that is different than the one actually carried out? Customized telepresence for individual use will foster the creation of subcultures to an unprecedented extent: small groups or tribes existing only on the Net, perhaps distributed over millions of square kilometers, whose members rarely or never meet each other—except as avatars. Cooperation within such groups, which will also be a model for the future organization of virtual businesses, will be loose, of short duration, and subject to enormous fluctuation. In addition, telepresence promotes the process of particularization, as can be observed in the ongoing explosion of knowledge, for it strengthens the growing diversity of thought, promotes individuation, and renders spurious fantasies of fusing into oneness null and void.

Trends toward global shifts in consciousness may also be boosted by telepresence. One example of an impetus for this was the perspective provided by the Gaia theory, proposed in 1979 by James Lovelock.[43] The telepresence installation *T_Vision* by ART+COM, 1995–1999, was an attempt to visualize this theory's view of life on earth. The entire surface of the earth was generated from topographical data and satellite images, providing an overview of its totality from space with the possibility of zooming in to experience its infinite detail. The work presents changing views of a model of the earth, as seen from a million kilometers above its surface, or from a desktop in Berlin (fig. 7.7).[44] Eric Davis's description is rather apt: "Spinning the earth, you feel like a god; plunging toward its surface, like a falling angel."[45] The utopian dream of "omnipresent" telepresence bears a remarkable similarity to the historical notion of the Sight of God; in 1453, Nicholas of Cusa was in no doubt that "the absolute seeing of God ... surpasses in clarity, velocity, and power that of all actual seers and those who will become seers."[46] "Your eye, Lord, reaches all, without having to turn it thereon.... The angle of your eye ... is not of any degree but infinite, that is, a circle, an endless sphere, for your gaze is the eye of the spherical and of endless perfection."[47] There is a similar description in pseudo-Dionysius: He imagines God to be pure spirit, ubiquitous, tran-

Figure 7.7 ART+COM, *TerraVision*, 1999. Telematic installation. By kind permission of Joachim Sauter.

scending time and space, immortal yet at the same time possessing endless life;[48] God is an immaterial realm, beyond the world and its relative nature. He is not only telematic, but both omnipresent and absent, invisible, intangible. Polylocal presence linked to the all-seeing eye is the essential core of the techno-utopia of telepresence.

Simon Penny's work in progress, *Traces*, is the first artwork to interrogate critically the vision of telepresence. *Traces* is not yet completely built, but the project's concept shows great potential for telepresence art and will give users a glimpse of how it feels both to have a dispersed body and to interact bodily in real time with spatial traces of other remote bodies. In this way, we could even reach the remotest parts of our planet and zap from one webcam to another. Conscious tel*experience*, however, starts with the concentration on one aspect, the drive for objectivity, and the establishment of distance. Possibly, insight will be gained to the extent that one is consciously aware of this situation: to return from technical self-relinquishment after the initial moment of experience and become aware of its relation to physical and material circumstances.

As soon as the speed of data transfer is fast enough, telepresence art will be accessible to the public on the Internet, whose rapidly growing numbers will soon represent a majority of the world's population—the *electronic community*. In 1990, Norbert Bolz was still of the opinion that the Net community was "not in competition with the general public, but outside it,"[49] that is, the Net lay outside the public domain. Ten years later, this forecast has proved incorrect. In the age of advanced technological communication, Zec saw the possibility to influence the future as lying "solely in this public arena outside the world of art and museums."[50] Here he approaches Carl Loeffler's position, which emphasizes the populist quality and socially egalitarian aspect of art on the Web.[51] Zec's and Loeffler's views were formulated at a time when the World Wide Web did not exist, transfer rates of real-time virtual reality images were still very slow, and high-speed computers were too expensive for the average user; thus, their claims do not necessarily hold for the future. Here, the decisive questions remain: who controls the channels,[52] who distributes rights of access, and who exercises economic and political authority over the networks?[53]

Perhaps before long we will be interacting with subjectlike characters, "fusing" with the image machinery in the form of avatars, and playing— within the limits of freedom granted us. The physical body's sensory

and communication apparatus will grow together with hardware and software interfaces, our sex possibly will change to androgynous. Roy Ascott's vision is "a multiplicity of bodies, each one equally and potentially telepresent, each with their own perceptual qualifications, each in their environment, each wearing their own reality."[54] Our physical skin, our protective sheath from the world, will be breached, and at the same time as the telematic body is extended, we shall see it penetrated by an amalgam of technologies that will bring forth a biotechnological hermaphroditic life form, which Donna Haraway has named a *cyborg*.[55]

The desire to overcome physical distance, to project ourselves outside the constraints and confines of our own physical bodies, has always been a powerful driving force in both art and technology. It has spurred scientists to develop extraordinary robotic and telecommunication technologies and to conceive of technologies that are even more extraordinary still. It has inspired artworks that strive to bring about what technology itself cannot realize.

The history of technological visions is the history of our dreams, our vagaries, and our errors. Media utopias fluctuate, often originating in a magical or occult ambience. After the collapse of the twentieth century's utopias, it is no coincidence that religion and ethnic identity are once again coming to the fore and that the most advanced media technology is also the projection screen for our utopian visions.

Notes

1. Kac (1993).

2. Among others, the 1998 *Leonardo* Award for Excellence.

3. Kac (1991, 1996), and Aleksandra Kostic, "Teleporting an unknown State on the Web," in Kac (2000).

4. On general aspects, see Pesce (2000), pp. 220–230.

5. See Boissier (1983).

6. Ascott (2001).

7. Dinkla and Brockhaus (1999).

8.　⟨http://imk.gmd.de/docs/ww/mars/proj1_4.mhtml⟩.

9.　See Penny, Smith, and Bernhard (1999), pp. 1–12, available at ⟨www-art.cfa.cmu.edu/www-penny/texts/traces⟩.

10.　See Goldberg (2000).

11.　For a different view, see Graevenitz (1987).

12.　Wolf (1930), pp. 18–56.

13.　Belting (1990).

14.　In pre-Columbian Mexico, it was the image of the God that they were trying to influence that worshippers killed in the human sacrifice, just as in Voodoo, a being that is not physically present is addressed and manipulated through the medium of the image.

15.　Agrippa (1529), vol. I, chap. 6 and vol. II, chap. 1.

16.　Goldberg (1985), p. 7.

17.　Baltrusaitis (1996 [1978]), p. 328.

18.　See Böckler (1661).

19.　Kircher (1646), vol. X, part 3, chap. 3, pp. 896–900.

20.　Already in 1843, the Scot Alexander Bain had designed a phototelegraph that scanned the original line by line. In 1863, the Italian physicist Giovanni Caselli's Pan Telegraph transmitted pictures between Paris and Lyon and, in 1880, Graham Bell used photocells of selenium, an element with electrical conducting properties that are changed by light oscillations, in his functioning Photophone.

21.　Riess (1916).

22.　"La Radia, Futuristisches Manifest vom Oktober 1933," in Weibel and Decker (1991), pp. 224–228.

23.　Carey et al. (1969–1970).

24. See Lévy (1995).

25. Marc Pesce at ⟨http://www.hyperreal.org/~mpesce/caiia.html⟩.

26. See Moravec (1998).

27. Diederichs (1922), p. 18. The term "avatar," one who travels with the mind or a version of a continuing basic entity, comes from the Sanskrit. See Parrinder (1970).

28. In addition to telepathy, the belief of the doubling self, which is held in certain esoteric circles, should be mentioned, according to which people suddenly but unconsciously appear in different places at the same time.

29. Plato's concept of the soul speaks about a resurrection and a life after death, an existence for the souls of the dead. See Plato's *Phaedo* (1993), p. 257.

30. Trismegistos (1964). See also Trietsch (1956).

31. Quint (1977), p. 308.

32. Emanuel Swedenborg (1688–1772), at first a pioneering champion of science, later became a visionary who, according to Kant, "saw" the great fire of Stockholm when he was 500 kilometers away.

33. According to Chris Griscom, "We leave behind our physical vehicle but move just one sequence farther into the astral frequency." Griscom (1988), p. 232.

34. On the cultural history and epistemology of telepresence, see Grau (2000c).

35. Term coined by Ken Goldberg. See Goldberg (2000).

36. Cassirer (1963 [1927]), p. 179.

37. Warburg (1991), pp. 171–173. Erwin Panofsky emphasized the decisive function of perspective in the construction of the ego and personal space in his (1927), p. 287.

38. Warburg (1995 [1923]).

39. Valéry (1973), p. 47 (transl. O.G.).

40. Albert Borgmann, "Information, nearness, and farness," in Goldberg (2000).

41. Hubert Dreyfus, "Descartes's last stand," in Goldberg (2000), pp. 58ff.

42. Martin Jay, "The speed of light and the virtualisation of reality," in Goldberg (2000). See esp. note 55.

43. Lovelock (1979).

44. ⟨www.artcom.de/projects/t_vision/welcome.en⟩.

45. Davis (1998), p. 305.

46. "Das absolute Sehen (Gottes) . . . alle Schärfe, Schnelligkeit und Kraft aller tatsächlich Sehenden und aller, die zu Sehenden werden können, übertrifft." Nicholas of Cusa: "Vom Sehen Gottes," in Gabriel (1967), vol. 3, pp. 93–219.

47. Ibid.

48. Ianka (1957).

49. Bolz (1993), p. 14.

50. Zec (1991), p. 112.

51. Loeffler (1992), p. 68.

52. Bolz (1993), p. 121.

53. See Bredekamp (1997b).

54. See Ascott (1997), p. 35.

55. See Haraway (1997).

8

Evolution

Genetic Art: Christa Sommerer and Laurent Mignonneau

The current renaissance of the classic alliance between art, technology, and science has seen the rise to prominence of a number of artists who are also affiliated with centers of scientific excellence. Two of the most important contemporary media artists, Christa Sommerer and Laurent Mignonneau, are representatives of this new alliance. Their works show at top international festivals and exhibitions and are discussed and published worldwide. Over 100 international exhibitions since 1992, when their collaboration began, document Sommerer and Mignonneau's public acclaim and success. Christa Sommerer, from Austria, and Laurent Mignonneau, from France, have received many international awards for their work,[1] and extensive press coverage has cemented their reputation. As scientists, they have lectured at universities and international symposia and have authored many research papers.

At an advanced technological level, Sommerer and Mignonneau's work engages with the upheavals wrought in contemporary art by the revolutions in imaging media and bioscience. They pioneered the use of natural interfaces that, together with artificial life, or "A-Life," and evolutionary imaging techniques, began a new chapter in the history of interactivity. The ideas driving their art are impressive for the scope of their engagement with the patterns of living nature, the idea of life itself, and people's interaction with artificial "natural" spaces. Sommerer and Mignonneau create exotic, sensuous worlds populated by luxuriant plants, countless A-life forms, amoebas, picturesque swarms of butterflies, or colorful symphonies of microcosmic organisms. Their unique aesthetic distinguishes their installations, for example, *Anthroposcope* (1993), *Trans Plant* (1995), *Intro Act* (1995), *MIC Exploration Space* (1995), *GENMA* (1996), *Life Spacies* (1997), *Life Spacies II* (1999), *HAZE Express* (1999), *VERBARIUM* (1999), *PICO_SCAN* (2000), and *IKI-IKI Phone* (2001), which have exhibited all over the world and are now permanently installed in media collections and museums. All these works deal specifically with the representation of life processes and human interaction with artificial beings in technological image spheres that have been "brought to life," reflecting the incisive transformations brought about by telecommunication. Whether in Norway, Korea, or Canada, Sommerer and Mignonneau's ingenious software and interface developments impress not only exhibition visitors interested in media art but also scientists.

Sommerer and Mignonneau are among the most well-known exponents of genetic art, which attempts to integrate the forms, processes, and effects of life into art. In conjunction with the visual principle of immersion, this comparatively young branch of digital art has begun to play an increasingly important role in the creation of illusions. From the beginning, a salient feature of this artist team's work was its naturalism. Sommerer studied biology and sculpture in Vienna, and Mignonneau studied video art, performance, and computer graphics at the Academy of Fine Arts in Angoulême. Prize money for a video film and an exchange program took him to the Institut für Neue Medien (Institute for New Media) in Frankfurt, then under the direction of Peter Weibel, where the two young artists met. There, Mignonneau's visual vocabulary and virtuoso computer skills combined with Sommerer's more conceptually oriented explorations. She had just completed sculptures and reliefs of leaf forms based on the Linnaean system and was looking for more realistic possibilities of representation, of including growth and differentiation as well as the time factor, processuality, in her artificial world.

The result of this artistic symbiosis was their first installation, *Interactive Plant Growing*, in 1992 (fig. 8.1). This work is already very clear in its intention to design a connection between virtual and real spheres as directly as possible, for which they coined the term "natural interface." *Interactive Plant Growing* visualizes principles of evolution, growth, and random mutation.[2] In a darkened room measuring 12×6 m, the visitors face a screen of approximately 4×3 m. There are five wooden stands in front of the screen, each with a different potted plant—a fern, a vine, moss, a sapling, and a cactus. This combination of plants does not exist in nature; it is a manifestly artificial, artistic order like the one shown in the Roman frescoes of the Villa Livia. When visitors touch one of the real plants, which are wired to a Silicon Graphics workstation, they activate graphic representations of more than 25 programmed types of plants. The system is capable of registering the varying voltage of the plant at a distance of 0 to 70 cm. This was the revolutionary principle of *Interactive Plant Growing*: to trigger computer images by touching a plant—a natural interface. Visitors watch as the colorful, screen-high, virtual plants grow on the screen in real time. The intensity of touch, the electrical potential difference of the user, is registered by the plant and relayed to the computer, which directs the growth of the virtual plants on the screen. Sommerer and Mignonneau

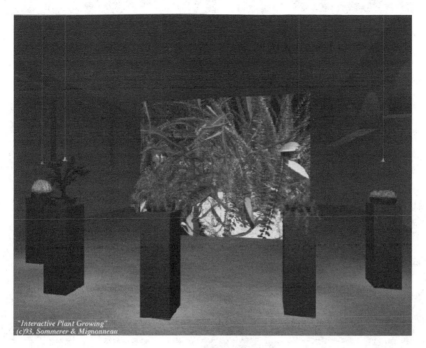

Figure 8.1 Christa Sommerer and Laurent Mignonneau, *Interactive Plant Growing*, 1992. Interactive real-time installation. By kind permission of the artists.

developed special algorithms to determine the variables of size, color, morphology, and growth characteristics, which are also very flexible and allow virtual plant growth that is not predetermined. Five or more visitors at a time can interact with the virtual vegetation until at some point, a "killer cactus" wipes out the plant population and a completely new and different artificial nature starts to grow again.

The art critic and curator Erkki Huhtamo saw *Interactive Plant Growing* at the Institute for New Media in Frankfurt and exhibited it in Finland; after that, the installation traveled round the world, reviewed extensively by the press and on TV.[3] A grant from Austria enabled Sommerer and Mignonneau to visit the Electronic Visualization Lab (EVL) in Chicago for six months where Dan Sandin and Tom De Fanti were working on the CAVE. In 1993, Donna Cox[4] invited them to work at the National Center for Supercomputing Applications (NCSA) at the Beckman Institute in Urbana-Champaign, Illinois, as artists in residence, where they remained until 1994. Since then, Sommerer and Mignonneau moved to Japan,

where they were supported by the media art curator Machiko Kusahara and sponsored by the Museum of Photography and the InterCommunication Center (ICC) in Tokyo, which was just being set up. From 1994, they worked as scientists at the Advanced Telecommunications Research Lab (ATR)[5] near Kyoto. In addition, Sommerer was professor for media art at the International Academy of Media Arts and Sciences (IAMAS) in Ogaki, founded in 1997 by Itsuo Sakane, pioneer and grand seigneur of Japanese media art, theoretician, curator, and science policy maker.[6] In the summer of 2001, Sommerer and Mignonneau began working at MIT.

A-Volve

Recently, artist-scientists such as Thomas Ray, Christa Sommerer, Karl Sims, and Jane Prophet have begun to simulate processes of life: Evolution, breeding, and selection have become methods for creating artworks. With the help of genetic algorithms, image worlds generated by computers are endowed with the semblance of being alive.[7] The debate on genetics and artificial life conducted at first within the life sciences[8] was later complemented by models, visions, and images developed by artists, which have become reference points and catalysts in this controversial debate. Sommerer and Mignonneau's real-time installation A-Volve, developed in the United States and Japan with the support of ICC and winner of Ars Electronica's Golden Nica award in 1994 for interactive art, allows observers to create artificial life forms, to interact with them, and watch them live, procreate, and die.[9] The goal is to make the virtual space come alive, this time not with simulated plants but with virtual creatures: subjectlike software agents. The observers create "their" creatures by drawing an outline and cross-section on a small digital touch screen, which a high definition projector[10] throws onto a mirror measuring 100×150 cm, which is the floor of a shallow pool of water with the dimensions $180 \times 135 \times 15$ cm. The pool stands on a podium 3 m^2 in the center of a room with black walls that is almost completely dark (fig. 8.2). The enveloping blackness of the surrounding space makes the artificial image creatures appear even more plastic and alive as they move in the illuminated water, automatically powered by the computer in real time. Gathered around the pool, their "creators" watch the survival of their amorphous, surprisingly lifelike creatures, which appear to swim and wiggle in the water, obeying the dictates of evolutionary programming (fig. 8.3). In this bright virtual

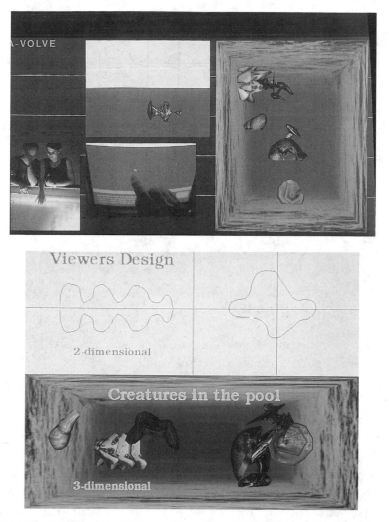

Figure 8.2 Christa Sommerer and Laurent Mignonneau, *A-Volve*. Interactive real-time installation, © 1994. Visitors interact with the creatures they have created. Supported by NTT-ICC Japan and NCSA Urbana/Champaign, USA.

Figure 8.3 *A-Volve*. By kind permission of the artists.

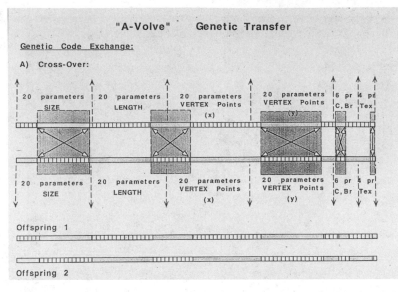

Figure 8.4 *A-Volve.* Supported by NTT-ICC Japan und NCSA Urbana/Champaign, USA. Simulation of cross-over and mutations. By kind permission of the artists.

habitat, Sommerer and Mignonneau stage the popular version of Darwin's principle, "survival of the fittest": Eat or be eaten.

By designing the creatures on the touch screen, the observers can, theoretically, sketch any kind of outline; this is converted automatically into twenty coordinates by the software. In a further step, the information regarding length and size is implanted in the "genetic code" that exists for each creature and added to the randomly generated information about color and texture, which the program derives from the pressure of the hand on the touch screen while sketching.[11] Each artificial life form, each "phenotype," has a "genome" with ninety variable parameters so that no two creatures look alike (fig. 8.4). Life, as understood by bioinformatics, appears to consist of information and here, too, the images of life are based on a form of code, which only through reiteration, the reproduction of texts as Hans-Jörg Rheinberger notes, allows the creatures to reproduce. A possible conclusion is that code/writing, RNA, DNA, and evolution are interdependent.[12] All the colorful creatures owe their "existence" to the interaction of the visitors and the random interaction among themselves. Constant change and processual development are the work's salient characteristics.

Their forms decide the movement and behavior of the virtual creatures. The algorithms developed by Mignonneau ensure that movements are smooth and natural, behavior is "animal-like" and in no way predetermined. A creature moves by contracting its virtual muscle: the intensity and frequency of this movement follow its level of stress, which is particularly high when it predates or tries to flee. During the growth phase, isolation, or under the protection of the viewers, the stress level decreases to almost zero.[13] Obviously, speed of propulsion is crucial for survival here. The virtual swimming muscle is equally pronounced in all the creatures, but certain forms can swim faster, compete more successfully, and mate and reproduce, thus passing on their "genes" to the next virtual generation. Behavior is thus dependent on the form that the user has given the virtual creature. This ranges from a streamlined shape, suited to predators, to a spherical form that is highly maneuverable. After approximately one minute of life, the selection mechanism of hunger has gotten rid of the weakest creatures in the pool. Some creatures begin as predators and, when stronger creatures are "born," they become prey. On its appearance in the pool, each creature possesses an energy level of $E = 1$.[14] When the energy level sinks below 1, hunger increases to refuel the energy supply above the critical level so that other creatures become potential food. Sommerer and Mignonneau have equipped their agents with a visual system that registers the surroundings at a $110°$ angle. The virtual creatures, images resembling life forms, are able to recognize potential prey or predators and avoid obstacles. The virtual eyes can also process information about the distance and energy level of other creatures. This decides who will be prey and who will be predator, for only agents with a lower level of "fitness" are attacked. When one creature attacks another, the visual system calculates the relative distance of the prey after each contraction of the muscle and continues this movement until its target is reached. The residual energy of the prey then transfers to the predator.

The observers "play God": they create new creatures and control the simulated biotope. Stroking the water gently, another "natural interface," lures the artificial creatures, which can then be held, wriggling, have their reproduction manipulated, or be "killed off" through withdrawal of "nourishment." The suggestive power of the images is so strong that the art theorist Machiko Kusahara wrote that the projections of the artificial aquatics feel as though they are made of jelly.[15] Technically, user

interaction is effected by a camera detection system that relays the movements of the users to an SGI Onyx workstation, which responds with the appropriate images in real time.

Sommerer and Mignonneau develop the artwork concepts and their technical realization in a symbiotic collaboration that produces remarkable synergies. Once there is an idea for a new installation, Mignonneau writes the basic structure of the program while Sommerer works on the design of forms and colors as well as the overall construction. Then Mignonneau develops the interface. After a preliminary solution of the main technical difficulties and construction of a prototype, the two artists work on design and range of freedom of interaction. At this stage, they seek first contact with an audience for feedback and reactions in order to elaborate the system further.

Personified by the Sommerer and Mignonneau partnership, art and science enter into an alliance of a very high standard where serious science is behind the artistic construction. With their comprehensive technical competence and creativity, they take full advantage of the exceptional working facilities at their disposal in the high-tech research institutions where they work, such as NCSA, ATR, and MIT. As artists, they are masters of the technology they employ; as scientists, they are engaged in further development of the hard- and software. This represents a new type of artist, who is not confined to taking technology ingeniously to its given limits but now pushes the boundaries of technology itself. Sommerer and Mignonneau do not regard technology as an end in itself. They attempt to create an artistic language, which, in contrast to the technological paradigm of virtual reality, acknowledges the responsibility of the artist to channel the suggestive power of the images and environments, while still visualizing processes and principles of life in a way that resembles the patterns of life.[16]

Artful Games: The Evolution of Images

A-Volve's evolution is based on genetic algorithms developed by Mignonneau. Generally, the object of these computational operations is to achieve a homogeneous, uniform optimum of adaptation innovatively and efficiently. To this end, evolution, without predetermined goals or purposes, is simulated, particularly the mechanism of natural selection, with crossovers and mutations.[17] Although the sexes do not exist as such in *A-Volve*,

reproduction is sexual, for a mixing of genes does take place: Two chains of vectors, the "chromosomes," containing an arbitrary number of elements correlated to individual physiognomy, exchange pairs of elements, which are recombined with the existing information. In this way, mutations and thus new creatures can be simulated by randomly inverting bits or whole segments of bits. Decisive for the success of an algorithm is the careful determination of the framework for selection.[18] With the implementation of genetic algorithms, A-Volve endeavors to incorporate biological mechanisms, such as growth, procreation, mutation, adaptation, and "intelligence." On the one hand, evolution here is like boring machinery whose most striking characteristic is extravagant and wasteful production of ever new forms of life through random mutation, testing and discarding them in a constantly changing environment: mass production with slight variations. Presumably, an artificial nature of this kind would be intractable and cruel. However, at the same time, such a complex interactive biosphere provides an opportunity for experiment, play, and surrogate experience of nature and its patterns. Something of the vital essence of the evolved world has entered these constructed worlds at a time when genetic engineering appears to be trying to outdo natural evolution and make it redundant through synthetic evolution.

For image production, evolution is a groundbreaking procedure: The more complex the random structures are, the more intensively the images appear to "live," not fixed but mutable, adaptable, even "capable of learning" after accumulated processes of selection. The application of the random principle allows the mechanism of evolution to generate unpredictable, unrepeatable, transient, unique images. Extrapolating this principle reveals the significance of this idea for art: The diversity of forms that can develop is, independent of the individual artist's imagination, theoretically boundless and includes all creatures living at present or in the future plus those that surpass our powers of imagination.

Image evolution takes control of the work away from the artist and assigns him or her the role of a passive onlooker of nonsensory processes. The original concept rapidly retreats before the random images among which artist and user can only select like breeders. Ironically, in this way the unique original returns once more to processual computer art, as the product of programmed chance, existing only for a minute or a few seconds. However, it is not the artist's original, it is the computer's.

The artist exercises control over the outcome by defining the mechanism of selection, which regulates interaction and the development of the work according to the direction intended, that is, the strategy.

In an interactive evolutionary artwork, the artist offers the users an array of degrees of freedom and rules to which they must adhere. This spectrum attains an importance for the process of the work that was hitherto unknown. Without interaction, *A-Volve* does not exist. Users actually do follow the survival of their creatures and try to protect them from others. The sociality of the users intervenes and, at the same time, serves to increase immersion in the environment through its projection onto the individualized software agents whose appearance is suggestive of social behavior, consciousness, and feelings. However, in *A-Volve* aesthetic distance has two poles: The removal of the boundary between virtual creatures and users, which is effected by social presence, has as its opposite a distance, which allows the creatures to be controlled in the first place and accepts the inevitability of their demise.

The category and meaning of the concept "game" spirals into unknown regions in interactive works like *A-Volve*. According to Huizinga, "in the game, we confront a function of a living creature which cannot be completely determined either biologically or logically,"[19] and Portmann defines a game as "an activity with tension and release, dealings with a partner."[20] Applying these definitions to *A-Volve*, we find that it closely adheres to these theoretical conceptions of a game.[21] Although the user is outside of the image space, the playful connection with the virtual creatures precludes assuming the position of an external distanced observer. The players are, as a rule, part of the world, which they survey at first from an internal perspective and in which they intervene according to the rules that constitute and regulate the game world. Alone or in groups, the users of *A-Volve* develop a game strategy to let their creature live as long as possible. *A-Volve* is a complex system constantly undergoing change. In the course of the game, the users learn how they can create better-adapted, "fitter" creatures, which in turn will give rise to new, mutated, faster propelled populations. Sommerer and Mignonneau have created a complex artificial biotope wherein the users immerse themselves with their creative actions, which they can continue, expand, influence, or destroy. It is creation within art and technology that acts as a substitute for the natural processes of creation and procreation. Meaning is produced within the

systemic structure created by the artists only through the activity of the users involved, which are also fluctuating, chance constellations of people. The genetic work of art is no longer a static quantity; like nature itself, it is subject to constant nonlinear mutations, changing itself and its observers.

A core element of *A-Volve* is the fascination exerted by the lifelike agents on the observers. These aquatics are transitional phenomena. Their rapid reactions to user actions, the rules determining their life cycle, their energy, and their interrelationships within their as-if world sustain the users' bond with the virtual artwork mentally, not in the way a 360° immersive environment does. The intensive confrontation with this bizarre evolutionary world does strongly affect the users' consciousness in that the difference from a world that is, in actuality, completely foreign is perceived as surmountable. This essence of game reality can indeed affect the way people think, particularly when, as in the case of *A-Volve*, the games of evolution progress in cycles, producing ever new generations and syntheses. The virtual space (of a game) is a space of endless possibilities, changing all the time. It is a world where the agents function as screens for the projection of the user's fantasies, energies, and desires. The artificial nature of *A-Volve* represents this both fascinating and disturbing development. Research efforts are directed at a "living" virtual space, which is felt to be all the more real the more "natural" the design of the connecting interface is. Art that utilizes models of A-life is based on the latest visual models produced by biological theories. The implantation of evolutionary processes in virtual scenarios means a further enhancement of the suggestive potential of their images.

A-Volve gives validity to the illusion it creates and fascinates the users with the creatures of its artificial creation whose survival and welfare depends on the inspired game of the visitors. The game communicates an experience, which may not be confined to dealings with art but in the future may give rise to a new experience of art.[22] The dream of a collective art, resulting from the multifarious combinatory talents of the participants and masterly use of what they are offered, may be realized in the near future of media art. A transcendental relationship to the artwork is also a possibility, where the suggestive potential of the latest, most advanced medium of images is coupled with the channeling of emotions, which history demonstrates, from the wall paintings of the Villa dei Misteri to

the genetic algorithms of *A-Volve*. However, there is no *Homo ludens* without a return from the game world to the real one.

Whatever conclusions we may draw from such image scenarios, it is certain that virtual image culture will be pushed strongly in the direction of illusion. This will come not so much from industrious engineers, working on refinement and precision of detail, but rather from combinatory random processes that generate the unexpected. It is also certain that technology, including interaction, interface design, and evolution, will pave the way for changes in aesthetics and potential of perception. The playful, seemingly autonomous agents,[23] which heighten interaction and social presence and, therefore, strengthen the connection with the image space, enhance the experience of immersion that the images and sounds evoke. Thus, it becomes imperative to engage with the technological bases of this illusion, to study their limitations, and distill an effective therapeutic agent to meet the widespread hype about these new images. For they are still images, when all is said and done, no more, but also no less.

A-Life's Party

In the meantime, the idea of evolution has taken over from the engineering principle in research on AI. After all prognoses of achieving intelligent prostheses have proved to be manifestly false, evolution is now in great demand. The application of evolutionary principles ranges from commercial uses, for example, in pharmaceutical research, to finance, telecommunication, and, as we have seen, media art. In computer networks, so the AI researchers now hope, these mechanisms will soon bring forth artificial systems capable of self-replication, language and gestures recognition, learning, and memorizing. Certain visionaries even expect consciousness to emerge.

Let us go back a step or two and ask: How has it become possible technically to simulate life processes in images? First, there are the artists and scientists who have inspired Sommerer and Mignonneau and from whose work they have profited. For example, the growth processes of plants were visualized by Przemyslaw Prusinkiewicz (fig. 8.5). Prusinkiewicz worked for many years with fractals before, at the end of the 1980s, he succeeded in combining computer graphics with mathematical models developed to explain the shapes of plants by the Dutch biologist Arstid Lindenmayer, so-called Lindenmayer-systems, or L-systems for short. Pru-

Figure 8.5 P. Prusinkiewicz, *Simulation Modeling of Plants and Plant Ecosystems*. In *Art@Science*, ed. Christa Sommerer and Laurent Mignonneau et al., New York: Springer, 1998, p. 89.

sinkiewicz used cellular automatons and recursive graphics programming to generate his convincing computer images of plants. A cellular automaton is a mathematical construct that consists of an array of "cells," which can have different states. A set of rules defines the transition from one state to another, for example, from white to black, according to the general rules of the system and the states of the neighboring cells. Using a relatively small number of simple rules relating to branching and leaf shapes, Lindenmayer and coworkers generated an astonishing number of plantlike objects, which resembled very closely plants found in nature. Prusinkiewicz and Lindenmayer's richly illustrated book *The Algorithmic Beauty of Plants*,[24] now a classic computer graphics book, is also an illustration of

Figure 8.6 Demetri Terzopoulos, *Go Fish!* 1993. Computer animation produced by Xiaoyuan Tu, Demetri Terzopoulos, and Eugene Fiume. Functioning artificial model of a fish. By kind permission of the scientist.

how patterns in nature can be better understood by recreating them in simulations.

In the early 1990s, Demetri Terzopoulos developed a biomechanical software model of a fish (fig. 8.6), an autonomous agent with a realistic, animated body and a "brain," which coordinated the perceptions of the artificial creature and controlled, in fact optimized, its swimming movements.[25] It was equipped with a so-called intention generator, which used eighty-seven interconnected elements to coordinate twelve virtual muscles of the fish. The intention generator also adapted the algorithms coordinating muscle movement to the environmental conditions, optimized them, and was capable of "learning" new techniques of maneuvering. Terzopoulos's model introduced 3-D image bodies with sensory capabilities, muscles, and modules of behavior and learning.[26]

At an early stage in their collaboration, Sommerer and Mignonneau became acquainted with the theoretical work of Louis Bec, which prompted them to interpret their own work as interscience. Bec's concern is not with creating artificial life but with developing a universal language that will allow humans, animals, and machines to communicate with each other. He represents so-called technozoosemiotics, a theoretical approach linking semiotics, ethnology, and the aesthetics of evolved com-

Figure 8.7 Louis Bec, *Melaskunodousse*, 1996. By kind permission of the artist.

puter-generated artificial life (fig. 8.7). His central hypothesis is that all living organisms, regardless of size and morphology, communicate socially. The goal of technozoosemiotics is to be the connection and medium for all these different codes of life. Bec's vision is of an all-encompassing medium that enables all languages, codes, and forms of exchange.[27]

The work of Karl Sims, who has a degree in life sciences from MIT and a graduate degree in visual studies from the MediaLab, was also an important influence on Sommerer and Mignonneau. In 1990, Sims's computer animation *Panspermia*, which used genetic algorithms, caused a sensation. *Panspermia* visualizes the theory that life can spread through the universe, or "seed" a dead planet, by the introduction of spores and

Figure 8.8 Karl Sims, *Galápagos*, 1997. Genetic art, interactive media installation, screenshot.
By kind permission of the artist.

bacteria. Sims's spectacular animation, which was only two minutes long, showed a speeded-up cycle of intergalactic life forms that self-replicated aggressively, once they got started.[28] According to random variation, the computer generates 3-D forests and plants with highly complex structures.[29] *Panspermia*, which won many awards, is an elegant visualization of scientific concepts, such as chaos, evolution, complexity, and the origins of life.

Sims's nonimmersive installation *Galápagos* (1997), now in the permanent collection of ICC in Tokyo, visualizes Darwin's mechanism of evolution, selection (fig. 8.8).[30] The system consists of twelve color monitors on pedestals arranged in a panoramatic semicircle each displaying a brightly colored virtual organism. A viewer picks one by standing on a step sensor in front of its monitor. The particular image's algorithm undergoes random alteration and eleven "offspring" appear on the other monitors. These new generations of images are both copies and combinations of the parent image, with greater or lesser mutations. The viewers choose images according to their own subjective preferences, for example, the most outlandish or the most aesthetically pleasing creature.[31] The successive gen-

Figure 8.9 Bernd Lintermann, *SonoMorphis*, 1999. Interactive installation, genetic art. By kind permission of the artist.

erations of artificial fauna tend to get more complex. Unattractive forms are not selected by the users, which means instant and final annihilation. More creatively, users can also pick and breed two organisms, that is, they can direct the avenue of evolution to be explored by *Galápagos*. Through its infinite varieties of virtual creatures, the installation succeeds in giving its users an intimation of possibilities that evolution holds for life, a hyperspace of the possible, which can be described most aptly with the aesthetic category of the sublime but can never be grasped intellectually in its entirety. It is the visualization of this abstraction that sets *Galápagos* apart from the majority of recent interactive installations.

SonoMorphis (fig. 8.9), an installation by Berndt Lintermann of the ZKM Karlsruhe in Germany, was created at around the same time as *Galápagos*. In *SonoMorphis*, the users also create generations of new biomorphic bodies based on genetic algorithms, but these are set in permanent rotation to sounds generated by random processes. With the aid of an

interface box, the users can select one from six possible mutants, which then becomes the basis for further variations. In addition, selection is possible via the Internet. The physiognomies of the creatures change step by step in the direction of the selections made on the Web while, at the same time, users' interventions in the real space of the installation influence the virtual impression on the Web. In this way, two levels of reception and interaction merge and constitute a game structure for distant users. Via recombination of the physiognomies, the marrying of visuals and acoustics leads to automatic sound compositions, which are also functions of the complex contours of the 3-D images, variations in resonance, and dynamic moving positions. Here, two distinct media, images and sounds, which also represent selected sequences of code of the genome, create a synthesis. Lintermann's aim is a highly flexible installation that should be understood as an instrument composed of visual and acoustic components. The number of possible forms is 10^{80}; according to Lintermann, this is on analogy with the number of atoms in the universe.[32] Indeed, the number of possible variants in *SonoMorphis* is incredibly high and impossible to explore. The installation's images are generally projected onto a screen measuring 5×3 m in a room of similar proportions. This restricted space of interaction, images, and sound suggests intimacy. At the media festival Stuttgarter Filmwinter, *SonoMorphis* was on view in the CAVE of Stuttgart's Fraunhofer Institute, which took aesthetic immersion to a new level.[33] This innovative strategy of Lintermann is a logical step, to connect the apparently living images produced by evolutionary techniques with the most developed apparatus for immersion: Today, this is CAVE technology.

Like no other work of genetic art, *A-Volve* symbolizes the research project of A-Life. But what is life? We know that it is a fluid admixture of time and space, surrounded by a membrane and separated from the universe by a thin coating. It cannot exist without the riddle of death. The expression of changing and evolving complexity and refinement, it arose from a cosmos of comparatively senseless unintelligent basic material. It is not a mechanical phenomenon. Each individual life contains the history of the species and thus of time and past experience. Life is a strategy to escape the tendency toward thermodynamic balance, heat-loss, and disintegration, which makes use of the method of chemical conservation. If we consider this as an abstract definition of what we call life, we should now try

to find out how the A-Life movement understands life. AI failed to deliver the goods of its own predictions, and now, since the end of the 1980s, the developing area of artificial life has been full of promise.

In comparison with previous paradigms, A-Life does have the advantage of evolutionary techniques of variation and selection. The term "A-Life" was coined by Christopher Langton and became well known through the conference of the same name that he organized on this theme in 1987 in New Mexico.[34] Whereas certain disciplines of the life sciences and sciences concerned with information theory[35] are looking for mathematical formulas to represent life in terms of information theory, much research on artificial life seeks to construct life beyond the constraints of any organic substrate and transfer it to mechanical systems. A-Life research is interested in gaining insight into the distinguishing features of life, which laws it follows, and how characteristic features arise. A key element of A-Life's interdisciplinary approach is the concept of self-organization, from simple to complex forms that can be modeled in computer simulations.[36] In order to describe and compute nonlinear and complex dynamics in nature, and thus to cope with contingency and complexity, A-Life research proceeds on the assumption that the self-organization of nature is ubiquitous. Intelligence may develop or it may not. According to this theory, software agents evolve spontaneously and autonomously through interaction with their environment, bring forth new and unforeseen developments and, with certain predefined guidelines, even intelligence, using cellular automatons. These originated from the ideas of the Hungarian mathematician John von Neumann.[37] He was the first to formulate the theory and concept of machines that self-organize and self-replicate. The programming of evolutionary processes, adaptation to the given, optimizations, and "learning" processes in an artificial life system leads to complex results that are impossible to steer. A-Life is mainly interested in probing the processes, mechanisms, and universal patterns of life, where life is understood as evolution of information; it is not interested in details of the evolution of life on earth.[38] There is fruitful exchange between A-Life research and a whole palette of disciplines, including theoretical biology, astrobiology, morphology, cognitive psychology, ethnology, evolutionary theory, computer science, and psychology; moreover, it particularly encourages functionalist approaches.[39] A-Life research mathematizes and reconstructs processes and change in the hope that, in this way, living organisms of

all varieties can be brought to life. It is logical that it seeks to transfer these essential and ubiquitous information structures and rules to synthetic media.

Sommerer and Mignonneau collaborated closely with the biologist Thomas Ray, who was engaged in fieldwork in the rainforests of South America for over ten years before joining them at the ATR Lab in Kyoto to develop *A-Volve*. Natural evolution is a very slow process, so Ray decided to speed things up a bit and invented the first computer-generated ecosystem, the evolutionary model *Tierra*.[40] In the night of January 3, 1990, the program ran for the first time without crashing, an overwhelming experience for its creator: "all hell broke loose. The power of evolution had been unleashed inside the machine, but accelerated to ... megahertz speeds."[41] In *Tierra*, which owes a debt to concepts developed by the mathematical biologist Nils Barricelli,[42] self-replicating and mutating pieces of code evolve into more complex codes. They contain around eighty instructions, including the command to replicate and to undergo spontaneous mutations. The resource that the code segments compete for is computing time. Similar to the evolutionary principle of *A-Volve*, the replication and mutation of the algorithms lead to changes and the emergence of new characteristics. Self-replicating segments of code on specially designed virtual computers undergo mutations that lead to heritable genetic variations and evolution of the offspring algorithms. Replication is asexual; however, since *Tierra* Version 4.0, it is possible to cross the genomes of different digital entities. This is possible only if the data is interpreted as being a representation of something else, for example, a population of insects. Over time, the many runs of the program produced astounding results: once Ray's self-replicator, or agent, had been released into the computer's memory, various phenomena arose for which there were no instructions, including social cooperation, digital parasites, and immunity to the parasites. In *Tierra*, the struggle for existence is played out among strings of bits.

Tierra was, in fact, a basic research project in biology, which simulated in fast motion the evolutionary cycles of hundreds and thousands of generations. Tierra's significance is that it appears to demonstrate the validity of Darwinian evolutionary theory independent of the material substrate of life as we know it—carbon and water. According to Ray, the *Tierra* system, as a quasi prerequisite for intelligence, facilitates the genesis of sili-

con- and electricity-based hormone and nervous systems as well as the spontaneous generation of multicellular life forms. Obviously, the populations in a computer running Tierra have nothing to do with real creatures; the system's aim is to synthesize new code. Virtuality allows it to evolve software while suspending the laws of physics and chemistry, and the procedure of self-replication guarantees that certain characteristics of the artificial life forms are left to the computer's programs. Although *Tierra's* evolutionary principle is similar to that used in *A-Volve*, the former's visualization of artificial life is restricted to a few amorphous, lit-up pixels, as quasi genotypes, and is thus not comparable with the much more lifelike phenomenologies of *A-Volve*. Ray's creatures are no different from their genomes; they are their genetic code. Therefore, a fundamental element of evolutionary theory—the differentiation between genotype and phenotype—has no correspondence in Tierra. Notwithstanding, Ray's digital populations adapt to defined parameters of the digital environment and develop characteristic features, just as the real creatures of the natural environment do, and all culminate in cylindrical forms with appendages.[43] In Ray's vision of the future, the combination of art and evolution will soon overtake and outdo the beauty of organic life, as sophisticated and complex artificial life forms evolve.[44] Thus, it is only logical for Ray that evolution obliges the artist to relinquish partial control over the creative evolutionary process.

One of the problems with representatives of the hard-core A-Life approach, like Langton and Ray, is that they regard computer ecospheres, such as *Tierra*, as "alive" in the conventional meaning of the word.[45] The A-Lifers claim that the projected creatures are not only similar to life but are life itself, which is, from a theoretical point of view, naïve. The pictorialism of A-Life may be suggested by its labeled images, but they are computations, like all digital images. As far as the functions and program of life processes is concerned, the image is an abstraction based on the biomorphic structure of concretization. The scientific legitimacy of an image is not only the result of the morphology's resemblance to life but also and especially the result of an algorithmic analogy to lifelike principles of evolution. Nonetheless, the process succeeds in visualizing facets of scientific theories about life and the results are images, no more, but also no less. Perhaps future observers of A-Life images will believe that they are seeing life itself, just as the sixteenth-century pilgrims to the Sacri

Monti, or early panorama-visitors, wanted to jump into the image space in order to extinguish the fires they saw there. And there was the terrified audience that fled from an oncoming train in the Lumière brothers' film. Misunderstandings of that "nature" are legion in the history of media of illusions.[46]

At the center of the vision of artificial life are genetics and recent theories, such as systems theory, information, and complexity theory, which play a significant role in newer branches of the life sciences and imply a radical new definition of the concept of life. Certain current trends in research see the decisive functions of life as taking place on a sub-microscopic and systemic level, in the form of information and control processes. Matter allegedly orders these processes, which are self-regulating and self-reproducing. Assuming these control and organizing processes are omnipresent in nature, both organic and inorganic matter can be treated and described in the same way. The production of new organisms becomes a question of the correct information.

Since May 1996, Tom Ray has been testing Tierra in the most appropriate environment for digital evolution: the Internet. Netlife, he hopes, will produce there a digital equivalent to the Cambrian explosion of diversification and its flowering of a vast range of anatomical possibilities.[47] Ray hopes to trigger this Big Bang of computer-aided evolution through the highly complex information-processing capabilities of networked parallel computing hardware structures, through the free capacity of CPU cycles in thousands of computers hooked up to the Net. Ray sees the evolution of complex structures as taking place in the context of interaction between co-evolving species or systems, which are exposed to different environmental conditions that change dynamically at random. The desired result would be software of unimaginable complexity, capable of fully exhausting the capacities of the hardware base.

The popularization of complex mathematical morphogenesis, such as Thom's catastrophe theory or Mandelbrodt's fractals, also resulted in modernization of the concept of emergence, which, according to certain biological theories, maintains that new characters and qualities appear at complex levels of organization that cannot be predicted from studying less complex levels alone. By implementing evolutionary processes, Ray's ideas not only aim to write a new chapter in the history of human-made media, they also seek to harness the creative power of evolution for emergence and

complexity in order to achieve new, unpredictable, and unexpected results and even to partially control evolution. Simon Penny has referred to this method as being a fundamental rejection of scientific reductionism, which attempts to organize complexity in units that are manageable and analyzable in order to obtain meaningful, verifiable results.[48] Without doubt, a method that relies on a bottom-up approach will achieve increased complexity and, with the aid of the random principle, reach solutions to problems that were unsolvable using traditional methods.

However, it is not the case that Ray and other A-Lifers abstain entirely from analytically reducing and defining their complex results. Emergency and complexity are certainly constructs for obtaining artificial creations.[49] The direction is toward phenomenologies or programs that are so multilayered, novel, and unmanageable that they can be regarded as a scientific analogue to a highly complex illusionism with its immersive essence that denies critical analysis. To put it bluntly, according to its logic, a critical and distanced appreciation of art corresponds to scientific reductionism where complexity and immersion can be described as antagonistic. They may present fascinating new programs and worlds of images but in essence, they are inaccessible to sober appreciation and understanding. The concept of emergence, when implemented in an artwork, surrenders most of the essential properties of an artwork—form, structure, construction, function, processuality, and statement: These become unpredictable, mechanical, and random outcomes. Sommerer and Mignonneau have also suggested an Internet-based phase transition system,[50] which is committed to the goal and research of increasing complexity and would be tested using their Net artwork *VERBARIUM* (1999) (fig. 8.10). To provide a testing ground for the complex systems and origin of life theories by Stewart Kauffman,[51] Charles Langton,[52] Norman Packard, Walter Fontana,[53] and Per Bak,[54] they propose an Internet-based environment, which, like their work *VERBARIUM*, allows participatory and interactive access via the Net. In the search for phases of complexity that might bear on intelligence, art has now become a testing ground for current scientific theories.[55]

Thomas Ray's Netlife goes even further than *VERBARIUM*: Ray predicts that artificial intelligence in machines will arise in the Internet, but he ascribes different distinguishing marks to this artificial life form than, for example, Alan Turing in his famous test of 1950.[56] Netlife, says Ray,

Figure 8.10 Christa Sommerer and Laurent Mignonneau, *VERBARIUM*, 1999. Interactive netartwork. By kind permission of the artists.

will be able to go, physically and autonomously, anywhere on the planet in a matter of milliseconds. The stream of data will be direct sensory experience for this species; although one wonders what sensorium Ray sees as being activated here. Digital, nonmaterial environmental conditions prevent humans from being able to imagine how such an existence "feels." The Turing test's superimposition of the concept of what is human onto machines is the reason it takes the wrong direction. The Netlife artificial life form, which Ray wants to bring to life with his work, lives an inconceivably foreign but totally independent life.

A-Life's Subhistory

To create artificial life, whether hydraulic, mechanical, electronic, or digital, is a perennial dream of artists that goes back at least as far as antiquity.[57] The legendary doctor Galen (129 to ca. 199 B.C.) outlined his pneumatic model of the human body after the hydraulics of his time. Art became automatized in the mechanical theater of Heron of Alexandria where, using a system of ropes, winches, and levers connected to counterweights, sound effects, and changes of scene, he brought the legend of Naplius to illusionary life. In the literature of Persia, India, China, and Greece, there are myriad references to, for example, mechanical flying

doves, dancing monkeys, or talking parrots. In fourteenth-century Florence, none other than Filippo Brunelleschi designed a mechanical stage for staging an imitation of Paradise. These mechanical imaginings conflicted with religious dogma, which decreed that God's creation, the *alter Deus*, possessed free will and an immortal soul, and thus there is a paucity of recorded evidence on automation until the sixteenth century.[58] Since antiquity, the imaginations of poets and artists have produced a long line of chimeras—golems, androids, mandrakes, living images—and in the seventeenth century, with the analogy of the human body and clockwork, the most advanced technology of its time, material-mechanistic ideas resurfaced. In 1615, Salomon de Caus published his famous collection of plans for automata and drawings of gardens (fig. 8.11), *Les Raisons des Forces mouvantes*. René Descartes knew de Caus's work very well and went on to envision an imaginary android of his own, which differed in no respect from a carbon-based human being;[59] Descartes also interpreted organic processes as mechanical experience. According to some contemporary accounts, in 1640 he built an automaton himself named *Ma Fille Francine*, which could perform somersaults on a rope; presumably, both a surrogate and a representation of his illegitimate daughter of the same name. The lifelike representation of this apparatus's gender was its downfall: On a sea voyage, the superstitious captain threw it overboard. Descartes's British contemporary, Thomas Hobbes, radicalized this mechanical and rationalist worldview: He interpreted all life on earth as bodies in motion and mental phenomena as the motion of endogenous matter in the head—"FOR REASON, in this sense, is nothing but reckoning...."[60]

The inexorable rise of the android dates from the eighteenth century. Contemporaneously with the marvelous automata constructed by Jacques de Vaucancon, the constructor of the famous mechanical duck (fig. 8.12), whose celebrated flutist could move eyes, lips, and fingers and play a dozen or so pieces, La Mettrie published his famous *L'homme machine*.[61] Around thirty years later, Wolfgang von Kempelen's Turkish chess player made its appearance, which in fact concealed a human master of chess. This early "chess computer" caused a sensation in western Europe as did the android built in 1774 by Pierre Jacquet-Droz—perhaps the most skillful constructor of all—who could write "cogito ergo sum." This machine sent chills of horror up and down the spines of contemporary audiences, conjuring

Figure 8.11 *Salomon de Caus: Les raisons des forces mouvantes.* Frontispiece, Frankfurt/M.
(Abraham Pacquart) 1615.

Figure 8.12 Jacques Vaucançon, *Canard digérant* (mechanical duck), 1783. From *Le monde des automates* (1928). ⟨http://www.culture.com.au/brain_proj/neur_net.htm⟩.

up fantasies and haunting anxieties.[62] Kleist's *Marionettentheater*, E. T. A. Hoffmann's Olimpia, Mary Shelley's feeling monster in *Frankenstein*, Jules Verne's Stilla, the machine-human in Fritz Lang's *Metropolis*, Ernst Jünger's Arbeiter: The lineage of disquieting robot fantasies is long. Like their ancestor, the Jewish Golem, they can also be read as metaphors warning us of the dangers of idolatry and elevating ourselves to the level of gods. They are a "menetekel," expressed through myth, and their inheritors now seek to create artificial life forms, artificial intelligence on the Web,[63] although it is still not understood how consciousness arises or how it functions.[64]

Thus, the project to create artificial life and artificial consciousness, however animated and illusionary it may seem, remains in essence a human projection onto human-made technology in transition. It represents a symbolic space, which above all says something about the level of development of technology and the reflection of the image of the human within it. To rediscover or redefine life and the human in terms of the latest, most advanced technology has a long ancestry in the history of technology, in particular with reference to hydraulics, mechanical engineering, electronics, and computer technology. The given model and prevailing contemporary definition of what life is is always in a state of change.

Correspondingly, different elements in different periods have been identi-
fied as driving the artists of this grand project to conflate art and technol-
ogy and bring it to life, from male envy of parturition to playing God.
Such male fantasies, however, are not the only motives that have led to the
creation of ideal images of the female; an essential element of the drive to
create artificial life touches on the connection of the nature of machines
with dreams of immortality.

In the entire history of artificial life, the search for the essence of life
and the fascination of processes resembling those of life have motivated
generations of researchers and engineers to invest enormous energies in
their work. To observers of later eras, their artifacts seem like curiosities
and artistic gadgets, rather like the early spaces of illusion and immersion
that have lost their illusionary potential but continue to fascinate because
they condense the mechanical achievements of their time. To later gen-
erations, the idea that they represent plausible models of life is mildly
ridiculous. It is more than probable that the contemporary project of arti-
ficial life will share the same fate in the near future: When its productive
and useful elements have been thoroughly recognized, it will be free of the
stereotyped myth of life created by humans, which has often been suc-
cessful in securing funding for costly research projects. A-Life and its art
promise extraordinary results for science, but with statements such as "the
Net images are alive" their proponents demonstrate themselves to be the
heirs of ancient believers in images.

Are science and art parallel universes, communicating osmotically with
one another, overlapping, and, from time to time, converging? C. P.
Snow's two worlds may not be the only ones; perhaps there are an in-
finite number. Many twentieth-century authors have drawn attention to
the creative parallels between art and science, for example, the Gestalt
psychologist Rudolf Arnheim in his studies on visual thought, or Anton
Ehrenzweig, who investigated the connections between abstraction in the
visual arts and science. The natural sciences, "science of nature," with
their tendency to view things from a distance, to "objectify," represent the
opposite of constructing subjects, feelings, and dreams. However, the
point where science is most attractive is where subject and artifact com-
bine, beyond the sterile separation of cold knowledge and l'art pour l'art.
Each new art form makes its own rules and develops its own methods. It
is not possible to discuss this question in depth here;[65] it is sufficient to

recall that if science rests traditionally on a particular combination of methods (an idea that Paul Feyerabend already opposed in 1978 with a plea for pluralistic methods in research, claiming that "anything goes"), art achieves its power principally by tolerating a range of methods. This playful dimension leads art, in its experimental dealings with new media, to surprising results and insights. Science is, in its mechanisms and methods, in its systems of truth and proof, a social construct. Art is, too, and in this sense, they are comparable.[66]

The relationship between culture and nature becomes controversial when scientists claim to explain social and cultural phenomena. One of the more recent examples of this is the meme theory of the neo-Darwinist Richard Dawkins.[67] According to Dawkins, memes—memory units—are units of cultural information that develop analogously to genes in evolutionary processes, whereby form arises through algorithmic procedures, entirely without the planning or control of an intelligence operating in the background. In the conception of proponents of "memesis," who take their ideas to be a "paradigm shift" in the cultural, cognitive, and social sciences, selfish memes compete with each other, proliferate like viruses, and adapt, as when they pass from one mind to another and mutate.[68] Adherents of meme theory see in the Internet an ideal medium for the spread and mutation of these cultural units. Although there is not a generally agreed-on definition of what a meme is (all the theorists cite different examples; in fact, the lack of terminological hygiene continues to handicap the development of this theory), the term is used by considerable number of writers. Daniel Dennett, for example, describes human beings as essentially congregations of memes. The debate on to what extent humans are determined by their genes or by cultural factors is also a debate about how much we are influenced by education, society, and environment, about self-determination and ethical responsibility. The notions that genes map to characters, that human beings are powerless tools of memes that dominate and program our brains, suggests once again that the brain-computer analogy and its implications are a fatalistic vision of human consciousness determined by agents, A-Life, and supercomputers. The meme theory is a new variant of older debates on nature versus nurture, which has arisen in the context of the massive scientific advances in biology made in the twentieth century, and proposes its own new view of life.

Thus the meme theory stands in a long tradition: from the mechanical view of the world of the early modern age to the physical ideals of the Enlightenment to the positivist and optimistic view of science in the nineteenth century, which was also the prelude to crimes against humanity committed in the name of social Darwinism. In the light of history, caution is indicated in approaching these latest visions of life and the world that are on offer. A polarized model, nature versus nurture, genes versus society, is not a viable construction. Many recent developments in science have underlined the necessity of confronting its tenets and its myths critically, including their extrapolation in popular forms that exhibit all the features of an ideology. More than ever, it will be imperative for there to be cross-fertilization between science, social sciences, and art. Much has been done to promote interdisciplinarity and to pull down the barriers erected during the course of the Enlightenment and the nineteenth century, but much more still remains to be done. To bring the natural and social sciences, technology and art, closer together is one of the greatest challenges of the new century. The scientistic and conservative outlook that has grown out of the theories of Dawkins and, before him, the sociobiologist E. O. Wilson[69] are not adequate to meet the needs of the unified knowledge that we require for the future. Sommerer and Mignonneau's *A-Volve*, which is at the same time a scientific model and an aesthetic one, represents a cultural expression, a reflection of this historical debate.

Transgenic Art

The twentieth century was the century of biology and gene technology, the method of human intervention in evolution, which appears to allow the human race to recreate itself. Not surprisingly, what appears to be possible in actuality is reflected at the level of new techniques for creating images. The accompanying rhetoric proclaims that we are on the threshold of expanding the sphere of digital image design to real bodies, although the effects of digital implants and genetically manipulated organisms are unknown and incalculable. Scientists are not the only ones searching for the DNA of species long extinct in order to rerun evolution and create dinosaurs, mammoths, or dodos: Artists are also active in this field. The Brazilian media artist and theorist, Eduardo Kac, outlined his concept of "transgenic art" at the 1999 Congress of the Inter-Society for the Elec-

tronic Arts in Sao Paulo,[70] a reflection and projection of possible biotechnological things to come.

Transgenic art does not postulate the "life" of images, as do the hardliners among the A-Lifers. Transgenic art seeks to create unique living creatures using genetic engineering techniques, that is, to transform life itself. Kac works with scientists to synthesize genes from plants and organisms, create synthetic genes, and transfer them to other organisms. For example, the dog, which has been domesticated for some 15,000 years, has been selected by Kac for an almost dadaistic contribution to biodiversity: His "work," GFP K-9, is a dog to which a green fluorescent protein from a Pacific Northwest jellyfish has been transferred.[71] Under ultraviolet light, GFP K-9 emits a greenish glow.[72] The canine genome was mapped faster than expected, so GFP K-9 did not remain a futuristic vision of the artistic imagination but became a reality. For some time now, goats with spider genes and pigs that produce human proteins have existed.

In 2000, Kac successfully created a transgenic rabbit and proposed its social integration in the context of its family. With this work Kac stimulated social debate about the cultural impact of biotechnology (fig. 8.13). Kac sees the transgenic animal as an original, as a material automatic sculpture elaborated from digital artistic visions that are otherwise ephemeral, and as a way out of the increasing number of species that are becoming extinct. Bodies are released from their passive status, are understood as potentially transformable through genetic engineering. This transgression of the boundary between fact and fiction redesigns the body, leading to a destabilization of the biological and anatomical basis of life, the body. The skin no longer represents the boundary between the subject and the external world: "With the future creation and procreation of bioluminescent mammals and other organisms," says Kac, "dialogic communication between the species will change fundamentally our present concept of interactive art."[73] Kac's work may seem ironic taken at face value or credited with false avant-gardism, where the intention is only superficially critical —art for art's sake. However, at present, it is the scientists who are actually creating green-glowing dogs; thus, genetic or transgenic art does not yet exist. Nevertheless, Kac's art plus science visualizes the debate on genetic manipulation, which up to now has really been two parallel

Figure 8.13 Eduardo Kac, *GFP Bunny*, 2000. Courtesy Julia Friedman Gallery, Chicago.

debates: one within science and one within the mass media. It is Kac's intention to shift the discussion of transgenics to an ethical, social, and historical context.[74] It should not be forgotten that powerful economic interests are behind this technology. Genetic engineering and transgenic organisms will play a greater role in our lives in the future, perhaps even an integral one. Perhaps to be human will mean, at some future point in time, that the human genome is not a constraint but a starting point. Kac's controversial art with its striking images throws open to public debate the whole area of genetics and its possibly drastic effects.

Tracing the history of automata and robots, we now confront the phenomenon that they are combining with genetic engineering. Based on manipulation or computer-aided evolutionary transformation of genetic codes, it is within the realm of possibility to create apparently "living" robots. Transgenic robotics, for the creation of biotech hybrids, is beginning to take on an outline; as yet in the form of images, but perhaps soon to cross over into the material sphere. The body appears less and less as the location of all that is natural, authentic, and original as it was stylized in the bourgeois thinking of the nineteenth century. Over and above its

physical make-up, the body is revealed increasingly as a construct, a screen on which changing historical inscriptions are projected that move between the poles of nature and artifact. Currently we are witnessing a dramatic caesura between epochs in which the old models of the world seem to be rapidly losing their validity. The divisions between technology and nature, mind and matter, humans and machines are crumbling. The opposition between thought and existence is losing its brisance. The visions of thinkers such as Hans Moravec or the more radical A-Lifers have seen the end of the project of the Enlightenment, of humanism, and have taken the human subject to pieces. Against the backdrop of the historical context I have sketched here, the typical metallic clang of their rhetoric is audible. The advocates of a new genetically manipulated utopia can try as much as they want to get us used to the monstrous and interpret the possibilities and visions of certain avenues of research as nature so that the thought does not arise that there are political alternatives. Those who view it as liberating that our species can now take evolution into its own hands do not appear to have thought about the direction future "construction" should take (or they are keeping quiet about it). According to which model will we be reconstructed? How will the new generations of reconstructions feel about the decisions taken that then govern their existence? The possibilities of exercise and concentration of power are monstrous, and responsibility reaches nightmare proportions. What self-image is possible when one realizes that one is an image that others have made—an image made in flesh?

Whereas A-Life can be viewed primarily as control over images and thus perhaps over consciousness, transgenic art takes consequences to extremes; it is the will to power over life itself. With the creation of transgenics, art crosses over into the unbounded territory of genetic manipulation.[75] Both models confront us with mechanisms of Darwinian evolution and the ideologies they have spawned. In Darwin's theory, natural selection drives the process of evolution. Yet, natural selection is not merely struggle; caring for offspring, cooperation, or coexistence with conspecifics, other species or plants, and good camouflage are equally important. Behavioral science has shown that strength or brute force is often not decisive for survival but the ability to associate and cooperate and the capacity for self-constraint are. The ubiquitous fight for survival, where it's every human for him- or herself—in economic liberalism, social

Darwinism after Spencer, to eugenics and the racial hygiene doctrine of the Nazis—was not the conclusion drawn by Darwin. For the biologist Ernst Ulrich von Weizacker, the very idea of eugenics contains a seed of crime, for who decides what is good and what is bad? Which genes are desirable? How can we protect diversity from the tyranny of fashions and fads, social insurance, money, or ideologies? Would it not be worthwhile in light of these developments to give serious consideration to Bruno Latour's suggestion that we should extend those rights we accord to humans also to all nonhumans, including technology?[76]

Notes

1. 2000: Life 2.0 Honorary Award, Life 2.0 competition; Telefonica Spain; 1999: Ars Electronica Interactive Art Honorary Mention Award, Prix Ars Electronica '99, Linz, Austria; 1995: Inter Design Award, Japan Inter Design Forum, Tokyo, Japan; 1995: Ovation Award, Interactive Media Festival, Los Angeles, United States; 1994 Multi Media Award, Multi Media Association, Tokyo, Japan; 1994: Golden Nica Award, Prix Ars Electronica '94 for Interactive Art, Linz, Austria; Silicon Graphics Award at the ISEA Festival, Helsinki, Finland; 1993: Interactiva Award (Phillip Morris), Cologne, Germany; 1992–1993: Chicago Scholarship, Ministry of Art and Science, Vienna, Austria; National Selection—New Creators, New Creators '93 catalog 93, Paris, France; DAAD German Research Grant, Bonn, Germany; Eurocreation Grant, Pepinière Européennes, France–Europe; 1992: Prisma Award for Computer Art, MEDIALE and INTERFACE 2, Hamburg, Germany.

2. Sommerer and Mignonneau (1993).

3. 1992: Institut für Neue Medien, Eigenwelt der Apparatewelt, Frankfurt; Otso Gallery, Interactive Garden, Helsinki 1993; Museum for Applied Arts—Museum für Angewandte Kunst, museum in progress plants in progress, Vienna; MEDIALE '93 and INTERFACE 2, International Media Festival, Hamburg; Palais de Tokyo, L'épreuve numerique, Paris; Secession Wien Junge Szene, Vienna; Arte Virtual: 12 Propuestas de Arte Reactivo, Madrid; Carre Seita—Rendez-Vous d'Imagina, Paris; IMAGINA, Monte Carlo, Monaco. 1993: FISEA, Fourth International Symposium on Electronic Art, Minneapolis; Eldorado, Media Festival Antwerp; InterActiva, International Festival for Interactive Media, Inter-Activa-Award, Cologne; SIGGRAPH 93—Machine Culture: The Virtual Frontier, Anaheim, California; Electronic Dictionary, Quebec; Angles of Incidence: Video Reflections of Multimedia Art Works, The Banff Centre, Alberta; Ars

Electronica '93, Genetic Art—Artificial Life, Linz; Kunsthalle Wien, Binaera: 14 Interactions—Art and Technology, Vienna.

4. Donna Cox, herself an artist, teaches at the local Academy of Arts and is professor of scientific visualization at NCSA. She was responsible for initiating the Artist in Residence program, assisted by George Francis, professor of mathematics. A hallmark of the Beckman Institute is interdisciplinarity: It brings together scientists from diverse disciplines such as biology, astronomy, mathematics, physics, complex systems, music, computer science, virtual reality, and scientific visualization.

5. The ATR, which employs around 200 scientists, is an international laboratory for research on different areas of telecommunications, including human interface, speech recognition, voice recognition, face recognition, speech translation, radio optics, and virtual reality. Its main sponsors are the Japanese government, NTT, Sony, und Panasonic.

6. ⟨http://www.iamas.ac.jp/⟩.

7. See Shanken (1998) and Tenhaaf (1998).

8. For example, Levy (1992); Ray (1992a,b,c); Langton (1995); Steels et al. (1995); Dawkins (1996); Bedau (1998); Davis (1998).

9. See Sommerer and Mignonneau (1994), pp. 172ff.; Sommerer and Mignonneau (1996); Duisburg (1997) (exhib. catalog), pp. 96–101; Falk (1996).

10. In most cases, a SONY VPH 1272Q Superdata EX Projector with 1280 × 1024 display resolution and a frequency of 80hz 80 khz; on occasions, a Barco 808.

11. There are three parameters for determination of color and tone and four for texture.

12. Rheinberger (1999). See also Derrida (1974) on the history of writing.

13. Sommerer and Mignonneau (1997), p. 16.

14. Sommerer and Mignonneau (1998b), p. 153.

15. Machiko Kusahara, "Interactive Plant Growing, A-Volve: Christa Som-merer and Laurent Mignonneau," in Honda et al. (1995), p. 104. Mathias Fuchs disagrees that here the borders between real and unreal are blurred; on the con-trary, in his opinion "the differentiation between instances of reality are enhanced by their juxtaposition." Fuchs (1996), p. 212.

16. See Sommerer and Mignonneau (1996), p. 351; and Mignonneau and Sommerer (2000a,b,c).

17. Stewart (1998), p. 97.

18. See Schöneburg (1994); Goldberg (1989).

19. Huizinga (1938), pp. 18–19.

20. Portmann (1976), p. 60.

21. More recently, see Sonderegger (2000). For a classic interpretation, see Winnicott (1973).

22. This is not a new idea: Kant, for example, wanted to judge games by their influence on our entire existence. See Kant (1973), p. 101.

23. See Binkley (1998).

24. Prusinkiewicz and Lindenmayer (1990).

25. Terzopoulos et al. (1993).

26. Terzopoulos et al. (1994).

27. Louis Bec, "Artificial life under tension: A lesson in epistemological fab-ulation," in Sommerer and Mignonneau (1998), pp. 92–98.

28. Sims (1991).

29. Sims used a Connection Machine CM-2 for the software and animation, and David Atherton, David Grimes, Steve Blake, and Target Productions created the sound.

30. Software and animation by Karl Sims; Gary Oberbrunner created the network and the step sensor. Most of the funding for Gálapagos came from the NTT InterCommunication Center.

31. For a general description of morphogenesis, see Kemp (1996).

32. Pers. comm.

33. The installation was on show from January 14 to 17, 1999.

34. Langton defines his view of the twofold use of A-Life thus: "In addition to providing new ways to study the biological phenomena associated with life here on Earth, *life-as-we-know-it*, Artificial Life allows us to extend our studies to the larger domain of "bio-logic," of possible life, *life-as-it-could-be*. . . ." In Langton (1992), p. xviii.

35. Keller (1995).

36. The suggestion met with incomprehension at the time, but in the late 1950s, John Henry Holland described a model of a parallel computer in his dissertation. Around the same period he bacame interested in the formalization of evolution and produced the first genetic algorithm. Holland did not use a computer, but his model of evolution included mutations that allowed adaptation to the environment.

37. Konrad Zuse claims to have developed the idea of a cellular automaton independently of von Neumann, which he described in his (1969).

38. See Langton (1995); Stewart (1998).

39. Boden (1996).

40. Ray (1992b, 1997); Metzger (1997). Tierra can run on a number of systems, including Silicon Graphics, SUN, Next, IBM RS 6000, Cray, Connection Machine CM5, most UNIX machines, and DOS computers.

41. Ray (1992c), pp. 5–6.

42. Barricelli (1962, 1985). For a detailed overview, see Dyson (1998).

43. Casti (1990).

44. Ray (1992a, 1997); Todd (1994), pp. 271–286.

45. See Ray (1992a).

46. See Grau (2000d).

47. In Tierra, a main hindrance to the evolution of complexity is the fact that one node, an algorithm of thirty or forty bytes that self-replicates comparatively fast, cannot be displaced by another more complex algorithm that self-replicates more slowly. The heterogeneous patterns of access to energy in the computer topology, it is hoped, will promote complexity. See Ray and Thearling (1994).

48. ⟨http://www-art.cfa.cmu.edu/Penny/texts/Darwin_Machine.html⟩.

49. Peter Cariani, "Emergence and artificial life," in Langton et al. (1992), pp. 779–789.

50. One of the first to refer to a "global phase transition" was the British biologist Mae-Won Ho. See Ho (1991), p. 607.

51. Kauffman (1995), pp. 23–112.

52. Charles Langton, "Life at the edge of chaos," in Langton et al. (1992), pp. 41–91.

53. Walter Fontana, "Algorithmic chemistry," in Langton et al. (1992), pp. 159–209.

54. Bak and Chen (1991).

55. Mignonneau and Sommerer (2000c); Rinaldo (1998).

56. Turing (1950).

57. See Bredekamp (1993, 1999); Bostic (1998); also Klein (1998).

58. Bredekamp cites Leonardo da Vinci as such an artist-engineer, who worked on concepts and theories of automata and constructed at least one himself:

See Bredekamp (1999), pp. 94ff. For a collection of medieval legends about automata, see Hammerstein (1986).

59. "Je desire, dis-je, que vous consideriez que ces fonctions suivent toutes naturellement, en cette Machine, de la seule disposition de ses organes, ne plus ne moins que font les mouvemens d'une horloge, ou autre automate, de celle de ses contrepoids & de ses roües; en sorte qu'il ne faut point à leur occasion concevoir en elle aucune autre Ame vegetative, ny sensitive, ny aucun autre principe de mouvement & de vie, que son sang & ses esprits, agitez par le chaleur du feu qui brûle continuellement dans son coeur, & qui n'est point d'autre nature que tous les feux qui sont dans les corps inanimez." René Descartes, "Traitté de l'homme," in Descartes (1974), vol. XI, p. 202. For a general view, scc Knauss (1780) and Kominstky (Comenius) (1657).

60. Thomas Hobbes, "De homine" (Of man), 1658, in Hobbes (1994), vol. III, part I, p. 30.

61. La Mettrie came to project autonomous motion and feelings onto the automata; see La Mettrie (1960 [1747]); Sutter (1988).

62. Tholen (1995).

63. See Steels et al. (1995). The German philosopher Gerd Döben-Henisch opines in all seriousness: "Confronted with the limited natural resources it would be conceivable in such a context that it would be better to reduce the human race almost to nothing." Döben-Henisch (1996).

64. See Searle (1996); Cairns-Smith (1996).

65. The kaleidoscope of far-reaching mutual influence of art and science is the subject of Jones and Galison's (1998) compilation.

66. Feyerabend (1984).

67. Dawkins (1996, 1989, 1982).

68. Dennett (1996), p. 83.

69. Wilson (1975).

70. ⟨http://www.itaucultural.org.br/invencao/invencao.htm⟩.

71. See Reichle (2000) and the extensive documentation by Kac (1999).

72. At almost the same time, scientists at the University of Herefordshire developed a concept for green-glowing fir trees which the inventors envisage as Christmas Trees selling at about 600 DM; in Oregon researchers are working on green-glowing monkeys: See *konr@d*, no. 6, 1999, p. 26.

73. Kac (1999), p. 300. On the transgenic work *Genesis* see Reichle (2001).

74. In Germany, the philosopher Peter Sloterdijk forwarded a set of provocative theses on precisely this subject that have received much public attention. See Sloterdijk (1999).

75. Both the risks to transgenic organisms themselves (i.e., premature aging, organ failure) and of releasing them into the environment are poorly understood. For example, in an experiment with tropical aquarium fish carrying a human gene, the release of 60 transgenic animals sufficed to wipe out a natural population of 60,000 fish.

76. Latour (1993).

9

Perspectives

This book began by arguing that ingress into virtual image spaces of the computer, which is now possible, is not the revolutionary innovation its protagonists are fond of interpreting it to be. The idea of virtual reality only appears to be without a history; in fact, it rests firmly on historical art traditions, which belong to a discontinuous movement of seeking illusionary image spaces. Although these were constrained by the specific media of the period and used to convey highly disparate content, the idea stretches back at least as far as classical antiquity and is alive again today in the immersive visualization strategies of virtual reality art. I am certain that additional examples of the phenomena and problematic discussed here will have occurred to most readers, which obviously could not all be covered here. This makes it abundantly clear how strongly the phenomenon of immersive spaces of illusion is anchored in the history of art. It is surprising that until now so little attention has been paid to it.

Utilizing contemporary image techniques, immersive art very often visualizes elements that can be described as Dionysian: ecstatic transport and exhilaration. The images of this art form tolerate hardly any comparisons or image-immanent contradictions that might diminish the illusion. Immersive art often molds propagandistic messages, conveyed by its images, thus working specifically against distanced and critical reflection. Frequently, it serves to bring about playful detachment and disinhibition in the observer—however one may judge this—and processes transforming consciousness may result. Aesthetic experience, understood in the sense of the Cassirer-Warburg concept of thought space or theories of distance, tends to be undermined by immersive strategies. The recurrent model follows the utopian notion of relocating the observer *in the image*, removing the distance to the image space, intensifying the illusion, and renewing the power exerted over the audience—an idea that has consistently driven constitutive dynamics in the development of new media of illusion. For, in essence, all socially relevant new image media, from classical antiquity to the revolution of digital images, have advanced to serve the interests of maintaining power and control or maximizing profits; hardly ever have they advanced solely for artistic purposes. This is despite the fact that in all epochs, artists have been the leading theorists and technicians of the image. Immersion arises when artwork and technologically advanced apparatus, message and medium, are perceived to merge inseparably. In this moment of calculated "totalization," the artwork is extinguished as an

autonomously perceived aesthetic object for a limited period of time. Then conscious illusion, as in the weaker form of trompe l'oeil, can shift right around for a few moments into unconscious illusion. The examples discussed here demonstrate that a constant characteristic of the principle of immersion is to conceal the appearance of the actual illusion medium by keeping it beneath the perceptive threshold of the observer to maximize the intensity of the messages that are being conveyed. The medium becomes invisible.

Almost without exception, new image media began with 360° arrangements, which led the medium toward its maximal effect. Sooner or later, the illusion spaces were recognized as such; sometimes, within a matter of seconds, sometimes immediately, sometimes after a longer period. This was always dependent on the variable of the subject's media competence. Whether illusion spaces communicated by and through media are perceived in the longer term as real, is, in this context, of lesser importance than the fact that the images and the content they communicate have such a sustained effect. If we consider the history of illusion spaces, from the Villa dei Misteri to the high-tech illusion *Osmose* or genetic and telematic art, then the enormous expense and effort that went into them is explicable in terms of the effect, of suggestion, that it was intended they should arouse in the observers, through which the message was conveyed. In its concentration, the transmedia functional continuum of the hermetic illusion space appears to be an anthropological constant. Despite this, the focus of further development of image media has been the defense of existing hegemony under changing social conditions, the marketability of products, and personal image cultivation. New image media, as a rule, enhance the power of the powerful; this is their primary purpose. There is just a slight possibility that the recent, ubiquitous spread of the new digital image media will, for the first time, begin to erode this gradually: Internet, open source, Quicktime VR, Streaming Video will perhaps, but only perhaps, make inroads into this power relation.

We regard historical media of illusion against the background of our increased, present-day media competence, and, from this viewpoint, we may judge their potential for suggestion as small. However, this may not correspond at all with the experience of contemporary observers. It can reasonably be assumed that because contemporary experience with such phenomena was slight, the suggestive potential of historical illusion media

would often have been experienced as stronger than that of media today. Seen in this light, a contemporary observer would have been gripped far more by Massacio's fresco of the Holy Trinity, the Lumières' approaching train, or a panorama-landscape that implemented state-of-the-art cognitive science of its day than we are today, for example, by a film such as *Terminator II*. The effect of illusion media on the observer is relative and dependent primarily on previous media experience.

Through the history of art and the media that support it runs a path that might almost be termed evolutionary (particularly before the "invention of art"). It is an artistic and scientific line of development that has invariably made use of the latest image media and techniques available. Vasari's descriptions of the lives of Renaissance artists, culminating with Michelangelo, can be read in this light, and art theorists' high regard for certain artists, such as Lommazzo's for Ferrari or Serlio's for Peruzzi, also fits with this reading. Consider the mighty media network that the churches established from the late Middle Ages onward. From Alberti's metaphor of the window to Massacio's Holy Trinity fresco, Leonardo's *The Last Supper*, and *quadratura* painting, the pictorial arts never relinquished their claim to real presence and the iconoclastic movements reflect this strength and magic power of images. Within the tradition of illusionism, virtual image spaces should be understood as a vanishing point, as an extreme, where the relationship of humans to images is highlighted with particular clarity.

In nearly all epochs, some examples of image suggestion that accompanied the introduction of a new image medium of illusion merely served the purpose of advertisement or used the topos of the artist as creator of worlds of his or her own. However, the examples are too numerous, the reports of experiences too continuous, precise, and well documented to be reduced to these two factors. At the inception of a new image medium of illusion, the relation between the suggestive potential of the images and the power of the observers to maintain distance from them shifts, in general to the disadvantage of the latter. Gradual habituation and increased media competence lead to a reversal of this relation. Only when a new image medium of illusion is introduced that is capable of displaying a surplus of power of illusion, is it able to increase the power of suggestion. This study, which covers several generations of image media of illusion, from rooms of frescoes to film and virtual reality, reveals a wavelike devel-

opment over time. This interdependent relationship is linked to the media experience of the observers, not only temporally but also spatially, from place of origin and its particular image traditions. It is entirely possible that this factor, however, will decline in importance as the global spread of the media advances. Over the last years of the twentieth century, the incidence of immersive image media has spread to all industrial nations and, thus, has helped the Euclidean representation of space to achieve dominance, in Asia as well. In this way, image traditions and conceptions that were formerly heterogeneous are becoming alike through the global spread of illusionary image media.

Illusion media may follow a genealogy, but they are not carried over one to one into new media. An illusion medium is composed of a number of factors; for example, film components include image definition, movement in real time, color, sound, and so on. New factors added to these, which represent a significant advance in proximity to the familiar environment, for example, communication with agents or interaction in the case of virtual reality, can for a period of time predominate vis à vis the other factors, which may even be less developed in comparison with the precursor medium (in virtual reality, for example, image definition and brilliance of color) and, in the short term, reduce decisively the observers' power to distance themselves from the image. Theoretically, this may offer an explanation for the shock effect of the Lumières' approaching train: The lower illusionary quality of other factors was thrust into the background by the new factor of movement.

Throughout history, ruling powers have tended to press the most advanced medium into their service, used it for self-glorification, and, according to prevailing circumstances, to denigrate or incriminate their opponents. This was accomplished with giant-size propaganda images, which were carried in triumphal processions through the cities of the early modern era, or later in panoramas, cinemas, and Internet images. It is an apparent feature of the concept of immersion that it engages with the spatial and pictorial concentration of the awareness of one's own people, the formation of collective identity through powerful images that occupy the functions of memory.

In the confrontation with new media of illusion, older ones lose their use value to a large extent but offer a free domain for artistic experiments. The gain in power of suggestion is thus revealed as a primary goal and core

motivation in the development of new media of illusion. This appears to be the main force driving their developers, who, with new potential for suggestion, enhance power over the observers in order to erect the next new regime of perception. Panorama, film, and computer image displays are aggregates of continually changing machines, forms of organization, and materials; in spite of all efforts at standardization, they are seldom stable but always driven by the fascination of increasing the illusion. We see a never-ending stream of phenomena, which, on closer scrutiny even of supposedly secure entities such as cinema, prove to be merely elements that continually regroup in a kaleidoscope of evolutionary art media development. An overview of their historical development demonstrates the monumental dimensions of the energy involved in the search for and production of ever-new spaces of illusion.

Because digital images are not confined to a particular medium for their realization, virtual art manifests itself in very different image formats and types: HMDs, CAVEs, large-scale projection screens, and so on. In the course of this process, the ontological status of the image is cut back to a successive light beam. The time and space parameters can be changed at will and virtual images utilized as a space for modeling and gaining experience. In a virtual image, not only do many existing forms of image with acoustic and appeals to other senses come together, but, in the 360° form, its tendency is to negate the image as an image. It is only though *computation in real time* that the ephemeral image spaces achieve the semblance of existence. Computation in real time is, at the same time, the prerequisite for the processual variability of the work and thus for the interaction of the observer with the image space.

An important finding of this study is that under the conditions of interactive real time computing operations, the quantities of artist, work, and observer begin to converge. The new parameters of virtual art play a decisive role in this: Interactivity challenges both the distinction between creator and observer as well as the status of an artwork and the function of exhibitions. However, although the work, or sphere of images, cannot exist either technically or aesthetically without the actions of the audience, this latter can intervene only within the framework of the program, according to the method of multiple choice. Where a balance exists between freedom of interaction and narrative or dramatic plot, the interactor can be steered by appropriate commands programmed into the system. The apparent loss

of power on the part of the artist can be countered by appropriately calculated storylines. If artificial creatures, agents, are present in the virtual image space, which behave like subjects and react to the observers, the feeling of *being inside the image space* is enhanced further. These autonomous agents are often an anthropomorphic or animal-like system within the simulated environment, where they usually meet an individual fate and exert influence on the future. The integration of a representation of the observer's own body in the image space, that is, an avatar, is also a means whereby immersion can be enhanced. In this way, the senses and communication systems of our flesh and blood bodies are able, via hard- and software interfaces, to enter into an exchange with all manner of simulated creatures. Incorporated in artificial bodies, which are, nevertheless, merely images, we may even experience certain evocative phenomena that influence our consciousness.

In a work of virtual art, in addition to interaction it is the interface—especially the natural interface—that represents the central domain of artistic creation, which can be implemented with emancipatory or manipulative purpose; both options are so closely intertwined that they are almost inseparable. Considering virtual image spaces' potential for suggestion, the issue of interface design, the connection to the body of data acquires great importance. In addition to individually composed facets of degrees of freedom, there is the variable area of contact with the computer, with the freedom to choose profile and design, as the connection between elements of hardware and software. It is here that the character and dimension of interaction is determined as well as the degree of observer psychological involvement with the digital work, immersion. Large portions of the image resources of our natural environment are combined with artificial images to produce mixed realities, where it is frequently impossible to distinguish between simulacrum and original. A collective art, which results from the multifarious combinatory talents of its participants and the inspired, virtuoso processing of found elements, stands before further development of media art as a utopia that is within reach. On the other hand, with the aid of natural interfaces, it appears that a transcending connection to works of images is possible, as has been brought about historically time and again through the pressurizing suggestion of the most advanced media of illusion and affect-driven renunciation of self and whose

path this book has sought to track, from the Villa dei Misteri to present-day genetic art.

However, *homo ludens* cannot exist if there is no return to reality from the world of games. In genetic art, the scenic image world of the computer has recently acquired the appearance of life. Here, the work results from evolutionary processes within the computer. Software agents that appear plastic inherit their phenomenology according to patterns borrowed from natural reproduction and evolution. New combinations arise by applying the principles of crossover and mutation, limited only by the mechanisms of selection laid down by the artist—a further example of how "power" over the observer is maintained. For image production theory, evolution is a groundbreaking event. Calculated use of the random principle enables unpredictable, nonreproducible, transient, and unique images. Images are out of control, seemingly self-generating and changeable. Independent of the artist's imagination, the complex variety of forms that develop in the course of this process is theoretically infinite. In the digitally produced virtual artwork, "being" now means "process"; finished and absolute are replaced by relativity, stability by dynamics. The institution of the author is subjected to machines to an unprecedented extent while at the same time being able to make use of them as never before. Reality is replaced by imagination, the original disappears in favor of technical reproduction and returns in the form of a random genetic product. This path does not lead us out of the realm of the possible but, like the labyrinth in *The Home of the Brain*, takes us deeper and deeper into the world of combinatorics, multiples, and the passing of phenomena.

Perhaps the single most important factor is the possibility to access and exchange images via global data networks. In conjunction with telepresence, this opens up new options. The epistemology of telepresence, as communicated through media, appears to contain a paradox: Although telepresence represents a view that is mediated and able to conquer vast distances, in the virtual environments themselves visual perception is immediately enriched by the human senses ("active" touch, "passive" feelings, and less frequently, smell), and this drives the abstract and conceptualizing function of distance into the background. Therefore, in the cultural history of our sensorium, we stand at a turning point, and, in the media history of the image, we are now confronted with dynamic virtual image spaces. The

image and the image space are transformed into a variable realm, where the intervention of the senses is translated into image spaces and fields, or creates them in the first place through interaction.

As the potential of computer technology increases, virtual data spaces are becoming available that may relegate humans to the role of mere actors in the infinite spaces of the electronic cosmos. The individual communicator, who wanders far and wide through the digital networks, would then find him- or herself fixed inside a *static vehicle*, which is the means for physical bodies to change into optical ones. On our planet, faced as it is with dangers and threats that are sufficiently well known, more and more of its inhabitants with less and less space at their disposal are gaining access to machine-generated illusionary spaces. On the one hand, these will have the character of surrogate experience, and, on the other, they marginalize distance in the communication between humans and cultures. This experience of direct and immediate communication, which underpins the new media and includes the encounters of fundamentally different societies, will not be able to avoid terrible conflicts. Obviously, like Plato's prisoners in the cave, what we need to do is to turn toward the light, to face the new and, armed with our knowledge, confront it squarely. The question is not to find a way out of the cave, for there is no way out of the history of media. There are only old and new media, old and new attempts to create illusions: It is imperative that we engage critically with their history and their future development.

Significantly, all examples of virtual artworks, created with the most modern imaging techniques, that I have discussed here are charged with mythical overtones: Yggdrasill, the tree of the world, the agora, the schema of the four thinkers, the theory of the four elements. The geometric form of the sphere, perhaps one of the greatest mythological figures, the idea of artificial life that spills out of the computer, return once more in high-tech guise. Their finely graduated naturalism refers back partly to premodern traditions of illusionism and the method of its functioning, for example, in the panorama. However, media art affects and expands the world of signs and phenomenologies in ways that are as yet unpredictable. The new world of images can be perceived temporally and spatially, the networked topology allows artists to create their own cosmologies of digital spaces, where observers, or players, navigate visual and acoustic spaces that do not conform to any hierarchical order, that are organized like a

hypertext. The processes of digitization create new areas of perception, which will lead to noticeable transformations in everyday life; however, they do not turn the concepts of truth and reality completely upside down. The roles that are offered, assigned, or forced on the users when interacting are an essential element in perception of the conditions of experience—experience both of the environment in a world transformed by media and of the self, which is constituted as never before from a continually expanding suite of options for action within dynamically changing surroundings. Artists play with and work on the paradigm of illusion, of resemblance to life, and of presence in other places. Their quest, which they pursue under the conditions of the new media, is to rediscover the criterion of self-reflection, the awareness of inner distance and perception. This applies particularly to the digital memory theater of Fleischmann, Hegedues, Knowbotic Research and Plewe, but also to Char Davies: So suggestive, so sensual, and so winning are her highly immersive works, they produce a place for contemplation that is at the same time all-embracing in its coercion.

Yet virtual art in particular and digital art in general have long ceased to operate exclusively at the level of developing aesthetic models of worlds and self-reflection on the constitutive conditions of spheres of experience communicated through media. Within the specific framework of the system of art, this art genre enters increasingly into discourse and debate on crucial social issues, such as the relationship between humans and machines, genetic engineering, and the unparalleled friction resulting from globalization and networks of virtual realities to which the cultures of the world are now exposed. Media art is, therefore, an essential component of how contemporary societies may achieve an adequate self-description and by which means they can seek to attain a critical distance to the increasing pace of change.

In the future, art history will engage more intensely with the subhistory of new media art just as media studies and the new research area of the "science of the image" will number the art history of the media among its foundations. Current debates concerning media art in cultural studies, media studies, and philosophy are broad in scope but poor in concrete examples and heavily focused on theoretical discussions of media art. This study, with its investigation and analysis of works and the resulting theoretical reflections on the metamorphosis of the triad of artist, artwork, and

observer, seeks to complement and enrich these ongoing debates. A historical overview with the theme of the history of immersive images, which in nearly all epochs have availed themselves of the most advanced techniques of the time to mobilize the maximum suggestive potential, touches the core of the relationship between humans and the image and is thus also of interest to anthropological approaches to the study of the image, which cannot be included here. A history of immersion in the image, which contextualizes archaeological image research on megalography and illusion spaces of the classical world with artifacts from the history of art and media, can also be of interest to archaeologists. For media and film studies and research on intermedia, it would be most helpful to investigate the neglected topic of filmic attempts at immersion, which are part of endeavors to extend or overcome the constraints of the film screen. The results and conclusions presented here also affect the emerging area of interdisciplinary image science and computer visualization, which are difficult to contemplate without a historical basis. A further area, which has not been investigated so far, is that of the interplay between designed, suggestive innovations in the illusions visualized in technologically based image spaces and the gradual forcing back of inner distance in the recipients of these images, a theme that runs through the entire history of art. This relative interdependence describes a central mechanism in the development of art media and thus of the history of the image itself.

It is not only the format of virtual reality that defines its genealogical relationship to illusionism; through real-time computation, interaction, and evolution, the observer is attaining a power to form the image that is unparalleled in history. At the same time, the observer is subjected to the greatest ever suggestive potential of images, which are now dynamic, interactive, evolutionary, and "alive" in immersive image spaces.

In spite of rapidly changing media technology, the idea of 360° images was a continuing phenomenon in the history of twentieth-century art and media. It is a model that maps onto the utopian idea of transporting the observer into the image, nullifies the distance to the image space, intensifies the illusion, and increases the artwork's power over the audience—an idea that has initiated, time and again, a constitutive dynamic in the development of new media of illusion. Immersion arises when the artwork and technical apparatus, the message and medium of perception, converge

into an inseparable whole. At this point of calculated "totalization," the artwork, which is perceived as an autonomous aesthetic object, can disappear as such for a limited period of time: This is the point where being conscious of the illusion turns into unconsciousness of it. As a general rule, one can say that the principle of immersion is used to withdraw the apparatus of the medium of illusion from the perception of the observers to maximize the intensity of the message being transported. The medium becomes invisible.

Visions of new media of illusion are, in the case of art, not merely reactions to technological innovations; art often plays a seminal role in their development. History has shown that there is permanent cross-fertilization between large-scale spaces of illusion that fully integrate the human body (e.g., rooms with 360° frescoes, the panorama, Stereopticon, Cinéorama, planetarium, Omnimax and IMAX cinemas, or the CAVEs) and apparatuses that are positioned immediately in front of the eyes (e.g., peepshows, stereoscopes, stereoscopic television, Sensorama, or HMDs). In addition, a history of ideas for artistic concepts of immersion runs parallel, ranging from Wagner's idea of a Gesamtkunstwerk to Monet's waterlilies panorama, Prampolini's plans for a Futurist Polydimensional Scenospace, Eisenstein's theories of multisensory *Sterokino*, Youngblood's Expanded Cinema, Heilig and Sutherland's media utopias, to the hype of the California Dream and beyond. Actual realization of technical innovations was, and is, always preceded by the envisionings of artists, which act as constituting elements in the genesis of new media of illusion, a driving force of media development whose inspiration was often found in art in the past and is once again coming to the fore.

The history of the development of film demonstrates a similar process of constant change around the core medium. Whereas cinema was preceded by the panorama (whose rotundas it later usurped), which in turn was preceded by the diorama and its derivatives, such as the cyclorama, pleorama, and dellorama, as it developed, film continually extended its address to the senses in ways that were outgrowths from the core medium. This is comparable with contemporary endeavors of the computer-based virtual reality media to achieve polyensory illusions, which are characterized by three principal motives: (a) the trend toward illusion in dimensions, color, proportions, plasticity, and lighting of images; (b) the element of

movement; and (c) the option of interaction with dynamic, continually recalculated images, which target increasingly more of the senses. The goal is a symbiosis of human being and computer image, where contact is effected via a polysensory interface that ultimately is not perceived by the human user and fades from consciousness. The part of media evolution outlined here thus appears to be a continual process undergoing constant change. The long-term establishment of certain media, for example, television, is the exception rather than the rule when compared with the vast number of blueprints for new media. Viewed in this light, computer-based virtual reality is not unleashing a revolution, however often its champions claim it to be so. Nevertheless, it does represent a decisive milestone within the historical evolution of the media. Since Sutherland built his HMD, a great number of visual displays have been developed and many more prototypes will leave the drawing boards or monitors until standards are established for human–machine interfaces—insofar as the idea of longer-term standards does not contradict fundamentally the evolutionary phenomenology of the media and their *telos*. For this study, it is ultimately immaterial whether a specific technical device will ever exist that can fulfill more efficiently the greater part of utopian ideas, for the purpose of the series of examples analyzed here is to demonstrate the search for an illusionary imperceptible bonding with the image that manifests itself in so many different imagistic media.

In summary, one can say that artistic visions reflect a continuing search for illusion using the technologically most advanced medium at hand. Without exception, the image fantasies of oneness, of symbiosis, are allied to media where the beginnings exist but are not yet realized, are still utopian. This was the case with Prampolini and it was no different with Eisenstein, Sutherland, Heilig, Youngblood, or Krueger. Moreover, it is apparent that new media, in their aesthetic content, always draw from their precursors, a perennial constituent. Today, not only are various audiovisual media, computers, home electronics, and telecommunication converging to form a polysensory and virtual *hypermedium*, but the expectations placed in this new medium of illusion appear to be more highly developed than ever before. A consequence of the constitutive function of artistic-illusionary utopias for the inception of new media of illusion is that the media are both a part of the history of culture and of technology. Thus, it is only logical that art is now making its way into the centers of high-

tech research, even though the necessary technology is military in origin and has been developed for commercially profitable spectacles. Media archaeology has excavated a wealth of experiments and designs, which failed to become established but nevertheless left their mark on the development of art media. That which was realized, or has survived, represents but a tiny fraction of the imaginings that all tell us something, often something unsettling, about the utopian dreams of their epochs.

References

Adorno, Theodor W. 1973. *Ästhetische Theorie*. Frankfurt am Main: Suhrkamp.

Agrippa, H. C. 1529. *De occulta philosophia*. Cologne.

Alberti, Leon Battista. 1950 (1435). *Della Pittura*. Ed. Luigi Mallé. Florence: Sansoni.

Alberti, Leon Battista. 1975. *De Pictura*. Rome: Laterza.

Alfrey, N. and S. Daniels, eds. 1990. *Mapping the Landscape: Essays on Art and Cartography*. Nottingham: University Art Gallery, Castle Museum.

Altick, Richard. 1978. *The Shows of London: A Panoramic History of Exhibitions 1600–1862*. Cambridge, MA: Belknap Press.

Amu Klein, Yves. 1998. Living sculpture: The art and science of creating robotic life. *Leonardo* 31, no. 5: 393–396.

Anders, Peter. 1998. *Envisioning Cyberspace: Designing 3D Electronic Spaces*. New York: McGraw-Hill.

Anderson, R. L. 1992. A real experiment in virtual environments: A virtual batting cage. *Presence: Teleoperators and Virtual Environments* 2, no. 1: 16–33.

Andreae, Bernhard. 1962. Der Zyklus der Odysseefresken im Vatikan. *Römische Mitteilungen* 69: 106–117.

Andreae, Bernhard. 1967. Römische Malerei. In *Propyläen Kunstgeschichte*, vol. 2, *Das römische Weltreich*, ed. Kurt Bittel et al., pp. 201–214. Berlin: Propyläen.

Andreae, Bernhard. 1973. *Römische Kunst*. Freiburg: Herder.

Anonymous. 1591. *Tractato de li capituli de passione: Questo sono li misteri che sono sopra el Monte di Varale* . . . , Milan, March 29, cimelino in unico esemplare alla Biblioteca Colombina di Siviglia.

Arndt, Hella. 1964. *Gartenzimmer des 18. Jahrhunderts*. Darmstadt: Schneekluth.

Arnheim, Rudolf. 1933. *Film*. London: Faber and Faber.

Arnheim, Rudolf. 1972. *Anschauliches Denken: Zur Einheit von Bild und Begriff*. Cologne: Du Mont.

Arnheim, Rudolf. 1978. *Kunst und Sehen: Eine Psychologie des schöpferischen Auges.* Berlin: Walter de Gryter.

Arnheim, Rudolf. 2000. The coming and going of images. *Leonardo* 33, no 3: 167–168.

Ascott, Roy. 1966. Behaviorist art and the cybernetic vision. *Cybernetica* (Naumur) 9, no. 3: 247–264.

Ascott, Roy. 1989. Gesamtdatenwerk: Konnektivität, Transformation und transzendenz. Im Netz der Systeme. *Kunstforum* 103: 100–109.

Ascott, Roy. 1992a. Keine einfache Materie: Der Künstler als Medienproduzent in einem Universum komplexer Systeme. In *Interface I: Elektronische Medien und künstlerische Kreativität*, ed. Klaus Peter Denker, pp. 75–79. Hamburg: Hans-Bredow-Institut für Rundfunk und Fernsehen.

Ascott, Roy. 1992b. The art of intelligent systems. In *Der Prix ars electronica 1992* (exhibition catalog), ed. Johannes Leopoldseder, pp. 25–33. Linz: Veritas.

Ascott, Roy. 1997. Technoetic aesthetics: Art and the construction of reality. In *Monterrey (1997)* (exhib. catalog), pp. 33–44.

Ascott, Roy, ed. 1999. *Reframing Consciousness: Art, Mind, and Technology.* Plymbridge: Intellect.

Ascott, Roy. 2001. *Telematic Embrace: Visionary Theories of Art, Technology, and Consciousness*, ed. Edward A. Shanken. Berkeley: Univ. of California Press.

Astheimer, Peter, et al. 1994. Realism in Virtual Reality. In *Artificial Life and Virtual Reality*, ed. Nadia Magnenat-Thalmann et al., pp. 189–210. Chichester: Wiley.

Auerbach, Alfred. 1942. *Panorama und Diorama: Ein Abriß über die Geschichte volkstümlicher Wirklichkeitskunst, Part 1: Das Panorama in den Anfängen und der Blütezeit, das Diorama bis auf Daguerre und Gropius.* Grimmen i. P.: Alfred Waberg.

Bachelard, Gaston. 1958. *La poétique de L'espace*. Paris: Presses Universitaires Paris.

Badler, Norman I., et al. 1995. The Center for Human Modeling and Simulation. *Presence: Teleoperators and Virtual Environments* 4, no. 1: 81–96.

Bahr, Hans-Dieter. 1983. *Über den Umgang mit Maschinen*. Tübingen: Konkursbuchverlag.

Bak, Peter and K. Chen. 1991. Self-organized criticality. *Scientific American* (January): 46–54.

Baltrusaitis, Jurgis. 1960. *Réveils et Prodiges: Le gothique fantastique*. Paris: Armand Colin.

Baltrusaitis, Jurgis. 1984. *Imaginäre Realitäten: Fiktion und Illusion als produktive Kraft*. Cologne: DuMont.

Baltrusaitis, Jurgis. 1996 (1978). *Der Spiegel: Entdeckungen, Täuschungen, Phantasien*. Giessen: Anabas.

Bandes, Susan J. 1981. Gaspard Dughet's frescoes in Palazzo Colonna, Rome. *The Burlington Magazine* 123: 77–88.

Bapst, Germain. 1891. *Essai sur l'histoire des Panoramas et des Dioramas: Extrait des Rapports du Jury international de l'Exposition universelle de 1889*. Paris: Impr. nationale.

Barck, K. et al., eds. 1990. *Ästhetische Grundbegriffe: Studien zu einem historischen Wörterbuch*. Berlin: Akademie Verlag.

Barfield, Woodrow, et al. 1995. Comparison of human sensory capabilities with technical specifications of virtual environment equipment. *Presence: Teleoperators and Virtual Environments* 4, no. 4: 329–355.

Barfield, Woodrow, and Thomas A. Furness, III. 1995. *Virtual Environments and Advanced Interface Design*. Oxford: Oxford Univ. Press.

Barricelli, Nils A. 1962. Numerical testing of evolution theories. *Acta Bioteoretica* 16: 69–98.

Barthes, Roland. 1980. *La chambre claire: Notes sur la photographie*. Paris: Gallimard.

Bartmann, Dominik. 1985. *Anton von Werner: Zur Kunst und Kunstpolitik im deutschen Kaiserreich*. Berlin: Deutscher Verein für Kunstwissenschaften.

Bätschmann, Oskar. 1989. *Entfernung der Natur: Landschaftsmalerei: 1750–1920*. Cologne: DuMont.

Battisti, Alberta, ed. 1996. *Andrea Pozzo*. Milan: Luni Editrice.

Baudelaire, Charles. 1899. *Les paradis artificiels*. Paris: Levy.

Baudrillard, Jean. 1982. *Der symbolische Tausch und der Tod*. Munich: Matthes and Seitz.

Baudrillard, Jean. 1989. Videowelt und Fraktales Subjekt. In *Philosophien der neuen Technologie: Ars Electronica*, ed. Jean Baudrillard, Hannes Böhringer, Vilem Flusser et al., pp. 113–131. Berlin: Merve.

Baudrillard, Jean. 1993. Der Xerox und das Unendliche. In *Cyberspace*, ed. Florian Rötzer et al., pp. 274–279. Munich: Boer.

Baudrillard, Jean. 1995. Illusion, Desillusion, Ästhetik. In *Illusion und Simulation: Begegnung mit der Realität*, ed. Stephan Iglhaut, pp. 90–101. Ostfildern: Cantz.

Baudrillard, Jean. 1996. *Das perfekte Verbrechen*. Munich: Matthes and Seitz.

Bedau, M. A. 1998. Philosophical content and method of artificial life. In *The Digital Phoenix: How Computers are Changing Philosophy*, ed. T. W. Bynam and J. H. Moor, pp. 135–152. Oxford: Blackwell.

Bek, Lise. 1980. *Towards Paradise on Earth: Modern Space Conception in Architecture. A Creation of Renaissance Humanism, Analecta Romana Instituti Danici IX*. Copenhagen: Munksgaard.

Belting, Hans. 1990. *Bild und Kult: Eine Geschichte des Bildes vor dem Zeitalter der Kunst*. Munich: Beck.

Belting, Hans. 2001. *Bild-Anthropologie: Entwürfe für eine Bildwissenschaft*. Munich: Fink.

Benayoun, Maurice and Jean-Baptiste Barriere. 1997. World Skin: Eine Photosafari ins Land des Krieges. In *Flesh Factor: Informationsmaschine Mensch, Ars Electronica Festival*, ed. Gerfried Stocker and Christiane Schöpf, pp. 212–315. Linz: Springer.

Benedikt, Michael L., ed. 1991. *Cyberspace: First Steps*. Cambridge, MA: MIT Press.

Benjamin, Walter. 1974. *Das Kunstwerk im Zeitalter seiner technischen Reproduzierbarkeit*, second ed. In *Gesammelte Schriften*, vol. I, part 2, ed. Rolf Tiedemann, pp. 471–508. Frankfurt/Main: Suhrkamp.

Benjamin, Walter. 1983. *Das Passagen-Werk*, ed. Rolf Tiedemann. Frankfurt/Main: Suhrkamp.

Berliner Tageblatt. Sept. 2, 1883, no. 409. Das Schlachtpanorama von Sedan, p. 4.

Berriot-Salvadore, Evelyne, ed. 1995. *Le Mythe de Jérusalem: Du Moyen Age à la Renaissance*. Saint-Étienne: Université de Saint-Étienne.

Beyen, H. G. 1960. *Die Pompejanische Wanddekoration vom zweiten bis zum vierten Stil*. Haag: Nijhoff.

Bieber, Margarete. 1928. De Mysteriensaal der Villa Item. *Jahrbuch des Deutschen Archäologischen Instituts* 43: 298ff.

Billinghurst, Mark, et al. 1999. Collaborative mixed reality. In *Mixed Reality: Merging Real and Virtual Worlds, Proceedings of the International Symposium on Mixed reality (ISMR 99)*, ed. Yuichi Ohta, pp. 261–284. Tokyo: Ohmsha.

Binkley, Timothy. 1998. Autonomous creations: Birthing intelligent agents. *Leonardo* 31, no. 5: 333–336.

Birringer, Johannes. 1992. Virtual realities: Cybernetic art in the museum of the future. *Tema Celeste* (Siracusa), no. 36: 64–69.

Blanc, Jean-Pierre, et al. 1991. *Avignon, ville d'art*. Avignon: Barthélemy.

Blase, Christoph Ü. and Kopp, Heinrich. 2000. *Vision Ruhr: Kunst Medien Interaktion auf der Zeche Zollern II/IV*. Dortmund, Ostilfdern: Cantz.

Blumenberg, Hans. 1989. *Höhlenausgänge*. Frankfurt/Main: Suhrkamp.

Blunt, Anthony, et al., eds. 1979. *Kunst und Kultur des Barock und Rokoko*. Freiburg.

Bock, Sybille. 1982. Bildliche Darstellungen von Krieg 1870/71. Ph.D. dissertation, Freiburg Universitäts.

Böckler, Georg Andreas. 1661. *Theatrum Machinarum Novum*. In *Verlegung Paulus Fuersten, Kunst- und Buchhaendl. Sel. Wittib und Erben*, ed. Christoff Gerhard. Nuremberg: Gerhard.

Boden, Margaret A. ed. 1996. *The Philosophy of Artificial Life*. New York: Oxford University Press.

Böhm, Gottfried. 1994. *Was ist ein Bild*. Munich: Fink.

Böhme, Gernot and Hartmut Böhme. 1996. *Feuer Wasser Erde Luft: Eine Kulturgeschichte der Elemente*. Munich: Beck.

Böhme, Hartmut. 1988. *Natur und Subjekt*. Frankfurt/Main: Suhrkamp.

Bohrdt, Hans. 1891. Wie entsteht ein Panorama? *Velhagen und Klasings Monatshefte* 6, no. 1 (Sept.): 119–130.

Boissier, Jean-Louis. 1983. *Electra: Electricity and Electronics in the Art of the XXth Century*. Paris: Musée d'Art Moderne de la Ville de Paris.

Boissier, Jean-Louis. 1995. Die Präsenz, Paradoxon des Virtuellen. In *Weltbilder. Bildwelten. Computergestützte Visionen, Interface II*, ed. Klaus Peter Denker. Hamburg: Hans-Bredow-Institut für Rundfunk und Fernsehen.

Bolt, Richard A. 1984. *The Human Interface: Where People and Computers Meet*. Belmont, CA: Lifetime Learning.

Bolz, Norbert. 1990. *Theorie der neuen Medien*. Munich: Raben-Verlag.

Bolz, Norbert. 1991. Die Wirklichkeit des Scheins. In *Strategien des Scheins: Kunst Computer Medien*, ed. Florian Rötzer and Peter Weibel, pp. 110–121. Munich: Boer.

Bolz, Norbert. 1992. *Eine kurze Geschichte des Scheins*. Munich: Fink.

Bolz, Norbert. 1993. *Die Welt als Chaos und als Simulation*. Munich: Fink.

Bolz, Norbert. 1996. Interaktive Medienzukunft. In *Interaktiv: Im Labyrinth der Wirklichkeiten*, ed. Wolfgang Zacharias, pp.120–126. Bonn: Edition Umbruch.

Bolz, Norbert, et al., eds. 1994. *Computer als Medium*. Munich: Fink.

Borbein, Adolf. H. 1975. Zur Deutung von Scherwand und Durchblick auf den Wandgemälden des zweiten pompejanischen Stils. In *Neue Forschungen in Pompeji*, ed. B. Andreae and H. Kyrieleis, pp. 61–70. Recklinghausen: Bongers.

Borchers, Detlef. 1998. Pionicrgeist im Netz. *Die Zeit*, November 12, p. 48.

Bordini, Silvia. 1981. Arte, Imitazione, Illusione: Documenti e note sulla pittura dei "Panorami" (1787–1910). In *Dimensioni: Studi sulle Interazioni tra Arte, Scienza e technologia*, no. 1, pp. 65–106. Rome: La Costruzione delle Imagini.

Bordini, Silvia. 1982. Paesaggi e Panorami: Immagine e immaginazione del viaggio nella cultura visiva dell'Ottocento. In *Ricerche di Storia dell'Arte, Rivista quadrimestrale*, no. 15. Rome: La Nuove Italia Scienfica.

Bordini, Silvia. 1984. *Storia del Panorama: La visione totale nella pittura del XIX secolo*. Rome: Officina Ed.

Börsch-Supan, Eva. 1967. *Garten-, Landschafts- und Paradiesmotive im Innenraum*. Berlin: Hessling.

Börsch-Supan, Helmut. 1981. Die Anfänge des Panoramas in Deutschland. In *Sind Briten hier? Relations between British and Continental Art 1680–1880*, ed. Zentralinstitut für Kunstgeschichte in München, pp. 161–180. Munich: Fink.

Börsch-Supan, Helmut. 1986. *Der Maler Antoine Pesne: Franzose und Preusse*. Friedberg: Podzun-Pallas.

Borsook, Paulina. 1996. The art of virtual reality. *Iris Universe*, no. 36: 36–40.

Bostic, Adam I. 1998. Automata: Seeing cyborg through the eyes of popular culture, computer-generated imagery, and contemporary theory. *Leonardo* 31, no. 5: 357–361.

Bredekamp, Horst. 1991. Mimesis, grundlos. *Kunstforum* 114: 278–288.

Bredekamp, Horst. 1992a. Der Mensch als "zweiter Gott." In *Elektronische Medien und künstlerische Kreativität*, ed. Klaus Peter Dencker, pp. 134–147. Hamburg: Hans-Bredow-Institut für Rundfunk und Fernsehen.

Bredekamp, Horst. 1992b. Der simulierte Benjamin: Mittelalterliche Bemerkungen zu seiner Aktualität. In *Frankfurter Schule und Kunstgeschichte*, ed. Andreas Berndt et al., pp. 117–140. Berlin: Reimer.

Bredekamp, Horst. 1995. *The Lure of Antiquity and the Cult of the Machine*. Princeton: M. Wiener Publishers.

Bredekamp, Horst. 1997a. Politische Theorien des Cyberspace. In *Kritik des Sehens*, ed. Ralf Konersmann, pp. 320–339. Leipzig: Reclam.

Bredekamp, Horst. 1997b. Metaphors of the end in the era of Images. In *Contemporary Art: The Collection of the ZKM*, ed. Heinrich Klotz, pp. 32–36. Munich: Prestel.

Bredekamp, Horst. 1999a. Kunstgeschichte im Iconic Turn. Interview with Hans Dieter Huber and Gottfried Kerscher. *Kritische Berichte* 26, no. 1: 85–93.

Bredekamp, Horst. 1999b. Überlegungen zur Unausweichlichkeit der Automaten. In *Phantasmen der Moderne, Kunstsammlung Nordrhein-Westfalen*, ed. Pia Müller-Tamm and Katarina Sykora, pp. 94–105. Cologne: Oktagon.

Breit, J., ed. 1996. *Virtual Reality World '96: Conference Documentation*. Munich: Computerwoche-Verlag.

Brendel, Otto J. 1966. Der Grosse Fries in der Villa dei Misteri. *Jahrbuch des Deutschen Archäologischen Instituts* 81: 206–260.

Brennan, Teresa and Martin Jay, eds. 1996. *Vision in Context: Historical and Contemporary Perspectives on Sight*. New York: Routledge.

Brew, Kathy. 1998. Digital portfolio. *Civilization: Magazine of the Library of Congress* (Oct.–Nov.): 79.

Bricken, Meredith. 1989. Inventing reality. Unpublished paper, Autodesk, inc., September. Sausalito, CA.

Brill, Louis M. 1993. Looking-glass playgrounds hit the entertainment bullseye. *Virtual Reality World* Nov./Dec.: 41–49.

Britton, John. 1827. *The Union of Architecture, Sculpture, and Painting: With Descriptive Accounts of the House and Galleries of John Soane*. N.p.

Broadbent, Donald, ed. 1993. *The Simulation of Human Intelligence*. Oxford: Blackwell.

Broll, Wolfgang, ed. 2001. *The Future of VR and AI Interfaces: Multi-modal, Humanoid, Adaptive, and Intelligent. Proceedings of the Workshop at IEEE Virtual Reality 2001*. Saint Augustin: GMD-Forschungszentrum Informationstechnik.

Brownlow, Kevin. 1997. *Pioniere des Films*. Basel: Stroemfeld.

Brugger, Ralf. 1993. *3D-Computergrafik und -animation*. Munich: Addison-Wesley.

Brunner-Traut, Emma. 1992. *Frühformen des Erkennens am Beispiel Altägyptens*. Darmstadt: Wissenschaftliche Buchgesellschaft.

Bryson, Norman. 1983. *Vision and Painting: The Logic of the Gaze*. New Haven: Yale University Press.

Buber, Martin. 1984. *Das dialogische Prinzip*. Heidelberg: Lambert Schmücker.

Buck, August, ed. 1976. *Petrarca*. Darmstadt: Wissenschaftliche Buchgesellschaft.

Buddemeier, Heinz. 1970. *Panorama, Diorama, Photographie: Entstehung und Wirkung neuer Medien im 19. Jahrhundert*. Munich: Fink.

Bühl, Achim. 1996. *Cybersociety. Mythos und Realität der Informationsgesellschaft*. Cologne: PapyRossa.

Burdea, Grigore. 1994. *Virtual Reality Technology*. New York: Wiley.

Bureau of Inverse Technology (BIT). 1995. *Osmose. Mute Digitalcritique*, no. 3: 13.

Burke, Edmund. 1757. *A Philosophical Enquiry into the Origin of Our Ideas of the Sublime and Beautiful*. London: R. and J. Dodsley.

Burkert, W. 1990. *Antike Mysterien: Funktionen und Gehalt*. Munich: Beck.

Butler, Samuel. 1928. *Ex Voto*. London: J. Cape.

Caillois, Roger. 1961. *Man, Play, and Games*. New York: Free Press.

Cairns-Smith, A. G. 1996. *Evolving the Mind: On the Nature of Matter and the Origin of Consciousness*. New York: Cambridge Univ. Press.

Camillo, Giulio. 1550. *L'Idea del Teatro*. Florence: Torrentino.

Cardini, Franco, ed. 1982. *Toscana e Terrasanta nel Medioevo*. Florence: Alinea.

Carey, James W. et al. 1969–1970. The mythos of the electronic revolution. *American Scholar* 39: 219–241, 395–424.

Carlisle, Isabel. 1997. Games with a magic edge. *The Times* (London), June 26, p. 39.

Carroll, J., ed. 1987. *Proceedings of the CHI and GI: Human Factors in Computing Systems*. Amsterdam: North-Holland.

Caselli, Fausto Piola. 1981. *La costruzione del Palazzo dei Papi di Avignone (1316–1367)*. Milan: Giuffrè.

Cassimatis, Marilena. 1985. *Zur Kunsttheorie des Malers Giovanni-Paolo Lomazzo (1538–1600)*. Frankfurt/Main: Lang.

Cassirer, Ernst. 1954. *Philosophie der Symbolischen Formen*. Darmstadt: Wissenschaftliche Buchgesellschaft.

Cassirer, Ernst. 1963 (1927). *Individuum und Kosmos*. Darmstadt: Wissenschaftliche Buchgesellschaft.

Castelnuovo, Enrico. 1991. *Un pittore italiano alla corte di Avignone: Matteo Giovanetti e la pittura in Provenza nel secolo XIV*. Turin: Einaudi.

Casti, John L. 1990. *Paradigms Lost: Tackling the Unanswered Mysteries of Modern Science*. New York: Avon.

Casti, John. 1997. *Would-be Worlds: How Simulation Is Changing the Frontiers of Science*. New York: Wiley.

Centralblatt der Bauverwaltung. 1884. Das Sedan-Panorama am Alexanderplatz in Berlin. No. 4, pp. 114–116.

Charlesworth, Michael. 1996. Thomas Sandby climbs the Hoober Stand: The politics of panoramatic drawing in eighteenth-century Britain. *Art History* 19, no. 2: 247–266.

Ciccuto, Marcello. 1991. *Figure di Petrarca: Giotto, Simone Martini, Franco Bolognese*. Naples: Federico and Ardia.

Clausberg, Karl. 1996. Der Mythos der Perspektive. In *Inszenierte Imagination: Beiträge zu einer historischen Anthropologie der Medien*, ed. Wolfgang Müller-Funk, pp. 163–183. Vienna: Springer.

Coffin, David R. 1979. *The Villa in the Life of Renaissance Rome*. Princeton: Princeton Univ. Press.

Comeau, Charles P., et al. 1961. Headsight television system provides remote surveillance. *Electronics* (Nov.): 86–90.

Comment, Bernhard. 1993. *Le XIXe siècle des panoramas*. Paris: Biro.

Conze, Werner. 1982. Das deutsche Kaiserreich 1871–1918: Wirtschaftlich soziale Bedingungen. In *Kunstpolitik und Kunstförderung im Kaiserreich: Kunst im Wandel der Sozial- und Wirtschaftsgeschichte*, ed. Ekkehard Mai et al., pp. 15–33. Berlin: Gebr. Mann.

Cook, R. L., ed. 1995. *SIGGRAPH '95, Proceedings*. Reading, Mass.: Addison Wesley.

Corner, George Richard. 1857. The panorama with memoirs of its inventor Robert Barker. *Art Journal* (Febr.): n.p.

Cotton, Bob, and Richard Oliver. 1993. *Understanding Hypermedia: From multimedia to Virtual Reality*. London: Phaidon Press.

Couchot, Edmont. 1993. Zwischen Reellem und Virtuellem: Die Kunst der Hybridation. In *Cyberspace*, ed. Florian Rötzer et al., pp. 340–349. Munich: Boer.

Couchot, Edmont. 1998. *La technologie dans l'art: De la photographie à la realité virtuelle*. Nimes: Chambon.

Courant, Michèle, et al. 1994. Managing entities: For an autonomous behavior. In *Artificial Life and Virtual Reality*, ed. Nadia Magnenat-Thalmann et al., pp. 83–95. Chichester: Wiley.

Cox, Donna. 1998. What can artists do for science: Cosmic voyage IMAX film. In *Art@science*, ed. C. Sommerer and L. Mignonneau, pp. 53–59. New York: Springer.

Coy, Wolfgang. 1994. Aus der Vorgeschichte des Mediums Computer. In *Computer als Medium*, ed. Norbert Bolz et al., pp.19–37. Munich: Fink.

Coy, Wolfgang. 1995. Automat—Werkzeug—Medium. *Informatik Spektrum* 18, no. 1: 31–38.

Coy, Wolfgang. 1996. (Inter-)actio = Reactio? In *Interaktiv: Im Labyrinth der Wirklichkeiten*, ed. Wolfgang Zacharias, pp. 126–131. Bonn, Essen: Klartext.

Crary, Jonathan. 1996. *Techniken des Betrachters*. Dresden: Verlag der Kunst.

Crary, Jonathan. 1999. *Suspensions of Perception: Attention, Spectacle, and Modern Culture*. Cambridge, MA: MIT Press.

Croft-Murray, Edward. 1970. *Decorative Painting in England 1537–1837*. London, Feltham: Country Life Books.

Cruz-Neira, Carolina, et al. 1993. Surround-screen projection-based virtual reality: The design and implementation of the cave. In *ACM SIGGRAPH '93, Computer Graphics Proceedings*, pp. 135–142. New York: ACM SIGGRAPH Papers.

Cugnioni, Giuseppe. 1878. *Agostino Chigi il Magnifico*. Rome: Staderini.

Cutts, Edward L. 1930. *Scenes and Characters of the Middle Ages*. London: Simpkin.

d'Amato, Brian. 1996. Virtual kitsch. *Art Forum* 34, no. 5: 35ff.

Damer, Bruce. 1998a. The cyberbiological worlds of Nerve Garden: A test bed for VRML 2.0. *Leonardo* 31, no. 5: 389–392.

Damer, Bruce. 1998b. AVATARS: Exploring and Building Virtual Worlds on the Internet. Berkeley, CA: Peachpit Press.

Damisch, Hubert. 1987. *The Origin of Perspective.* Cambridge, MA: MIT.

Daniels, Dieter. 1997. *Medien Kunst Aktion: Die 60er und 70er Jahre in Deutschland.* New York: Springer.

Darken, Rudolph P., et al. 1998. Spacial orientation and wayfinding in large-scale virtual spaces. *Presence: Teleoperators and Virtual Environments* 7, no. 2: 101–107.

Davies, Charlotte. 1998a. *Osmose*: Notes on being in immersive virtual space. *Digital Creativity* 9, no. 2: 65–74.

Davies, Charlotte. 1998b. Changing space: VR as an arena of being. In *The Virtual Dimension: Architecture, Representation, and Crash Culture*, ed. John Beckman. Boston: Princeton Architectural Press.

Davies, Charlotte and John Harrison. 1996. Osmose: Towards broadening the aesthetics of virtual reality. *Computer Graphics: Annual Conference Series* 30, no. 4.

Davis, Douglas. 1975. *Vom Experiment zur Idee: Die Kunst des 20. Jahrhunderts im Zeichen von Wissenschaft und Technologie.* Cologne: DuMont.

Davis, Erik. 1996. *Osmose. Wired*, no. 8: 138–140, 190–192.

Davis, Erik. 1998. *TechGnosis: Myth, Magic, and Mysticism in the Age of Information.* New York: Three Rivers Press.

Davis, Lawrence, ed. 1998. *Handbook of Genetic Algorithms.* London: International Thomson Computer Press.

Dawkins, Richard. 1982. *The Extended Phenotype.* Oxford: Oxford Univ. Press.

Dawkins, Richard. 1989. *The Selfish Gene*, second ed. Oxford: Oxford Univ. Press.

Dawkins, Richard. 1996. Mind viruses. In Linz (1996) (exhib. catalog), pp. 40–47.

Debord, Guy. 1983. *Society of the Spectacle.* Detroit: Black and Red.

Deering, Michael F. 1993. Explorations of display interfaces for virtual reality. In *Virtual Reality Annual International Symposium*, pp. 141–147 September 18–22, 1993. Seattle.

De Kerckhove, Derrick. 1997. *Connected Intelligence: The Arrival of the Web Society.* Toronto: Somerville House Books.

Dennett, Daniel. 1996. *Darwin's Dangerous Idea.* New York: Touchstone.

Derrida, Jacques. 1974. *Grammatologie.* Frankfurt/Main: Surhkamp.

Descartes, René. 1974. *Oeuvres de Descartes.* Ed. Carles Adam and Paul Tannery. Paris: Vrin.

Deutsche Bauzeitung. June 25, 1884, no. 51, Exkursion zum Sedan-Panorama, p. 302.

Deutsche Bauzeitung. Dec. 36, 1883, no. 103, vol. 17. Berlin 1883, Berliner Neubauten. Das Sedanpanorama am Bahnhof Alexanderplatz, pp. 613–616.

Deutscher Reichs-Anzeiger und Königlich Preußischer Staats-Anzeiger Berlin, Sept. 3, 1883, no. 206, evening edition, pp. 2–3.

Dewey, John. 1987. *The Late Works*. Ed. J. A. Boydston. Carbondale and Edwardsville: Southern Illinois Univ. Press.

Didi-Huberman, Georges. 1999. *Was wir sehen blickt uns an*. Munich: Fink.

Diederichs, W. V. Leopold von Schroeder. 1922. *Bhagavadgita: Des Erhabenen Sang*. Jena.

Dieng, Rose, et al. 1994. Agent-based knowledge acquisition. In *A Future for Knowledge Acquisition*, ed. Luc Steels et al., pp. 63–82. Berlin: Springer.

Die Post. Sept. 3, 1883, no. 240, Zur Einweihung des Sedanpanoramas, p. 1.

DiLalla, L. I. and Watson, M. W. 1988. Differentiation of fantasy and reality. *Developmental Psychology* 2: 286–291.

Dinkla, Söke. 1997. *Pioniere Interaktiver Kunst von 1970 bis heute: Myron Krueger, Jeffrey Shaw, David Rokeby, Lynn Hershman, Grahame Weinbren, Ken Feingold*. Edition ZKM Karlsruhe. Ostfildern: Cantz.

Dinkla, Söke and Christoph Brockhaus, eds. 1999. *Connected Cities* (exhib. catalog). Ostfildern: Hatje Cantz.

Döben-Henisch, Gerd. 1996. "Artificial consciousness: Will art replace the artist?" Paper presented to the panel on Künstliche Kunst—Art and Aesthetics in Times of the Artificial, ISEA'96, September 18–20, Rotterdam.

Doob, P. R. 1990. *The Idea of the Labyrinth from Classical Antiquity through the Middle Ages*. Ithaca: Cornell Univ. Press.

Doren, Alfred. 1927. Wunschträume und Wunschzeiten. In *Vorträge der Bibliothek Warburg, 1924–1925*, ed. Fritz Saxl et al., pp. 158–205. Leipzig: Teubner.

D'Otrange Mastai, M. L. 1975. *Illusion in Art: Trompe l'Oeil: A History of Pictorial Illusionism*. New York: Abaris Books.

Dotzler, Bernhard. 2001. Hamlet/Maschine. *Trajekte: Newsletter des Zentrums für Literaturforschung Berlin* 2, no. 3: 13–16.

Dove, Toni. 1994. Theater without actors. Immersion and response in installation. *Leonardo* 27, no. 4: 281–287.

Dreyfus, Hubert. 1972. *What Computers Can't Do*. New York: Harper and Row.

Dreyfus, Hubert L. 1992. *What Computers Still Can't Do: A Critique of Artificial Reason*. Cambridge, MA: MIT Press.

Dufourny, L. 1937. Rapport sur le Panorama. In *Proces verbaux de l'Academie des Beaux-Arts, 75e Séance du 28 Fructidor an 8, Procès-verbaux de la classe de Littérature et beaux-arts*, ed. M. Bonnaire, I, VIII, pp. 255–262. Paris: Colin.

Durand, R. 1995. *Le temps de l'image*. Paris: La Différence.

Durlach, Nathaniel I. and Anne S. Mavor, eds. 1995. *Virtual Reality: Scientific and Technological Challenges*. Washington, D.C.: National Academy Press.

Dyens, Oliver. 1994. The emotion of cyberspace: Art and cyber-ecology. *Leonardo* 27, no. 4: 327–333.

Dyson, George B. 1998. *Darwin among the Machines: The Evolution of Global Intelligence*. Reading, MA: Helix Books.

Eco, Umberto. 1973. *Das offene Kunstwerk*. Frankfurt/Main: Harvard Univ. Press.

Eggeling, Tilo. 1990. *Die Wohnungen Friedrichs des Grossen im Schloss Charlottenburg*. Berlin: Verwaltung der Staatlichen Schlösser und Gärten.

Eisenstein, Sergei. 1943. *The Film Sense*. London: Faber and Faber.

Eisenstein, Sergei. 1949. "About Stereoscopic Cinema," *The Penguin Film Review*, no. 8: 35–45.

Eisenstein, Sergei. 1988. *Das dynamische Quadrat: Schriften zum Film*. Ed. Oksana Bulgakova et al. Leipzig: Reclam.

Elkins, James. 1994. Art history and the criticism of computer-generated images. *Leonardo* 27, no. 4: 335–342.

Elkins, James. 1999. *Why Are Our Pictures Puzzles? On the Modern Origins of Pictorial Complexity*. New York: Routledge.

Ellis, S. R. 1991. Nature and origins of virtual environments: A bibliographical essay. *Computing Systems in Engineering*, no. 4: 321–347.

Ende, Hermann and Wilhelm Böckmann. 1884. Das Sedanpanorama am Alexanderplatz in Berlin. *Zentralblatt der Bauverwaltung*, no. 4: 114–116.

Engemann, J. 1967. Zu den "Odysseelandschaften" vom Esquilin. *Römische Mitteilungen* 12, suppl.: Architektur-Darstellungen des frühen zweiten Stils, Appendix I: 141–146.

Escoffier-Robida, Francoise. 1976. Les Panoramas, la recherche de l'illusion. *Histoire pour tous*, no. 200, H. 12, pp. 6–16. Paris: Roulff.

Esmeijer, Anna C. 1978. *Divina Quaternitas: A Preliminary Study in the Method and Application of Visual Exegesis*. Amsterdam/Assen: Van Gorcum.

Esposito, Elena. 1995. Interaktion, Interaktivität und die Personalisierung der Massenmedien. *Soziale Systeme*, no. 2: 225–259.

Esposito, Elena. 1998. Fiktion und Virtualität. In *Medien Computer Realität, Wirklichkeitsvorstellungen und Neue Medien*, ed. Sybille Krämer, pp. 269–296. Frankfurt/Main: Suhrkamp.

Ewering, Ute. 1993. *Der mythologische Fries der Sala delle Prospettive in der Villa Farnesina zu Rom*. Münster: Lit.

Falk, Lorne. 1996. Brave new worlds of Sommerer and Mignonneau. *IRIS Universe*, no. 35 (spring): 36–39.

Falkenhausen, Susanne von. 1979. *Der Zweite Futurismus und die Kunstpolitik des Faschismus in Italien von 1922–1943*. Frankfurt/Main: Haag and Herchen.

Fassler, Manfred. 1996. *Mediale Interaktion: Speicher, Individualität, Öffentlichkeit*. Munich: Fink.

Fassler, Manfred, ed. 1999. *Alle möglichen Welten. Virtuelle Realität—Wahrnehmung —Ethik der Kommunikation*. Munich: Fink.

Faulstich, W. 1997. *Das Medium als Kult*. Göttingen: Vandenhoeck und Ruprecht.

Feldenkirchen, Wilfried. 1982. Staatliche Kunstfinanzierung im 19. Jahrhundert. In *Kunstpolitik und Kunstförderung im Kaiserreich: Kunst im Wandel der Sozial- und Wirtschaftsgeschichte*, ed. Ekkehard Mai et al., pp. 35–54. Berlin: Gebr. Mann.

Feyerabend, Paul. 1984. *Wissenschaft als Kunst*. Frankfurt/Main: Suhrkamp.

Ferri-Piccaluga, Gabriella. 1989. Il "monte sacro" dei Filosofi e la pratica sel "pellegrinaggio della conoscenza." In *La "Gerusalemme" di San Vivaldo e i Sacri monti in Europa, Comune di Montaione*, ed. Serigo Gensini, pp. 109–132. Ospedaletto: Pacini.

Fink, Karl August. 1968. Das große Schisma bis zum Konzil von Pisa. In *Handbuch der Kirchengeschichte*, ed. Hubert Jedin, pp. 490–516. Freiburg: Herder.

Fisher, Scott S. 1991. Virtual environments: Personal simulation and telepresence. In *Virtual Reality: Theory, Practice, and Promise*, ed. Sandra K. Helsel and Judith Paris Roth, pp. 101–110. London: Meckler.

Fisher, Scott S., M. McGreevy, et al. 1986. Virtual Environment Display System, ACM 1986, Workshop on interactive 3-D Graphics. University of North Carolina. Chapel Hill, NC: ACM SIGGRAPH.

Fleischmann, M. 1993. A virtual walk through Berlin. Visiting a virtual museum. *Virtual Reality World* 1: n.p.

Fleischmann, M. 1997a. Jetztzeit: Now. In *Interaktiv: Im Labyrinth der Wirklichkeiten*, ed. Wolfgang Zacharias, pp. 396–406. Remscheid: BKJ.

Fleischmann, M. 1997b. Weltweite vernetzte Strukturen—Neue Medien in Kunst und Kultur. *Globalisierung: Herausforderung für Wissenschaft und Wirtschaft*, GMD Spiegel no. 2, GMD-Research Center for Information Technology, Schloss Birlinghoven, Saint Augustin: 52–56.

Fleischmann, M. 2000. Virtualität und Interaktivität als Medium: Die Auflösung des Raumes. *GMD-Motor für die Informationsgesellschaft 2000*, GMD Spiegel no. 1, GMD-Research Center for Information Technology, Schloss Birlinghoven, Saint Augustin: 42–44.

Fleischmann, M. and W. Strauss. 1992. Home of the Brain. In *Prix Ars Electronica International Compendium of the Computer Arts*, ed. Johannes Leopoldseder, pp. 100–105. Linz: Cantz.

Fleischmann, M. and W. Strauss. 1993a. ART ı COM, Mente Global. In *Artificial Life: Art Futura 1993*. Barcelona: Instituto de la Cinematografia y los Artes Audiovisuales.

Fleischmann, M. and W. Strauss. 1993b. Cyber City, Home of the Brain. *Intercommunication*, no. 9: n.p.

Fleischmann, M. and W. Strauss. 1994. Illusions of reality and virtuality. *Technoculturematrix*, no. 2: 84–85.

Fleischmann, M. and W. Strauss. 1995. The body as interface and representation. *Tight Rope*, HBK Saar, Saarbrücken (Oct.): 34–35.

Fleischmann, M. and W. Strauss. 1996a. Digitale Muse Internet. In *Perspektiven der Medienkunst, Museumspraxis und Kunstwissenschaft antworten auf die digitale Herausforderung*, ed. Heinrich Klotz, pp. 110–116. Ostfildern: Cantz.

Fleischmann, M. and W. Strauss. 1996b. Digitale Körperbilder oder Inter-Faces als Schlüssel zur Imagination, Die Zukunft des Körpers I. *Kunstforum International* 132: 136–141.

Fleischmann, M. and W. Strauss. 1998. Images of the body in the house of illusion. In *Art@Science*, cd. C. Sommerer und L. Mignonneau, pp. 133–147. New York: Springer.

Fleischmann, M. and W. Strauss. 1999. Staging the space of mixed reality reconsidering the concept of a multi-user environment. In *VRML 99, Fourth Symposium on the Virtual Reality Modeling Language*, ed. Stephen N. Spencer, pp. 93–98. New York: ACM Press.

Fleischmann, M. and W. Strauss, eds. 2001. *Cast01//Living in Mixed Realities: Proceedings of the Conference on Artistic, Cultural, and Scientific Aspects of Experimental Media Spaces*. Bonn: Fraunhofer Institut.

Fleischmann, M., W. Strauss, E. Bannwart, and P. Paulusek. 1991. Telecomputing im Bereich Stadtplanung. In *Karl-Dietrich Abel: Tele-Medien für Morgen*, pp. 107–117. Berlin: Vistas-Verlag.

Flusser, Vilém. 1985. *Ins Universum der technischen Bilder*. Göttingen: European photography.

Flusser Vilém. 1989a. Alle Revolutionen sind technische Revolutionen. Im Gespräch mit Florian Rötzer. *Kunstforum* 97: 120–126.

Flusser, Vilém. 1989b. *Für eine Philosophie der Fotografie*. Göttingen: European Photography.

Flusser, Vilém. 1991a. Digitaler Schein. In *Digitaler Schein*, ed. Florian Rötzer, pp. 147–159. Frankfurt/Main: Suhrkamp.

Flusser, Vilém. 1991b. Gesellschaftsspiele. *Kunstforum* 116: 66–69.

Flusser, Vilém. 1998. *Standpunkte: Text zur Fotografie*. Göttingen: European Photography.

Foley, James D. 1987. Interfaces for advanced computing. *Scientific American* 257, no. 4 (Oct.): 126–135.

Foucault, Michel. 1975. *Surveiller et punir: Naissance de la prison*. Paris: Gallimard.

Freedberg, David. 1989. *The Power of the Images: Studies in the History and Theory of Response*. Chicago: Univ. of Chicago Press.

Freeman, Jonathan. 1999. Effects of sensory information and prior experience on direct subjective ratings of presence. *Presence: Teleoperators and Virtual Environments* 8, no. 1: 1–13.

Frey, G., E. J. Beer, and K. A. Wirth. 1958. *Real Lexikon des Kirchengeschichte*. Stuttgart.

Friedberg, Anne. 1993. *Window Shopping: Cinema and the Postmodern*. Berkeley: Univ. of California Press.

Frommel, Christoph Luitpold. 1961. *Die Farnesina und Peruzzis architektonisches Frühwerk*. Berlin: de Gruyter.

Frommel, Christoph Luitpold. 1968. *Baldassare Peruzzi als Maler und Zeichner*. Munich: Schroll.

Fuchs, G. 1962. Varros Vogelhaus bei Casinum. *Römische Mitteilungen* 69, part 1: 96–105.

Fuchs, Matthias. 1996. ParaReal. In *Wunschmaschine Welterfindung: Geschichte der Technikvisionen seit dem 18. Jahrhundert*, ed. Brigitte Felderer. Vienna: Springer Verlag.

Fumagalli, A. 1831. *Discorso intorno alle opere di G. Ferrari: letto nella grande aula del I. R. Palazzo delle Scienze ed Arti. . . .* Milan.

Gabriel, Leo, ed. 1967. *Philosophisch-Theologische Schriften*. Vienna: Herder.

Gabriel, Mabel. 1955. *Livia's Garden Room at Primaporta*. New York: New York University Press.

Gaehtgens, Thomas. 1990. *Anton von Werner: Die Proklamierung des Deutschen Kaiserreichs*. Frankfurt: Du Mont.

Gagnière, Sylvain. 1965. *Le Palais des Papes d'Avignon*. Paris: Caisse nationale des monuments historiques.

Gagnon, Jean. 1998. Dionysus and reverie: Immersion in Char Davies' environments. In *Char Davies: Ephémère* (exhib. catalog), ed. Jean Gagnon. Ottawa: National Gallery of Canada.

Galison, Peter Louis. 2001. *Science in Culture*. New Brunswick, NJ: Transaction Publ.

Gallus, Aegidius. 1551. *De viridario Augustini Chigii, Patri Sene*, 5, II. Rome.

Ganz, Paul Leonhard. 1963. Das Zeitalter der Bilderpanoramen. *Das Werk* 50, no. 12: 478–482.

Gaskell, Ivan and Michael Jonker, eds. 1998. *Vermeer Studies*. New Haven: Yale Univ. Press.

Gates, Bill. 1995. *Der Weg nach vorn: Die Zukunft der Informationsgesellschaft*. Hamburg: Hoffman and Campe.

Gehlen, Arnold. 1957. *Die Seele im technischen Zeitalter: Soziopsychologische Probleme in der industriellen Gesellschaft*. Reinbek bei Hamburg: Rowohlt.

Gehlen, Arnold. 1986. Zeitbilder. Frankfurt/Main: Klostermann.

Gendolla, Peter, and Thomas Kamphusmann, eds. 2000. *Die Künste des Zufalls*. Frankfurt/Main: Suhrkamp.

Generalstabswerk. 1874–1881. *Der deutsch-französische Krieg 1870/1: Redigiert von der kriegsgeschichtlichen Abtheilung des großen Generalstabes, Erster Theil, Geschichte des Krieges bis zum Sturz des Kaiserreichs*, vol. II. Berlin.

Gerlini, Elsa. 1988. *Villa Farnesina alla lungara Roma*. Rome: Istituto Poligraf. e Zecca dello Stato.

Germania Zeitung für das Deutsche Volk. Sept. 2, 1883, vol. 13., no. 200, p. 3.

Gessert, George. 1996. The angel of extinction. *Northwest Review* 34, no. 3: 115–121.

Gibson, James J. 1950. *The Perception of the Visual World*. Boston: Riverside Press.

Gibson, James J. 1966. *The Senses Considered as Perceptual Systems*. New York: Mifflin.

Gibson, James J. 1986. *The Ecological Approach to Visual Perception*. Hillsdale, NJ: Erlbaum.

Gibson, William. 1990. *Newromancer*. Munich: Wilhelm Heyne.

Giebel, Marion. 1990. *Das Geheimnis der Mysterien: Antike Kulte in Griechenland, Rom und Ägypten*. Zürich: Artemis.

Gigante, Michael A. 1993a. Virtual reality: Definitions, history, and applications. In *Virtual Reality Systems*, ed. Michael A. Gigante et al., pp. 3–14. London: Academic Press.

Gigante, Michael A. 1993b. Virtual reality: Enabling technologies. In *Virtual Reality Systems*, ed. Michael A. Gigante et al., pp. 15–25. London: Academic Press.

Gigliotti, Carol. 1995. Aesthetics of a virtual world. *Leonardo* 28, no. 4: 289–295.

Glaser, Hermann. 1984. *Die Kultur der Wilhelminischen Zeit: Topographie einer Epoche*. Frankfurt/Main: S. Fischer.

Godé, Véronique. 1999. Rendez-vous incontournable des arts électroniques. *Création numerique* (January).

Goethe, J. W. von. 1899. *Goethes Werke, Weimarer Ausgabe II*, vol. 31. Weimar: Böhlau.

Goethe, J. W. von. 1903. *Goethes Werke*. Ed. Hermann Böhlau. Weimar: Böhlau.

Goethe, J. W. von. 1904. *Goethes Werke*. Ed. Hermann Böhlau. Weimar: Böhlau.

Goethe, J. W. von. 1988. *Farbenlehre*, vol. 1. Ed. Gerhard Ott et al. Stuttgart: Verlag Freies Geistesleben.

Goldberg, Benjamin. 1985. *The Mirror and Man*. Charlottesville, VA: Univ. of Virginia Press.

Goldberg, David E. 1989. *Genetic Algorithms in Search, Optimalisation, and Machine Learning*. Reading, MA: Addison-Wesley.

Goldberg, Ken. 1998. Virtual reality in the age of telepresence. *Convergence Journal* 4, no. 1 (spring): 33–37.

Goldberg, Ken, ed. 2000. *The Robot in the Garden: Telerobotics and Telepistemology on the Internet*. Cambridge, MA: MIT Press.

Gombrich, Ernst. 1982. *The Image and the Eye: Further Studies in the Psychology of Pictorial Representation*. Oxford: Phaidon.

Gombrich, Ernst H. 1984. *Bild und Auge: Neue Studien zur Psychologie der bildlichen Darstellung*. Stuttgart: Klett-Cotta.

Gombrich, Ernst H. 1986. *Kunst und Illusion: Zur Psychologie der bildlichen Darstellung*. Stuttgart: Belser.

Goodman, Cynthia. 1987. *Digital Visions: Computers and Art*. New York: Abrams.

Goodman, Nelson. 1968. *Languages of Art: An Approach to a Theory of Symbols*. Indianapolis: Bobbs-Merrill.

Goodman, Nelson. 1978. *Ways of Worldmaking*. Indianapolis: Hackett.

Goslin, Mike and Jacquelyn Ford Morie. 1996. Virtopia: Emotional experiences in virtual environments. *Leonardo* 29, no. 2: 95–100.

Gosztonyi, Alexander. 1976. *Der Raum: Geschichte seiner Probleme in Philosophie und Wissenschaften*. Munich: Alber.

Graevenitz, Gerhard von. 1987. *Mythos: Zur Geschichte einer Denkgewohnheit*. Stuttgart: Metzler.

Grau, Oliver. 1994. Hingabe an das Nichts: Der Cyberspace zwischen Utopie, Ökonomie und Kunst. *Medien. Kunst. Passagen* 4: 17–30.

Grau, Oliver. 1997a. Vom Zen des Tauchens: Die virtuelle Installation *Osmose* lässt erstmals die Macht der neuen Illusionskunst erahnen. *Die Zeit*, June 20, p. 62.

Grau, Oliver. 1997b. In das *lebendige* Bild: Die Virtuelle Realität setzt der Kunst neue Spielregeln. *neue bildende kunst*, no. 6: 28–36.

Grau, Oliver. 1998a. Vademecum digitaler Kunst: von Söke Dinkla: Pioniere interaktiver Kunst von 1970 bis heute (Rezension). In *computer art faszination*, ed. Gerhard Dotzler, pp. 275–276. Frankfurt am Main: Dot-Verlag.

Grau, Oliver. 1998b. Zur Kunstgeschichte der Virtuellen Realität: Eine Forschungsnotiz. *Kunstchronik: Monatszeitschrift für Kunstwissenschaft, Museumswesen und Denkmalpflege*, no. 7: 354–355.

Grau, Oliver. 1999a. Archaeology of the virtual review of Stephan Oettermann's *The Panorama: History of a Mass Medium. Leonardo* 32, no. 2: 143–144.

Grau, Oliver. 1999b. Into the belly of the image: Historical aspects of virtual reality. *Leonardo* 32, no. 5: 365–372.

Grau, Oliver. 2000a. Verlust des Zeugen: Das lebendige Werk. In *Metamorphosen: Gedächtnismedien im Computerzeitalter*, ed. Götz Darsow, pp. 101–121. Stuttgart/ Bad Cannstatt: Fromann-Holzboog.

Grau, Oliver. 2000b. The history of telepresence: Automata, illusion, and the rejection of the body. In *The Robot in the Garden: Telerobotics and Telepistemology on the Internet*, ed. Ken Goldberg, pp. 226–246. Cambridge, MA: MIT Press.

Grau, Oliver. 2000c. Lebendige Bilder schaffen: Virtuelle Realität, Artificial Life und Transgenic Art. In *Sieben Hügel: Dschungel. Sammeln, Ordnen, Bewahren: Von der Vielfalt des Lebens zur Kultur der Natur*, ed. B.-M. Baumunk und J. Joerges, pp. 47–53. Berlin: Henschel Verlag.

Grau, Oliver. 2001b. Zur relativen Interdependenz zwischen bildlicher Wirkung und reflektierter Distanzgewinnung. In *Vom Realismus der Bilder: Interdisziplinäre Forschungen zur Semantik bildlicher Darstellungsformen*, ed. Klaus Sachs-Hombach, pp. 213–227. Magdeburg: Scriptum-Verlag.

Grau, Oliver. 2001c. Datenbank der Virtuellen Kunst. In *Electronic Imaging and the Visual Arts 2001*, pp. 135–140. Berlin: Gesellschaft zur Förderung angewandter Informatik l.v.

Grieco, Gennaro. 1979. La grande frise de la Villa des Mystères et l'initiation dionysiaque. *La Parola del Passato* 24: 417–441.

Griscom, Chris. 1988. *Die Frequenz der Ekstase: Bewusstseinsentwicklung durch die Kraft des Lichts*. Munich: Goldmann.

Groh, Ruth and Dieter Groh. 1996. *Zur Kulturgeschichte der Natur*. Frankfurt/ Main: Suhrkamp.

Gronert, Siegfried. 1981. Das Panorama. *Kritische Berichte* 9, no. 3: 39–50.

Grosskinski, Manfred. 1992. *Eugen Bracht (1842–1921): Landschaftsmaler im wilhelminischen Kaiserreich*. Darmstadt: Institut Mathildenhöhe.

Grossklaus, Götz. 1995. *Medien-Zeit Medien-Raum: Zum Wandel der raumzeitlichen Wahrnehmung in der Moderne*. Frankfurt/Main: Suhrkamp.

Grote, Rolf-Jürgen. 1991. Raumkunst der Renaissance und des Barock. In *Raumkunst in Niedersachsen: Die Farbigkeit historischer Innenräume*, ed. Rolf-Jürgen Grote, pp. 55–80. Munich: Deutscher Kunstverlag.

Guillaud, Jacqueline and Maurice Guillaud. 1990. *La pittura a fresco al tempo di pompeji*. Paris: Guillaud Editions.

Guilliatt, Richard. 1989. SF and the tales of a new romancer. *Melbourne Sunday Herald*, December 17.

Gullichsen, Eric, Randel Walser, and Patrice Gelband. 1989a. Cyberspace: Experiential computing. In *NEXUS '89: Science Fiction and Science Fact* 6 (Dec.): 46–47.

Günter, T. 1998. *Medien—Ritual—Religion: Zur religiösen Funktion des Fernsehens.* Frankfurt/Main: Suhrkamp.

Halbach, Wulf R. 1994a. Reality engines. In *Computer als Medium*, ed. Norbert Bolz et al., pp. 231–244. Munich: Fink.

Halbach, Wulf R. 1994b. *Interfaces: Medien- und kommunikationstheoretische Elemente einer Interface Theorie.* Munich: Fink.

Halbwachs, M. 1925. *Les cadres sociaux de la mémoire.* Paris: Alcan.

Hammerstein, Reinhold. 1986. *Macht und Klang: Tönende Automaten als Realität und Fiktion in der alten und mittelalterlichen Welt.* Bern: Francke.

Haraway, Donna. 1991. The actors are cyborg, nature is coyote, and the geography is elsewhere: Postscript to cyborgs at large. In *Cultural Politics 3: Technoculture*, ed. Constance Penley et al., pp. 21–26. Minneapolis: Univ. Minnesota Press.

Haraway, Donna J. 1997. *Modest-Witness@Second Millennium: FemaleMan Meets Oncomouse: Feminism and Technoscience.* New York: Routledge.

Hatfield, J. A. 1984. *The Relationship between Late Baroque Architecture and Scenography, 1703–1778.* Ph.D. diss., Ann Arbor, University of Michigan.

Hausmann, G. 1889. Die Erfindung der Panoramen. *Die Kunst für Alle* 13, no. 4: 198–202.

Hausmann, G. 1890. Die neueste Entwicklung in der deutschen Panoramenmalerei. *Die Kunst für Alle* 17, no. 5: 257–263.

Hayes, R. M. 1989. *3-D Movies: A History and Filmography of Stereoscopic Cinema.* Jefferson, New York, London: McFarland.

Hayles, Katherine. 1996. Narratives of artificial life. In *Future Natural*, ed. Jon Bird et al., pp. 146–164. London: Routledge.

Heeter, Carrie. 1992. Being there: The subjective experience of presence. *Presence: Teleoperators and Virtual Environments* 1, no. 2: 262–271.

Heidegger, Martin. 1990. *Der Ursprung des Kunstwerkes.* Stuttgart: Reclam.

Heilbronner, Robert L. 1994. Do machines make history? In *Does Technology Drive History?* ed. Merritt Roe Smith et al., pp. 53–66. Cambridge, MA: MIT Press.

Heilig, Morton L. 1992. El Cine del Futuro: The cinema of the future. *Presence* 1, no. 3: 297–294. (Reprint from *Espacios* 23–24, 1955.)

Heim, Michael. 1991. The metaphysics of virtual reality. In *Virtual Reality: Theory, Practice, and Promise*, ed. Sandra K. Helsel and Judith Paris Roth, pp. 27–34. London: Meckler.

Heim, Michael. 1998. *Virtual Realism.* Oxford: Oxford Univ. Press.

Heintz, Bettina. 1993. *Die Herrschaft der Regel: Zur Grundlagengeschichte des Computers*. Frankfurt/Main: Campus.

Helbig, Wolfgang. 1969. *Führer durch die öffentlichen Sammlungen klassischer Altertümer in Rom. 3: Die Staatlichen Sammlungen Museo Nazionale de Villa Giulia*, ed. Hermine Speier. Tübingen: Wasmuth.

Held, Richard M. and Nathaniel I. Durlach. 1992. Telepresence. *Presence: Teleoperators and Virtual Environments* 1, no. 1: 109–112.

Helmholtz, Hermann von. 1896. *Handbuch der Physiologischen Optik*, second ed. Hamburg/Leipzig: Voss.

Helmholtz, Hermann von. 1903. Optisches über Malerei. In *Vorträge und Reden*, fifth ed. Braunschweig: Vieweg.

Helmreich, Stefan. 1998. *Silicon Second Nature: Cultivating Artificial Life in a Digital World*. Berkeley: Univ. of California Press.

Helsel, Sandra K. and Judith Paris Roth, eds. 1991. *Virtual Reality: Theory, Practice, and Promise*. London: Meckler.

Henri, Adrian. 1974a. *Environments and Happenings*. London: Thames and Hudson.

Henri, Adrian. 1974b. *Total Art: Environments, Happenings, and Performance*. New York: Oxford Univ. Press.

Herbig, Reinhard. 1958. *Neue Beobachtungen am Fries der Mysterien-Villa in Pompeji*. Baden-Baden: Grimm.

Hermann, A. 1964. Porphyra und Pyramide: Zur bedeutungsgeschichtlichen Überlieferung eines Baugedankens. *Jahrbuch für Antike und Christentum* 7: 117–138.

Hermann, Luke. 1986. *Paul and Thomas Sandby*. London: Batsford.

Hersh, Harry and Richard Rubinstein. 1984. *The Human Factor: Designing Computer Systems for People*. Maynard, MA: Digital Press.

Hildebrand, Arnold. 1934. Bei Friedrich dem Großen in Schloß Charlottenburg: Zu den neuentdeckten Wandbildern im Stile des Antoine Pesne. *Atlantis: Länder/Völker/Reisen*, vol. 6, ed. Martin Hürlimann, pp. 436–443. Freiburg i. Br., Zürich: Atlantis.

Ho, Mae-Won. 1991. Reanimating nature: The integration of science with human experience. *Leonardo* 24, no. 5: 607.

Hobbes, Thomas. 1994. *The Collected Works of Thomas Hobbes*. Ed. Sir W. Molesworth. London: Routledge.

Hoffman, Hunter G. 1998. Physically touching virtual objects using tactile augmentation enhances the realism of virtual environments. In *IEEE 1998 Virtual Reality Annual International Symposium*, pp. 59–63. Los Alamitos, CA: IEEE Computer Society.

Hohorst, Gerd, et al., eds. 1975. *Sozialgeschichtliches Arbeitsbuch II: Materialien zur Statistik des Kaiserreichs 1870–1914*. Munich: Beck.

Holmgren, Douglas E. 1993. Scanned laser displays for virtual reality: A feasibility study. *Presence: Teleoperators and Virtual Environments* 2, no. 3: 171–184.

Honda, Hideo, et al., eds. 1995. *Annual InterCommunication*. Tokyo: NTT Publishing.

Hood, William. 1984. The Sacro Monte of Varallo: Renaissance art and popular religion. In *Monasticism and the Arts*, ed. Timothy Verdon et al., pp. 291–311. New York: Syracuse Univ. Press.

Hopkirk, Peter. 1990. *The Great Game: On Secret Service in High Asia*. London: John Murray.

Housley, Norman. 1986. *The Avignon Papacy and the Crusades, 1305–1378*. Oxford: Clarendon Press.

Huges, Peter. 1972. Paul Sandby and Sir Watkins Williams-Wynn. *The Burlington Magazine* 114, no. 832: 459–466.

Huhtamo, Erkki. 1996. From cybernation to interaction. In *Wunschmaschine Welterfindung*, ed. B. Felderer, pp. 192–207. Vienna: Kunsthalle Wien.

Huhtamo, Erkki. 1997. From kaleidoscomaniac to cybernerd: Notes toward an archaeology of the media. *Leonardo* 30, no. 3: 221–224.

Huizinga, Johann. 1938. *Homo Ludens: Versuch einer Bestimmung des Spielelements der Kultur*. Basel: Akademische Verlagsanstalt Pantheon.

Humboldt, Alexander von. 1993. *Kosmos: Entwurf einer physischen Weltbeschreibung*, ed. Hanno Beck, vol. 7.2. Darmstadt: Wissenschaftliche Buchgesellschaft.

Hundsalz, Brigitte. 1991. Neues zum großen Fries der Mysterienvilla. In *Kölner Jahrbuch für Vor- und Frühgeschichte 24*, ed. Römisch-Germanisches Museum et al., pp. 73–78. Berlin: Mann.

Hyde, Ralph. 1985. *Gilded Scenes and Shining Prospects: Panoramic Views of British Towns 1575–1900*. New Haven, CT: Yale Center for British Art.

Hyde, Ralph. 1988. *Panoramania! The Art and Entertainment of the "All-embracing" View*. London: Trefoil.

Ianka, E. von. 1957. *Dionysus Areopagita: Von den Namen zum Unnennbaren*. Einsiedeln: Johannes-Verlag.

IEEE, ed. 2001. *Virtual Reality 2001*. Yokohama: NTCS.

Illustrierte Geschichte des Krieges von 1870/71 für Volk und Heer, Vom Kriegsschauplatz. 1870/71. *Illustrierte Kriegszeitung für Volk und Heer*, no. 23, 5. Stuttgart: Hallberger.

Jacobson, Linda, ed. 1992. *Cyberarts: Exploring Art and Technology*. San Francisco: Miller Freemann.

Jauß, Hans Robert. 1982. *Ästhetische Erfahrung und literarische Hermeneutik*. Frankfurt/Main: Surhkamp.

Jay, Martin. 1993. *Downcast Eyes*. Berkeley: Univ. of California Press.

Jedin, Hubert, ed. 1968. *Handbuch der Kirchengeschichte III/2*. Freiburg: Herder.

Johnson, David. 1995. IWERKS entertainment. *Theatre Crafts International* 29 (Jan.): 22–23.

Johnson, George. 1993. *In den Palästen der Erinnerung: Wie die Welt im Kopf entsteht*. Munich: Droemer Knaur.

Jonas, Hans. 1973. *Organismus und Freiheit: Ansätze zu einer philosophischen Biologie*. Göttingen: Vandehoeck and Ruprecht.

Jonas, Hans. 1984. *Das Prinzip Verantwortung: Versuch einer Ethik für die technologische Zivilisation*. Frankfurt/Main: Suhrkamp.

Jones, C. and P. Galison, eds. 1998. *Picturing Science Producing Art*. New York: Routledge.

Jung, C. G. 1926. *Das Unbewusste im normalen und kranken Seelenleben*. Zürich: Rascher.

Jung, C. G. 1928. *Die Beziehungen zwischen dem Ich und dem Unbewussten*. Darmstadt: Reichl.

Jung, C. G. et al. 1968. *Der Mensch und seine Symbole*. Olten, Freiburg i. Br.: Walter.

Kac, Eduardo. 1991. Ornitorrinco: Exploring telepresence and remote sensing. *Leonardo* 24, no. 2: 233.

Kac, Eduardo. 1993. Telepresence art. In *Teleskulptur*, ed. Richard Kriesche, pp. 48–72. Graz: Kulturdata.

Kac, Eduardo. 1996. Ornitorrinco and Rara Avis: Telepresence art on the internet. *Leonardo* 29, no. 5: 389–400.

Kac, Eduardo. 1998. Além de Tela. *Veredas* 3, no. 32: 12–15.

Kac, Eduardo. 1999. Transgene Kunst. In *LifeScience, Ars Electronica 99*, ed. Gerfried Stocker, pp. 289–303. Vienna: Springer.

Kac, Eduardo. 2000. *Telepresence, Biotelematics, and Transgenic Art*. Ed. Peter T. Dobrila and Aleksandra Kostic. Maribor, Slovenia: Kibla.

Kaes, Anton, ed. 1979. *Die Kino-Debatte: Texte zum Verhältnis von Literatur und Film 1909–1929*. Tübingen: Niemayer.

Kamper, Dietmar. 1991a. Das Nadelöhr: Ein weiterer Versuch, zwischen Mimesis und Simulation zu unterscheiden. In *Stategien des Scheins: Kunst Computer Medien*, ed. Florian Rötzer and Peter Weibel, pp. 16–22. Munich: Boer.

Kamper, Dietmar. 1991b. Der Januskopf der Medien: Ästhetisierung der Wirklichkeit, Entrüstung der Sinne. In *Digitaler Schein*, ed. Florian Rötzer, pp. 93–99. Frankfurt/Main: Suhrkamp.

Kamper, Dietmar. 1995. *Unmögliche Gegenwart: Zur Theorie der Phantasie*. Munich: Fink.

Kant, Immanuel. 1973. *Kritik der praktischen Vernunft*. Stuttgart: Reclam.

Kaufhold, Enno von. 1986. *Bilder des Übergangs*. Marburg: Jonas.

Kauffman, Stewart. 1995. *At Home in the Universe: The Search for Laws of Complexity*. New York: Oxford Univ. Press.

Kelle, Olaf. 1995. *Dynamische Tiefenwahrnehmungskriterien in computergenerierten interaktiven Szenarien und virtuellen Simulationsumgebungen*. Düsseldorf: Vdi Verlag.

Keller, Evelyn Fox. 1995. *Refiguring Life: Metaphors of Twentieth-Century Biology*. New York: Columbia Univ. Press.

Kelly, Kevin. 1995. *Out of Control: The New Biology of Machines*. London: Fourth Estate.

Kelso, Margret, Peter Weyhrauch, and Joseph Bates. 1993. Dramatic presence. *Presence: Teleoperators and Virtual Environments* 2, no. 1: 1–15.

Kemner, Gerhard, ed. 1989. *Stereoskopie: Technik, Wissenschaft, Kunst und Hobby*. Materialien 5. Berlin: Museum für Verkehr und Technik.

Kemp, Martin. 1990. *The Science of Art: Optical Themes in Western Art from Brunelleschi to Seurat*. New Haven, CT: Yale Univ. Press.

Kemp, Martin. 1996. Doing what comes naturally: Morphogenesis and the limits of the genetic code. *Art Journal* 55, no. 1: 27–32.

Kemp, Martin. 2000. *Visualisations: The Nature Book of Art and Science*. Berkeley: Univ. California Press.

Kemp, Wolfgang, ed. 1983. *Der Anteil des Betrachters: Rezeptionsästhetische Studien zur Malerei des 19. Jahrhunderts*. Munich: Mäander.

Kemp, Wolfgang. 1985. Kunstwissenschaft und Rezeptionsästhetik. In *Der Betrachter ist im Bild*, ed. W. Kemp, pp. 7–27. Cologne: DuMont.

Kemp, Wolfgang. 1991. Die Revolutionierung der Medien im 19. Jahrhundert: Das Beispiel Panorama. In *Moderne Kunst 1, Das Funkkolleg zum Verständnis der Gegenwartskunst*, ed. Monika Wagner, pp. 75–93. Reinbek: Rowohlt.

Kennedy, Robert S., et al. 1992. Profile analysis of simulator sickness symptoms: Application to virtual environment systems. *Presence: Teleoperators and Virtual Environments* 1, no. 3: 295–301.

Kern, Hermann. 1982. *Labyrinthe. Erscheinungsformen und Deutungen; 5000 Jahre Gegenwart eines Urbilds*. Munich: Prestel.

Khaynach, Friedrich Freiherr von. 1893. *Anton von Werner und die Berliner Hofmalerei*. Zürich: Verlags-Magazin.

Kiefer, Erich. 1991. Künstliche Intelligenz und Virtuelle Realität. In *Strategien des Scheins: Kunst Computer Medien*, ed. Florian Rötzer and Peter Weibel, pp. 176–214. Munich: Boer.

Kiefer, Erich. 1993. Leonardos Traum: Auf dem Weg zum Intelligenten Virtuellen Realitätssystem. In *Cyberspace*, ed. Florian Rötzer et al., pp. 214–255. Munich: Boer.

Kircher, Athanasius. 1646. *Ars magna lucis et umbrae*. Rome: Scheus.

Kittler, Friedrich. 1988. Fiktion und Simulation. In *Philosophien der neuen Technologie*, ed. Ars Electronica, pp. 57–79. Berlin: Merve.

Kittler, Friedrich. 1989. Synergie von Mensch und Maschine, im Gespräch mit Florian Rötzer. *Kunstforum* 98: 108–117.

Kittler, Friedrich. 1991. Protected mode. In *Strategien des Scheins: Kunst Computer Medien*, ed. Florian Rötzer and Peter Weibel, pp. 256–267. Munich: Boer.

Klein, Yves Amu. 1998. Living sculpture: The art and science of creating robotic life. *Leonardo* 31, no. 5: 393–396.

Kleinspehn, Thomas. 1989. *Der flüchtige Blick: Sehen und Identität in der Kultur der Neuzeit*. Reinbek: Rowohlt.

Kleist, Heinrich von. 1978. Letter dated 16 Aug. 1800 an das Stiftsfräulein Wilhelmine von Zenge. In *Werke und Briefe in vier Bänden*, ed. Siegfried Streller, pp. 68f. Berlin (East): Aufbau.

Kloss, Jörg H., et al. 1998. *VRML97: Der internationale Standard für interaktive 3D-Welten im World Wide Web*. Bonn: Addison-Wesley.

Klyce, B. 1997. Can computers mimic neo-Darwinian evolution? ⟨http://www.panspermia.org/computr2.htm⟩.

Knauss, F. von. 1780. *Selbstschreibende Wundermaschinen*. Vienna: Knauß.

Knoepfli, Albert. 1970. Farbillusionistische Werkstoffe. *Palette*, no. 34: 7–52.

Knowbotic Research. 1994. Co-realities. *Medien Kunst Passagen*, no. 4.

Knowbotic Research. 1996. Postorganic immortality. *Kunstforum International* 33: 160–165.

Kolasinski, E. 1996. *Prediction of Simulator Sickness in a Virtual Environment*. Ph.D. dissertation, Univ. of Central Florida, Orlando, Florida.

Kominstky (Comenius), John Amos. 1658. *Orbis Sensualium Pictus*. Nürnberg: Endter.

Korfhage, R. and Isaacson, P., eds. 1977. *Computer: National Computer Conference NCC; Proceedings. 13–16 June 1977*. Arlington, Va.: AFIPS Press.

Koschorke, Albrecht. 1990. *Die Geschichte des Horizonts. Grenze und Grenzüberschreitungen in literarischen Landschaftsbildern*. Frankfurt/Main: Suhrkamp.

Kossak, Adalbert von. 1913. *Erinnerungen*. Berlin: Morawe and Scheffelt Verlag.

Kosslyn, St. M. 1994. *Image and Brain: The Resolution of the Imagery Debate*. Cambridge, MA: MIT Press.

Kozakiewicz, Stefan. 1972. *Bernardo Bellotto genannt Canaletto*, vol. I: *Leben und Werk*. Recklinghausen: Bongers.

Krämer, Sybille. 1997. Zentralperspektive, Kalkül, Virtuelle Realität. In *Medien-Welten Wirklichkeiten*, ed. Gianni Vattimo and Wolfgang Welsch, pp. 27–37. Munich: Fink.

Krämer, Sybille. 1998. Was haben die Medien, der Computer und die Realität miteinander zu tun? In *Medien Computer Realität, Wirklichkeitsvorstellungen und Neue Medien*, ed. Sybille Krämer, pp. 9–26. Frankfurt/Main: Suhrkamp.

Krampen, Martin, et al., eds. 1967. *Computers in Design and Communication*. New York: Hastings House.

Krapp, Holger, et al., eds. 1997. *Künstliche Paradiese virtuelle Realitäten*. Munich: Fink.

Kris, Ernst. 1977. *Die ästhetische Illusion: Phänomenologie der Kunst in der Sicht der Psychoanalyse*. Frankfurt/Main: Suhrkamp.

Krueger, Myron. 1983. *Artificial Reality*. Reading, MA: Addison-Wesley.

Krueger, Myron. 1991a. Artificial reality: Past and future. In *Virtual Reality: Theory, Practice, and Promise*, ed. Sandra K. Helsel and Judith Paris Roth, pp. 19–25. London: Meckler.

Krueger, Myron. 1991b. *Artificial Reality II*. Reading, MA: Addison-Wesley.

Krueger, Myron. 1993a. The experience society. *Presence: Teleoperators and Virtual Environments* 2, no. 2: 162–168.

Krueger, Myron W. 1993b. The emperor's new realities. *Virtual Reality World* (Nov./Dec.): 18–33.

Kubler, G. 1962. *The Shape of Time: Remarks on the History of Things*. New Haven, CT: Yale Univ. Press.

Kubler, George. 1990. Sacred mountains in Europe and America. In *Christanity and the Renaissance: Image and Religious Imagination in the Quattrocento*, ed. Timothy Verdon et al., pp. 413–444. New York: Syracuse Univ. Press.

Kühn, Margarete. 1955. *Schloss Charlottenburg*. Berlin: Deutscher Verein für Kunstwissenschaften.

Kunst und Ausstellungshalle der Bundesrepublik Deutschland, ed. 1998. *Der Sinn der Sinne*. Göttingen: Steidel, Bonn.

Kurzweil, Ray. 1999. *Homo S@piens. Kiepenheuer and Witsch. The Age of Spiritual Machines*. London: Orion Business Books.

Kusahara, Machiko. 1998. Transition of concept of life in art and culture from automata to network. In *Art@Science*, ed. Christa Sommerer and Laurent Mignonneau, pp. 99–119. New York: Springer.

Lacan, Jacques. 1974. *Télévision*. Paris: Ed. du Seuil.

Laclotte, Michel and Dominique Thiébaut. 1983. *L'Ecole d'Avignon*. Paris: Flammarion.

La Mettrie, Julien Offray de. 1748. *L'Homme Machine*. Paris: Leyde: De L'Imp. D'Elie Luzac.

La Mettrie, Julien Offray de. 1960 (1747). *L'Homme Machine: A Study in the Origins of an Idea*. Critical ed. by Aram Vartanian. Princeton: Princeton Univ. Press.

Langbehn, Julius. 1909. *Rembrandt als Erzieher: Von einem Deutschen*. Leipzig: Hirschfeld.

Langton, Christopher G., ed. 1995. *Artificial Life: An Overview*. Cambridge, MA: MIT Press.

Langton, Christopher, et al., eds. 1992. *Artificial Life II: Proceedings of the Workshop on Artificial Life*. Redwood City, CA: Addison-Wesley.

Lanier, Jaron. 1989. Virtual reality: An interview with Jaron Lanier by Kevin Kelly. *Whole Earth Review*, no. 64: 108–119.

Lanier, Jaron. 1992. Virtual reality: A status report. In *Cyberarts: Exploring Art and Technology*, ed. Linda Jacobson, pp. 272–279. San Francisco: Miller Freeman.

Latour, Bruno. 1993. On technical mediation: The new energy lectures on the evolution of civilization, Cornell University, April, no. 9. Working Paper Series, Institute of Economic Research, Lund University.

Latour, Bruno. 1994. On technical mediation: Philosophy, sociology, genealogy. *Common Knowledge* 3, no. 2: 29–64.

Latour, Bruno. 1996. Arbeit mit Bildern oder: Die Umverteilung der wissenschaftlichen Intelligenz. In *Der Berliner Schlüssel: Erkundungen eines Liebhabers der Wissenschaften*, ed. B. Latour, pp. 159–190. Berlin: Akademie Verlag.

Laurel, Brenda, ed. 1990. *The Art of Human-Computer Interface Design*. Reading, MA: Addison-Wesley.

Laurel, Brenda. 1991. *Computers as Theatre*. Reading, MA: Addison-Wesley.

Leary, Timothy. 1991. Das interpersonale, interaktive, interdimensionale Interface. In *Cyberspace: Ausflüge in virtuelle Wirklichkeiten*, ed. Manfred Waffender, pp. 274–281. Reinbek: Rowohlt.

Leavitt, Ruth, ed. 1976. *Artist and Computer*. New York: Harmony Books.

Leiss, J. 1961. *Bildtapeten aus alter und neuerer Zeit*. Hamburg: Broschek.

Lenders, Winfried. 1996. Virtuelle Welten als Repräsentationen. *Zeitschrift für Semiotik* 18, no. 2–3: 277–295.

Leonardo da Vinci. 1882. *Das Buch von der Malerei, nach dem Codex Vaticanus (Urbinas) 1270*. 3 vols., ed. and trans. Heinrich Ludwig. Vienna: Braumüller.

Leroy, Isabelle. 1993. Belgische Panoramagesellschaften 1879–1889: Modelle des internationalen Kapitalismus. In *Sehsucht: Das Panorama als Massenunterhaltung des 19. Jahrhunderts* (exhib. catalog), ed. Kunst und Ausstellungshalle der Bundesrepublik Deutschland in Bonn, pp. 74–83. Frankfurt/Main: Stroemfeld/ Roter Stern.

Levavi, Arye. 1977. *Kunst und Unendlichkeit*. Frankfurt/Main: Lang.

Lévy, Pierre. 1995. *L'intelligence collective. Pour une anthropologie du cyberspace*. Paris: Ed. La Découverte.

Levy, Steven. 1992. *Artificial Life*. New York: Pantheon Books.

Licklider, J. C. R. 1960. Man–computer symbiosis. *IRE: Transactions on Human Factors in Electronics* HFE-1 (March): 4–11.

Licklider, J. C. R. 1968. The computer as a communication device. *Science and Technology* (Apr.): 21–31.

Ling, Roger. 1991. *Roman Painting*. Cambridge: Cambridge Univ. Press.

Lipton, Leonard. 1964. Now step into a movie: Sensorama. *Popular Photography* 61–62 (July): 114, 116.

Lischka, Johann G. and Peter Weibel. 1989. Polylog, Für eine Interaktive Kunst. *Kunstforum* 103: 65–86.

Loeffler, Carl Eugene. 1992. Interaktive Computerkunst. In *Interface I: Elektronische Medien und künstlerische Kreativität*, ed. Klaus Peter Denker, pp. 65–69. Hamburg: Verlag Hans-Bredow-Institut für Rundfunk und Fernsehen.

Loeffler, Carl Eugene, ed. 1994. *The Virtual Reality Casebook*. New York/London: Van Nostrand Reinhold.

Loiperdinger, Martin. 1996. Lumieres Ankunft des Zuges. *KINtop* 5: 37–70.

Lomazzo, Paolo. 1785. *Idea del Tempio della Pittura*. Bologna: Instituto delle Scienze. (Mailand, 1590.)

Longo, Pier Giorgio. 1984. Alle origini del Sacro Monte di Varallo, la proposta religiosa di Bernadino Caimi. *Novarien* 14: 19–98.

Lovelock, James. 1979. *Gaia: A New Look at Life on Earth*. Oxford: Oxford Univ. Press.

Lucian. 1913. *The Hall (De Domo)*, vol. I. Ed. T. E. Page. London.

Luecking, Stephen. 1994. Almost there: Sculpture in virtual space. *Sculpture* 13 (July–Aug.): 28–33.

Luhmann, Niklas. 1997. *Die Kunst der Gesellschaft*. Frankfurt: Suhrkamp.

Lundwall, Sune. 1964. *Johann Michael Sattler und sein Werk mit einem Exkurs über Panoramenmalerei*. Ph.D. diss., Univ. of Innsbruck.

Lunenfeld, Peter. 1993. Digital dialectics: A hybrid theory of computer media. *Afterimage* 21 (Nov.): 5–7.

Lunenfeld, Peter. 1996. Char Davies. *Art+Text*, no. 53: 82–83.

Lunenfeld, Peter. 1999. *Digital Dialectic: New Essays on New Media*. Cambridge, MA: MIT Press.

Maag, Georg. 1986. *Kunst und Industrie im Zeitalter der ersten Weltausstellungen: Synchronische Analyse einer Epochenschwelle*. Munich: Fink.

Macdonald, Lindsay. 1994. Interacting with graphic arts images. In *Interacting with Virtual Environments*, ed. L. MacDonald, pp. 149–165. New York: Wiley.

Macedonia, Michael R. 1994. NPSNET: A network software architecture for large-scale virtual environments. *Presence: Teleoperators and Virtual Environments* 3, no. 4: 265–287.

Macho, Thomas. 1997. Überlegungen zu einem bildwissenschaftlichen Forschungsfeld. In *Archimedia: Institute for Arts and Technology*, ed. Projekte 95/97, pp. 38–45. Linz: Projekte 95/97.

Mackinnon, Richard C. 1995. Searching for the Leviathan in the Usenet. In *Cybersociety: Computer Mediated Comunication and Community*, ed. Steven G. Jones, pp. 112–138. Thousand Oaks, CA: Sage.

Maes, Pattie. 1990. Situated agents can have goals. *Robotics and Autonomous Systems* 6, no. 1 (June): 49–70.

Magnenat-Thalmann, Nadia, and Daniel Thalmann. 1992. *Creating and Animating the Virtual World*. New York: Springer.

Mai, Ekkehard. 1981a. Die Berliner Kunstakademie im 19. Jahrhundert: Kunstpolitik und Kunstpraxis. In *Kunstverwaltung, Bau- und Denkmalpolitik im Kaiserreich*, ed. E. Mai et al., pp. 431–480. Berlin: Gebr. Mann.

Mai, Ekkehard, ed. 1981b. *Kunstverwaltung, Bau- und Denkmalpolitik im Kaiserreich*, 3 vols. Berlin: Gebr. Mann.

Malina, Roger. 1996. Moist realities: The arts and the new biologies. *Leonardo* 29, no. 5: 351–353.

Malkowsky, Georg. 1900. *Die Pariser Weltausstellung in Wort und Bild*. Berlin: Kirchhoff.

Mallé, Luigi. 1969. *Incontri con Gaudenzio: Raccolta di studi e note su problemi gaudenziani*. Torino: Tipografia Impronta.

Manovich, Lev. 1992. Virtual cave dwellers: Siggraph '92. *Afterimage* (Oct.): 3–4.

Manovich, Lev. 2001. *The Language of New Media*. Cambridge, MA: MIT Press.

Masterson, Piers. 1994. V-Topia: Visions of a virtual world. *Art Monthly*, no. 180: 33–34.

Matussek, Peter. 2000. Computer als Gedächtnistheater. In *Metamorphosen: Gedächtnismedien im Computerzeitalter*, ed. Götz-Lothar Darsow, pp. 81–100. Stuttgart-Bad Cannstadt: Fromann-Holzboog.

Max, Nelson. 1982. SIGGRAPH '84 Call for Omnimax Films. *Computer Graphics* 16, no. 4: 208–214.

McCullough, Malcolm. 1996. *Abstracting Craft: The Practiced Digital Hand*. Cambridge, MA: MIT Press.

McLuhan, Marshall. 1964. *Understanding Media: The Extensions of Man*. London: McGraw-Hill.

Mèndes France, Michel and Alain Hénaut. 1994. Art, therefore entropy. *Leonardo* 27, no. 3: 219–221.

Mérindol, Christian de. 1993. Clément VI, seigneur et pape, d'apres le témoignage de L'emblématique et de la thématique. La chambre du cerf. L'abbatiale de La chaise-Dieu. *Cahiers de Fanjeaux* 28: 331–361.

Merkelbach, R. 1962. *Roman und Mysterium in der Antike*. Munich: Beck.

Merkelbach, R. 1988. *Die Hirten des Dionysos. Die Dionysos-Mysterien der römischen Kaiserzeit und der bukolische Roman des Longos*. Stuttgart: Teubner.

Metzger, Hans-Joachim. 1997. Genesis in Silico: Zur digitalen Synthese. In *HyperKult: Geschichte, Theorie, und Kontext digitaler Medien*, ed. Georg Christoph Tholen et al., pp. 461–510. Basel: Stroemfeld.

Mignonneau, Laurent and Christa Sommerer. 2000a. Creating artificial life for interactive art and entertainment. In *Artificial Life VII: Proceedings of the Seventh International Conference on Artificial Life*, ed. Marc Bedau et al., pp. 149–153. Cambridge, MA: MIT Press.

Mignonneau, Laurent and Christa Sommerer. 2000b. Designing interfaces for interactive artworks. In *KES 2000: Knowledge-Based Intelligent Engineering Systems Conference Proceedings*, ed. R. J. Howlett and L. C. Jain. Brighton: Institute of Electrical and Electronics Engineers.

Mignonneau, Laurent and Christa Sommerer. 2000c. Modelling emergence of complexity: The application of complex system and origin of life theory to interactive art on the Internet. In *Artificial Life VII: Proceedings of the Seventh International Conference on Artificual Life*, ed. Marc Bedau, et al., pp. 547–554. Cambridge, MA: MIT Press.

Mikos, Lothar. 1992. Cyberspace als populärer Text. Medienwissenschaftliche Anmerkungen zu einem kulturellen Phänomen. *Wechselwirkung—Technik Naturwissenschaft Gesellschaft* 14, no. 57: 10–14.

Minato, Chihiro. 2000. The light and shadow of future. In *Information Design Series, vol. 5: Creative Potentials of Image Expression*, ed. Kyoto University of Art and Design. Kyoto: Kadokawa Shoten.

Minsky, Marvin. 1980. Telepresence. *Omni* (June): 44–50.

Minsky, Marvin. 1988. *The Society of Mind*. New York: Touchstone.

Minsky, Marvin. 1990a. Die künftige Verschmelzung von Wissenschaft, Kunst und Psychologie. In *Ars Electronica 1990* (exhib. catalog), ed. Gottfried Hattinger et al., pp. 97–106. Linz: Veritas-Verlag.

Minsky, Marvin. 1990b. Alles ist mechanisierbar, Interview. *Kunstforum International* 110: 100–103.

Minsky, Marvin. 1991. Marvin Minsky philosophiert über Mensch und Maschine. *Übermorgen* 3, no. 7: 12–13.

Mirapaul, Matthew. 1998a. An intense dose of virtual reality. *The New York Times Online*. July 9.

Mirapaul, Matthew. 1998b. World-wide views on the World Wide Web. *Wall Street Journal* (Step. 3), p. A20.

Mitchell, William J. 1992. *The Reconfigured Eye: Visual Truth in the Post-Photographic Era*. Cambridge, MA: MIT Press.

Mitchell, William J. 1995. *City of Bits*. Cambridge, MA: MIT Press.

Mitchell, William J. 1999. *e-topia: "Urban Life, Jim—But Not As We Know It."* Cambridge, MA: MIT Press.

Mitchell, William T. 1995. *Picture Theory: Essays on Verbal and Visual Representation*. Chicago: Univ. Chicago Press.

Möbius, Hanno, ed. 1990. *Die Mechanik in den Künsten*. Marburg: Jonas-Verlag.

Monaco, James. 1980. *Film verstehen. Kunst, Technik, Sprache: Geschichte und Theorie des Films*. Reinbek: Rowohlt.

Moravec, Hans. 1988. *Mind Children: The Future of Robot and Human Intelligence*. Cambridge, MA: Harvard Univ. Press.

Moravec, Hans. 1996. Körper, Roboter, Geist. *Kunstforum International* 133: 98–112.

Moravec, Hans. 1998. *Robot: Mere Machine to Transcendent Mind*. Oxford: Oxford Univ. Press.

Moravec, Hans. 1999. *Computer übernehmen die Macht: Vom Siegeszug der künstlichen Intelligenz*. Hamburg: Hoffmann and Campe.

Morse, Margaret. 1998. *Virtualities: Television, Media Art, and Cyberculture*. Bloomington/Indianapolis: Indiana Univ. Press.

Moser, Mary Anne, et al., eds. 1996. *Immersed in Technology: Art and Virtual Environments*. Cambridge, MA: MIT Press.

Müller, Gernot. 1990. Heinrich von Kleist und die Erfindung der Panoramamalerei. In *Begegnungen mit dem Fremden: Grenzen–Traditionen–Vergleiche. Akten des VIII. Internationalen Germanistenkongresses, Tokyo 1990*, vol. 7, ed. Eijiro Iwasahi. Munich: Unicum.

Mumford, Lewis. 1977. *Mythos Maschine: Kultur, Technik und Macht*. Frankfurt/Main: Fischer.

Naimark, Michael. 1995. Präsenz bei Interface. Oder Woher weißt Du, dass dies Film ist (und wann ist das wichtig)? In *Weltbilder—Bildwelten*, ed. Klaus Peter Dencker. Hamburg: Hans-Bredow-Institut.

Naimark, Michael. 1997. What's wrong with this picture? Presence and abstraction in the age of cyberspace. In *CAiiA: Consciousness Reframed: Art and Consciousness in the Post-biological Era* (July 5–6, 1997), proceedings, ed. Roy Ascott. Newport: Univ. of Wales College.

Nationalzeitung, Sept. 1, 1883, vol. 36, no. 410, Das neue Sedan-Panorama, p. 2.

Nationalzeitung, Sept. 2, 1883, suppl. 1 to no. 411, Das neue Sedan-Panorama, p. 2.

Negroponte, Nicholas. 1972. *The Architecture Machine*. Cambridge, MA: MIT Press.

Negroponte, Nicholas. 1995. *Being Digital*. London: Hodder and Stoughton.

Negroponte, Nicholas and Richard A. Bolt. 1976. *Augmentation of human resources in command and control through multiple media man—machine integration, proposal to U.S. Defense Advanced Research Projects Agency (DARPA)*. Cambridge, MA: MIT Architecture Group.

Nelson, Max. 1982. Call for Omnimax Films, SIGGRAPH '84. *Computer Graphics* 16, no. 4: 208–214.

Neumeyer, Alfred. 1964. *Der Blick aus dem Bilde*. Berlin: Gebr. Mann.

Nipperdey, Thomas. 1992. *Deutsche Geschichte 1866–1918, vol. 2: Machtstaat vor der Demokratie*. Munich: Beck.

Noll, Michael. 1965a. Computer-generated three-dimensional movies. *Computers and Automation* 14, no. 11: 20–23.

Noll, Michael. 1965b. Stereographic projections by digital computer. *Computers and Automation* 14, no. 5: 32–34.

Norddeutsche Allgemeine Zeitung. Sept. 1, 1883, vol. 22, Das Panorama der Schlacht von Sedan, pp. 1, 2.

Noser, Hansrudi and Daniel Thalmann. 1994. Simulating life of virtual plants, fishes, and butterflies. In *Artificial Life and Virtual Reality*, ed. Nadia Magnenat-Thalmann, pp. 45–59. New York: Wiley.

Nouvel, Jean. 2000. Mobilität. *ARCH+: Zeitung fur Architektur und Städtebau*, no. 149/150 (April): 88–91.

Nova, Alessandro. 1995. "Popular" art in renaissance Italy: Early response to the holy mountain at Varallo. In *Reframing the Renaissance: Visual Culture in Europe and Latin America 1450–1650*, ed. Claire Farago, pp. 113–126. New Haven, CT: Yale Univ. Press.

Oerter, Rolf. 1993. *Psychologie des Spiels: Ein handlungstheoretischer Ansatz*. Munich: Quintessenz.

Oettermann, Stephan. 1993. Die Reise mit den Augen—"Oramas" in Deutschland. In *Sehsucht: Das Panorama als Massenunterhaltung des 19. Jahrhunderts* (exhib. catalog), ed. Kunst und Ausstellungshalle der Bundesrepublik Deutschland in Bonn, pp. 42–51. Frankfurt/Main: Stroemfeld/Roter Stern.

Oettermann, Stephan. 1997. *The Panorama: History of a Mass Medium*. Trans. Deborah Lucas Schneider. New York: Zone Books. (Orig. published 1980.)

Ohta, Yuichi, ed. 1999. *Mixed Reality: Merging Real and Virtual Worlds*. Tokyo: Ohmsha.

Oppé, Paul. 1947. The memoir of Paul Sandby by his son. *Burlington Magazine* 48: 143–147.

O'Sullivan, Dan. 1994. Choosing tools for virtual environments. *Leonardo* 27, no. 4: 297–304.

Paleotti, Gabriele. 1582. *Discorso intorno alle imagini sacre e profane*. Bologna: A. Benacci.

Panofsky, Erwin. 1927. *Die Perspektive als Symbolische Form*, Veröffentlichungen der Bibliothek Warburg. Berlin: Teubner.

Panofsky, Erwin. 1930. Original und Faksimilereproduktion. *Der Kreis: Zeitschrift für künstlerische Kultur* 7: 3–16.

Panofsky, Erwin. 1936. On movies. *Bulletin of the Department of Art and Archaeology of Princeton University* (June): 5–15.

Panofsky, Erwin. 1980. *Aufsätze zu Grundfragen der Kunstwissenschaft*. Ed. Hariolf Oberer et al. Berlin: Spiess.

Pappalardo, Umberto. 1982. Beobachtungen am Fries der Mysterien-Villa in Pompeji. *Antike Welt* 13, no. 3: 10–20.

Paret, Peter. 1980. *The Berlin Secession*. Cambridge, MA: Belknap Press.

Paret, Peter. 1988. *Art as History: Episodes in the Culture and Politics of Nineteenth-century Germany*. Princeton: Princeton Univ. Press.

Parrinder, Geoffrey. 1970. *Avatar and Incarnation: The Wilde Lectures in Narrative and Comparative Religion in the University of Oxford*. London: Faber and Faber.

Pecht, Friedrich. 1888. *Geschichte der Münchner Kunst im neunzehnten Jahrhundert*. Munich: Verl.-Anstalt für Kunst und Wiss.

Penny, Simon, ed. 1995. *Critical Issues in Electronic Media*. Albany, NY: Univ. of New York Press.

Penny, Simon, Smith, Jeffrey, and Bernhard, Andre. 1999. Traces: Wireless Full Body Tracking in the CAVE. Paper accepted by ICAT virtual reality conference, Japan, December 1999. Available at ⟨www-art.cfa.cmu.edu/www-penny/texts/traces⟩.

Penrose, Roger. 1989. *The Emperor's New Mind: Concerning Computers, Minds, and the Law of Physics*. Oxford: Oxford Univ. Press.

Peres, Constanze. 1990. Nachahmung der Natur: Herkunft und Implikation eines Topos. In *Die Trauben des Zeuxis: Formen künstlerischer Wirklichkeitsaneignung*, ed. Hans Körner, pp. 1–39. Hildesheim: Georg Olms.

Perincioli, Cristina and Cillie Rentmeister. 1990. *Computer und Kreativität*. Cologne: Du Mont.

Perlman, G., G. K. Green, and M. S. Wogalts, eds. 1995. *Human Factors Perspectives on Human–Computer Interaction: Selections from Proceedings of Human Factors and Ergonomic Society Annual Meetings 1983–94*. Santa Monica, CA: The Human Factors Society.

Pernoud, Emmanuel. 1984. Baudelaire, Guys et le kaléidoscope. *Gazette des Beaux-Arts* 104 : 73–76.

Pesce, Marc. 2000. *The Playful World: How Technology Is Transforming Our Imagination*. New York: Ballantine Books.

Petrarca, Francesco. 1931. An Francesco Dionigi von Borgo San Sepolcro in Paris. In *Briefe des Francesco Petrarca*, trans. Hans Nachod and Paul Stern, pp. 40–49. Berlin: Verlag die Runde (1336).

Petrarch, Francesco. 1925. *Venice 1503: Librorum Francisci Petrarche impressorum Annotatio*. Trans. Paul Piur. Halle: Max Niemeyer.

Pfeiffer, K. Ludwig. 1999. *Das Mediale und das Imaginäre*. Frankfurt/Main: Suhrkamp.

Pflugk-Harttung, J. von, ed. 1895. *Krieg und Sieg 1870–71*. Berlin: Schall and Brund.

Pieske, Christa. 1993. Vermittlung von Geschichte. In *Anton von Werner: Geschichte in Bildern*, ed. Dominik Bartmann. Berlin: Hirmer.

Pietsch, Ludwig. ca. 1883. *Das Panorama der Schlacht von Sedan*. Berlin: n.p.

Piur, Paul. 1925. *Petrarcas "Buch ohne Namen" und die päpstliche Kurie: Ein Beitrag zur Geistesgeschichte der Frührenaissance*. Halle: Niemeyer.

Plant, Margaret. 1983. *Fresco Painting in Avignon and Northern Italy: A Study of Some Fourteenth-Century Cycles of Saints' Lives outside Tuscany*. Ph.D. diss. (1981). Ann Arbor, MI: Univ. Microfilms Internat.

Plato. 1993. *Phaedo*. Ed. C. J. Rowe. Cambridge: Cambridge Univ. Press.

Plewe, Daniela Alina. 1998. Ultima Ratio. Software und Interaktive Installation. In *Ars Electronica 98: Infowar: Information, Macht, Krieg*, ed. Gerfried Stocker and Christine Schöpf, pp. 136–143. Vienna/New York: Springer Verlag.

Pochat, Götz. 1973. *Figur und Landschaft: Eine historische Interpretation der Landschaftsmalerei von der Antike bis zur Renaissance*. Berlin: De Gruyter.

Pochat, Götz. 1990. *Theater und Bildende Kunst im Mittelalter und in der Renaissance in Italien*. Graz: Akad. Druck-u. Verl.-Anst.

Pohlenz, Max. 1992. *Die Stoa: Geschichte einer geistigen Bewegung*. Göttingen: Vandenhoeck and Ruprecht.

Pope, Stephen Travis and Lennart E. Fahlén. 1993. The use of 3-D audio in a synthetic environment: An aural renderer for a distributed virtual reality system. In *1993 IEEE Virtual Reality Annual International Symposium*, pp. 176–182. New York: IEEE.

Popper, Frank. 1975. *Art, Action, and Participation*. London: Studio Vista.

Popper, Frank. 1991. High technology art. In *Digitaler Schein*, ed. Florian Rötzer, pp. 249–266. Frankfurt/Main: Suhrkamp.

Popper, Frank. 1993. *Art of the Electronic Age*. New York: Abrams.

Porter, Steven. 1996. Journey into VR. *Computer Graphics World* 16, no. 10: 59–60.

Portmann, Adolf. 1976. Das Spiel als gestaltete Zeit. In *Der Mensch und das Spiel in der verplanten Welt*, ed. A. Flitner et al. Munich: Deutscher Taschenbuch Verlag.

Pozzo, Andrea. 1700–1702. *Prospettiva de Pittorie architetti*, vol. 1. Rome: Komarek.

Pozzo, Andrea. 1828 (1694). *Significati delle Pitture fatte nella Volta della Chiesa di S. Ignazio.* First published 1694 and reprinted in 1828.

Pragnell, Hubert J. 1968. *The London Panoramas of Robert Barker and Thomas Girtin circa 1800.* London Topographical Soicety, no. 109.

Prampolini, Enrico. 1924. L'atmosfera scenica futurista. *NOI: Rivista d'arte futurista* 1 (spec. issue): 6–7.

Preece, Jenny, Yvonne Rogers, et al. 1994. *Human–Computer Interaction.* Reading MA: Addison-Wesley.

Promis, D. and G. Muller, eds. 1863. *Lettere ed Orazioni latine di Gerolamo Morone, Miscelanea di Storia Italiana*, II. Torino: Bocca.

Prueitt, Melvin L. 1984. *Art and the Computer.* New York: McGraw-Hill.

Prusinkiewicz, Przemyslaw and Aristid Lindenmayer. 1990. *The Algorithmic Beauty of Plants.* New York: Springer.

Quinlan-McGrath, Mary. 1984. The astrological vault of the Villa Farnesina: Agostino Chigi's rising sign. *Journal of the Warburg and Courtauld Institutes* 47: 91–105.

Quint, Josef, ed. 1977. *Meister Eckhart: Deutsche Predigten und Traktate.* Munich: Hanser.

Ravelli, P. and A. 1608. *F. Zuccaro: Il passagio per L'Italia con la dimora in Parma.* Bologna.

Ray, Thomas S. 1992a. An approach to the synthesis of life. In Langton et al., eds. (1992), pp. 371–408. Redwood City, CA: Addison-Wesley.

Ray, Thomas. 1992b. Evolution and optimization of digital organisms. In *Scientific Excellence in Supercomputing: The IBM 1990 Contest Prize Papers*, ed. Keith R. Billingsley, Hilton U. Brown III, and Ed. Derohanesl. Athens, GA: Baldwin Press.

Ray, Thomas. 1992c. How I created life in a virtual universe. Unpublished paper, School of Life and Health Sciences, Univ. of Delaware (March 29).

Ray, Thomas. 1997. An evolutionary approach to synthetic biology: Zen and the art of creating life. In Langton (1995), pp. 179–209.

Ray, Thomas and Kurt Thearling. 1994. Evolving multicellular artificial Life. In *Artificial Life IV*, ed. Rodney Brooks and Pattie Maes, pp. 283–288. Cambridge, MA: MIT Press.

Reck, Hans Ulrich. 1996. Zur Programmatik einer historischen Anthropologie der Medien. In *Inszenierte Imagination: Beiträge zu einer historischen Anthropologie der Medien*, ed. Wolfgang Müller- Funk, pp. 231ff. Vienna: Springer.

Reck, Hans-Ulrich and Harald Szeemann, eds. 1999. *Junggesellenmaschinen* (expanded exhib. catalog). New York: Springer.

Reck, H.-U., S. Zielinski, W. Ernst, and N. Röller, eds. 1996. LAB 1996: Yearbook of the Academy of Media Arts (KHM). Cologne: KHM and Verlag Walter König.

Recki, Birgit. 1991. Mimesis: Nachahmung der Natur: Kleine Apologie eines missverstandenen Leitbegriffs. *Kunstforum* 114: 116–126.

Regan, E. C. 1994. Some side-effects of immersion in virtual reality. In *Virtual Interfaces: Research and Applications*, Agard Conference Proceedings 541. Neuilly-sur-Seine: Agard.

Reichardt, Jasia, ed. 1969. *Cybernetic Serendipity: The Computer and the Arts*. New York: Frederick A. Praeger.

Reichle, Ingeborg. 2000. Kunst und Biomasse: Zur Verschränkung von Biotechnologie und Medienkunst in den 90er Jahren. *kritische berichte* 28, no. 1: 23–33.

Reichle, Ingeborg. 2001a. TechnoSphere: Körper und Kommunikation im Cyberspace. In *Bildhandeln*, vol. 3, ed. Klaus Sachs-Hombach. Magdeburg: Scriptum.

Reichle, Ingeborg. 2001b. Kunst und Genetik: Zur Rezeption der Gentechnik in der zeitgenössischen Kunst. *Die Philosophin. Forum für feministische Theorie und Philosophie* 12, no. 23: p. 28–42.

Rempeters, Georg. 1994. *Die Technikdroge des 21. Jahrhunderts: Virtuelle Welten im Computer*. Frankfurt/Main: Fischer.

Reudenbach, Bruno. 1989. Natur und Geschichte bei Ledoux und Boullée. *Idea Jahrbuch der Hamburger Kunsthalle* 8: 31–56.

Reudenbach, Bruno, et al., eds. 1992. *Erwin Panofsky, Beiträge des Symposions Hamburg 1992*. Berlin: Akademie Verlag.

Rheinberger, Hans-Jörg. 1999. Alles, was überhaupt zu einer Inskription führen kann. In *Wissensbilder: Strategien der Überlieferung*, ed. Ulrich Raulff and Gary Smith, pp. 265–277. Berlin: Akademie Verlag.

Rheingold, Howard. 1991. *Virtual Reality*. New York: Simon and Schuster.

Richter, Fleur. 1995. *Die Ästhetik geometrischer Körper in der Renaissance*. Stuttgart: Hatje.

Riess, C. 1916. *Sehende Maschinen*. Munich: Hubers Verlag.

Rinaldo, Kenneth E. 1998. Technology recapitulates phylogeny: Artificial life art. *Leonardo* 31, no. 5: 371–376.

Rivoire, Annick. 1998. Pilleurs de la peau du monde. *Libération* (July 24).

Robertson, Barbara. 1994. Char Davies. *Computer Artist* (Feb./March): 19.

Robichon, François. 1979. Les Panoramas de Champigny et Rezonville par Edouard detaille et Alphonse De Neuville. *Bulletin de la Société de Histoire de l'Art Français*: 259–279.

Robichon, François. 1985. Emotion et sentiment dans les panoramas militaires après 1870. *Zeitschrift für Schweizerische Archäologie und Kunstgeschichte* 42: 281–287.

Robichon, François. 1993. Die Illusion eines Jahrhunderts—Panoramen in Frankreich. In *Sehsucht: Das Panorama als Massenunterhaltung des 19. Jahrhunderts* (exhib. catalog), ed. Kunst- und Ausstellungshalle der Bundesrepublik Deutschland in Bonn, pp. 52–63. Frankfurt/Main: Stroemfeld/Roter Stern.

Robinson, D. 1993. *The Lantern Image: Iconography of the Magic Lantern 1420–1880*. Nutnay, East Sussex: Magic Lantern Society.

Roethlisberger, Marcel. 1967. The Colonna Frescoes of Pietro Tempesta. *Burlington Magazine* 109: 12–16.

Roethlisberger, Marcel. 1985a. A panoramic view by Claude Lorrain. *Museum Studies* 11, no. 2: 103–116.

Roethlisberger, Marcel. 1985b. Räume mit durchgehenden Landschaftsdarstellungen. *Zeitschrift für Schweizerische Archäologie und Kunstgeschichte* 42: 243–250.

Roethlisberger-Bianco, Marcel. 1970. *Cavalier Pietro Tempesta and His Time*. Cranbury: Univ. of Delaware Press.

Rolland, Jannick P. and William Gibson. 1995. Towards quantifying depth and size perception in virtual environments. *Presence: Teleoperators and Virtual Environments* 4, no. 1: 24–49.

Rosenberg, Adolf. 1883. Das Sedanpanorama in Berlin. *Kunstchronik* 18, no. 43: 730.

Rosenberg, Adolf. 1895. *Anton v. Werner*. Bielefeld: Velhagen and Klasing.

Rosenman, Julian, et al. 1991. Virtual simulation: Initial clinical results. *International Journal of Radiation, Oncology, Biology, Physics* 22: 843–851.

Rössler, Otto E. *Endophysik*. Berlin: Merve, 1992.

Roth, Martin. 2000. Szenographie: Zur Entstehung von neuen Bildwelten. *ARCH+: Zeitung für Architektur und Städtebau*, no. 149/150 (April): 84ff.

Roth, Martin, et al., eds. 2000. *Der Themenpark der EXPO 2000: die Entdeckung einer neuen Welt*. New York: Springer.

Rötzer, Florian. 1988. Technoimaginäres—Ende des Imaginären? *Kunstforum* 97: 64–74.

Rötzer, Florian. 1989. Technoimaginäres—Ende des Imaginären? *Kunstforum* 98: 54–59.

Rötzer, Florian. 1991a. Mediales und Digitales. In *Digitaler Schein*, ed. Florian Rötzer, pp. 9–80. Frankfurt/Main: Suhrkamp.

Rötzer, Florian. 1991b. Für eine Synthese von Kunst und Medientechnologie. *Kunstforum* 114: 393.

Rötzer, Florian. 1992. Von Beobachtern und Bildern erster, zweiter und *n*-ter Ordnung. In *Endo and Nano, Ars Electronica*, ed. Peter Gerbel, pp. 22–37. Linz: Pvs Verlag.

Rötzer, Florian. 1993a. Ästhetische Herausforderungen von Cyberspace. In *Raum und Verfahren*, ed. Jörg Huber, pp. 29–42. Frankfurt/Main: Stroemfeld/Roter Stern.

Rötzer, Florian, et al., eds. 1993b. *Künstliche Spiele*. Munich: Boer.

Rötzer, Florian. 1997. Aspekte der Spielkultur in der Informationsgesellschaft. In *Medien-Welten Wirklichkeiten*, ed. Gianni Vattimo and Wolfgang Welsch, pp. 149–172. Munich: Fink.

Rötzer, Florian and Peter Weibel, eds. 1991. *Strategien des Scheins: Kunst Computer Medien*. Munich: Boer.

Rötzer, Florian and Peter Weibel, eds. 1993 *Cyberspace—Zum Medialen Gesamtkunstwerk*. Munich: Boer.

Rowland, I. D. 1984. Some panegyrics to Agostino Chigi. *Journal of the Warburg and Courtauld Institutes* 47: 194–199.

Rupp, Friedrich. 1940. *Das Panorama in der spätbarocken Kunst Süddeutschlands*. Ph.D. diss., Univ. of Erlangen.

Ruskin, John. 1908. *The Works of John Ruskin*. Ed. E. T. Cook and Alexander Wedderburn. London: George Allen.

Rutledge, Virginia. 1996. Reality by other means. *Art in America* (June): 39.

Sachs-Hombach, Klaus and Klaus Rehkämper, eds. 1999. *Bildgrammatik: Interdisziplinäre Forschungen zur Syntax bildlicher Darstellungsformen*. Magdeburg: Scriptum-Verlag.

Sagner-Düchting, Karin. 1985. *Claude Monet: Nymphéas: Eine Annäherung (Studien zur Kunstgeschichte)*. Hildesheim: Olms.

Sakane, Itsuo. 1993. Durch Interaktive Kunst zur Selbsterkenntnis. In *Künstliche Spiele*, ed. Florian Rötzer et al., pp. 91–94. Munich: Boer.

Sakane, Itsuo. 1989. Introduction to Interactive Art. In *Wonderland of Science Art—Invitation to Interactive Art*, pp. 3–8; 38–42. Kawasaki: Kanagawa Science Park.

Sandby, Thomas Paul. 1813. Memoir of the late Paul Sandby, Esqre., R.A., . . . *Monthly Magazine*, no. 213: 437.

Santarcangeli, Paolo. 1967. *Il Libro dei labirinti: Storia di un mito e di un simbolo.* Florence: Vallecchi.

Sattler, Hubert. 1920. Aus dem Leben des Malers Hubert Sattler (Satler). In *Studien und Skizzen zur Gemäldekunde,* ed. Theodor Frimmel, pp. 87–91. Vienna: Gerold.

Saxl, Fritz, ed. 1923. *Vorträge der Bibliothek Warburg.* Leipzig.

Schefold, Karl. 1952. *Pompejanische Malerei: Sinn und Ideengeschichte.* Basel: Schwabe.

Schelhowe, Heidi. 1997. *Das Medium aus der Maschine: Zur Metamorphose des Computers.* Frankfurt/Main: Campus.

Schiessl, Ulrich. 1979. *Rokokofassung und Materialillusion: Untersuchungen zur Polychromie sakraler Bildwerke im Süddeutschen Rokoko.* Mittenwald: Mäander-Kunstverlag.

Schiller, Friedrich. 1965. *Über die ästhetische Erziehung des Menschen.* Stuttgart: Reclam.

Schloerb, David W. 1995. A quantitative measure of telepresence. *Presence: Teleoperators and Virtual Environments* 4, no. 1: 64–80.

Schmidt, D. 1970. *Die Pyramide im frühen 19. Jahrhundert.* Ph.D. dissertation, Georg-August Universitat, Göttingen.

Schönberger, Otto. 1995. Die "Bilder" des Philostratos. In *Beschreibungskunst—Kunstbeschreibung: Ekphrasis von der Antike bis zur Gegenwart,* ed. Gottfried Boehm, pp. 157–176. Munich: Fink.

Schöne, Wolfgang. 1961. Zur Bedeutung der Schrägsicht für die Deckenmalerei des Barock. In *Festschrift für Kurt Badt zum 70. Geburtstag. Beiträge aus Kunst und Geistesgeschichte,* ed. Martin Gosebruch, pp. 144–172. Berlin: De Gruyter.

Schöneburg, Eberhard. 1994. *Genetische Algorithmen und Evolutionsstrategien.* Bonn: Addison-Wesley.

Schulze, Franz. 1986. *Mies van der Rohe: Leben und Werk.* Berlin: Ernst.

Schulze, Holger. 2000. *Das aleatorische Spiel.* Munich: Fink.

Schwarz, Hans-Peter. 1997. *Medien-Kunst-Geschichte.* Munich: Prestel.

Schwitters, Kurt. 1973–1981. *Das literarische Werk (Collected Works),* 5 vols. Ed. Friedhelm Lach. Cologne: Du Mont.

Searle, John R. 1996. Das Rätsel des Bewusstseins: Biologie des Geistes—Mathematik der Seele. *Lettre International,* no. 32: 34–43.

Sedlmayr, Hans. 1939–1940. Die Kugel als Gebäude, or: das Bodenlose. Das Werk des Künstlers 1: 278–310.

Seel, Martin. 1996. Vor dem Schein kommt das Erscheinen: Bemerkungen zu einer Ästhetik der Medien. In *Ethisch-ästhetische Studien,* ed. M. Seel, pp. 104–125. Frankfurt/Main: Suhrkamp.

Segeburg, Harro, ed. 1996. *Die Mobilisierung des Sehens, Mediengeschichte des Films*. Munich: Fink.

Seidel, P., ed. 1907. *Der Kaiser und die Kunst*. Berlin: Reichsdruck.

Selle, Ralf-Michael. 1989. Computergrafik als Ergebnis rechnergestützter bildkünstlerischer Tätigkeit. *Bildende Kunst* 37, no. 2: 25–28.

Serlio, Sebastiano. 1978 (1584). *I Sette Libri dell'Architettura*. Venice: Forni.

Serres, M. 1981. *Capaccio: Ästhetische Zugänge*. Reinbek: Rowohlt.

Serres, Michel, ed. 1994. *Elemente einer Geschichte der Wissenschaften*. Frankfurt: Suhrkamp.

Shanken, Edward A. 1997. Technology and intuition: A love story? Roy Ascott's telematic embrace. *Leonardo Online*, ⟨http://mitpress.mit.edu/e-JOURNALS/Leonardo/isast/articles/shanken.html⟩.

Shanken, Edward. 1998. Life as we know it and/or life as it could be: Epistemology and the ontology/ontogeny of artificial life. *Leonardo* 31, no. 5: 383–388.

Shaw, Philip. 1993. "Mimic Sights": A note on panorama and other indoor displays in Book 7 of *The Prelude*. *Notes and Queries* 238, no. 4: 462–464.

Shikata, Yukiko. 2000. Art-criticism-curating—as connective process. In *Information Design Series, vol. 6: Information Space and Changing Expression*, ed. Kyoto University of Art and Design. Kyoto: Kadokawa Shoten.

Shimoga, Karun B. 1993. A survey of perceptual feedback issues in dexterous telemanipulation: Part I. Finger force feedback. In *1993 IEEE Virtual Reality Annual International Symposium*, pp. 263–270. Piscataway, NJ: IEEE.

Simon, Erika. 1961. Zum Fries der Mysterienvilla bei Pompeji. *Jahrbuch des Deutschen archäologischen Instituts* 76: 111–172.

Sims, Dave. 1996. Osmose: Is VR supposed to be this relaxing? *IEEE Computer Graphics and Applications* 16, no. 6: 4–5.

Sims, Karl. 1991. Artificial evolution for computer graphics. *Computer Graphics* 25, no. 4: 319–328.

Sjöström, J. 1978. *Quadratura: Studies in Italian Ceiling Painting*. Stockholm: Libertryck.

Slater, Mel and Martin Usoh. 1993. Presence in Immersive Virtual Environments. In *1993 IEEE Virtual Reality Annual International Symposium*, pp. 90–96. Piscataway, NJ: IEEE.

Slater, Mel and Martin Usoh. 1994a. Body centered interaction in immersive virtual environments. In *Artificial Life and Virtual Reality*, ed. Nadia Magnenat-Thalmann et al., pp. 125–147. New York: Wiley.

Slater, Mel and Martin Usoh. 1994b. Depth of presence in virtual environments. *Presence: Teleoperators and Virtual Environments* 3, no. 2: 130–144.

Slater, Mel and Sylvia Wilbur. 1997. A framework for immersive virtual environments (five): Speculations on the role of presence in virtual environments. *Presence: Teleoperators and Virtual Environments* 6, no. 6: 603–616.

Sloterdijk, Peter. 1999. "Der Streit um den Menschen." *ZEITdokument*, no. 2, Hamburg.

Sloterdijk, Peter. 2000. *Sphären*. Frankfurt: Suhrkamp.

Smith, Gillian Crampton. 1994. The art of interaction. In *Interacting with Virtual Environments*, ed. Lindsay MacDonald et al., pp. 79–94. New York: Wiley.

Snow, C. P. 1960. *The Two Cultures and the Scientific Revolution*. Cambridge: Cambridge Univ. Press.

Snow, C. P. 1967. *Die zwei Kulturen*. Stuttgart: Klett.

Solar, Gustav. 1979. *Das Panorama und seine Vorentwicklung bis zu Conrad Escher von der Linth*. Zürich: Füssli.

Sommerer, Christine and Laurent Mignonneau. 1993. Interactive plant growing. In *Visual Proceedings of the SIGGRAPH'93 Conference*, ed. Thomas E. Linneham and Ann Redelfs, pp. 164–165. New York: ACM.

Sommerer, Christa and Laurent Mignonneau. 1994. *A-Volve*: A real-time interactive environment. In *ACM Siggraph Visual Proceedings*, ed. Andrew S. Glassher and Mike Keeles, pp. 172–173. New York: ACM Siggraph.

Sommerer, Christa and Laurent Mignonneau. 1996. Art as living system. *Systems, Control and Information, ISCIE* 40, no. 8: 16–23.

Sommerer, Christa and Laurent Mignonneau. 1997. Interacting with artificial Life: *A-Volve. Complexity* 2, no. 6: 13–21.

Sommerer, Christa and Laurent Mignonneau, eds. 1998a. *Art@Science*. New York: Springer.

Sommerer, Christa and Laurent Mignonneau. 1998b. The application of artificial life to interactive computer installations. *Artificial Life and Robotics, ISAROB* 2, no. 4: 151–156.

Sonderegger, Ruth. 2000. *Für eine Ästhetik des Spiels*. Frankfurt: Suhrkamp.

Spalter, Anne Morgan. 1999. *The Computer in the Visual Arts*. Reading, MA: Addison-Wesley.

Spielmann, Yvonne and Gundolf Winter, eds. 1999. *Bild—Medium—Kunst*. Munich: Fink.

Stafford, Barbara Maria. 1991. *Body Criticism: Imaging the Unseen in Enlightenment Art and Medicine*. Cambridge, MA: MIT Press.

Stafford, Barbara Maria. 1998. *Kunstvolle Wissenschaft: Aufklärung, Unterhaltung und Niedergang der visuellen Bildung*. Amsterdam: Verlag der Kunst.

Stanney, K. 1998. Human factors: Issues in virtual environments. *Presence: Teleoperators and Virtual Environments* 7, no. 4: 327–351.

Stedelijk Museum, Amsterdam, and City Gallery Wellington, eds. 1996. *The World Over, Under Capricorn: Art in the Age of Globalisation*. Amsterdam: Stedelijk Museum.

Steels, Luc, et al., eds. 1995. *The Artificial Life Route to Artificial Intelligence: Building Embodied, Situated Agents*. Hillsdale, NJ: Erlbaum.

Stenger, Erich. 1911. Panoramenaufnahmen und Panoramenapparate. *Prometheus* 22, no. 1137 (Aug. 12): 710–715.

Stephenson, Uwe M. 1994. Raumakustische Simulation und Auralisation— Methoden und Anwendungen. In *Virtual Reality '94: Anwendungen und Trends*, ed. Hans-Jörg Bullinger, pp. 181–212. Berlin: Springer.

Sterling, Bruce. 1990. Die Zukunft des Cyberspace—Wildes Grenzland gegen hyperrealen Grundbesitz. In *Ars Electronica*, vol. 2, ed. Gottfried Hattinger et al., pp. 228–231. Linz: Veritas-Verlag.

Sternberger, Dolf. 1974. *Panorama oder Ansichten vom 19. Jahrhundert*. Frankfurt/Main: Suhrkamp.

Steuer, Jonathan. 1992. Defining virtual reality: Dimensions determining telepresence. *Journal of Communication* 42, no. 4: 73–93.

Stewart, Ian. 1998. *Life's Other Secret: The New Mathematics of the Living World*. New York: Wiley.

Stoichita, Victor. 1998. *Das selbstbewußte Bild: Vom Ursprung der Metamalerei*. Munich: Fink.

Stolze, F. 1909. *Die Panoramenapparate in ihren Vorzügen und Mängeln sowie ihre Verwendung in der Praxis*. Halle: Knapp.

Stone, Allucquère Roseanne. 1992a. Will the real body please stand up? Boundary stories about virtual cultures. In *Cyberspace: First Steps*, ed. Michael Benedikt, pp. 81–118. Cambridge, MA: MIT Press.

Stone, Allucquère Roseanne. 1992b. Virtual Systems. In *Incorporations*, vol. 6, ed. Jonathan Crary and Sanford Kwinter, pp. 608–621. New York: Urzone.

Stone, Allucquère Rosanne. 1995a. *The War of Desire and Technology at the Close of the Mechanical Age*. Cambridge, MA: MIT Press.

Stone, Allucquère Rosanne. 1995b. Innocence and awakening: Cyberdämmerung at the Ashibe Research Laboratory. In *Technoscientific Imaginaries: Conversations, Profiles, and Memoires*, ed. George E. Marcus, pp. 177–195. Chicago: Univ. of Chicago Press.

Strauss, Wolfgang. 1995. Tanz im Haus der Illusion. *Tight Rope*, no. 3 (Oct.): 62–64.

Strauss, Wolfgang and Monika Fleischmann. 1993. Virtuelle Architektur und Imagination. In *film+arc: Internationales Festival Film+Architektur, Graz 2–5 Dec. 1993, ed. Artimage*, pp. 172–180. Graz: Artimage.

Strauss, Wolfgang, Monika Fleischmann, Mette Thomsen, et al., eds. 1999. Staging the space of mixed reality: Reconsidering the concept of a multi user environment. In *VRML 99: Fourth Symposium on the Virtual Reality Modeling Language*, ed. Stephen N. Spencer, pp. 93–98. New York: ACM.

Streicher, Gebhard. 1990. Panoramen. Fragen an die Geschichte einer Kunstform. In *Das Panorama in Altötting: Beiträge zu Geschichte und Restaurierung*, ed. Michael Petzet, pp. 17–22. Munich: Lipp.

Strocka, Volker Michael. 1990. Der Zweite Pompejanische Stil. In *Pompejanische Wandmalerei*, ed. Giuseppina Cerulli Irelli et al., pp. 213–222. Stuttgart: Belser.

Sutherland, Ivan E. 1965. The ultimate display. In *Proceedings of International Federation of Information Processing (IFIP)*, vol. 2, ed. Wayne A. Kalenich, pp. 506–508. Washington, D. C.: Spartan; London: Macmillan.

Sutherland, Ivan E. 1968. A head-mounted three dimensional display. In *Proceedings of the Fall Joint Computer Conference (AFIPS)*, vol. 33, ed. AFIPS Conference Proceedings, pp. 757–764. Washington, D.C.: Thompson Book Company.

Sutherland, Ivan E. 1970. Computer displays. *Scientific American* 222, no. 6: 57–81.

Sutter, Alex. 1988. *Göttliche Maschinen: Die Automaten für Lebendiges bei Descartes, Leibniz, La Mettrie, und Kant*. Frankfurt: Athenäum.

Sweetmann, John. 1981. *The Panoramic Image*. Southampton: John Hansard Gallery.

Tägliche Rundschau: Zeitung für Nichtpolitiker (Berlin). Sept 2, 1883, vol. 3, no. 204, pp. 2ff.

Tarkovsky, Andrey. 1986. *Sculpting in Time: Reflexions on Cinema*. Austin: Univ. of Texas Press.

Telbin, W. 1900. The painting of panoramas. *The Magazine of Art*, no. 24: 555–558.

Tenhaaf, Nell. 1998. As art is lifelike: Evolution and the readymade. *Leonardo* 31, no. 5: 397–404.

Terzopoulous, Demetri et al. 1993. Go fish! Computer animation. In *ACM SIGGRAPH Video Review, no. 91, SIGGRAPH 93, Electronic Theater*. New York: ACM Press.

Terzopoulos, Demetri, Xiaoyuan TU, and Radek Grzeszcuk. 1994. Artificial fishes: Autonomous locomotion, perception, behaviour, and learning in a simulated physical world. *Artificial Life I* 4: 327–351.

Thalmann, Daniel. 1994. Automatic control and behavior of virtual actors. In *Interacting with Virtual Environments*, ed. Lindsay MacDonald et al., pp. 217–228. New York: Wiley.

Theilmann, Rudolf, ed. 1973. *Die Lebenserinnerungen von Eugen Bracht*. Karlsruhe: n.p.

Tholen, Christoph. 1995. Der befremdliche Blick. In *Phantasma und Phantome: Gestalten des Unheimlichen in Kunst und Psychoanalyse*, ed. Martin Sturm, pp. 11–34. Linz: Schriftenreihe Offenes Kulturhaus.

Thompson, Jack George. 1988. *The Psychobiology of Emotions*. New York: Plenum Press.

Thompson, Jeremy, ed. 1993. *Virtual Reality: An International Directory of Research Projects*. London: Meckler.

Thompson, Steven L. 1987. The big picture. *Air and Space* (April/May): 75–83.

Tice, Steve, and Linda Jacobson. 1992. The art of building virtual realities. In *Cyberarts: Exploring Art and Technology*, ed. Linda Jacobson, pp. 280–286. San Francisco: Miller Freeman.

Tintelnot, Hans. 1951. *Die barocke Freskomalerei in Deutschland: Ihre Entwicklung und europäische Wirkung*. Munich: F. Bruckmann.

Tittel, Lutz. 1981. Monumentaldenkmäler von 1871 bis 1918 in Deutschland. Ein Beitrag zum Thema. In *Kunstverwaltung, Bau- und Denkmalpolitik im Kaiserreich*, ed. Ekkehard Mai et al., pp. 215–276. Berlin: Gebr. Mann.

Toeplitz, Jerzy. 1979. *Geschichte des Films 1895–1928*. Berlin: Henschel.

Toffler, Alvin and Heidi Toffler. 1995. *Creating a New Civilization: The Politics of the Third Wave*. Preface by Newt Gingrich. Atlanta, GA: Turner.

Toulet, Emmanuelle. 1995. *Pioniere des Kinos*. Ravensburg: Ravensburger Buchverlag.

Toynbee, Jocelyn. 1929. The villa item and a bride's ordeal. *Journal of Roman Studies* 19: 67ff.

Trietsch, Walter, ed. and trans. 1956. *Dionysos Areopagita: Mystische Theologie und andere Schriften*. Munich: Barth.

Trismegistos, Hermes. 1964. *Die XVII Bücher des Hermes Trismegistos*. Icking: Alaska.

Turing, Alan. 1950. Computing machinery and intelligence. *Mind* 59, no. 236: 433–460.

Turkle, Sherry. 1995. *Life on the Screen: Identity in the Age of the Internet*. New York: Simon and Schuster.

Valéry, Paul. 1973. Die Eroberung der Allgegenwärtigkeit. In *Über Kunst*, ed. Paul Valéry. Frankfurt/Main: Suhrkamp.

Van den Boom, Holger. 1991. Künstliche Intelligenz und Fiktion. In *Strategien des Scheins: Kunst Computer Medien*, ed. Florian Rötzer and Peter Weibel, pp. 96–109. Munich: Boer.

Vannugli, Antonio. 1984. Aggiunte a Pietro Mulier. *Storia dell'arte* 50: 131–135.

Varoli-Piazza, Rosalia, ed. 1981. *La Sala delle Prospettive: Storia e Restauro.* Rome: Comas Grafica.

Varoli-Piazza, Rosalia. 1987. Il fregio della Sala delle Prospettive un'ipotesi per la Bottega del Peruzzi. In *Baldassare Peruzzi: Pittura scena e architettura nel cinquecento*, ed. Marcello Fagiollo et al., pp. 363–398. Rome: Istituto della Enciclopedia Italiana.

Vasari, Giorgio. 1976 (1568). *Le Vite*, vol. IV. Florence: Studio per Editioni scette.

Vattimo, Gianni. 1998. Die Grenzen der Wirklichkeitsauflösung. In *Medien-Welten Wirklichkeiten*, ed. G. Vattimo et al., pp. 15–26. Munich: Fink.

Vief, Bernhard. 1988. Bild ohne Dimensionen—Das Computerbild. In *Fotovision: Projekt Fotografie nach 150 Jahren*, adapted by Bernd Busch et al., pp. 240–243. Hannover: Sprengel-Museum.

Vincent, Jean Didier. 1990. *Biologie des Begehrens: Wie Gefühle entstehen.* Reinbek: Rowohlt.

Virilio, Paul. 1986a. *Krieg und Kino.* Munich: Hanser.

Virilio, Paul. 1986b. *Ästhetik des Verschwindens.* Berlin: Merve.

Virilio, Paul. 1989. *Die Sehmaschine.* Berlin: Merve.

Virilio, Paul. 1991. Das öffentliche Bild. In *Digitaler Schein*, ed. Florian Rötzer, pp. 343–345. Frankfurt/Main: Suhrkamp.

Virilio, Paul. 1992a. *Rasender Stillstand.* Munich: Hanser.

Virilio, Paul. 1992b. Achtung, Augen auf! In *Medienkunstpreis 1992*, ed. Zentrum für Kunst und Medientechnologie Karlsruhe (ZKM), pp. 41–51. Karlsruhe: ZKM.

Virilio, Paul. 1994. *Die Eroberung des Körpers: Vom Übermenschen zum überreizten Menschen.* Frankfurt/Main: Fischer.

Virilio, Paul. 1998. *La bombe informatique.* Paris: Galilée.

Virtual Reality World'96. 1996. Conference Documentation, ed. Computerwoche Verlag. Munich: Computerwoche Verlag.

Vogt, Adolf Max. 1969. Boulées Newton-Denkmal. Sakralbau und Kugelidee. Basel: Birkhäuser.

Volino, P., M. Courchesne, and N. Magnenat Thalmann. 1995. Versatile and efficient techniques for simulating cloth and other deformable objects. In *SIGGRAPH'95 Proceedings*, ed. Robert Cook and Leo Hourvitz, pp. 137–144. New York: ACM.

Vossische Zeitung (Berlin). Sept. 2, 1883, no. 409, morning edition, Das Sedan-panorama, pp. 2–3.

Waffender, Manfred, ed. 1991. *Cyberspace.* Reinbek: Rowohlt.

Wagner, Richard. 1887. *Gesammelte Schriften.* Leipzig: Fritzsch.

Walker, John. 1988. Through the looking glass: Beyond user interfaces. Internal paper, September. Sausalito CA: Autodesk.

Wallach, Alan. 1990. Making a picture of the view from Mount Holyoke. *Bulletin of the Detroit Institute of Arts* 66, no. 1: 35–46.

Walser, Randal. 1988. On the road to Cyberia. Internal paper, November. Sausalito, CA: Autodesk.

Walser, Randal. 1990. The emerging technology of cyberspace. In *Ars Electronica 1990*, vol. 2, ed. Gottfried Hattinger et al., pp. 197–201. Linz: Veritas-Verlag.

Warburg, Aby. 1988. *Schlangenritual: Ein Reisebericht.* (Lecture, Apr. 21, 1923, Kreuzlingen.) Berlin: Wagenbach.

Warburg, Aby. 1991. Einleitung zum Mnemosyne-Atlas. In *Die Beredsamkeit des Leibes. Zur Körpersprache der Kunst*, ed. Ilsebill Barta Fliedl and Christoph Geissmar, pp. 171–173. Vienna: Residenz-Verlag.

Warburg, A. 1995 (1923). *Images from the Region of the Pueblo Indians of North America.* Ithaca: Cornell Univ. Press.

Warnke, Martin. 1992. *Politische Landschrift: Zur Kunstgeschichte der Natur.* Munich: Hanser.

Weber, Bruno. 1985. Formen und Funktionen älterer Panoramen: Eine Übersicht. *Zeitschrift für Schweizerische Archäologie und Kunstgeschichte* 42: 257–268.

Weber, Bruno. 1993. La nature à coup d'oeil: Wie der panoramatische Blick antizipiert worden ist. In *Sehsucht: Das Panorama als Massenunterhaltung des 19. Jahrhunderts* (exhib. catalog), ed. Kunst und Ausstellungshalle der Bundesrepublik Deutschland in Bonn, pp. 20–27. Frankfurt/Main: Stroemfeld/Roter Stern.

Weibel, Peter. 1989a. Der Ausstieg aus der Kunst als höchste Form der Kunst. *Kunstforum* 98: 60–75.

Weibel, Peter. 1989b. Momente der Interaktivität. *Kunstforum* 103: 87–99.

Weibel, Peter. 1990. Des Kaisers neue Körper. In *Ars Electronica 1990*, vol. 2, ed. Gottfried Hattinger et al., pp. 9–38. Linz: Veritas-Verlag.

Weibel, Peter. 1991a. Transformationen der Techno-Ästhetik. In *Digitaler Schein*, ed. Florian Rötzer, pp. 205–248. Frankfurt/Main: Suhrkamp.

Weibel, Peter. 1991b. Abschied vom Vertrauten. *Du. Die Zeitschrift der Kultur* no. 11: 49–51; 100.

Weibel, Peter. 1992. Endo and Nano über die Grenzen des Realen. In *Endo und Nano. Ars Electronica*, ed. Peter Gerbel, pp. 8–12. Linz: PVS-Verlag.

Weibel, Peter. 1993. Virtuelle Realität: Der Endo-Zugang zur Elektronik. In *Cyberspace*, ed. Florian Rötzer et al., pp. 15–46. Munich: Boer.

Weibel, Peter. 1994a. Die Welt der Virtuellen Bilder. *Camera Austria*, no. 15: 42–51.

Weibel, Peter. 1994b. Vom Bild zur Konstruktion Kontextgesteuerter Ereigniswelten. *Camera Austria International*, no. 49: 33–45.

Weibel, Peter and Edith Decker, eds. 1991. *Vom Verschwinden der Ferne: Telekommunikation und Kunst*. Cologne: Du Mont.

Weidemann, B. 1988. *Psychische Prozesse beim Verstehen von Bildern*. Bern: Huber.

Weintraub, Annette. 1995. Artifice, artifact: The landscape of the constructed digital environment. *Leonardo* 28, no. 5: 361–367.

Weizenbaum, Joseph. 1976. *Computer Power and Human Reason. From Judgement to Calculation*. San Francisco: W. H. Freeman.

Weizenbaum, Joseph. 1992. Künstliche Intelligenz als ein Schlüssel zur elektronischen Produktion von Wissen? In *Interface I: Elektronische medien und künstlerische Kreativität*, ed. Klaus Peter Denker, pp. 166–174. Hamburg: Hans-Bredow-Institut für Rundfunk und Fernsehen.

Welsch, Wolfgang. 1995. Künstliche Paradiese? Betrachtungen zur Welt der elektronischen Medien und zu anderen Welten. *Paragrana* 1, no. 4: 255–277.

Werner, Anton von. 1896. *Ansprachen und Reden*. Berlin: Schuster.

Werner, Anton von. 1913. *Erlebnisse und Eindrücke 1870–1890*. Berlin: Mittler.

Wertheim, Margaret. 1996. Lux interior. *21C*, no. 4: 26–31.

Wertheim, Margaret. 1999. Out of this world. *New Scientist* (Feb. 6): 38–41.

Wertheim, Margaret. 1999. *The Pearly Gates of Cyberspace*. New York: Norton.

Wesenberg, Burkhardt. 1985. Römische Wandmalerei am Ausgang der Republik: Der zweite Pompejanische Stil. *Gymnasium* 92: 470–488.

Wesenberg, Burkhardt. 1991. Zur Bildvorstellung im großen Fries der Mysterienvilla. *Kölner Jahrbuch für Vor- und Frühgeschichte* 24: 67–72.

Wheatstone, C. 1838. Contributions to the physiology of vision. Part I. On some remarkable and hitherto unobserved phenomena of binocular vision. *Philosophical Transactions of the Royal Society of London* 128, Part II: 371–394.

Whitelaw, Mitchell. 1998. Tom Ray's hammer: Emergence and excess in A-Life art. *Leonardo* 31, no. 5: 377–381.

Whitley, William T. 1968. *Artists and Their Friends in England 1700–1799*, vol. 2. New York: Benjamin Blom.

Wiener, Norbert. 1961. *Cybernetics or Control and Communication in the Aniimal and the Machine*. Cambridge, MA: MIT Press.

Wilcox, Scott. 1993. Erfindung und Entwicklung des Panoramas in Großbritannien. In *Sehsucht: Das Panorama als Massenunterhaltung des 19. Jahrhunderts* (exhib. catalog), ed. Kunst und Ausstellungshalle der Bundesrepublik Deutschland in Bonn, pp. 29–35. Frankfurt/Main: Stroemfeld/Roter Stern.

Willim, Bernd, ed. 1992. *Designer im Bereich Animation und Cyberspace. Aus- und Weiterbildungsmöglichkeiten in Deutschland*. Berlin: Drei-R-Verlag.

Wilson, E. O. 1975. *Sociobiology*. Cambridge, MA: Harvard Univ. Press.

Wingler, Hans M., ed. 1985. *Die Bühne am Bauhaus*. Mainz: Kupferberg.

Winnicott, D. W. 1973. *Vom Spiel zur Kreativität*. Stuttgart: Klett-Cotta.

Witasek, Stephan. 1910. *Psychologie der Raumwahrnehmung des Auges*. Heidelberg: Winter.

Witmer, Bob. 1998. Measuring presence in virtual environments: A presence questionnaire. *Presence: Teleoperators and Virtual Environments* 7, no. 3: 225–240.

Wohlfeil, Rainer and Trudl Wohlfeil. 1982. Landsknechte im Bild: Überlegungen zur "Historischen Bildkunde." In *Bauer Reich und Reformation*, ed. Peter Blickle, pp. 104–119. Stuttgart: Ulmer.

Wolf, Alfred. 1930. Die germanische Sippe *bil*. In *Uppsala Universitets Årsskrift*, pp. 17–156. Uppsala: Lundequist.

Wolf, Fritz. 1998. Kino für Stereogucker. *M* 3: 14.

Wonders, Karen. 1993. *Habitat Dioramas: Illusions of Wilderness in Museums of Natural History*. Uppsala: Almqvist and Wiksell.

Woolley, Benjamin. 1992. *Virtual Worlds*. Oxford: Blackwell.

Yates, Francis A. 1966. *The Art of Memory*. Chicago: Chicago Univ. Press.

Youngblood, Gene. 1970. *Expanded Cinema*. New York: E. P. Dutton.

Youngblood, Gene. 1989. Metadesign. *Kunstforum* 98: 76–84.

Youngblood, Gene. 1991. The Aura of the Simulacrum. Der Computer und die Zukunft der Kunst. Lecture at the Kunsthochschule für Medien, Cologne, May 14, 1991. Edited version by Jürgen Kisters, *Kunstforum* 114: 398–399.

Zahorik, Pavel. 1998. Presence as Being-in-the-World. *Presence: Teleoperators and Virtual Environments* 7, no. 1: 78–89.

Zec, Peter. 1991. Das Medienwerk. In *Digitaler Schein*, ed. Florian Rötzer, pp. 100–116. Frankfurt/Main: Suhrkamp.

Zehentbauer, Joseph. 1992. *Körpereigene Drogen: Die ungenützten Fähigkeiten unseres Gehirns*. Munich: Artemis and Winkler.

Zell, Andreas, et al. 1994. Low cost 3D visualisation of neural networks. In *Virtual Reality '94 Proceedings*, ed. Hans-Jörg Bullinger, pp. 161–169. Berlin: Springer.

Zelzer, David. 1994. Virtual actors and virtual environments. In *Interacting with Virtual Environments*, ed. Lindsay MacDonald et al., pp. 229–255. New York: Wiley.

Zglinicki, Friedrich von. 1979. *Der Weg des Films*. Hildesheim: Olms.

Zielinski, Siegfried. 1999. *Audiovisions: Cinema and Television as Entr'actes in History*. Amsterdam: Amsterdam Univ. Press.

ZKM. 1997. *Hardware—Software—Artware: Die Konvergenz von Kunst und Technologie. Kunstpraktiken am ZKM Institut für Bildmedien 1992–1997*. Ostfildern: Cantz.

ZKM and Heinrich Klotz, eds. 1997. *Jeffrey Shaw—A User's Manual: From Expanded Cinema to Virtual Reality*. Ostfildern: Cantz.

Zuboff, Shoshana. 1988. *In the Age of the Smart Machine: The Future of Work and Power*. New York: Basic Books.

Zuse, Conrad. 1969. *Rechnender Raum*. Braunschweig: Viehweg.

Exhibition Catalogs

(Berlin 1993) *Anton von Werner, Geschichte in Bildern*, ed. Dominik Bartmann. Berlin: Hirmer.

(Berlin 2000) *Sieben Hügel: Bilder und Zeichen des 21. Jahrhunderts*, ed. Bodo Baumunk. Berlin: Henschel.

(Bern 1975) *Junggesellenmaschinen/Les Machines Célebataires*, ed. Harald Szeemann, Kunsthalle Bern. Venice: Alfieri.

(Bonn 1993) Sehsucht: Das Panorama als Massenunterhaltung des 19. Jahrhunderts, ed. Kunst und Ausstellungshalle der BRD, Marie-Louise von Plesser. Ffrankfurt/Main: Stroemfeld/Roter Stern.

(Bonn 1998) *Der elektronische Raum: 15 Positionen zur Medienkunst*, ed. Kunst und Ausstellungshalle der BRD. Ostfildern: Cantz.

(Dortmund 2000) Vision Ruhr: Kunst Medien Interaktion, ed. Christoph Blasé. Ostfildern: Hatje Cantz.

(Duisburg 1997) *InterAct! Schlüsselwerke Interaktiver Kunst*, ed. Söke Dinkla. Ostfildern: Hatje Cantz.

(Duisburg 1999) Connected Cities: Processes of Art in the Urban Network, ed. Söke Dinkla. Ostfildern: Hatje Cantz.

(Gorizia 1994) *Panorami della Mitteleuropa*, ed. Mariano de Grassi. Monfalcone: Edizione della Laguna.

(Hamburg 1993a) *Mediale*, ed. MACup Verlag and Mediale Büro. Hamburg: MACup Verlag.

(Hamburg 1993b) *Post Human*, ed. Jeffrey Deitch (New York 1992). Feldkirchen: Oktagon.

(Linz 1990) *Ars Electronica*, 2 vols., ed. Gottfried Hattinger et al. Linz: Brucknerhaus.

(Linz 1991a) *Der Prix Ars Electronica 1991, Internationales Kompendium der Computerkünste*, ed. Hannes Leopoltseder. Linz: Veritas-Verlag.

(Linz 1991b) *Out of Control, Ars Electronica*, ed. Karl Gerbel. Linz: Landesverlag Veritas-Verlag.

(Linz 1993) *Der Prix Ars Electronica 1993, Internationales Kompendium der Computerkünste*, ed. Johannes Leopoldseder. Linz: Veritas-Verlag.

(Linz 1996a) Der Prix Ars Electronica 1996, ed. Johannes Leopoldseder. Vienna: Springer.

(Linz 1996b) Memesis: The Future of Evolution, Ars Electronica 1996, ed. Gerfried Stocker. Vienna: Springer.

(Linz 1999) LifeScience: Ars Electronica 99, ed. Gerfried Stocker. Wien: Springer.

(London 1988) Panoramania! The Art and Entertainment of the "All-embracing" View. Introduction by Scott B. Wilcox, ed. Ralph Hyde. London: Trefoil.

(Madrid 1996) "A-Volve": Evolution Artificial, by Christa Sommerer and Laurent Mignonneau. Madrid: Fundation Arte y technologia.

(Monterrey 1997) Arte Virtual Realidad Plural, ed. Karin Ohlenschläger. Monterrey: Museo de Monterrey, Mexico.

(Munich 1994) Rosebud: Jenny Holzer, Matt Mullican, Lawrence Weiner, ed. Michael Tarantino et al. Munich: Städt Galerie im Lenbachhaus.

(New Haven 1985) The Art of Paul Sandby, ed. E. Bruce Robertson. New Haven: Yale Center for British Art.

(New York 1968) The Machine as Seen at the End of the Mechanical Age, ed. Pontus Hultén. New York: Museum of Modern Art.

(New York 1993) Iterations: The New Image, ed. Timothy Druckrey. (International Center of Photography, New York.) Cambridge, MA: MIT Press.

(Paris 1990) Décors de l'imaginaire, Papiers peints panoramiques, 1790–1865, ed. Odile Nouvel-Kammerer. Paris: Musée der Arts Décoratifs.

(Rome 1981) La Sala delle Prospettive. Storia e Restauro, ed. R. Varoli Piazza. Rome: Comas Grafica.

(Rostock 2001) Natürlichkünstlich: Artificial Life, ed. Enno Kaufhold. Berlin: Joris.

(Saint Denis 1994) Artifices 3: Salle de la Légion D'Honneur, 6 place de la Légion d'Honneur, ed. Jean-Louis Boissier et al. Saint Denis: Direction des affaires culturelles.

(San Francisco 2001) 010101: Art in Technological Times, ed. John S. Weber et al. San Francisco: San Fransciso Museum of Modern Art.

(Schwäbisch-Hall 1986) Louis Braun (1836–1916) Panoramen von Krieg und Frieden aus dem Deutschen Kaiserreich, exhibition and catalog by Harald Siebenmorgen. Schwäbisch-Hall: Hällisch-Fränkisches Museum.

(Tokyo 1993) Ulrike Gabriel: Perceptual Arena: Space Paradox Interactive Environment, Canon Artlab 3, Tokyo.

(Tokyo 1996a) Seiko Mikami: Molecular Informatics: Morphogenetic Substance via Eye-tracking, Canon Art Lab, Tokyo.

(Tokyo 1996b) 3D-Beyond the Stereography, ed. T. Moriyama. Tokyo: Tokyo Metropolitan Museum of Photography.

(Tokyo 1997) *ICC Concept Book*. Tokyo: NTT InterCommunication Center.

(Toronto 1995) *Press Enter: Between Seduction and Disbelief*, ed. Alison Reid. Toronto: The Power Plant Contemporary Art Gallery at Harbourfront Centre.

(Warsaw 1995) *Lab 5*. International Film, Video and Computer Art Exhibition, Centre of Contemporary Art, Warsaw.

(Zürich 1989) *Imitationen*, ed. Jörg Huber. Frankfurt/Main: Stroemfeld/Roter Stern.

(Zürich 1993) *Zeitreise, Bilder, Maschinen, Strategien, Rätsel*, ed. Georg Christoph Tholen. Museum für Gestaltung Zürich. Frankfurt/Main: Stroemfeld/Stern.

Author Index

Subject Index

Actors, 145, 155

Advanced Technology Research Institute (ATR), 175

Aerial perspective, 32

Aesthetic pleasure, 16, 17

A-Life (artificial life), 7, 297, 300–304, 329, 333n34
artful games, evolution of images, and, 304–308
subhistory, 320–326

A-Life's party, 308–320

Animals. *See A-Volve*; Transgenic art

Anthropology, new, 226

Archetypes, 221, 229, 230, 261n34

Architectonic designs/structures, 151

Architecture, and computers, 165

Ars combinatoria, 230–231

Art and science, 3–4, 216, 324–325

ART+COM, 288, 289

Art history, 4, 6

Artificial intelligence (AI), 220, 223–225, 315

Artificial life, 7, 279, 281, 297, 323–324. *See also* A-Life

Artificial space, 29

Artist, depersonalization of, 122

Artistic style, relinquishment of, 122

"As if," 17, 252

Aspen-Moviemap (Naimark), 244

Atari, 167, 244

Aura, 127

Authoritarianism, 110

Automata, 281, 321, 328. *See also* Knowbots

Automation, 279

Avatars, 175, 199, 245–247, 252, 271, 288, 290, 344

Avignon, 36

A-Volve, 300–307, 314, 316, 317

Balustrade, 58–59

Banff Center for the Arts, 174

Barriers, eradication of, 144–145. *See also* Observer

Battle of Champigny, The (Robida), 108, 109

Battle of Sedan, The (Werner), 6, 91, 94, 95, 105, 107–108, 110–112. *See also* Sedan panorama rotunda
battle in the picture, 92–96
central conceptual element, 113
opening, 91–92
political objectives, 101–103, 109
power of illusion, suggestion, and immersion, 96–98

Franco-Prussian War of 1870–1871, 91–93, 103. *See also Battle of Sedan, The*

Frescoes, 5, 6, 8, 13, 25, 27, 29, 33, 35–39, 42, 44, 46, 49, 53, 298, 341, 349

Futurama, 148–150

Futurist Cinema Manifesto of 1916 (Marinetti), 144

Futurist stage, polydimensional, 144, 145

Galápagos (Sims), 312–313

Games, artful, 306, 307

Genetic art, 297–300, 327. *See also A-Volve*

Genetic engineering, 226, 326–328

German Reich, 92

Germany, 91. *See also See also Battle of Sedan, The*

Gesamtkunstwerk, 126

GFP K-9, 327, 328

Global data networks, 219, 345

Glove, data, 167

God and Golem (Wiener), 283

Graphics interfaces, computer, 166. *See also Osmose*

Graphics programs, 162, 256–257

Graphic user interface (GUI), 256

Great Frieze in the Villa dei Misteri at Pompeii, 25

Gulf War, 172

Gunfire, 240. *See also* Battles

Habituation, 152

"Happening," 205

Head-mounted display (HMD), 163, 195, 196, 198, 206, 245, 247, 251

Headtracking, 163

Heaven, 46–49

"Hindustan" panorama wallpaper, 61

Holy Mount at Varallo, The (Bordiga), 41–42

Home of the Brain—Stoa of Berlin, The (Fleischmann and Strauss), 218–222, 224, 225, 228–231, 245, 247, 271

Homo ludens, 345

Horizontal view, 111, 114

Human Interface Technology Lab (HIT), 167

Hyperrealism, 275

Idolatry, 32

Illusion(s), 342. *See also* Trompe l'oeil; *specific topics*

of being in picture (*see* Immersive (image) strategies; Observer)

in cinema, 146, 151–152

classic function of, 17

media for, 141

mystery, magic, and pictorial, 32

power of, in *The Battle of Sedan*, 96–98

representatives of spatial, 49

Illusionism, 14–18, 45, 119, 121–122. *See also* Trompe l'oeil

Illusion spaces, 5, 6, 8, 16, 340. *See also* Panorama(s)

360°, 59, 62, 340

Image(s). *See also specific topics*

"artistic," 11

evolution of, 304–307

history of, 279

metamorphosis of concept, 7

nature and meaning of, 16, 205, 279

poles of meaning, 14

science of the, 11–13

Knowbotic Research (RK+cF), 213–217

Knowbots (knowledge robots), 213, 214, 267

"La nature à coup d'oeil," 56

Landscape Room in Drakelowe Hall (Sandby), 55

Landscapes, 32–35, 39, 54–56, 115

illusionistic, 56–60

unity and uniformity, 32

Welsh, 54, 57

Language, visual, 235

La Plissure du Texte (Ascott), 272

Leicester Square, 58

Le Panorama de la Bataille de Champigny (Robida), 108, 109

Life

concept of, 318

power over, 329

Life forms, artificial. *See A-Volve*

Light and lighting methods, 31, 59, 97, 111, 206

in cinema, 152

London. *See* England

Lord Howe's Victory and The Glorious First of June (R. Barker), 91

Mathematical morphogenesis, 318

Media art, 3–4, 10

Media evolution, art and, 173–176

Media strategy, 7

Media theory, Virilio's, 227

Memes (memory units) and meme theory, 325–326

Memory Theater VR (Hegedues), 231–234

Mentopolis, 223

Military actions, glorifying, 110

Mimesis, 15, 16

Mind-body dualism, 278

Mirrors, 280

Modern art, 7

Modernism, 100, 130n24

Moore's Law, 170

Morphogenesis, mathematical, 318

Movement, impression of, 108

Murmuring Fields (Fleischmann and Strauss), 245

Music. *See* Opera; Sound

Myths, 279, 346

Napoleonic Wars, 91

NASA, 167

Nature and natural sciences, 37, 57, 204, 271–272, 324, 325

Nave of Sant'Ignazio, The (Pozzo), 46, 47

Neue Nationalgalerie (New National Gallery), 219–220

"Objectification of view," 40

Observation, 17

Observer. *See also* Computer(s), "ultimate" union with; Immersion

desire to be in picture, 141

effect on medium, 110

in the image, 174

installed in panorama, 57

"integration" of, 29

position of ideal, 63

relocated in the image, 339

removing distance between image space and, 143

Odyssey, The, 31–32

Oikeiosis, 223

Omnimax, 159–160

Opera, as grand illusion, 50

"Opera Aperta" (Eco), 205

Optics and painting, 105